Renaissance jewels, gold boxes and objets de vertu

THE THYSSEN-BORNEMISZA COLLECTION

Renaissance jewels
gold boxes and objets de vertu

Anna Somers Cocks and Charles Truman

GENERAL EDITOR SIMON DE PURY

Sotheby Publications

30270

Photographic acknowledgments

AMSTERDAM
Rijksmuseum

BALTIMORE, MARYLAND
Walters Art Gallery

BERLIN
Staatliche Museen, Preussischer Kulturbesitz

CAMBRIDGE
Fitzwilliam Museum

CORNING, NEW YORK
Corning Museum of Glass

DRESDEN
Stadtmuseum

FLORENCE
Museo degli Argenti
Museo Mediceo

FRIBOURG
Leo Hilber

HAMBURG
Staats- und Universitätsbibliothek

LEEDS
City Art Gallery

LENINGRAD
State Hermitage Museum

LONDON
HM the Queen (Lord Chamberlain's Office)
Trustees of the will of the late Earl Berkely
British Museum
Christie's
Stanley Eost and Peter MacDonald
Museum of the Order of St John
S. J. Phillips
Richard Philp Collection
Public Record Office
A. K. Snowman Collection
A. von Solodkoff Collection
Sotheby's
Victoria and Albert Museum
Wallace Collection

LÜBECK
Museum für Kunst- und Kulturgeschichte

LUTON HOO
Wernher Collection

MUNICH
Alte Pinakothek
Bayerische Staatsbibliothek
Bayerische Staatsgemäldesammlungen
Schatzkammer der Münchner Residenz

NEW HAVEN, CONNECTICUT
Yale Center for British Art, Paul Mellon Collection

NEW YORK
A la Vieille Russie
Hispanic Society of America
Metropolitan Museum of Art

PARIS
Bibliothèque Nationale
Musée de Cluny
Musée du Louvre

SEVRES
Musée Nationale de Ceramique

STOCKHOLM
Nordiska Museet

SZCZECIN
Muzeum Narodowe

VIENNA
Kunsthistorisches Museum
Museum für Angewandte Kunst

WADDESDON
National Trust, Waddesdon Manor

ZURICH
Edwin Bucher Collection

© The Thyssen-Bornemisza Collection 1984
First published in 1984 for Sotheby Publications by
Philip Wilson Publishers Ltd
Russell Chambers, Covent Garden, London WC2E 8AA

All rights reserved. No part of this publication may be reproduced,
stored in a retrieval system or transmitted in any form
or by any means without prior permission of the publisher.

ISBN 0 85667 172 X

Designed by Gillian Greenwood
Typeset in England by Jolly & Barber Ltd, Rugby
Printed in Belgium by Snoeck, Ducaju & Zoon, NV, Ghent

Contents

Acknowledgements

I must thank, first and foremost, Mr Claude Blair, former Keeper of the Department of Metalwork, Victoria and Albert Museum, and Mrs Shirley Bury, Keeper, for their innumerable pieces of good advice and for reading my manuscript. The late Dr John Hayward also lent his encyclopedic knowledge of his particular field to reading the text. Apart from these, I have had much counsel and help from Miss Marian Campbell, Mr Anthony North and Mrs Madeleine Ginsburg, all of the Victoria and Albert Museum; Mr E. Besley of the Coins and Medals Department, Miss Judy Rudoe, Mrs Charlotte Gere and Mr R. Good, of the Department of Medieval and Later Antiquities, British Museum; Dr Reynold Higgins, Miss Janet Arnold; Dr Rudolf Distelberger and Dr Manfred Leithe-Jasper of the Kunsthistorisches Museum, Vienna; Dr Lorenz Seelig of the Residenz Schatzkammer, Munich; Dr K. Aschengreen Piacenti and Dr M. McCrory of the Museo degli Argenti, Florence; Mme E. Taburet of the Musée de Cluny, Paris; Dr P. Arnold of the Münzkabinett and Dr K. Arnold of the Städtisches Museum, Dresden.

Anna Somers Cocks

Of the many authorities who have kindly offered advice in the preparation of this catalogue, I should particularly like to thank Mrs Clare Le Corbeiller of the Metropolitan Museum of Art, New York, Miss Julia Clarke of Sotheby's and Mr Alexander von Solodkoff of Christie's, and, of course, the redoubtable Mr Kenneth Snowman whose pioneering works still form the basis for the study of gold boxes and Fabergé.

Charles Truman

Foreword

The Thyssen-Bornemisza Collection is best known for its paintings. It is now considered the greatest private collection in the world, second only to the Royal Collection of England. It is the achievement of two generations of passionate collectors: Baron Heinrich Thyssen-Bornemisza (1875–1947) and his son, Baron Hans Heinrich Thyssen-Bornemisza (b. 1921), present owner of the collection.

The former began to collect during the 1920s and at the outset, his goal was to illustrate a panorama of European paintings ranging from the fourteenth to the eighteenth century. He was then living in the castle of Rohoncz in Hungary, and it is as 'Sammlung Schloss Rohoncz' that the collection first became known. Due to the revolution of Bela Kun, the Baron was forced to leave Hungary for Holland. In 1930 the general public became aware of the collection when a large part of it received its first exhibition at the Neue Pinakothek in Munich.

In 1932, Baron Heinrich Thyssen-Bornemisza bought the Villa Favorita, a late seventeenth-century house on the shores of the Lake of Lugano, where he decided to spend the rest of his life. Next to the villa he built a gallery to hold his collection. After his death, his son, Hans Heinrich, opened the gallery to the public during the summer season. He inherited an important part of his father's collection and in an effort to re-assemble the whole began to buy back from his elder brother and his two sisters paintings which they had inherited. As a result, he acquired a passion for collecting which has not left him to the present day. He gradually ventured into areas that had not been covered by his father, such as European and American paintings of the nineteenth and twentieth centuries. These acquisitions now outnumber the collection of old master paintings. With a collection expanding on a near daily basis, the Villa Favorita soon became too small to contain it all. Since 1977, therefore, part of the collection has been in Daylesford House, Gloucestershire, the country house that was built between 1788 and 1796 for Warren Hastings (1723–1818) by Samuel Pepys Cockerell (1753–1823).

Baron Thyssen-Bornemisza feels that all of these works were not created just for his own exclusive pleasure; he believes in sharing them with a wider public. Over the last few years parts of the collection of paintings have been exhibited in Europe, the United States of America, the Soviet Union, Japan, Australia and New Zealand.

The one aspect of the Thyssen-Bornemisza Collection that has so far remained virtually unknown is the collection of decorative works of art. The present Baron's father had acquired a number of carpets, medieval works of art, sculpture and Renaissance furniture, some of which was catalogued in 1941 by Adolf Feulner. The present Baron has assembled an important group of Renaissance jewels, gold boxes, *objets de vertu*, silver, medieval ivories, Renaissance bronzes and furniture. The contents of this catalogue is entirely due to his own collecting efforts. The only criterion for acquisition of all the works discussed here was the appeal they held for the Baron.

This volume is the first in a series of catalogues to be published over the next few years, on all the various aspects of the Thyssen-Bornemisza Collection. Eminent scholars in each field have been invited to write material more informative than a mere inventory of what is in the collection. The ultimate aim is to create a comprehensive survey of each particular subject that will be of equal interest to the scholar and to the general public.

Simon de Pury

INTRODUCTION

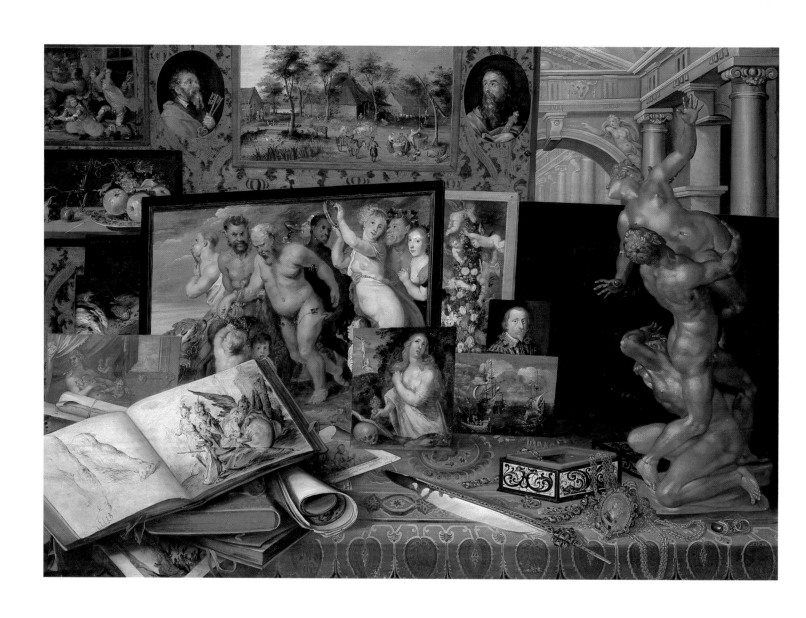

1 *Etienne de la Hyre. The Kunstkammer of Prince Vladislaus Sigismundus Vasa, future King Vladislaus* IV *of Poland, 1626. Some of the Prince's jewellery, all of the wearable sort, spills out from an ebony box at the front, and among it is a Gnadenfpennig with his portrait (private collection)*

ONE

Jewellery, princes and treasuries in the High Renaissance

The modern hierarchy of art values, still so dominated by the fine arts, makes it difficult for one to appreciate how important jewels, semi-precious stone vessels and bejewelled works of art were to the sixteenth-century collector. At the very heart of Grand Duke Francesco de Medici's galleries in the Uffizi was his octagonal treasure chamber, the Tribuna, designed by Buontalenti to hold the pick of his collection. The vaulted ceiling was covered with mother-of-pearl on a blue ground, a rich mosaic lined the floor, busts and statuettes adorned the walls and the finest paintings filled the spaces in between. Below were secret doors which opened to reveal semi-precious stone cups, vessels of mother-of-pearl and rock crystal. In the centre, like a tabernacle to a chapel, was a small temple of ebony inlaid with semi-precious stones, and in this were kept the most valuable objects of all, the cameos and jewels.[1] Typically, today only paintings and sculpture remain in this room.

Of course, princes and noblemen had always owned precious objects and jewels; it was their duty to 'live nobly', to look magnificent, to keep great state, and to make lavish presents of jewels and plate. But during the sixteenth century, the attitude towards such precious objects changed, and it is largely because of this change that more jewels of this period have come down to us than from the whole of the Middle Ages put together. First, the concept of crown jewels came into being; that is, a certain group of pieces – regalia, of course, but also other purely decorative works – were no longer to be the exclusive property of the ruler to do with as he pleased, but were inalienable property of his line or of the State, as the case might be. Second, the formation of organised collections, the *Kunstkammers* of the German princes (fig 1), the *Cabinet du Roi* of the French king, with their curators and their inventories again meant that the depradations were to some extent limited as the objects were admired for their individual qualities more than for just their intrinsic value.

François I was the first to declare a group of jewellery crown jewels: by Letters Patent dated 15 June 1530 eight pieces (none of them regalia) were decreed to be property of the State, never to be alienated.[2] The concept of the State was of course a relatively new one, and the kings of France and their theorists were busy identifying the monarchy with it. Thus, by emphasising the office as opposed to the person, the act of establishing crown jewels increased the status of both. The *Chambre de Comptes* was put in charge of these jewels, while the King's personal jewels came under the *trésorier de l'epargne*, Jean de le Barre, governor and Provost of Paris. The emphasis in the Letters Patent is very much on the gemstones and their values rather than on the jewellery as such. For example, one of the pieces is described simply as being 'a pendant with, in the middle, a large diamond called the Pointe-de-Bretagne, worth 27,000 *écus*'.[3] None of these pieces of jewellery, nor even the gemstones, survives in any form which is recognisable from this list, not least because the terms of the Letters Patent explicitly allowed them to be reset as long as their quantity and size remained unchanged; indeed, they were re-modelled as soon as 1559, on the occasion of the succession of François II.[4]

On the other hand, when Duke Albrecht V of Bavaria made his Disposition of 19 March 1565 which linked twenty-seven pieces of jewellery and jewelled objects to his dynasty (he did not say State because that would have been inappropriate for a dukedom which was part of the

Holy Roman Empire) in perpetuity, he was quite clear that he meant those very objects, not just the precious materials of which they were made. They were not to be sold, nor pawned unnecessarily, nor to be changed into any other form, and if they were damaged, then they were to be repaired 'without being made smaller, or having anything removed'. These twenty-seven pieces then went into the treasury tower of the old medieval ducal residence while at the same time, 1563–67, a building was being put up which was for Albrecht's *Kunstkammer*.[4] This strictly worded Disposition has led to eight of these original pieces coming down to us.

The distinction between crown jewels and personal jewels is also apparent in the inventory made in 1619 of the deceased Emperor Matthias's possessions, and the 'Hauskleinodien', which included all the imperial regalia, are explicitly excluded.[5] These also survive, in the treasury of the Kunsthistorisches Museum, Vienna.

Both the French and the Bavarian decrees were due to an increased dynastic awareness, the same which had led Emperor Maximilian I (permanently short of money as he was, and always on the move, so that he never had an opportunity to set up a Treasury) to buy two of the famous pieces of jewellery which had been captured along with Charles the Bold's possessions at the battle of Grandson in 1476. These were the so-called Feather, and a jewelled garter of the Order of the Garter,[6] and he paid the powerful, international imperial banking family, the Fuggers of Augsburg 38,000 florins for them in 1513. Maximilian was married to Charles's daughter and heiress, Mary, a union which brought with it Burgundy and the Netherlands, and was of great significance to the Habsburg line, so it was because of their association that these already legendary great jewels were highly desirable. The Fuggers, who also owned the other great Burgundian jewel set with three table-cut diamonds known as the Three Brothers, continued to hope that they would sell it to the Hapsburgs. In 1555, Anton Fugger says that they had turned down an offer from Sultan Soliman the Magnificent (Sultan of Turkey, 1620–66) because they believed 'that such a noble jewel . . . would remain among Christians and also would return to the lands of Austria'.[7] In the event it was never bought by the Hapsburgs, but acquired by Henry VIII of England, descended to James I, and has since disappeared.

A combined historical and dynastic awareness also makes itself felt in the inventories of the lesser nobility as in the will of Sir Robert Campbell of Glenurquhy, dated 19 May 1640. It begins by listing pieces given to the family by James V of Scotland, and Anne of Denmark, Queen of James I of Great Britain (VI of Scotland), and then it describes 'Ane stone of the quantity of half ane hen's egg set in silver, being flat at the ane end and round at the other like ane peire, Sir Colin Campbell first laird of Glenurquhy wore when he fought in the Battell at Rhodes against the Turks, he being ane of the knights of Rhodes'.[8] This refers to an ancestor of two centuries earlier, and the jewel itself, obviously not something of great intrinsic value or adornment, was kept for reasons of family piety and historical interest.

The state portraits of the period cram in as many of these jewels as possible, identifying the person of the ruler with his riches, and making this image of power and splendour public. For example, when a peace treaty was signed between Spain and Great Britain in 1605, Juan Pantoja de la Cruz, the Spanish court painter, depicted Margaret of Austria, Queen of Philip III, for a portrait which was sent to England, in a dress woven with heraldic devices of the parts of Spain and of the Empire, and around her neck the famous 'joyel de los Austrias', a great square table diamond in an enamelled scrolling setting, and a chain of lozenge shaped and circular elements closely set with diamonds (fig 3). Apparently, she wore these at the signing of the peace treaty and also later, at the tournaments celebrating the baptism of her son Philip IV;[9] the same diamond-set chain appears worn by Philip IV in a portrait of some twenty-five years later,

2 *Watercolour of a pendant offered to Henry VIII in 1546 by his agent in Antwerp (Public Record Office, London)*

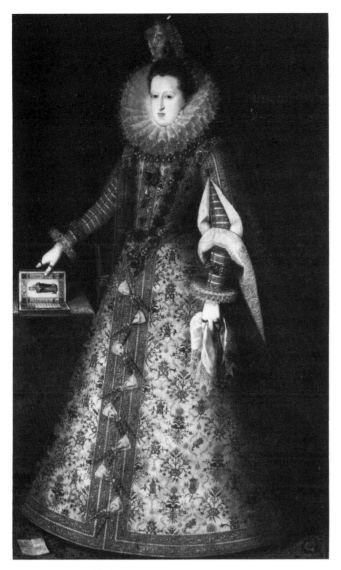

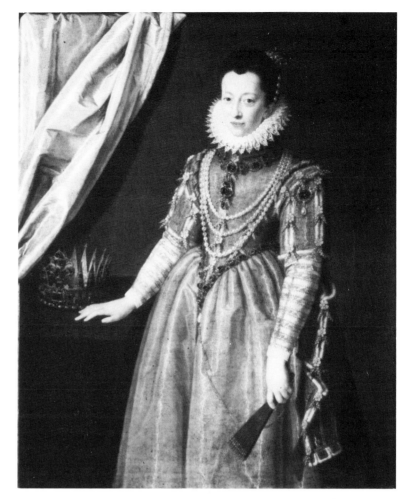

3 *Juan Pantoja de la Cruz, Margaret of Austria, Queen of Philip III of Spain, 1605 (Royal Collection, Hampton Court)*

4 *Scipio Pulzone. Cristina di Lorena, painted shortly after her marriage in 1590 to Ferdinand I de Medici (Museo Mediceo, Florence)*

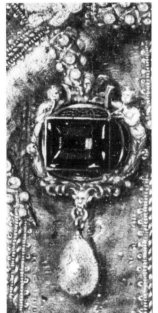

5 *Detail of fig 4, showing what is almost certainly the same pendant as in fig 2*

now in the Carnegie Institute, Pittsburgh.

These great jewels are so accurately depicted that they can be followed from portrait to portrait, and in some cases the progress of a piece around Europe can be traced. Thus, Henry VIII was offered a pendant set with a diamond valued at 50,000 crowns by the Antwerp branch of the Fugger bank in 1546; its appearance is known from a watercolour in the Public Records Office, London (fig 2).[10] What is almost certainly the same pendant turns up, worn on the arm of Cristina di Lorena, wife of Grand Duke Francesco de Medici, in a state portrait of about 1590 in the Museo Mediceo (figs 4 and 5). To supplement these accurate depictions of the great, and for the most part, vanished, jewels of the day are the inventories which in some cases are detailed enough to give a very good picture of what they are listing. The 1619 inventory of Emperor Matthias's collections is a particularly good one, and many of the cameos now in the Kunsthistorisches Museum, Vienna, have been identified in it. The section on chains, all lost, is typical: '1049 A ducat-gold chain with twisted elements, weighing 67 ducats; 1050 A knitted chain with 6 lengths, weighing $67\frac{1}{2}$ crowns; 1051 A curb chain one width long, weighing $72\frac{1}{2}$ crowns; 1052 A "muzzle" chain, weighing together with the golden lamb $11\frac{1}{2}$ crowns; 1053 A rectangular wirework chain, weighing together with the golden fleece $88\frac{1}{2}$ crowns. . . .'[11]

François I's Letters Patent of 1530 actually included a painting of each of the pieces listed; this has now vanished, but the pictorial inventory of the jewels of Anna of Bavaria painted between 1552 and 1555 by Hans Mielich still survives (see fig 1, cat. no. 7).[12]

The whole collecting movement, which gained momentum throughout the sixteenth century until there was scarcely a prince in Europe who did not have a collection of works of art, antiquities and jewels, contributed to this improved accuracy of recording. (The great exceptions to this trend were Emperor Charles V and Elizabeth I of England. Although quantities of valuable works of art passed through Charles's hands, there was not, except perhaps in the case of the Altarpiece of San Yuste by Titian, the identification with them shown by, for example, the Bavarian dukes or Emperor Rudolph II. As for Elizabeth, while she was very happy to accept the outward signs of her subject's loyalty in the form of jewels, she was not interested in spending money on any works of art or jewellery beyond what was necessary for her adornment.) For the most part, however, there was great competition for anything which was rare, curious or beautiful; as Duke Albrecht V of Bavaria's Council expressed it, 'Whenever he hears of or sees anything costly, exotic or curious, anything which gives pleasure and delight, that he wishes to own, nay he must own; so messengers are sent, letters written, and everyone involved [in acquiring it]' (fig 6).[13]

The collections which were being formed in Germany, in particular, reflected the late Renaissance preoccupation with the wonders of the world: they were a Theatrum Mundi, a microcosm of everything made by God and man, the Naturalia and the Artificialia, combined with a third category, Antiquitas, represented by the remains of the classical world.[14] This is what the Augsburg patrician and art dealer, Philip Hainhofer, alludes to when he writes to the Duke of Pommern-Stettin in 1611 saying that the Duke of Bavaria, the Elector of the Pfalz, the Duke of Mantua and the Duke of Württemberg all have collections of rock crystal vessels, and that these are 'most suitable for princes . . . because they are both Nature and Art'.[15] These collections were being organised into categories according to an intellectual scheme thus making them the earliest form of museum. Archduke Ferdinand II (1529–95), whose famous Kunstkammer survives relatively intact in Ambras, the castle near Innsbruck where he set it up, arranged his objects according to the admirably simple method of dividing them by materials and keeping them in special cupboards painted a colour to complement them: thus the gold and silver-gilt pieces had blue behind them, the brown musical instruments, white, and so on.[16] In 1602, Henri IV appointed the antiquarian, Rascas de Bagarris (b. 1562), his cimèliarque to collect together, after the depredations of the previous war-ridden years, what remained of the Cabinet du Roi, which, more strictly classical than the German equivalents, had contained engraved gems, medals and antiquities. His instructions were to inventory it and seek new acquisitions, and one of the rooms in the palace of Fontainebleu was made available to house it.[17] A similar role was played at various times by the Mantuan-born architect, designer, antiquarian and numismatist, Jacopo Strada (1507–88) for Emperor Maximilian II and for Albrecht V of Bavaria.

The greatest Kunstkammer collector of them all was Emperor Rudolph II. He had intended to make a great collection which would be not only for himself, but to the honour of the whole Austrian house, and to this end he had runners searching for him all over Europe and bringing back pieces to his residence, the Hradschin in Prague. He typified the Mannerist obsession with exotic materials like ivory, ebony, pietra dura, minerals of all sorts, and of course gems, both engraved and set as gemstones. Virtuoso goldsmiths' work he loved, and, like Francesco de Medici, he was friends with his top goldsmith. Towards the end of his life he became more and

6 *Miniature showing unmounted stones in the possession of Duke Albrecht V of Bavaria, tempera on vellum, 1551 (Bayerisches Nationalmuseum, Inv. no. R 8220)*

more of a recluse, so the revelation of what his castle actually contained after his death in 1612 caused great excitement. The fluent and gossipy Venetian Ambassador, Girolamo Soranzo, writes letter after letter to the Doge describing the rumours flying around, '. . . every day new curiosities are found in the Emperor's palace, there being more than three thousand pictures by famous artists, both old and modern, and they fill not only all the halls, galleries and rooms but there are so many wrapped up, and piled up in corners that instead of adorning the palace, they make it almost wearisome because there are so many. Of precious vases and jewels more are being found hidden in every corner and in every nook, but day by day the sum of money is dwindling, and they say for certain that it will not be more than a million in gold'.[18] This vast collection was divided up between Rudolph's various heirs, and only a small proportion of it survives, but nearly all those pieces which have done so, significantly enough, descended to modern times preserved by the Habsburg dynasty, and reverted to the imperial collections, finally to go on display in the Kunsthistorisches Museum, Vienna, thus making it the direct heir of Rudolph's *Kunstkammer*.

Jewellery and precious objects, besides being important as the outward signs of a prince's standing, were also a supplementary currency by which the courtiers and court officials were rewarded, and other princes and their ambassadors honoured. The giving of gifts was in many cases reciprocal, confirming the bond of friendship or loyalty between both parties; the practice has survived until the present day.

The presents were given mostly on certain well-established occasions, the most important annual one being New Year, the others being all rites of passage, that is, weddings, coronations, christenings; and visits to towns and important subjects, and the reception of embassies. By the early seventeenth century, the kinds of presents had become largely standardised,[19] with the average wedding present from, for example, the Emperor to a member of the lesser nobility, or a court employee, costing about 25 to 30 gulders, and the transaction organised automatically through the court exchequer.

The presents given by Ferdinand II on his coronation as King of Bohemia in 1617 give an idea of the sliding scale of costs according to rank.

> To the Lord Chamberlain, von Osterhausen, a chain for 200 gulders.
> To von Schonberg, President of the Privy Council, a chain for 400 gulders.
> To the Chancellor, a Privy Councillor, a chain for 300 gulders.
> To von Prandenstein, a chain for 300 gulders.
> To von Loss, imperial mint master, a chain for 200 gulders.
> To his brother, also a Privy Councillor, a chain for 200 gulders.
> To von Wolframstorf, a chain for 100 gulders.
> To the Master of the Horse, Taube, a chain for 100 gulders.
> To the Captain, Pflug, a chain for 100 gulders. . . .
> To the head huntsman, Ziegerer, a drinking vessel for 50 gulders.
> To the head cook, a drinking vessel for 50 gulders.
> To the five gentlemen in waiting . . . each a drinking vessel for 50 gulders. . . .
> To the rest of the nobility according to the occasion and if they ask for something.[20].

The artistry which went into making chains and vessels for such ritualised gifts was probably not very great. For example, when Anton Fugger was charged with getting the presents which the town of Augsburg was going to give to the Emperor's secretary and the Duke of Alba after its capitulation in 1547, he instructed that a double cup be made worth at least 3000 crowns but 'as plain as possible', 'quite smooth' and without 'elaboration and embossing' in order to save on the making cost, and for a second similar present, he said that that 'it should not be beautiful as it will be broken up soon'.[21]

This rather mercenary and calculating attitude towards the ritual did not of course totally supplant unexpected and more personal acts of splendid prodigality, such as the Venetian

ambassador, Girolamo Soranzo, recounts in June 1612. Apparently the Archbishop of Mainz had sent the Empress Anna a bowl of perfumed cherry wood via his nephew, and Matthias 'not knowing how else to honour the little boy, took from his own neck a beautiful diamond necklace worth 12,000 *scudi* and put it on him'.[22] The fact that he bothered to tell the Doge about it suggests, however, that it was a rare occurrence.

Notes

1 K. Aschengreen Piacenti, *Il Museo degli Argenti* (Milan, 1968) p 7

2 G. Bapst, *Histoire des Joyaux de la Couronne de France* (Paris, 1889) pp 3–9

3 *ibid*, p 7 and note 2. Bapst quotes from the inventory of the Crown Jewels (Arch. Nat. J, 947); the Pointe-de-Bretagne was the same which had belonged to Anne of Brittany and which, in 1496, she paid the diamond cutter Jehan Cayou to 'passer sur son moulinet pour la retailler'

4 *Schatzkammer der Residenz, München*, catalogue (Munich, 1970) pp 7–20; quoted from the Geheimes Hausarchiv in the Hauptstaatsarchiv München, 5/2 no. 1253

5 *Jahrbuch der Kunsthistorischen Sammlungen* XX (1899) pp XLI-CXXIII

6 Lhotsky, p 133 and note 113

7 Lieb II, pp 137–38

8 S.R.O. GD. 112/20/ Box 5/ 51–3 Breadalbane f. 1. I am most grateful to Miss Ierne Grant for drawing my attention to this will

9 Muller, pp 53–54; see also *Princely Magnificence* no. 26

10 P.R.O. SP1/213, see *Princely Magnificence*, no. G48

11 . . . '1049 Ain ducatenguldene Ketten mit krausten gliedern, wigt 67 ducaten. 1050 Ain gestrickte ketten mit 6 lenge wigt 67½ cronen; 1052 Ain Maulkorbketten, wigt sambt dem gulden lambl 11½ cronen; 1051 Ain panzerketten ain breite lang wigt 72¾ cronen; Ain tratharbeitketten, vierecket wigt sambt den gilden fliess 88½ cronen' . . . *Jahrbuch der Kunsthistorischen Sammlungen* XX (1899) pp XLI-CXXIII

12 Bayerische Staatsbibliothek, Cod. icon. 429

13 . . . 'sonder was man chostlichs, frembds oder seltzams sieht, wovon man hort, sonderlich was zu freid und lust dient, das will man haben, man muess haben; da schickt man, da schreibt man, da schafft man den nechsten an . . .' From a Protocol of the Ducal Council, 1557, quoted in Krempel, p 115

14 The classic work on this subject is J. von Schlosser, *Die Kunst- und Wunderkammern der Spätrenaissance. Ein Beitrag zur Geschichte des Sammelwesens* (Leipzig, 1908); see also the introduction to the *Catalogue of the Kunstkammer* at Schloss Ambras (Innsbruck, 1977) and E. Scheicher, *Die Kunst- und Wunderkammern der Hapsburger* (Vienna, 1979)

15 From a letter dated 20 Feb–2 March 1611. Quoted in O. Doering, 'Des Augsburger Patricier Philipp Hainhofer Beziehungen zum Herzog Philipp II von Pommern-Stettin', *Quellenschriften für Kunstgeschichte und Kunsttechnik* VI (1894)

16 See *Catalogue of the Kunstkammer* at Schloss Ambras (Innsbruck, 1977) note 14

17 Babelon, p CXIX

18 Dispacci di Germania, Senato III Secreta 46, f. 3v and 4, *Jahrbuch der Kunsthistorischen Sammlungen* XX (1899) no. 17099

19 For an essay on the sociological significance of this present-giving, see P. Burke, 'Renaissance Jewels in their Social Setting', *Princely Magnificence*

20 'Dem Hofmarschall von Osterhausen ain khett per 200 gulden.
Dem von Schonberg, geheimen rat praesidenten, ain khett per 400 gulden.
Dem canzler und geheimen rat ain khetten per 300 gulden.
Dem von Prandenstein ain khetten per 300 gulden.
Dem von Loss, reichspfennigmeister, ain khetten per 200 gulden.
Seinem brudern, auch geheimen rat, ain khettern per 200 gulden.
Dem von Wolframstorf, ain khetten per 100 gulden.
Dem stallmaister Taube ain khetten per 100 gulden.
Dem obersten Pflug, ain khetten per 100 gulden. . . .
Jagermaister Ziegerer trinkgeschirr per 60 gulden.
Oberkuchelmaister trinkgeschirr per 50 gulden.
5 camerjunkhern . . . jedem ain geschirr von 24 gulden . . .
Denen anderen vom Adel darbei nach gelegenhait und erkundigung.'
Quoted in *Jahrbuch der Kunsthistorischen Sammlungen* XX (1899) pt II, no. 17370

21 Lieb II, p 146

22 . . . 'Ne sapendo con che altra maniera honorar quel figliuolino, si levó dal proprio collo una bellissima collana di diamanti di valore di 12000 scudi e la pose al collo di lui' from a letter to Doge Leonardo Doná (Dispacci di Germania, Senato III, Secreta 46 f. 114 and v.) *Jahrbuch der Kunsthistorischen Sammlungen* XX (1899) no. 17125

The gold snuff-box in the eighteenth century

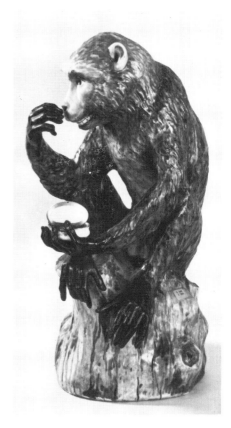

7 Pompeo Batoni, Sir Thomas Gascoigne (Lotherton Hall, Leeds, Leeds City Art Gallery)

8 Figure of a monkey satirising the habit of snuff-taking, hard-paste porcelain, painted in enamels and gilt, Meissen, circa 1733, modelled by J. G. Kirchner (Thyssen-Bornemisza Collection, Lugano)

The man of taste in the eighteenth century was obliged to conform to the prevalent social habit of the day, the taking of snuff, and in consequence it would have been usual for him to equip himself with an elegant and fashionable gold box to contain the aromatic herb. Louis-Sebastien Mercier, writing at the close of the *ancien régime* advised a gentleman to carry a different box for every day of the year, using a heavy box in winter and a lighter one for summer.[1] Indeed the snuff-box was considered such an important part of a man's, or woman's attire that we find portraits in which the sitter is depicted with one, as, for example, in the portrait of Maria Louisa of Parma by Pécheux in the Metropolitan Museum of Art, New York,[2] or that of Juste-Mathieu

Boucher by Deshays de Colleville,[3] or the splendid Pompeo Batoni of Sir Thomas Gascoigne at Lotherton Hall, Leeds (fig 7).[4] Another example is the miniature of a lady of the court with her snuff-box in the lid of cat. no. 83. Indeed, so popular was the taking of snuff that it soon became satirised, even by the sculptors and modellers at the Meissen porcelain factory (fig 8). Furthermore the social acceptability of the snuff-box is demonstrated by the large number which were offered as diplomatic gifts by the kings of France.

The history of the snuff-box and of snuff-taking has been dealt with elsewhere.[5] However, an examination of the function of these rich and complex pieces of goldsmith's work within the context of royal present-giving, and of their production, may assist in the appreciation of these microcosms of eighteenth-century art.

The continuing practice of royal present-giving is well documented in France for the years between 1668 and 1786. The records of the diplomatic gifts, *Les Registres des Presents du Roi*, are preserved in the Ministère des Affaires Etrangères in Paris.[6] By the end of the seventeenth century, the system had become more or less standardised, the most usual gift being the *boîte à portrait* whose precise form has been a matter for dispute amongst scholars. Maze-Sencier and

9 Engraving by Mondon inscribed 'Boîte à Portrait que le Roi dóne aux Princes et aux Ambassadeurs'

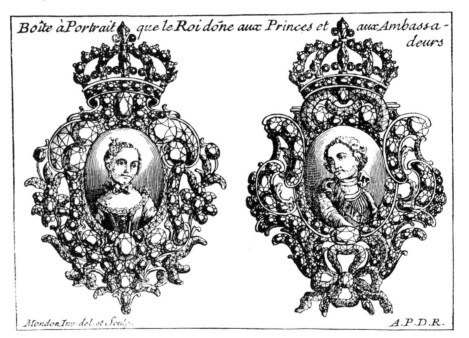

Nocq appear to agree that a *boîte à portrait* is not a box as such but a framing for a miniature.[7] In support of this argument Nocq and Dreyfus illustrate a design by Mondon which clearly shows two miniatures mounted in elaborate settings of precious stones and which is inscribed 'Boîte à Portrait que le Roi dóne aux Princes et aux Ambassadeurs' (fig 9). However, Sir Francis Watson considers that the design is for the lid of a box set with the miniatures, and sites as a prototype for *boîtes à portrait* the small turned ivory boxes which enclosed miniatures such as that by Hans Holbein of Anne of Cleves now in the Victoria and Albert Museum.[8] Nevertheless, it seems probable from the *Registres des Presents du Roi* that at least in the late seventeenth and early eighteenth century a distinction was made between *boîtes à portrait* and *boîtes d'or* or *tabatières*. For example, on 19 July 1719, M. de Koenigseck, a German ambassador, received a box set with forty-nine brilliants and a portrait of the King in enamel by Chatillon which is referred to as a *boîte d'or* rather than as a *boîte à portrait*.[9] Two boxes by Daniel Gouers now in the Louvre, both containing portraits of the King, are described as *tabatières* in the *Registre* for 3

February 1726 and 10 February 1727.[10] A further, and later, indication of this distinction is found in the entry for August 1730 where a *tabatière* by Gouers containing a portrait of Louis XV valued at 3678 livres and presented to M. Franken, the envoy from the Palatinate, is listed whereas the gift to the English ambassador, Horace Walpole, was a *boîte à portrait* set with diamonds valued at 13,021 livres.[11] However, the term had certainly become interchangeable by the mid 1770s, for a box given to the Sardinian ambassador, comte de Viri, is referred to as both a *boîte à portrait* in 1775 and as a *tabatière* in 1777.[12]

Whatever their form, these extravagant diplomatic gifts were supplied by various *marchands-orfèvres-joailliers* throughout the period covered by the *Registres*: Daniel Gouers, Laurent Rondé, Jean Ducrollay, Pierre-André Jacqmin, Louis-Phillippe Demay, Jean-Michel Solle and Ange-Joseph Aubert.

The cost of these presents is a key both to the rank of the recipient and to the service which he had performed. Thus, on 30 November 1685 Count Wielopolski, the Polish Chancellor and ambassador, received a *boîte à portrait* valued at 22,030 livres whilst his secretary, M. Tavenoski was given a gold chain worth 1500 livres.[13] One cannot but wonder, as does Maze-Sencier, what M. le Marquis Scotti, the envoy from Parma, had done to deserve the gift of a box set with fifty-two brilliants and fifteen rose diamonds containing a portrait of the King by Massé which cost a staggering 129,852 livres on 29 March 1720.[14]

An indication of the purely financial significance of these boxes is provided by the case of a box given to Walpole, plenipotentiary minister from England, in 1771, which had been given to Baron Gleichen in the previous year and returned for cash, and which may be the same box given to the Papal nuncio.[15] An even more obvious case is the box given to the Sardinian ambassador, comte de Viri. In honour of the marriage of Mme Clotilde de France to the prince of Piedmont in 1770, de Viri received a box valued at 29,940 livres which he promptly returned to the goldsmith, Solle, who had supplied it. On 7 August 1777, the same box was presented to him once again, and the ambassador once more sent it back to Solle, who on the nineteenth of the same month sold it back to the Ministère des Affaires Etrangères. Less than a month later the box reappears in the *Registres*, described as being set with rubies, ninety-seven diamonds and with green foliage. At this date it was noted that the box had been 'emaillée en jonquille' when given to the comte de Viri.[16]

Following the Revolution, Napoleon continued the custom of presenting boxes and several bearing his portrait are known. One in the Victoria and Albert Museum by Veuve Blerzy was presented by the Emperor to Captain Ussher commander of HMS *Undaunted* which carried Napoleon into exile on Elba in 1814 (fig 10), and another, in the British Museum, was a gift to the sculptor Mrs Seymour Damer in 1815.

The practice of presenting gold boxes was followed elsewhere in Europe although it appears to be less well documented than in France. Frederick the Great certainly gave away some of the astonishing boxes which were commissioned by the Fabrique Royale from the goldsmiths Christian Ludwig Gotzkowsky, Veitel Ephraim and his son, from André and Jean-Louis Jordan and Daniel Baudesson. For example, two were given to members of the Anhalt-Dassau family and one to the Furst Dohna-Schlobitten (cat. no. 96). That the custom held at the Austrian court is witnessed by the gold box with enamels painted by Philip Ernst Schindler (cat. no. 100) given by Maria-Theresa to Maximilian Joseph of Bavaria.

In England, where the political force lay with Parliament rather than with an absolute monarch, and where the structure of the court differed from that of France or Germany, the gift of royal boxes tended to be of a personal rather than of a political nature. However, the box

became the standard gift of city corporations when bestowing honorary freedoms of cities on particular dignitaries. The City of London, for example was wont to provide boxes of fifty, one hundred, 150, or 200 guineas with honorary freedoms. This right to confer Honorary Freedom was restricted solely to the Corporation of the City of London in England, and to the corporations of Scotland and Ireland by acts of Parliament in 1835 and 1882. For some reason, which ought to be explainable other than by a statement of Irish generosity, the cities of Ireland were particularly free with the distribution of boxes. An example is that presented by the city of Cork to Viscount Royston in 1802 (cat. no. 107).

10 *Snuff-box of gold, enamelled and set with pastes and a miniature of Napoleon, given by the Emperor to Captain Ussher, commander of* HMS *Undaunted, the ship which carried him to exile on Elba. The box by Veuve Blerzy, Paris, 1809–14 (Victoria and Albert Museum, London)*

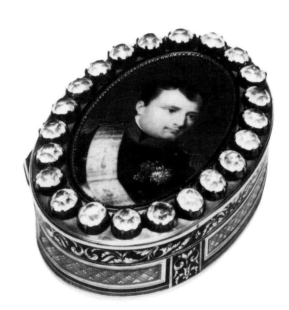

Notes
1 Le Corbeiller, p 15
2 Le Corbeiller, p 92
3 Nocq and Dreyfus, frontispiece
4 Anthony Wells-Cole, *Gold boxes and étuis in the Leeds Art Galleries* (n.d.) back cover
5 Notably Snowman (1966), (1974), Le Corbeiller, Watson and in the Waddesdon catalogue
6 Maze-Sencier, pp 164–84
7 Nocq and Dreyfus, p VI
8 Watson, p 94
9 Maze-Sencier, p 167
10 Grandjean, nos 121 and 122 and Maze-Sencier, p 168
11 Maze-Sencier, p 169. In the eighteenth century the French units of currency were the écu = 3 livres, and 1 livre = 20 sous. For most of the eighteenth century, 24 livres were equivalent to the English pound sterling, or the French louis
12 Maze-Sencier, p 180
13 Maze-Sencier, p 165
14 Maze-Sencier, pp 167–68
15 Maze-Sencier, p 179
16 Maze-Sencier, p 180

The production and acquisition of jewellery and treasury pieces in the High Renaissance

A surprisingly large amount of the jewellery and the luxury works of art of the High Renaissance could be bought ready-made rather than bespoke. Some of it was obviously not the most expensive sort, but, for example, the 'openwork rosettes and buttons' for which Archduke Ferdinand paid Simon Cordie, a 'Jubelier' from Nürnberg, 1143 gulden in 1613.[1] Some of these had been bought at the Shrove Tuesday fair in Graz, and may perhaps have been of the stamped-out, filigree enamel sort like the rosettes in cat. no. 20. Other ready-made pieces on the market were, however, very costly, and, astonishingly, there are accounts of them being sent by post across Europe to their prospective buyer. The Antwerp goldsmith, Leonard Zaerle, who worked in Frankfurt and enjoyed a close relationship with the Florentine court goldsmith, Jaques Bylivelt, and thus had the entrée to the Grand Dukes, repeatedly sent pieces to Florence at his own risk; in 1593, for example, a diamond-set parrot and pelican arrived, wrapped to look like ordinary letters.[2] When ready-made pieces were offered around the courts it was usually by a middleman, rather than by the maker himself: these were often dealer-goldsmiths, like the Simon Cordie mentioned above, and nearly always members of a goldsmiths' guild, although not necessarily working goldsmiths themselves. It is interesting that the Grand Duke Ferdinand needed the offices of Cordie to acquire jewels from the fair held in his own home town. The Milanese workshops specialising in the costly semi-precious stone vessels used a dealer called Giovanni Antonio Scala to travel to Munich in early 1573 with two crystal vessels worth 500 scudi and an emerald matrix ewer worth 400.[3] The jewel-loving James I of England and his queen, Anne of Denmark, used the services of, among others, the Dutchman Arnold Lulls, whose book of record paintings, coupled with some jewellery designs, is now in the Victoria and Albert Museum.[4] The same role was played for the imperial court at the end of the sixteenth century by the Augsburg dealers, Arnold I Schanternell, Philipp II Warnberger and George Beuerl.[5] These middlemen had to have considerable capital resources as they often bore the huge expense of acquiring stones and having a piece made for a long time before they were paid: the great diamond-set trophy of Duke Maximilian of Bavaria which is dated 1603 was supplied by Beuerl who had to wait until 1610 for the 1300 florins which he was owed for it.[6]

The small fair at Graz has already been mentioned, but the bulk of the jewellery changed hands at the great fairs of Antwerp, Frankfurt and St Germain, and anywhere where the Augsburg banking family, the Fuggers, had a branch, there also was active dealing in precious objects. Indeed, if one was having a new piece made and needed precious stones, one could either send to Venice, Antwerp, or Lisbon, the great jewel-trading centres, or go straight to the Fuggers. In 1536, stocktaking showed that out of a working capital of 3,811,000 florins they had 20,000 in gemstones.[7] In 1546, Anton Fugger, the head of the firm, surveying the market with an experienced eye, recommended finding a buyer for some stones at the Regensburg Reichstag where there would be a notable assembly of the great and rich, rather than in Venice where the market happened to be depressed,[8] and he was kept up to date on his factor, Johann von Schuren's purchases in Lisbon from 1549–1551, by means of pictures of the stones.[9]

Venice, Lisbon, Antwerp and Paris were the great gem-trading centres. The stones arrived in

Venice either via the Persian Gulf and Constantinople, or via Aden, Cairo and Alexandria. Lisbon, and then Antwerp, additionally got them via the Cape Route discovered in 1498. Most diamonds used in Renaissance jewellery came from India. The sources of rubies could have been Afghanistan as well as Ceylon and Burma, but close examination of a number of sixteenth-century pieces in the Victoria and Albert Museum has shown them all to be Burmese. Sapphires almost certainly came from the large deposits in Ceylon although, again, Burma was also a possibility. Emeralds were mined in Egypt and at Habachtal in the Salzburg Alps until the exploitation of the Colombian mines by the Spanish from the 1550s onwards provided a massive alternative source for them (see the contemporary gemmologist, Anselm de Boodt's remarks on this subject, pp 46–48).

Pearl fisheries existed in the Persian Gulf, the Gulf of Manaar off the coast of Ceylon and, for a while, along the coasts of Venezuela, especially near Trinidad.[10]

With the second quarter of the sixteenth century and the Spanish conquest of the Inca empire, gold began to be shipped over in large quantities from Peru, but up till then it had been obtained in small quantities from many of the metalliferous areas of Europe, often as a by-product of base metal mining. There were deposits in Wales, Scotland, Ireland, Spain, Piedmont, Bohemia, Transylvania and Serbia, and much of the gold in circulation was old gold melted down.[11]

In many instances, new stones were not needed as old pieces of jewellery were broken up and supplied by the client himself. In 1581, for example, Jaques Bylivelt made a small ring for the Cardinal de Medici in Rome, and this was set with twenty-five diamonds, twenty-four of which had belonged to the Cardinal.[12] The pieces which were sacrificed to make the Liechtenstein ducal coronet are actually known, because it is recorded that Daniel de Briers, the Frankfurt dealer in charge of the project, took with him from the Liechtenstein treasury a mass of loose stones – thirty-three large and ninety-nine small diamonds totalling $38\frac{1}{2}$ carats, sixteen rubies totalling 19 carats, twenty-six pearls, two rings and an old box setting – plus two presumably outmoded pieces, a jewel which the duke had only just bought.[13]

Of all the princes of the period, Emperor Rudolph II was the one who tried most seriously to improve his own personal supplies of gemstones. His court was at Prague, the capital of Bohemia, a land rich in semi-precious stone deposits, principally garnets and the quartz family such as cornelian, amethyst, chrysoprase, agate and so on. As the Jesuit Balbinus said, writing at the end of the seventeenth century, the stone which the herdsman threw at the cow there was often more valuable than the cow itself,[14] so Rudolph was sitting on the means to improve his personal wealth and satisfy his craving for exotic materials which was both aesthetic and quasi-scientific in its motivation. Thus, on 3 May 1588, he issued a general mandate decreeing that stones should be looked for in the whole of Bohemia; in 1590, he granted the stone-cutter Mathes Khraz a patent to look for stones in the whole kingdom, and in 1601 he sent stone-cutters to Baden to look for minerals, and the Markgrave Georg Friedrich gave them access to his mines.[15]

It is not known exactly what success he had, but the many loose garnets and crystals listed in the inventory of his possessions probably include some of the finds made for him, and he may have been able to supply his semi-precious stone carving workshop with its raw materials. For the true precious stones, the ruby, diamond, emerald and so on, he would, of course, have had to turn to the same sources as everyone else.

The choice of places to have one's jewellery made up was enormous. At least in Germany, every qualified goldsmith was theoretically capable of making jewellery as one of the tests

before attaining mastership was the making of a ring. Since there were dozens of towns with goldsmiths' guilds, one can assume that there was an almost equal number of centres where at least the simple sorts of jewellery – gold chains and rings – could be made. There has been a strong tendency in studies of Renaissance jewellery to attribute all surviving pieces to the major centres, particularly those on which more research has been done, but in fact any town with a court as well as any flourishing mercantile town probably had some level of jewellery production. An insight into the state of affairs in Leipzig, a medium-sized town under the Elector of Saxony, in the 1580s, is given by an account of the problems of a certain Sebastian von der Felde. He had gone to Nürnberg to learn filigree making, 'Parisian' work, as it was called. On his return he fell foul of the restrictive practices of the local goldsmiths' guild of which he was not a member; eventually, because there was no one in the town who could do this sort of work, he was permitted, 'To make small chains, enamelled rings, rosettes and other Parisian work, also bracelets of hollow drawn work where the wire is soldered lengthways; but he may not make large chains even if hollow, rings set with stones, and all the work which the goldsmiths here are capable of, at risk of severe punishment by the Council'.[16] This reveals that Leipzig, not usually believed to have been of any significance in the production of jewellery, made at least the more ordinary sorts of it and could also support a specialised craftsman.

The most sophisticated works of the day required a wide range of skills from the goldsmith, so not surprisingly the workshops in the major centres of production show considerable specialisation. Of the numerous goldsmiths who worked for the Medici Grand Dukes in the last third of the sixteenth and the early seventeenth centuries, three, Matteo and Savestro Castrucci, and Alfonso Cervi mostly made usable plate; one, Michele Mazzafirri, worked for the mint and at casting silver statuettes; two, Joris Distelhof and Giovanni Domes, both Flemings, specialised in enamelled gold work, and only three, Giovanbattista Cervi, Lorenzo della Nera, and the head of the workshop Bylivelt himself, practised all aspects of the craft.[17] Furthermore, these craftsmen were backed up by a fluctuating but usually large number of highly specialised 'lavoranti' such as Zacharia Vais, a German goldsmith and stone setter, who was employed by Bylivelt from July 1585 to 1587.[18]

Thus, if one wanted something simple one would get it from one's local centre, if something more expensive and lavish, one turned to one of the exporting towns. In Germany, Nürnberg dominated the scene during the first half of the century, and in the second half, Augsburg. In the 1540s Nürnberg was making pieces for as far afield as Denmark and Poland, and Albrecht of Brandenburg, first Duke of Prussia, bought repeatedly from there, as when in 1545 he paid 5208 gulden for 171 rings to give away as presents.[19] Augsburg was definitely in the ascendant in the second half of the century, not least because of its favoured position vis à vis the Emperor, and because it was the centre of the flourishing international Fugger banking network. But Munich had also become a major centre because of the discrimination and interest in goldsmiths' work of Dukes Albrecht v and Wilhelm v, and further afield, Hamburg and Frankfurt were obviously rising to importance.[20] Emperor Maximilian II (1562–76), who bought jewellery to the extent expected of a great prince for the required present-giving, but who had no personal passion for it, gave his commissions largely to Augsburg and Munich – in 1571 to Hans Hurlinger and Georg Reiger in the former, and Isaac Melper and Georg Unger in the latter – but he also gave expensive work to the Viennese goldsmiths and on the occasion of the marriage of the Duke of Prussia he ordered a splendid necklace from the Antwerp family of 'Juweliers', the Schmissart.[21] In the second half of the century, the Bavarian dukes bought exclusively from Munich and Augsburg goldsmiths.

As mentioned above, the important commissions nearly always went through a middleman and the work was then farmed out. A well-documented example of this is the making of the Abbot of Averbode's pectoral cross. Between 1549 and 1565, the abbot of this Premonstratensian monastery was a luxury-loving man called Mattieu 's Volders who restocked the treasury after a fire.[22] Over a period of fourteen years he gave a number of lavish commissions for liturgical plate which was often gem-set to the Antwerp goldsmith, Renier van Jaerswelt, and in 1562 he commissioned a pectoral cross for himself (see fig 5, cat. no. 7). The relevant document shows that van Jaerswelt bought the stones for it, got Hans Collaert the Elder to design it and Hieronymus Jakob, a Frankfurt goldsmith working in Antwerp, to make it. Similarly, the contract for the making of the Liechtenstein ducal coronet was given to the Frankfurt 'Juwelier' Daniel de Briers who had also supplied the imperial court, but the actual making was by Jobst von Brussel with minor assistance by Godtfried Nick.[23] In both cases the costs are known. The cross was set with a sapphire valued at 34 carol., a diamond and ruby at 93 carol. and emerald at 84 carol. The pearls cost 2 carol. 30 stuf.; Hieronymus Jakob received 45 carol. for making it; the case cost 20 stuf. and the design by Collaert only fractionally more at 30 stuf.

For the coronet Jobst von Brussel received 4500 florins which must have included the cost of some materials as well as his fee for making it, as it is such an enormous sum; Godtfried Nick was given 27 florins 30 kreuzer for finishing it, Hans Berckman got 8 florins for some work on the stones, the furrier was paid 6 florins for the fur border, and the hat maker 2 florins for the cap inside it. Daniel de Briers, however, received 9000 florins, no doubt partly to pay for stones, but still twice as much as Jobst von Brussel. [25] It was therefore perhaps in part to avoid the expense of such middlemen that a number of princes had their own court goldsmiths.

The French king was one of these, and some of his goldsmiths were dignified with the title of 'valet de chambre'. For example, the *Maison du Roi* in 1599 included Jean Allain, 'joaillier', Féré Mathurin, goldsmith, and Albin de Carnoy, 'joaillier', goldsmith and 'valet de chambre'. The first two were paid 10 livres, the last, 33.[26]

Of the Bavarian dukes, Albrecht V and Wilhelm V, but not Maximilian I, had craftsmen with the title of court goldsmith, and they also practically monopolised at least one Augsburg goldsmith, Abraham Lotter, who worked directly for Albrecht V without any middleman. This is shown by a petition which he put to the town council in 1572 asking permission for a workshop with barred windows (an open workshop was required by most goldsmith guilds so that fraudulent practices could readily be detected) because, as he said, he worked mostly for the Bavarian duke and His Imperial Majesty and 'Such work must be kept secret and not allowed to become commonplace'.[27]

Rudolph II, the most avidly concerned with art of all the princes, was the first emperor to create a court workshop for himself, and he had two degrees of court goldsmith: the ordinary ones for general court work, and his chamber goldsmith for personal work. In 1597, he employed Hans Vermeyen at 10 gulden per month as the latter[28] and it was almost certainly he who made the imperial crown under his master's instruction.

The relative remuneration of the various chamber craftsmen under his successor, Matthias, can be seen from a document dated 29 March 1615, when many of the names were the same as under Rudolph who had died two years previously. Hans von Lander, the head tapestry worker, got 15 florins monthly; Johan Kepler, 'Mathematicus', 25 florins; Hans Schwaiger, seal cutter, 10 florins; Alessandro Abondio, wax modeller, 20 florins, and Andreas Osnabruck, chamber goldsmith, 15 florins (to list only a few).[29]

But the desire to have a team of craftsmen working directly for one at court, especially in that

most princely area of artistic production, goldsmiths' work, must have reflected the prince's personal interest in the subject. This was after all the century when a duke could take the trouble to write a detailed and technical criticism of the design of a piece being offered to him,[30] and when Grand Duke Francesco de Medici actually sat down in the workshop to make a mother-of-pearl mountain studded with jewels and with the figures in silver-gilt of Christ being tempted by the devil.[31]

Notes

1 It is possible that Graz, not a great mercantile thoroughfare, was where these rosettes and buttons were made. *Jahrbuch der Kunsthistorischen Sammlungen* XX (1899) pt II, no. 17190.
 It is worth giving a few rough equivalents here for the different coinages which will be quoted. A gulden or florin was a gold coin. The ducat which was struck by the Hungarians, was approximately 1/12 heavier than the gulden and its equivalent in value were the French gold écu, the Italian scudo, the Spanish escudo, the Dutch croon and the English crown. The carolus was a gold coin in use in the Netherlands, minted under Charles V, and weighing 5.3 grammes, slightly heavier than the ducat, écu etc. It was also known as the Keisersreaal and was made up of 60 stuivers

2 Fock (1974) p 126 and note 168

3 R. Distelberger, 'Die Saracchi-Werkstatt und Annibale Fontana', *Jahrbuch der Kunsthistorischen Sammlungen* LXXI (1975) p 100

4 Inv. no. D6 (1–25)–1896

5 Lhotsky, p 271. For example, on 30 June 1585 Georg Beuerl and Roland of Holland delivered three pieces of jewellery worth 3266 gulden 40 kreuzer as part of a large present for Archduke Ferdinand of Tirol on the occasion of his second marriage

6 In the Residenz, Munich; see *Official Guide to the Schatzkammer of the Munich Residenz* III (Munich, 1970) p 631. Beuerl is described in the Augsburg guild archives as a 'Juwelier' and he supplied a variety of goods from gold chains to ewers and basins and unmounted stones to the Bavarian court in 1593, 1599, 1600, 1602, 1607, 1610, 1613, see H. Seling, *Die Kunst der Augsburger Goldschmiede 1529–1868* III (Munich, 1980) no. 2824

7 Lieb II, p 134

8 Lieb II, p 135

9 Lieb II, p 136

10 For a fuller discussion of this subject, see E. A. Jobbins, 'Sources of Gemstones in the Renaissance', *Princely Magnificence*, pp 12–19

11 I am very grateful to Dr R Crockett of the Geological Museum, London for this information

12 From his account book, published by Fock (1974) p 160

13 Wilhelm, pp 10–11

14 B. A. Balbinus, *Miscellanea historica regni Bohemiae* (Prague, 1679–88)

15 Lhotsky, p 246

16 'Dass er kleine Kettlein, geschmeltzte Ringlein, Röslein und andere parisische Arbeit, auch Armbänder von hohler ausgezogener Arbeit, da der Draht langweis gelöthet worden, machen möge: aber grosse Ketten, wenn die gleich hohl, Ringe, darein Steine versetzt und andere Arbeit, so die Goldschmiede allhier machen konnen, soll er durchaus nicht verfertigen, bei des Raths ernster Straf'. Quoted in E. von Watzdorf, 'Fürstlicher Schmuck der Renaissance aus dem Besitz der Kurfürstin Anna von Sachsen', *Münchner Jahrbuch der Bildenden Künste* XI (1934) p 62

17 Fock (1974) p 246

18 Fock (1974) p 162, note 400

19 H. Kohlhaussen, *Nürnberger Goldschmiedekunst des Mittelalters und der Dürerzeit* (Berlin, 1968) p 420

20 Nürnberg must, however, have continued to do some jewellery trade as craftsmen from abroad still petitioned for citizenship of the town in order to be able to plie their craft there: for example, in 1582 Melchior Cuterel of Antwerp goldsmith in 'Parisian' work was finally granted citizenship after some difficulty, and in 1586, Hans de Gui of Paris, dealer in precious stones was also granted citizenship; Th. von Hampe (ed.) 'Nürnberger Ratsverlässe über Kunst und Künstler 1474–1618', *Quellenschrifte für Kunstgeschichte und Kunsthandel* XI (1904) nos 586 and 870

21 Lhotsky, p 169

22 F. van Molle, 'De Pax van Averbode in de Hofkirche te Innsbruck en het Borstkruis van Abb. Mattheus 's Volders', *Révue Belge* XLI (1972) app. I

23 Wilhelm, pp 12–13

24 F. van Molle, *idem*

25 Wilhelm, pp 12–13

26 'Liste des Peintres, sculpteurs, architectes, graveurs et autres artistes de la Maison du Roi . . .
 pendant le seizième, dix-septième et dix-huitième siècles', *Nouvelles Archives de l'Art Français*
 (1872) pp 55–108
27 Krempel, p 138
28 Lhotsky, p 255
29 *Jahrbuch der Kunsthistorischen Sammlungen* XX (1899) pt II, no 17337
30 See the letter from Albrecht V to his heir, Wilhelm, dated 1574 about the design for a crystal
 nef being offered to him: 'An der Kanten wellen uns die mascora oder angesicht nit gefallen,
 dann sie nit wollen possieren (*sic*) gedeichte uns do si gar nit daran, berürte kanten würde
 vil formlicher sehen'. ('At the sides the masks or faces do not please us, as they do not stick
 out well (?), and we think that if they were not there, shaped sides would look much more
 pleasing'). Quoted in Krempel, p 116
31 Described in the 1589 inventory of the Tribuna as having been made by the Grand Duke
 Francesco; Fock (1974) p 107

The production of gold boxes in the eighteenth century

Unlike the monarchs of earlier periods, it seems that the kings of Europe were prepared to accept the designs to which goldsmiths worked in the eighteenth century. An exception may have been Frederick the Great of Prussia, who is reputed to have been personally concerned with the design of goldsmith's work, and porcelain, which he intended to give away.

It is, however, impossible to apportion the credit for the design and manufacture of goldsmith's work with any accuracy. It is customary to ascribe a box to the goldsmith whose mark appears on it, but it may well be that he, or she, was but one of many anonymous craftsmen that worked on the piece and the goldsmith was almost certainly not responsible for the design. In the case of gold boxes, where several skills were required to complete the whole, the division of labour was most apparent.

Working to a design supplied by a *marchand-mercier*, an artist, or possibly a private client, the goldsmith whose mark is found on a box would have established its form and sent the pieces in a rough state to the *maison commune* or guildhall for assay and marking. In Paris under the *ancien régime*, the system of marking gold and silver was extremely strict. The mark of the master goldsmith, discussed below, is found in conjunction with the marks of the wardens of the guild and of the office of the *sous-fermier* or tax official. The wardens' mark indicated the purity of the metal, 20.25 carats for gold after 1721, and comprised a crowned cursive letter from a twenty-three letter alphabet, J, U and W being omitted. This mark was made obligatory in 1506 in order that it should be possible to trace the warden responsible for the assay of metal which subsequently proved to be substandard. The first tax mark, the charge, was struck on the rough work to indicate the liability to pay tax on the metal and consisted of a device or letter. These marks were to be struck in the base, in the walls and in the lid of a box. Following the completion of a piece, it was assessed for tax, and, when this had been paid, was struck with the discharge mark, first used in conjunction with the charge in 1677. If pieces were in a goldsmith's shop when the office of *sous-fermier* changed hands, they were struck with the counter-mark of the new *sous-fermier* to indicate that the marks of his predecessor were in order. The

statutes and rules affecting the goldsmiths of Paris are recorded by Pierre Leroy, *Statutes et Privelèges du Corps des Marchands-Orfèvres-Joyailliers* (Paris, 1759) and Poulin de Vieville's *Code de l'Orfèvrerie* (Paris, 1785).

In Paris the number of goldsmiths, that is to say, members of the *Corporation des marchands-orfèvres-joailliers*, was limited to 300, with the addition of several *orfèvres priviligiés* who were appointed by the King or who were attached to one of the royal households.[1] One such was Barnabé Sageret, the maker of the box (cat. no. 55), who was a member of the duc d'Orleans' household. To join the *maîtrise* an aspiring goldsmith began his career between the ages of ten and sixteen, when he was apprenticed to a master goldsmith. The length of the apprenticeship had been established in the fourteenth century at eight years, but the sons of masters were exempt since it was assumed that they would learn the craft in their father's workshop. Only one apprentice was allowed for each master. Following the apprenticeship, a further minimum of three years was spent as a journeyman (*campagnon*) in the workshop of a master. It is clear that the relationship between master and journeyman could be stormy. The goldsmith Joseph Bouillerot complained in 1782 that a *compagnon* named Dehanne had seduced his two daughters and beaten Mme Bouillerot with a walking stick.[2] Having completed the required three years, and being over the age of twenty, the *aspirans à la maîtrise* were eligible to join the guild, provided that there was a vacancy, the number of vacancies being equally divided between apprentices and the sons of masters. The *aspirans* were first examined on such questions as weights, alloys, and the price of gold and silver, and six *gardes* of the guild would satisfy themselves that the candidate was of sound character before they would allow him to proceed with the making of his *chef-d'oeuvre* or masterpiece. This was not usually a very complicated piece – Robert-Joseph Auguste, for example, produced a knife and fork,[3] but it had to be made under the scrutiny of the *gardes*. If the *gardes*, and, for that matter, other influential members of the guild, were satisfied with the work, the *aspiran* was then conducted to the Cour des Monnaies for further examination by the officials of the mint. Here the *aspiran* swore to uphold the rules and regulations of the guild, and, as a newly received master of the guild, had to provide a *caution* of 1000 livres. This was usually, but not always, supplied by the master under whom the apprentice had served. Finally the *maître* struck his mark, which comprised a crowned fleur de lis, two *grains de remède* (small dots which referred to the tolerance of two grains allowed in the standard of metal), his initials and a distinguishing device, the *différent*, which frequently alluded to his place of work or surname. For example, Jean George whose shop was at the sign of l'Observatoire used a star, whereas Mathieu Coiny used a quince (*coing*).

The workshops of goldsmiths were carefully controlled by the guild. In order to prevent any forgery, goldsmiths had to work in full view of the street (fig 11), and there are frequent incidents of masters incurring fines for working upstairs, in back rooms, or outside the proscribed hours of between five or six in the morning and eight or nine at night. Stricter penalties applied to those who sought to mark their wares falsely with punches of their own rather than those of the guild. Martin Laignier was banished from the kingdom and his stock confiscated in 1766 for possessing fraudulently marked gold boxes,[4] but the unfortunate Jean-Baptiste Lecadieu suffered a worse fate when in 1758 two punches for false marks were discovered in his breeches' pocket and four more beneath a cupboard in his house. Having been convicted, he was tortured and condemned to death, a sentence subsequently commuted to a life of slavery in the galleys which the French navy still used for coastal protection in the eighteenth century.[5]

The case of Lecadieu is also useful in giving an indication of the number of people who worked in the shop of a master goldsmith. Amongst those questioned about the false punches

11 *The interior of a goldsmith's shop, a plate from Diderot and d'Alembert's Encyclopédie (Paris, 1755). Note the open door onto the street, obligatory by law so that the goldsmith could be seen to be honest*

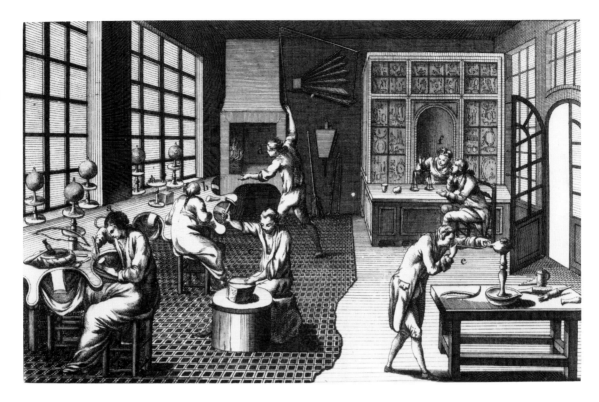

were three *compagnons*, an apprentice, two young *apprentis à l'essai*, a craftsman called Pierre Gougelau and one Louis-Antoine Taillepied, who may be the goldsmith of the same name who attained the *maîtrise* in 1760.[6] No doubt other workshops were larger or smaller depending on the success and reputation of the master, but what is important to appreciate is that the goldsmith did not work alone. Furthermore, although goldsmiths were permitted to perform various forms of decoration such as enamelling, though not to excess, and engraving,[7] these functions were frequently performed by out-workers who specialised in a particular craft. At the death of Jean-Jacques Tonnellier in 1768, his wife explained to Commissaire Thierry that some of her husband's work was with M. Fouquet, an engraver, M. Blanchet, a *tourneur* and M. Fresnel, a chaser.[8] Indeed it is clear that goldsmiths could experience difficulties in securing the return of pieces which had been sent for decoration. Charles Spire complained in 1749 that Billet, a chaser from outside Paris, had absconded with a tureen which he had sent him three months previously,[9] and the famous maker of gold boxes, Jean-Joseph Barrière sought the return of 'une boîte à usage de femme, ovale avec ors de couleurs et dessus un sujet de fable' which he had sent to an engraver named Cotteau, on the quai Pelletier, and who had not completed the work and could not return the box.[10]

The *Almanach Dauphin* for the years 1769 and 1777 list several other chasers and engravers: Auguste, Cassin, Debèche, Hauer, Hurter, Laurent and Vanot.[11] Of these, only the work of two, Auguste and Debèche has been identified. Five gold boxes by Robert-Joseph Auguste are recorded: in Leningrad dated 1760–61,[12] in the Louvre dated 1762–63,[13] in the Metropolitan Museum, New York dated 1766–67 (fig 12),[14] in the collection of the Earl Spencer at Althorp, dated 1767–68,[15] and in the Victoria and Albert Museum, dated 1770–71.[16] Unlike the other *graveurs-ciseleurs* Auguste was himself a goldsmith of considerable renown who had registered a mark, a crowned fleur de lis, RJA, a palm and two *grains de remède*, in 1757.[17] However, although the art of chasing is attributed to him in the *Almanach Dauphin*, it is known that he

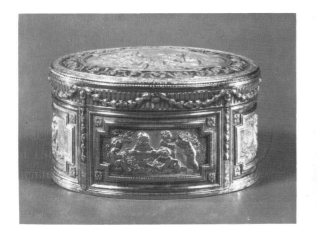

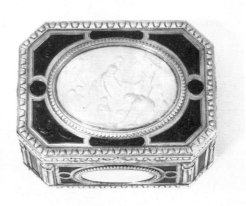

12 *Gold snuff-box by Robert-Joseph Auguste, Paris, 1766–67 (Metropolitan Museum of Art, New York)*

13 *Snuff-box of gold, enamelled in translucent green and set with plaques of chased gold. The box by Pierre-François Drais, Paris, 1771–72; the panels by Gérard Debèche (Sotheby's, Zurich, 7 November 1975, lot 101)*

employed George Boetger, *ciseleur*, in 1782.[18] Two boxes are known with chased decoration by Gérard Debèche; one by Henry Bodson, of 1768–69,[19] and the other by Pierre-François Drais, of 1771–72 (fig 13).[20] Gérard Debèche père, was born in Liège in 1706, and worked for the famous goldsmith Daniel Gouers in whose house he lived. He was evidently a colourful character with a reputation as a drunkard and a womaniser, as well as being a highly skilled craftsman. At the bankruptcy of Gouers in 1737, Debèche had four boxes to decorate for which he was charging 120 livres per box.[21] Rather surprisingly for a chaser, Debèche *marchand* is recorded as having supplied a snuff-box with enamelled chinoiserie decoration for the *corbeille de marriage* of the Dauphine Marie-Josèphe de Saxe in 1747.[22] The account of the *corbeille de marriage* of Marie-Antoinette of 1770 notes that Drais supplied a 'boîte à huit pans, les milieux ciselé d'après l'antique par Debèche; les panneaux en magellan, les bordures à feuille de lierre, la monture à guirlandes et les cartouches de la bâte à figure'.[23] However, Debèche père had a son who was also a chaser and whose name was Gérard, so it is unclear whether the refined style of the box 1771–72 is by the same hand as the bolder work on the box of 1768–69, which, as Sir Francis Watson suggests, may contain plaques of an earlier date.

That several engravers were employed by various box makers is confirmed by the presence of different goldsmith's signatures engraved by the same hand, and by the signatures of the same goldsmiths engraved by different hands. Examples of this may be noted in the signature on a box by François-Guillaume Tiron, dated 1765–66 (cat.no.68), and that on the box by Pierre-François Drais dated 1770–71 (cat.no.72), or by the two signatures on boxes by Drais dated 1769–70 and 1770–71 in the Louvre.[24]

On 4 May 1756, an *arrêt de conseil* permitted the manufacture of boxes containing panels not made of gold mounted *à cage*, that is to say, held to the body of the box by a cagework of gold.[25] Stone, lacquer, shell and miniatures were frequently mounted in this way. The *arrêt* stated that boxes mounted *à cage* should not be sold by weight and should be marked 'Garnie'. It is clear that most goldsmiths ignored this last instruction, but one box in the Wallace Collection is so marked (fig 14). However, a fashion for boxes mounted *à cage* existed before the *arrêt* of 1756. In 1749, the *marchand-mercier* Hébert supplied the Menus Plaisirs with 'une tabatière d'écaille piqué de Devert, pour femme, à cage, doublée d'or, émaillée de vert, 1200 livres'.[26] On 7 August 1752, Lazare Duvaux sold the 'certissures d'une tabatière montée en cage, fourni les six plaques de jaspe sanguin ajustées,' and in December 1753 Madame de Pompadour bought from him 'une tabatière d'agathe-onyx, montée en cage'.[27]

From the 1740s, the increasing use of enamel is noticeable on gold boxes. The enamellers in

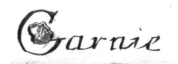

14 *Engraved mark on an à cage box in accordance with the arrêt of 4 May 1756 which permitted the manufacture of boxes not wholly of gold. The box by Jean-Marie Tiron, Paris, 1767–69 (Wallace Collection, London, Inv. no. G45)*

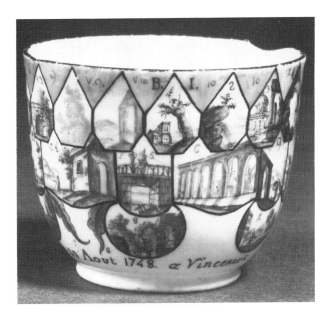

15 'Inventaire' of P. A. H. Taunay, 1748. Enamellers painted such pieces, in this case a cup from the Vincennes factory, in order to know the true colours of enamels after firing (Musée Nationale de Ceramique, Sèvres)

Paris in the eighteenth century could have been members of one of three guilds. Some belonged to the *Patrenôtriers et Boutonniers en émail*, which had been incorporated in the guild of *Verriers-Fayenciers* in 1706, and which included such diverse craftsmen as the makers of glass, and those who covered bottles with wickerwork, and who probably included the decorators of porcelain in Paris. Those outside the city limits were not subject to guild regulations. Others were members of the *Communauté des Maîtres Peintres et Sculpteurs*, and others, probably those who decorated goldsmith's work were members of the guild of *Marchands-Orfèvres-Joailliers*. Despite the many names which are known from the signatures on boxes, we have surprisingly little knowledge of the artists themselves. The *Encyclopédie* of Diderot and d'Alembert gives special mention of André Rouquet, Jean-Etienne Liotard and L. Durand,[28] and Maze-Sencier enlarges the group with Aubert, Bourgoing, Le Bel, Le Seuer, Hamelin and Maillé.[29] Others who signed enamels or who are known to be enamellers at the time include P. A. H. Taunay, who worked at Sèvres (fig 15), but whose enamels were sold to goldsmiths through Louis Leroy at cour neuve du Palais;[30] Ignace-Joseph Reys of the rue du Battoir, in the parish of St André des Arts, who was owed fifty livres at the death of the goldsmith L.-G. Cassé in 1768 and who may be the same artist as 'Reyz' at Vincennes between 1753 and 1755, or a close relative;[31] M. Desvignes, a creditor of the goldsmith J.-C. Génu;[32] Hubert-Louis Cheval de St Hubert, one of the experts who made the inventory of Louis-François Aubert and who was the son of the goldsmith Hubert Cheval (see cat. nos 55, 56 and 58);[33] Louis-Philippe Demay whose signature appears on at least one enamel,[34] and who seems to have regularly employed Charles-Jacques de Mailly, and the latter's widow, Jacqueline-Emilie Mallet, who died in 1777.[35] The *Almanach Dauphin* increases the list with mentions of Mlle Duplessis (in 1753–54), Couniot (1753 and 1777), and Liot (1754), all of whose signatures appear on gold boxes in the Louvre, as does that of Jean-Baptiste-Joseph Le Tellier.[36] Inventories of many others survive but it is unclear whether these craftsmen enamelled on gold, or on base metal, pottery or porcelain, or glass.

Of these artists, perhaps Louis-François Aubert deserves additional attention since his style was clearly recognised by his contemporaries. He was baptised on 3 February 1721 in the church of Notre-Dame at Mézières in the north east of France. He began his apprenticeship with the goldsmith Charles Clément on 18 October 1736 in Paris, with whom he remained until he joined the *maîtrise* on 9 January 1748. He struck his mark, a crowned fleur de lis, two *grains de remède*, and LFA with a crescent.[37] Aubert's enamel appears to have been popular and distinctive, for so far as is known only one example of his work is signed (fig 16), and yet enamels are frequently ascribed to his hand in eighteenth-century documents. For example, in 1751, Jean

16 L.-F. Aubert. Louis XV, enamel on copper, signed (Edwin Bucher Collection, Switzerland)

Ducrollay supplied to the Menus Plaisirs 'une boîte d'or, émaillée par Aubert, à fleurs de relief, fond mat à mosaique et bordure d'or polie' at 2184 livres. Another of similar description and costing the same amount accompanied it. In 1753, the Menus Plaisirs bought from the *marchand-mercier* La Hoguette 'une boîte d'or, émaillée à fleurs peintes par Aubert' for 1272 livres for the abbé de Lascarie, and three others for the marechale de Maillebois, the marquis de Grammont and the marquis Duchastel.[38] The following year, between 24 and 26 April 1754, Madame de Pompadour acquired 'une tabatière d'écaille piqué, en cage, à contours, la garniture en or émaillé de rose par Aubert' from Lazare Duvaux.[39] From the inventory made following her death in 1764, it is evident that the marquise possessed two further examples of his work: 'une boeste en or, émaillée par Aubert, 437 livres,' and 'une autre émaillée à fleurs en relief par Aubert, 400 livres.'[40] In order to determine the nature of Aubert's enamelling we must look, therefore, for a group of unsigned but easily identifiable enamels probably with 'fleurs à relief' dating from between 1748 and 20 October 1755 when Louis-François Aubert died. One such group comprises boxes dated 1747–48 (cat. no. 47), 1748–49 (cat. no. 49), and one by Jean Moynat dated 1748–49 (cat. no. 48). Nevertheless, the attribution of these remarkable pieces of goldsmith's work to L.-F. Aubert is apparently condemned by the existence in the Metropolitan Museum, New York (Wrightsman Collection) of an oval gold box by Jean Frémin dated 1756–57, with enamelled flowers probably by the same hand.[41] However, despite the apparent inconsistency of the date of Aubert's death and that of the Frémin box, all the enamels may be by Aubert, or his widow, or his workshop. Following his death on the first floor of a house in the rue du Four, his widow, Marie-Antoinette Rapillard du Clos, had the property sealed as was customary. But she requested that certain items of enamelled gold should be handed over to her for completion and sale. Amongst these were plaques and the cover for a *boîte à mouches*, and several unfinished boxes of enamelled gold and an unfinished gold watchcase.[42] Thus we have evidence that Veuve Aubert was prepared to continue her late husband's business, as she was entitled to do under the regulations of the guild of *marchands-orfèvres-joailliers* of which he had been a member. It is not clear from the *scellés* whether Veuve Aubert was capable of completing the work alone or whether there was a workshop for her to run. Either way the widow had died by 19 October 1758 and no box enamelled in this style is known to the author after that date.

In England, Germany and Austria specialist enamellers were similarly employed by goldsmiths to decorate gold boxes and related items. In England, probably the most famous of the independent decorators on gold was George Michael Moser, a Swiss from Schaffhausen who arrived in England probably in 1726. Moser had trained as a coppersmith, and later as a chaser of gold, and it was this last that won praise from George Vertue and André Rouquet. For portraits in enamel Rouquet recommended 'Mr. Zinck' (C.F. Zincke, see cat. no. 44), of whom he wrote, 'Never was there a man before him, that managed the enamel with such ease'.[43] Other English enamellers known to have been working on gold boxes in the eighteenth century include William Hopkins Craft, Lewis and Simon Augustin Toussaint, Robert and Charles Lukin, Gabriel Wirgman, William Charron and James Morisset.[44]

Mention should be made of the large number of enamels on copper which were produced in England mainly in the third quarter of the eighteenth century. In 1751, an Irish engraver John Brooks, developed a technique of printing onto pottery, porcelain, enamel and glass. This process was first performed in Birmingham, 'the Toyshop of Europe,' although a similar method of decoration was used at Doccia in Italy at more or less the same time. Brooks's development was taken up by a concern funded by Stephen Theodore Janssen at York House, Battersea, in London, but the factory was only in production between 1753 and 1756. However, the Battersea

factory was not alone in the making of enamelled copper boxes. Several London craftsmen were engaged in a similar way, but by far the largest centre of production was Birmingham, where John Taylor was one of the leading manufacturers. It was said in 1781, that at his factory 'one servant earned £3 – 10 – 0 a week painting them [painted snuff-boxes] at a farthing each'. On this estimate one man was decorating over 3000 boxes per week, and Mr Taylor employed 500 workers to make buttons and boxes. Even allowing for exaggeration, the output must have been considerable. Enamels were also made in large numbers in Bilston and Wednesbury to the north west of Birmingham in Staffordshire.[45]

In Germany the names of several enamellers are known. Perhaps the most famous and most accomplished was Daniel Chodowiecki of Berlin whose work is often associated with that of Daniel Baudesson. Jean Guillaume George Krüger, a native of England who had studied in Paris, was already in Berlin by 1753, and was responsible for the enamel on a box in the Hohenzollern Collection at Schloss Charlottenburg, as well as for the drawings mentioned below for boxes in the style which has become associated with Frederick the Great. Whilst in Dresden, Georg Friedrich Dinglinger enamelled with astonishing results the hectic compositions of his more famous brother Johann Melchior Dinglinger.

As in England, Germany boasted an industry of enamellers of base metal. Many of the highly skilled *hausmaler*, independent painters, worked on enamels as well as porcelain, but one Berlin establishment, that of Alexander Fromery, who succeeded to his father's business in 1738, achieved a distinctive style (cat. no. 91). Christian Friedrich Heröld, one of the leading decorators at Meissen, also worked in the Fromery workshop, where he not only painted enamels but developed a technique of encrusting the surface of the enamel with raised gold foil. This form of decoration was used by Heröld on Meissen porcelain, and a similar technique was used in France, at St Cloud and elsewhere on enamel, and by the peripatic Conrad Hunger.[46]

Thus the production of a box should be seen not as the work of a single craftsmen but the result of the cooperation of a group of designers, goldsmiths, chasers, engravers and enamellers. Only since the Arts and Crafts movement of the last century has an individual been expected to possess the ability to design and manufacture with equal facility. Some have succeeded, but those who fail should find solace in the thought that such demands were not made of their eighteenth-century forebears.

Notes

1 Watson, pp 106 and 310
2 Nocq I, pp 163–64
3 Faith Dennis, *Three centuries of French Silver* II (New York, 1960) p 10
4 Nocq III, p 13
5 Nocq III, p 59
6 Nocq IV, p 37
7 Leroy, p 225
8 Nocq IV, p 59
9 Nocq IV, p 34
10 Nocq I, p 72–73
11 Maze-Sencier, p 207
12 Inv. no. 3.4144. Marina Torneus, 'Elegance and Craftsmanship' *Apollo* CI (June 1975) p 469
13 Grandjean, no. 1
14 Inv. no. 65,255
15 Hugh Honour, *Goldsmiths and Silversmiths* (London, 1971) p 223
16 Inv. no. M.137–1917
17 Nocq I, pp 31–33
18 Nocq I, pp 31–33
19 Watson, pp 164–69
20 Sotheby's, Zurich, 7 November 1975, lot 101

21 Nocq II, p 272–73 and E. Campardon and J. Guiffrey, 'Gerard de Bèche', *Nouvelles Archives de l'Art Français* Iᵉ serie (1876) pp 359–72
22 Maze-Sencier, p 152
23 Maze-Sencier, p 157
24 Nocq and Dreyfus, nos 97 and 99 where both signatures are reproduced, and Grandjean, nos 82 and 84
25 Nocq IV, p 174
26 Maze-Sencier, p 153
27 Courajod II, pp 133 and 147
28 Diderot and d'Alembert (Paris, 1755) p 536
29 Maze-Sencier, p 150
30 Nocq II, p 120
31 Nocq I, p 225
32 Nocq II, p 233
33 Nocq I, p 263–64
34 Christie's, London, 30 June 1982, lot 51
35 J. Guiffrey, 'Liste de Scellés d'Artistes et d'Artisans', *Nouvelles Archives de l'Art Français* 2ᵉ serie, v (1884)
36 Grandjean, nos 114, 235, 98 and 118
37 Nocq I, p 23
38 Maze-Sencier, pp 153–54
39 Courajod II, p 197
40 Cordey, pp 197–98
41 Watson, pp 151–52
42 J. Guiffrey, *op.cit.*, pp 215–16
43 Rouquet, p 54
44 Claude Blair, *Three Presentation Swords* (HMSO London, 1972) pp 4–6
45 B. Watney and R. Charleston, 'Petitions for Patents, etc', *Transactions of the English Ceramic Circle* VI (London, 1966) pt 2, p 57 ff
46 H. Tait, 'Heröld and Hunger', *British Museum Quarterly* XXV (1962) nos 1–2, p 39

The Fabergé workshops

Whilst the firm of Fabergé employed more or less the same techniques as those used in preceding centuries, the workshops were established in quite a different manner.[1] Born on 30 May 1846, the son of a prosperous jeweller of St Petersburg, Peter Carl Fabergé was sent as a young man to work for the jeweller, Friedmann, in Frankfurt-am-Main. He subsequently visited France, England and Italy and it is clear that the impressions of French eighteenth-century goldsmith's work, and of the princely collections in Dresden and Florence gained during this youthful travelling strongly influenced the style of the firm under his administration. It is not, therefore, surprising to find him making a pastiche of a box by Joseph-Etienne Blerzy, dated 1777–78, formerly in the Hermitage, in answer to a comment by the Tsar that eighteenth-century work could not be rivalled.[2] Similarly, the Easter Egg presented by Alexander III to Marie Feodorovna in 1894[3] is a version of the chalcedony casket, mounted in enamelled gold by the Dutch goldsmith Le Roy which is now in the Green Vaults, Dresden.[4] The hardstone figures in the Palazzo Pitti, Florence, made in the grand ducal workshops in the early seventeenth century are the most likely source of the figures of Russian national characters that the firm was to produce,[5] just as the ormolu peacock by the English eighteenth-century toy-maker, James Cox, in the Hermitage was the model for 'surprise' in the 1908 Peacock Egg given by Nicholas II to his mother in 1908.[6] A personal taste for *netsuke* led to the production of several small carvings in the Japanese taste such as the stylised sparrows (Japanese *Fukura Suzume*)[7] and a coiled snake

in the Royal Collection at Sandringham[8] which is copied directly from a *netsuke* in the Bauer Collection, Geneva, and which may have been in Fabergé's own collection numbering over 500 pieces.

In 1870, Fabergé assumed control of his father's business. The firm moved into larger premises in Bolshaya Morskaya Street where they remained until moving to a still grander establishment in the same street in 1900. Here from his office on the ground floor, near the showroom, Fabergé administered his business empire.[9] On the floor above was his flat and the workshop of August Hollming, a Finn, who had worked with the firm since 1876, and who specialised in boxes and cases. On the floor above was the workshop of the head workmaster. The first to occupy this position under Carl Fabergé was Erik Kollin, another Finn, who retained the post until 1886. He was followed by the Russian Michael Perchin, probably the most famous of all Fabergé's workmasters. Perchin died in 1903 and was succeeded by his assistant Henrik Wigström, again of Finnish extraction. Credit for mounting the majority of the hardstone animals is given to him. It was in the head workmaster's shop that the enamellers Alexander and Nicholas Petrov, and Vassili Boitzov practised their craft with such skill. On the third floor was the jewellery workshop of August Holmström, the senior of Fabergé's workmasters. He began with the firm in 1857, and was succeeded by his son Albert on his death in 1903. Alfred Thielemann's jewellery workshop was on the floor above. Thielemann's birth and death dates are unknown, but his workshop was taken over by his son Karl Rudolph between 1890 and 1910. Thus unlike the diverse industry of the eighteenth century, Fabergé's St Petersburg workmen were concentrated in one large establishment under the constant supervision of the firm's owner (figs 17–19).

17 *The design studio, photographed by Nicholas Fabergé. On the left are shown, from back to front, Eugene Fabergé, Oscar May, Alexander Fabergé and Ivan Lieberg, and on the right stands Alexander Ivashev (A. K. Snowman Collection, London)*

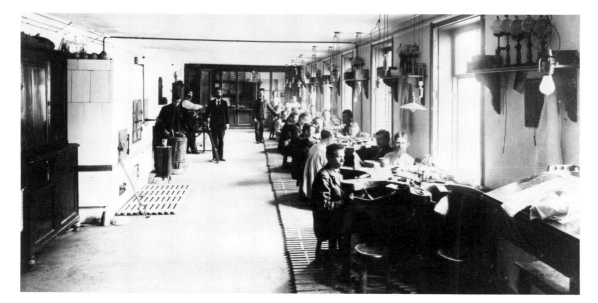

18 *A workshop in the Moscow branch of Fabergé. Many features such as the benches and so-called 'lace makers' lamps' appear in the illustrations of earlier workshops (figs 11 and 36) (A. K. Snowman Collection, London)*

In Moscow, where a branch was opened in 1887, the Bowe brothers, Allan, Arthur and Charles, acted as managers until 1906, when Otto Jarke took control. He was succeeded by Andrea Marchetti and he, in turn, by Alexander Fabergé. Here the workshops containing about one hundred craftsmen were supervised by three workmasters. Michael Tcherpunov was in charge of the silversmiths, Oskar Pihl, the jewellers and Gustav Jahr, the makers of *objets de vertu*.

Small workshops were set up in Odessa (1890–1918) and Kiev (1905–10) and in London (1910–17). The London branch, first run by Arthur Bowe (1903–1906) and later by Henry Bainbridge (1907–17), clashed with the Worshipful Company of Goldsmiths over the problems of hall-marking items on entry into England. In 1910, the courts found for the Goldsmiths and a small workshop was established to take care of any work necessary after hall-marking.

Whilst Fabergé was himself the prime mover in the realm of creativity, he relied on a team of designers to prepare drawings for the workmasters. The most senior of these was François Birbaum, a Swiss, who oversaw a studio comprised of Alexander Ivashov, Zosim Kritzky, Jan Lieberg-Nyberg and Eugene Jacobson designed mainly for silversmiths, Oscar May and Hugo Oeberg concentrated mainly on *objets de vertu* and Alina Zwerschinskaya and Alma Pihl on jewellery.[10] The Moscow branch boasted seven more.

Estimates of the total workforce employed by Fabergé vary. Bainbridge, von Habsburg and von Solodkoff estimate that between 1907 and 1917, the period of Bainbridge's management of the London branch, about 700 craftsmen worked for the firm. This figure has been doubted by Snowman, who after consultation with Eugene Fabergé and Andrea Marchetti concludes that the figure should be nearer 500.[11] The hours that this enormous group of craftsmen, designers and salesmen worked were long, even by eighteenth-century standards. The normal day was from 7 o'clock in the morning until 11 o'clock at night, and from 8 o'clock in the morning until 1 o'clock in the afternoon on Sundays.

The marks found on the work emanating from the house of Fabergé fall into three categories: the standard marks, the workmasters' marks and the marks of the firm itself. Russian standard marks until 1899 comprised a town mark, the mark of the assay-master and the standard mark showing the proportion of pure metal to 96 zolotniks of alloy.[12] Thus 96 zolotniks equalled 24 carats, 72 zolotniks equalled 18 carats and 56 zolotniks equalled 14 carats. In 1899, the

19 *Interior of one of Fabergé's workshops. The youth of some of the craftsmen is remarkable (A. K. Snowman Collection, London)*

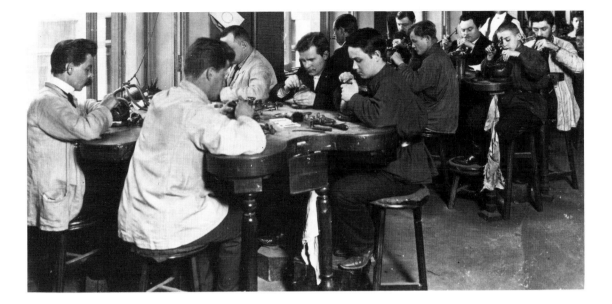

standard marks changed to an oval mark containing a female head in profile wearing the traditional Russian headdress, the kokoshnik, accompanied by the standard in zolotniks and the assay-master's initials. From 1908 until the Revolution of 1917, the mark showed the female head in a kokoshnik in the opposite sense together with the standard and a Greek letter indicating in which town the piece had been assayed. Pieces made by the firm in St Petersburg were marked with the initials of the workmaster, usually with the mark 'Fabergé' in Cyrillic. In Moscow, the firm rather than the workmaster was seen as the manufacturer so there items were marked 'K.Fabergé' in Cyrillic, frequently beneath the imperial two-headed eagle displayed which denoted that the firm held the imperial warrant.

Carl Fabergé was not alone in producing the extravagant bibelots for which he is famed. Karl Gustavovitch Hahn and Alexander Tillander (cat.no. 136) were his rivals both in quality and reputation, whilst Ivan Khlebnikov (cat.nos 134 and 135) and Pavel Ovchennikov, who worked in a more traditional style, both received imperial warrants. However, not even the illustrious firm of Carl and Henrik Bolin, with whom the court placed many orders, is so well remembered today.

The appeal of Fabergé lies not just with the romance of an extravagant monarchy, brutally overthrown, but in an appreciation for the quality of manufacture and attention to detail which had not been seen since the eighteenth century, and which is hard to find today.

Notes
1 Bainbridge, Snowman (1962), and *Carl Fabergé* (London, 1979), Habsburg, Hermione Waterfield and C.Forbes, *Fabergé* (New York, 1978)
2 Both piece are now in the Forbes Magazine Collection, New York. London, Victoria and Albert Museum, *Fabergé 1846–1920* (London, 1977) nos L. 16 and 17
3 Snowman (1962) pl LXXII
4 J.L.Sponsel, *Das Grunes Gewolbe zu Dresden* III (1929) p232
5 Snowman (1962) figs 263–66 and pls XLV, XLVI, XLVII and XLVIII
6 Snowman (1962) figs 356 and 357
7 Neil K.Davey, *Netsuke* (London, 1974) p64, no.161
8 London, Victoria and Albert Museum, *Fabergé 1846–1920* (London, 1977) no.C10
9 Habsburg, p46ff
10 Snowman (1962) p120
11 Snowman (1962) p144
12 For a detailed study of Russian hall-marks, see Goldberg and Solodkoff

Techniques of the jeweller–goldsmith in the High Renaissance

There are two contemporary treatises which deal with the techniques used by the goldsmith–jeweller during this period: Vannoccio Biringuccio's *De la Pirotechnia*[1] first published in Venice in 1540, and Cellini's *Treatises on Goldsmiths' Work and Sculpture*, which first appeared in Florence in 1568, three years before he died.[2] For more details of how the objects were made one has to extrapolate from guild regulations, patrons' instructions and the objects themselves.

Design

The beginning of the process of making a piece of jewellery was obviously the design: Cellini insists on the importance of a knowledge of drawing to prevent the goldsmith from making technical mistakes in the setting of stones,[3] and indeed, many goldsmiths of this period were accomplished designers and engravers. There was still considerable overlap between their art and the so-called 'fine' and graphic arts. Dürer, who produced many designs for goldsmiths' work including jewellery, was the son of a goldsmith and had served a goldsmithing apprenticeship: Etienne Delaune was an engraver, medallist, goldsmith and extremely accomplished designer of not only jewellery but of armour for Henri II,[4] and many goldsmiths such as Hans Collaert of Antwerp continued the natural association between their engraving skills and the graphic arts by producing engraved designs for jewellery.

The sixteenth century is the earliest period for which we have an abundance of goldsmiths' designs, both drawn and engraved, but the exact status of this material must be looked at quite carefully. There is no doubt that goldsmiths' and hardstone cutting workshops like that of the Miseroni in Milan used working drawings of which very few have come down to us because they wore out with heavy usage. These were not necessarily highly finished, as is shown by the drawings in that rare survival, a German goldsmith's pocket book (British Museum). This dates from the 1540s and includes pages on which ideas for jewellery and snatches or ornaments are worked out (fig 20). It has a page of soldering instructions, and, neatly illustrating the point made above about the natural inter-relationship of the goldsmith's and engraver's craft, some pulls, both inked and blind, from engraved moresque on the backs of various pieces of jewellery. It also has some extraneous, drawings by another hand which may have been inserted by the goldsmith whose book it was.[5]

Among these extraneous designs are three very highly finished ones on the more expensive material of vellum, their ink outlines enhanced with a wash of colour. Such designs were more likely to be the projects submitted to the client for approval, or, if very elaborate, they were not true designs at all. The fourteen designs in the Victoria and Albert Museum by or in the style of Giulio Romano (*circa* 1499–1546) include some which come into the former category.[6] They are also, incidentally, the largest group of sixteenth-century Italian jewellery designs known to survive and are datable on internal evidence between 1527 and 1531. Giulio, although not a goldsmith, was a painter and architect who also devoted himself while working for the Gonzagas at Mantua to designing for the decorative arts. One of these designs (fig 21) shows a necklace composed of tied-together tube-like elements, and a very similar gold necklace is

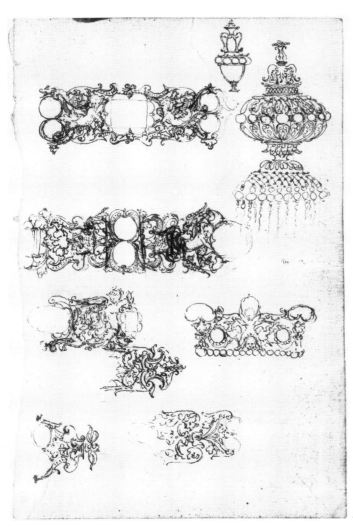

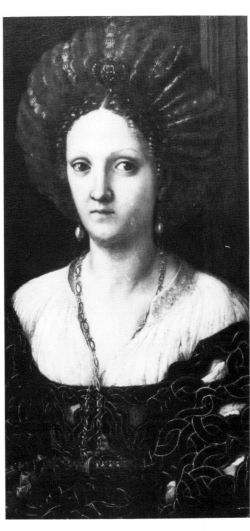

20 21 22

20 Page of designs from a goldsmith's pocket book, pen and brown ink over a chalk drawing, German, circa 1540 (British Museum, London, Inv. no. 1978–12–16–15)

21 Giulio Romano. Design for a necklace, pen and ink on a chalk drawing, Italian, circa 1530 (Victoria and Albert Museum, London, Inv. no. 8951–59)

22 Giulio Romano. Portrait, possibly of Isabella d'Este, showing a necklace similar to that in fig 21, circa 1530 (Royal Collection, Hampton Court)

shown in the portrait by Giulio presumably of Isabella d'Este at Hampton Court (fig 22), suggesting that she is wearing a piece after this design.

The fact that a design is a drawing and not an engraving does not guarantee the originality of the concept: many are very derivative, indeed, sometimes actual copies of engravings and thus interesting documents of taste, but not accurate evidence for dating or locating purposes. A good example of this is in the *Llibres de Passanties* (Museu de la Historia de la Ciudad, Barcelona), the albums in which sample designs by prospective masters in the Barcelona goldsmiths' guild were bound; many of these depend heavily on prints, and f. 199 in vol. II shows a pendant drawn by a certain Juan Ximenis in 1561 which is copied from an engraving by the Frenchman Pierre Woeriot (1532–96).[7]

Some very highly finished miniature paintings of jewellery are, as has been suggested before, not designs, but paintings of pieces already in existence. Fig 1, cat. no. 7, for example, shows a cross which belonged to Duchess Anna of Bavaria and which the court painter, Hans Mielich, depicted together with all her other jewels, between 1552 and 1555, as a kind of stocktaking exercise for use by the Duchess. On 23 July 1539, the head office of the Fugger bank in Augsburg paid the quite distinguished artist Christopher Amberger 1 florin 10 kreuzer to portray a large diamond set in a pendant.[8]

Not a single piece of jewellery survives which is exactly after a known design, whether drawn or engraved, and great caution is required even when one says that a piece is close to a design

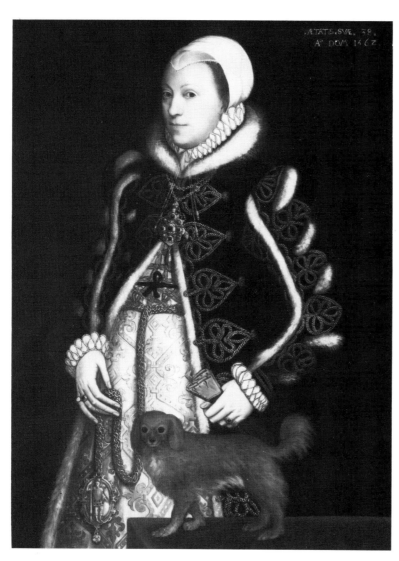

23 Steven van de Meulen. Catherine Lady Knollys, 1562 (Yale Center for British Art, Paul Mellon Collection)

24 Detail of fig 23

25 Hans Holbein the Younger. Design for a pendant, pen and ink washes and body colour, circa 1532–43 (British Museum, London, Inv. no. 5308–107)

26 Virgil Solis. Engraved design for a pendant, Nürnberg, 1540s

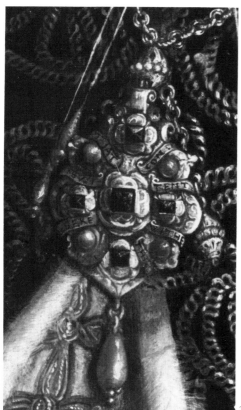

24

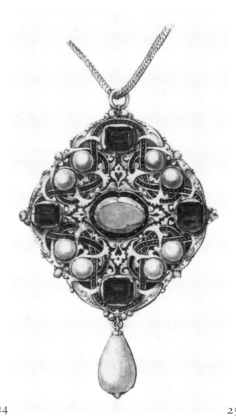

25

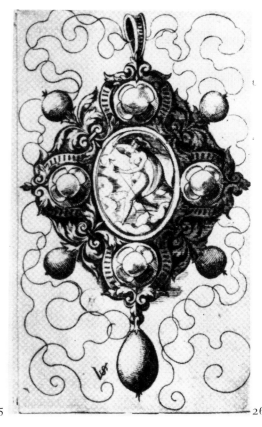

26

by a particular craftsman. Hans Holbein the Younger's (1497/8–1543) drawings for jewellery are known from some examples mainly in the British Museum; there are also pieces worn by his sitters in portraits by him which look so like some of his designs (for example, his design for a circular jewel showing Lot and his family fleeing,[9] and the jewel worn by the woman called Catherine Howard in the Toledo Art Museum, Ohio), that one wonders whether he had a hand in designing these as well, whether he had invented them for the painting, or whether they were existing pieces which merely shared in his decorative style. Again, a portrait of Catherine Lady Knollys (fig 23) painted by Steven van der Meulen in 1562 shows her wearing a pendant with an English inscription which must have been made in the 1540s (fig 24) and which is very much in the same manner as a highly finished design by Holbein (fig 25), but this same idiom is also reflected in a group of contemporary jewellery designs engraved by the prolific Nürnberg artist, Virgil Solis (1514–62) (fig 26), who, to complicate matters, seems to have had a Holbein-esque vein. Thus the question of cause and effect where drawings, engravings and actual objects is concerned is not easily answered. The most one can say is that, for the first time, any new ornament could rapidly become international now by means of published designs. Two good examples of this are the moresque and strapwork.

The moresque is a closely intertwining pattern of fine, flat scrollwork ending in narrow pointed leaf shapes. It was introduced from Turkish territories via Venice and was sufficiently well established by 1530 to warrant a pattern book, Francesco Pellegrini's *La fleur de science de broderie, façon arabique et italique*, published in Paris. It was worked over by numerous artists, from Holbein and Peter Flötner and Virgil Solis, to the anonymous German author of the goldsmiths' pattern book (see above) and Jean Gourmont (*circa* 1506–51); in England the first pattern book of moresque was published by that plagiarist, Thomas Geminus in 1548,[10] copying Jacques Ducerceau's (1515–85) engravings of before 1540.[11]

27 *Matthias Zundt. Engraved design for two strapwork jewellery elements, perhaps for collars or bracelets, Nürnberg, 1553*

Strapwork, on the other hand, is essentially three-dimensional, involving broad scrolling strap-like elements. It was an invention of Raphael's pupil, Rosso Fiorentino who was working on the Gallery at Fontainebleu between 1533 and 1535 with ideas derived from the grotesques in the Loggie at the Vatican. By the 1540s it had been wholly absorbed into jewellery design and new sorts of pendant such as fig 2 of about 1546 were being produced. This one uses the strapwork to articulate the grotesque elements of masks, snakes and fishtailed fawns. In 1553, Matthias Zundt (1498–1586) was one of the engravers to produce jewellery designs which incorporated strapwork (fig 27) and these, like René Boyvin's (1525–1610) designs, which

date from after 1550 when he set up as an engraver, show that published designs lagged well behind the style of actual pieces; occasionally, designs which must have been long out of fashion were re-published as in the case of Hans Brossamer's (fl. *circa* 1520–54) pendants of about 1540, reissued in 1570.

When a goldsmith set about making a piece of jewellery at this period, one has to suppose that he had some sort of design prepared, whether a rough working sketch, or something more finished. He almost certainly went on to produce a three-dimensional mock-up of the piece, whether by modelling in wax or possibly plaster, or by carving a wooden version of it. He might also have a lead pattern which had been cast from a previous production, or from a model (fig 28). These models served the double purpose of providing the patron with a preview of what his piece would look like,[12] and enabling the craftsman to work out his ideas. Cellini describes modelling in wax,[13] and wooden models for the jewelled gold mounts on the hardstone vases being produced in the Milanese workshops are also recorded.[14] The purpose of the lead and wooden models was to enable sand casts to be taken of them.

28 *Model for a pendent jewel, gilt-bronze set with pastes, German, circa 1570 (Victoria and Albert Museum, Inv. no.* M549–1911)

Sand casting

This was by far the most common method of producing the basic framework of jewels, lost wax casting only being used if a heavily undercut shape had to be reproduced. A good account of the process is given by Biringuccio in his VIIIth book 'Concerning the small art of casting', and he recommends it as being the process most suitable for producing a large number of works of one kind 'as it is short and requires least time and expense'.[15] Thus the rosettes in cat. no. 23 were produced by this method as many examples of the same piece were required.

The process involves making a mould in two halves of the model in two rectangular frames; the first frame is filled with what is called sand, but is actually a much denser material which should hold its shape if moistened and squeezed in the hand: one of Biringuccio's recipes recommends fine river gravel combined with ram's ashes and old flour, while Cellini extols the virtues of a particular loam found only in the bed of the Seine near the Ste Chapelle.[16] The level surface of the sand is dusted with charcoal powder to prevent the model sticking to it and the model is pressed into it up to half way. The second frame is then fitted on top of the first and also filled with the sand. One of the frames is levered off and the model removed; channels to allow for the expansion of the metal are made running from the negative impression to the edge of the sand, and the two frames are then joined together again, and the molten metal cast in the mould.

Embossing

Casting uses a great deal of metal and also gives a certain rigidity of effect, so where a piece has a backplate to strengthen it, the goldsmith could emboss a sculptural piece. Cellini clearly prided himself on his mastery of this technique and gives a detailed account not only of how he did it, but a description of three pieces he made.

'After the model in wax has been made and you have decided what it is you want to create, you take a sheet of gold . . . thin at the sides and thick in the centre, and you little by little beat it from the back with your larger punches until it is bossed up much like your model.' He recommends the use of 22½-carat gold as being the ideal malleability, to be worked with punches of both steel and dogwood. One of the jewels which he describes in detail is a mixed material piece, like the pendant with an amorous couple (cat. no. 1), their bodies of embossed gold and pearl against a bloodstone ground. A love-sick young Florentine, Federigo Ginori, wanted a jewelled

medallion to give to his lady love, the subject to be Atlas with the heavens on his back, and the cost, limitless. So Cellini made the backplate of lapis lazuli, the heavens a ball of crystal with the signs of the zodiac engraved upon it, and the figure of gold. He did all the main raising of the figure with his punches and a stake and then added the fine details with the gold laid on a bed of pitch, chasing them in from the front. He fixed the figure to the stone by means of two little pins or stakes and fitted it into a 'most sumptuous frame adorned with gold, full of foliage, fruits and other conceits' . . .[17]

Chasing

Chasing, the refining of the design by moving the metal with a chasing tool, is a vital stage not only of embossed work, but also of cast work which always needs to be cleaned up and made more precise when it comes out of the mould. It is distinguished from engraving by the fact that it does not actually excise any metal but merely moves it around. The ultimate refinement of a piece of goldsmiths' work depends a great deal on the skill with which it has been chased. Some of the pendants in the Thyssen-Bornemisza Collection also have contrasting textures in their goldwork, some parts being polished, others finely matted (for example, the Cimon and Pero pendant (cat. no. 14), which is not only *sablé* matted on the front, but has a fine diaper pattern pounced on the back). Cellini achieved this effect by using a hard steel punch with its head broken off, that is *'camosciare'*, 'sueding', or by using a punch with a very small head, that is *'granire'*, graining; alternatively he hatched the metal diagonally with engraved lines.[18] The contrasting polished areas he burnished with stones used with powdered pumice.

29 Cornelis Beelt. Interior of a Dutch goldsmith's shop, circa 1660. Note the goods for sale in the window and the show case on the wall, the open workshop decreed by law so that malpractice could be spotted, the casting patterns on the wall next to the chimney and the wire-drawing machine under the window (formerly Galerie Sanct Lucas, Vienna)

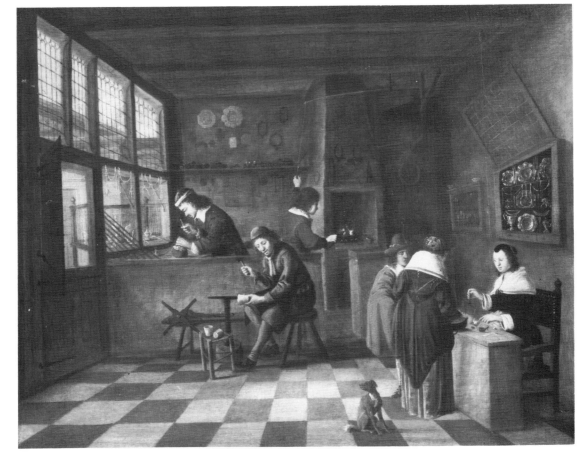

Stamping

Certain small, thin, and therefore fragile bits of goldsmiths' work such as the gold relief portrait of Charles v (cat. no. 40) were made by stamping out the sheet metal. Puzzlingly, although most of the stamped-out portraits like this one are closely related to medallic prototypes, they are not identical with them, therefore the craftsmen did not avail themselves of the medallic die to make them, but merely based their stamp (a positive rather than a negative) on it. Where small repeating elements of jewellery were needed a form of mass production was introduced, probably in South Germany, in the second half of the sixteenth century. For example, the same workshop which made the pomander (cat. no. 21), made a large number of the dress jewels now in the Museum für Angewandte Kunst, Vienna, which were part of the dowry brought by the Archduchesses Maria Christierna and Eleonora to the convent at Hall near Innsbruck when they became nuns there in 1607. These all have very flimsy stamped-out backplates to which the filigree decoration on the front is soldered. The stamping machine has left slightly ragged turned-over edges to the perforations where metal has been dragged down.

Filigree

The essential components of filigree are fine wire and granules of silver or gold. The first is made by drawing the metal through progressively finer and finer holes in a steel wire-drawing plate until the requisite thinness is achieved. Biringuccio describes and illustrates (fig 30) the various methods of doing so, by means of a capstan, a windlass or drums. He recommends that the gold and silver be fine and soft, and that it be kept well annealed to a degree where it can be put on the drum by hand at the start. He also describes the fraudulent manufacture of gold-plated silver wire on the Sheffield plate principle. 'Certainly, if it is not done for fraud, this process is a beautiful thing . . . especially since the gold that is applied thins out over the thing to which it is soldered and never reveals it to the outside. The wire may be drawn out so fine that the eye can scarcely perceive it, yet it is always very well gilded all over.'[19]

The granules were produced according to the same principles as now, by cutting gold wire into short lengths, putting it into a crucible filled with powdered charcoal and heating the whole up to melting point, causing the gold to become granules. The wire and granules were attached to each other or the backplate also by very much the same method as used now: a solder of two parts silver to one of copper was made, filed down very fine and added in three parts to one part of borax. Then the filigree elements were stuck together with gum tragacanth and, before the tragacanth water had dried, a little soldering powder was thrown onto it, 'Just as much as may suffice to solder your spray work and not more. The object of putting just enough on, is that the work when soldered shall be graceful and slender, for too much solder will make it look fat.' The whole is then heated so that the solder flows and attaches the various parts to one another. Filigree produces an effect of richness with the minimum use of precious metal and Cellini lists its principal uses as being belt buckles, crosses, pendants, boxes, buttons, capsules to be filled with musk, and bracelets.[20]

30 *A capstan, windlass and drums used to draw wire, a woodcut from Biringuccio's De la Pirotechnia (Venice, 1540)*

Enamelling

The skill at which Renaissance goldsmiths excelled, and which, more than any other quality, distinguishes the work of the period, is enamelling. Cellini lists the possible colours as being flesh, green, red, violet, yellowish-brown, blue, grey and grey-brown; yellow, white and aquamarine apparently were possible on both gold and silver. With very few exceptions all Renaissance enamelled jewellery is on gold not silver, in contrast with the many Austro-Hungarian and German nineteenth-century jewels in the Renaissance manner which more often than not are on silver.

With characteristic jingoism Cellini claims the invention of the art for Florence although he concedes that the French and the Flemings also excelled at it. He singles out one colour, a rich translucent red which could only be achieved on gold, as being the most beautiful of all, and gives its French name *'rogia chlero'* (*rouge clair*),[21] suggesting that it was still particularly associated with France at the time of writing. This is interesting because one knows that it was indeed a French invention of 200 years earlier, the oldest surviving example of it being the Reliquary of the Holy Thorn, *circa* 1325–50, in the British Museum.[22] Certainly, from surviving sixteenth-century examples, it is clear that this enamel colour had spread all over Europe by 1500.

For the rest of the colours, the attempt to attribute a specific palette range to a particular centre or workshop is still in its infancy, and only certain rather blatant colour combinations are easily 'placed': for example, the white, translucent and opaque dark green, blue and opaque pale blue of Hungary and the Adriatic, seen on the ship pendant (cat. no. 11), and the coarse black and white of much early seventeenth-century Spanish jewellery, as on the border of the crystal 'window' of the heart pendant (cat. no. 22).

From the 1540s onwards, enamelling, from being a mere accenting of the gold surface, tends to become essential to the appearance of the piece, and eventually every technique of enamelling can be found: *champlevé*, *basse-taille*, *ronde-bosse*, *cloisonné* and filigree enamel, and the technically demanding *émail en resille sur verre*. Painted enamel began to be used to add touches of colour to an enamelled ground at the very end of the sixteenth century.

Enamel is essentially fused glass, and Cellini describes its manufacture as follows: you put glass into a steel mortar, such as, he says could be bought in Milan, and crush it under water. The resulting glass flux must be washed repeatedly until there are no impurities left. Then you must take a piece of paper and chew it, 'Which, alas, I cannot do, as I have [no teeth] left', squeeze it out and use it to dry the flux which you then apply to the metal as though doing a painting. You put the object to be enamelled onto a sheet of iron big enough to be held with pincers and put it in the furnace and as soon as the enamels have begun to move but not flow, it should be brought out, and a second layer of flux applied. This must be heated to a high temperature and withdrawn quickly, and cooled with bellows otherwise the *rouge clair* will go yellow. The surface is then polished with an agate and finally with Fuller's earth.

The names for the different kinds of enamel refer to the varying ways of preparing the ground to take the flux, and Cellini describes the *basse-taille* method in detail. This involves depressing the whole area of the metal to be enamelled and in this shallow declivity 'no deeper than two sheets of paper', chasing whatever motif is needed in shallow relief and keying the ground slightly to help retain the translucent enamel which is fired on top. The blackplate of the South German pendent cross (cat. no. 7), is enamelled in this way with sea horses, c-scrolls and dolphins. The Augsburg workshops of the 1570s and '80s often incorporated opaque enamels in this technique, although this actually defeated the whole object of it, namely to show the chasing of the metal beneath.

Cloisonné involves building up retaining walls of metal (*cloisons*) by soldering them onto a backplate and enamelling within them. This technique was much used by the workshop or workshops which produced pieces like the necklace with a pendant (cat. no. 20), and the dress jewels from the convent of Hall near Innsbruck (Museum für Angewandte Kunst, Vienna). Filigree enamel, as on the ship pendant (cat. no. 11), is a variation on this with the filigree wires serving as *cloisons*.

Ronde-bosse enamelling is the covering of a convex surface with enamel, either opaque or translucent, by the simple technique of roughening the ground to provide a key. Cellini comments that for such relief enamelling, as on 'Fruit, masks, small animals and leaves', very fine carefully washed enamel must be used. This is the sixteenth-century enamelling technique par excellence as so much jewellery of the period is sculptural and polychrome. A typical example is the pendant with the figure of Faith (cat. no. 16).

Champlevé enamelling enjoyed a revival during the sixteenth century and was brought to an unprecedented level of perfection with, sometimes, only the finest scrolls of gold left in reserve between the trenches. The technique is used most commonly with the opaque colours; a trench is cut for the flux in the surface of the metal, which must therefore be relatively thick; the enamel is fired and then polished flush with the metal. The central stem of the French pomander (cat. no. 21) illustrates this technique. The segmental panels are examples of *émail en resille sur verre*. Here the ground is not metal but glass; the design is engraved into it in low intaglio and the hollows lined with thin glass foil and filled with the flux; the skill when firing it lies in melting the flux without damaging the glass backplate.

Gems and gem-setting

Relatively few pieces of jewellery from this period survive which are set with massive stones, and this gives a false impression of the aesthetic of the day. To be sure, fine sculptural goldsmith's work rich with enamelling was highly prized, but, as shown from the decree by which François I established the French crown jewels, its value was as nothing compared to that of the big gems with which much of the jewellery depicted in state portraits such as the one of Cristina di Lorena (fig 4) was set. Gemstones were as much admired for their natural beauty and their value as an alternative currency as they are now, and in addition, many people still believed that they possessed magical and thaumaturgical properties.

Cellini is brief on the subject of gem-cutting as it was not his craft, but he mentions three cuts which change the diamond 'From its roughness into those lovely shapes so familiar to us, the Table, the Facetted and the Point'. The method which he describes is in principle the same as that used now: the diamond was first shaped (bruted) by rubbing it with another diamond held in a stick. 'With the powder which falls from the diamond the last operation for the completion of the cut is made. For this purpose the stones are fixed into small lead or tin cups, and with a special clamping device, held against a steel wheel which is provided with oil and diamond dust. This wheel must have the thickness of a finger and the size of the palm of the hand; it must consist of the finest well-hardened steel and be fixed to a mill-stone so that through the rotation of the latter it also comes into rapid movement. At the same time 4 to 6 diamonds can be attached to the wheel. A weight placed on the clamping device can increase the friction of the stone against the moving wheel. In this way the polishing is completed.'[23]

A much more detailed account of the machinery is given by Anselm Boetius de Boodt in his treatise on gemstones,[24] first published in 1609. He illustrates diagrams, including one of a machine which he claims to have invented himself, with which, 'One can give form to numerous

31 *A machine for bruting numerous diamonds at one go, a woodcut from de Boodt's Gemmarum et Lapidum Historia (Hanau, 1609)*

diamonds at one go, and cut them artistically, and even if small, give them the desired and suitable facets, all of which would take a very long time if they had to be cut separately' (fig 31).[25] Later he says that while a diamond may be cut into various shapes, the most noble is the table, and more precisely, an oblong table. An alternative is the pointed shape, but all others he regards as being merely forced on the gem-cutter by the natural shape of the stone and his desire to remove as little material as possible.[26] This is interesting because it proves that the most frequently encountered diamond shape during this period, the table-cut, was the result of a deliberate aesthetic choice; there is no doubt that much more complex cuts were possible long before the mid seventeenth century when they became popular, but they must simply not have found favour, and thus were not developed to their full potential. A good example of a kind of rectangular rose-cut (that is, a flat back with a domed and faceted front) is the diamond on the right of the second row beneath the date 1551 in the painting of gemstones belonging to Albrecht V of Bavaria (fig 6).[27]

The principle of faceting the stone beneath the girdle to reflect back the light, an essential step towards the development in the seventeenth century of the brilliant cut, was grasped by the very early seventeenth century. De Boodt complains of the difficulty of detecting the foiling of stones to fraudulent ends because, 'The lapidaries have learnt to cut the lower surfaces of the stone so cleverly with many angles that, because of the reflections, the detection of the fraud is not always so easy'.[28] He also describes, rather poetically in his introductory chapter on faking, how faceting below the girdle makes a precious stone seem bigger, 'For by the multiple reflection of the rays which fall on the various facets and plains, they paint their image in the air roundabout'.[29]

Cellini and de Boodt do not agree in the valuation which they put on stones: Cellini estimates a ruby at 800 gold scudi, a comparable emerald at 400, a diamond at 100 and a sapphire at about ten; de Boodt makes an altogether more sophisticated assessment, with observations which still ring true today, such as that diamonds weighing less than 4 carats change price frequently, while those above keep a constant value.[30] Diamonds he values more highly than any other stone and he says that they are growing more and more popular and therefore more expensive. As a general rule of thumb he gives the price of a good 1-carat diamond as 130 thalers.[31]

A 4-carat ruby, if of perfect colour, is worth the same as a 4-carat diamond, and rubies which cannot be table-cut, and which look more beautiful when simply polished rather than

'prepared' are worth the same. But the others, 'Which are chosen only for the necklaces of venerable matrons and which have an imprecise shape, are valued beneath those which are table-cut'.[32]

The emerald he puts at a quarter of the value of a diamond of the same weight although he admits that not all authorities agree with him. Linscotanus, 'Who describes the route from the East Indies', rates an oriental emerald above a diamond, but de Boodt disputes this because of the many emeralds which have been coming in from the Americas, and he records that many jewellers prefer the Peruvian ones to the Eastern ones because of their more pleasing colour.[33] The sapphire de Boodt values lowest of the four at two thalers per carat.[34]

Both Cellini and de Boodt talk a great deal about the dangers of being deceived by a fake, the commonest means of deception being by the use of coloured foils, by heating the stone to change its colour, and by doubleting. For example, the ruby can be imitated by putting a red foil behind a white sapphire, a crystal or a topaz or by sticking a sliver of ruby onto a larger crystal base. Cellini notes that ruby and emerald doublets were made in Milan, set in silver, and were very fashionable among the peasant folk.[35] Emerald doublets can be seen set into the frame of the portrait miniature (cat. no. 6).

Fraud was particularly difficult to detect because, with very few exceptions, all jewels were put in closed settings (one of the exceptions being the great pointed diamond bought for 36,000 camera ducats which Cellini describes setting open in claws in the centre of large morse which he made for Pope Clement VII). A highly polished foil was put behind stones to improve their colour and to reflect the light back out of them. The setting of gemstones was obviously regarded as an important specialised skill by Cellini who devotes many words to the techniques involved.[36] Yellow foil was the one most commonly used and this was made from sheet metal composed of 9 parts gold to 18 of silver and 72 of copper. Red, blue and green foils were also used, however, and their composition was 20:16:18, 4:2:16 and 1:6:10, respectively. He tells that when he was an apprentice, there had been a master who specialised in foils, one Salvestro del Lavacchio; his were thicker than those made in France or Venice, which made the working of them more difficult, but the effect achieved was better. Unorthodox methods could also be used to improve the colour of a stone, as when he set a 3000 scudo ruby with some freshly cut red silk behind it, with astonishing success.

With a diamond which has not been cut as either a rose or a brilliant the problem is to prevent all the light from disappearing out of the back of the stone, and to do this Cellini recommends covering the back of the diamond with lamp black mixed with mastic.[37] Where the diamond is too thin to take black colouring a crystal mirror blackened with soot could be placed in the base of the box setting, with a gap between the crystal and the diamond. He notes that beryls, white sapphires, white amethysts and citrines should also be set in this way, as the direct application of lamp black only makes them look black.[38]

Clearly, from the amount of space which he devotes to improving the colour of gemstones this was not only a speciality of his but something which was very much required of the gem-setter at the time.

Notes

1 This was a popular work which was published eight times during the sixteenth century. Venice, first edn: Venturino Roffinello, 1540; second edn: Giovan Padoano, 1550; third edn: Comin da Trino di Monferrato, 1558–59; fourth edn: P. Gironimo Giglio, 1559. France, first edn: Paris, Claude Fremy, 1556; second edn: *ibid*, 1572. England, first edn: London, William Powell, 1555; second edn: London, 1560. The most recent translation of it is by C. S. Smith and M. T. Gnudi (New York, 1959), and it is this edition which has been used here

2 *Due trattati intorno alle otto principali arti dell'oreficeria. L'altro in materia dell'arte della scultura ecc* (Florence, Valente Panizzi e Marco Peri, 1568). There was not a second edition until 1731. An English version, translated and edited by C. R. Ashbee (London, 1898), has been used here

3 *ibid*, p 24

4 B. Thomas, 'Die Münchner Waffenvorzeichnungen des Etienne Delaune und die Prunkschilde Heinrichs II von Frankreich', *Jahrbuch der Kunsthistorischen Sammlungen* LVIII (1962) pp 101–68

5 *Princely Magnificence*, no. 17

6 *Princely Magnificence*, no. G 3

7 *Princely Magnificence*, no. G I

8 Lieb II, p 135

9 British Museum, Department of Prints and Drawings

10 Thomas Geminus, *Morysse and Damassin renewed and increased very profitable for Goldsmythes and Embroderers* (London, 1548)

11 Three sets, n.d., one entitled *Ornement de damasquinerie pour les fourbisseurs A Paris chès P. Mariette*; see *Katalog der Ornamentstichsammlung der staatlichen Kunstbibliothek Berlin* (Berlin, 1936) nos 280–82

12 When Henry VIII was offered the pendant in fig 2 by the Fuggers in 1546, they also offered to send him 'the pattern of the jewel in lead'; quoted from the attached letter; see *Princely Magnificence*, no. G 48

13 Cellini, p 49

14 A bill dated 1601, in the Florentine archives pays Bartolommeo di Jacopo (Santini), 'tornaio', for making five wooden beakers of various forms, and five vase bases as models 'di farsene di gioie', which were delivered to the workshop of Ambrogio Milanese. Quoted in W. Fock, *Der Goldschmied Jaques Bylivelt aus Delft* (Alphen aan de Rijn, 1975) p 38, note 106.
 These lead and wooden models meant that a form could potentially be diffused very easily, and indeed, could spread from one craft to another: for example, a tabernacle pendant design by Jean Collaert is applied to the side of a stoneware jug by a Raeren maker; see H. Hellebrandt, *Raerener Steinzeug* (Aachen, 1967) p 97

15 Biringuccio, p 326

16 Cellini, p 62

17 Cellini, pp 45–52

18 Cellini, p 57

19 Biringuccio, pp 377–80. 'Concerning this drawing of gold and silver I wish to tell you how it is customary to proceed today in almost all works in order to effect a saving of the quantity of gold that would enter the materials that are woven, or in order to alter it for fraud. This wire is also fabricated so that it appears to be all fine gold and actually is almost all silver, for the weight of only one ducat of gold is put on every pound; and some, desirous of greater fraud, make the core not even of fine silver but of copper, and gild it. Briefly, to do this a cast bar of copper or fine silver is made, then beaten and made round by the hammer. After being well filed and cleaned, a covering of fine hammered gold is soldered over it (or if it is copper you can make this covering of silver) in that quantity by weight that you wish to put on. Solder it on a little furnace with charcoal and with flames of elder, almost bringing to a melt before rubbing it with a dry stick, as is customary, or with chalcedony or bloodstone, so that the applied covering may spread out all over it and everywhere come in contact with the thing to which it is to be soldered. Then it is cooled, annealed again, hammered thin, and it is ready to be put in the drawplate . . .' This is not closeplating, which involves the use of a soldering medium between the two metals, but, as with Sheffield plating, heat alone is used to join them; Biringuccio also realised the principle on which Sheffield plating is based, namely, that the two metals would stretch and spread as one once fused

20 Cellini, chap. II

21 Cellini, chap. III

22 See M. Campbell, 'The Campion Hall Triptych and its Workshop', *Apollo* CXI (June 1980) pt 2, pp 421–22 and note 31

23 Cellini, pp 31–32

24 Anselm Boetius de Boodt, *Gemmarum et lapidum Historia* (Hanau, 1609); the quotations here are from the French edition *Le Parfaict Ioallier ou Histoire des Pierreries* (Lyon, 1644)

25 *ibid*, p 97

26 *ibid*, pp 173–74; see also the excellent article by the gemmologist and jeweller H. Tillander, 'Die Tafeldiamanten der Schatzkammer in Munchen', *Gold und Silber* (April 1969) pp 96–101

27 Tempera on vellum, 55.4 × 35.5 cm. Bayerisches Nationalmuseum, Inv. no. R 8220

28 de Boodt, pp 186–87

29 de Boodt, p 77

30 de Boodt, p 161

31 de Boodt, p 173

32 de Boodt, p 185

33 de Boodt, p 256

34 de Boodt, p 240

35 Cellini, p 27; see also the reference in the inventory dated 28 November 1631 of jewels and goldsmiths' work moved from Prague to the imperial treasury in Vienna, which lists under item 69, 'Mehr dreiunddreissig ring mit schlechten steinen, bohaimbischen diamantdobletten und etliche mit cranaten versetzt'. ('Plus thirty-three rings set with poor stones, bohemian diamond [i.e. rock crystal] doublets and some set with garnets'). *Jahrbuch der Kunsthistorischen Sammlungen* XXV (1905) pt I, no. 19429

36 Cellini, chap. V and VI

37 Cellini, chap. IX

38 Cellini, chap. X

Techniques of the gold box makers

The techniques of eighteenth-century goldsmiths varied little from those used by their Renaissance forebears, the main exception being in the use of coloured golds. However, the makers of gold boxes, especially those in France, adopted an idiosyncratic, if practical, method of construction which is worthy of comment. Rather than use solder to bind the elements of a snuff-box together, the makers of boxes frequently used pins. Such a method of construction allowed the box to be assembled without damage to enamels, miniatures or precious plaques, and to be dismantled should the box need repair or partial replacement. A further distinctive aspect of the production of a box in eighteenth-century Paris was the care lavished on making the hinge. Indeed so important was this aspect of manufacture that the author of the section on snuff-boxes in the *Encyclopédie* devotes three-quarters of his text to it. The hinge had not only to render the box airtight, it should not be unsightly (indeed, in many instances it is almost invisible), and it should allow the lid to open with ease to just the correct angle to allow the box to balance evenly in the hand.

Designs

The starting point in the manufacture of gold boxes is represented by the several volumes of designs which have survived from France, Germany, Austria and England. Many of these can be attributed to individual artists. For example, amongst the drawings for boxes and rubbings of boxes in the Victoria and Albert Museum[1] are examples signed by Mondon, Mornay, Mongenor, Gabriel de St Aubin and Leseure (figs 32–35). Drawings by Meissonier, P. Moreau and Hubert Gravelot for gold boxes are preseved in the Musée des Arts Decoratifs.[2] Sheets of designs by Jean

32 *Design for a gold box, body colour and ink on paper, by Gabriel de St Aubin (1724–80) (Victoria and Albert Museum, London, Inv. no. E88–1938)*

33 *Design for a gold box, body colour and ink on paper, French, mid eighteenth century (Victoria and Albert Museum, London, Inv. no. E289–1938)*

34 *Design for a gold box, body colour and ink on paper, French, circa 1770 (Victoria and Albert Museum, London, Inv. no. E208–1938)*

35 *Design for a gold box, body colour and ink on paper, French, mid eighteenth century (Victoria and Albert Museum, London, Inv. no. E211–1938)*

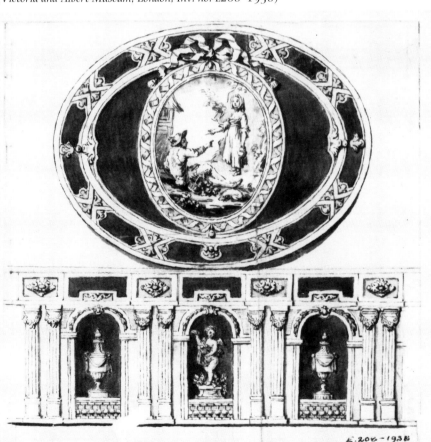

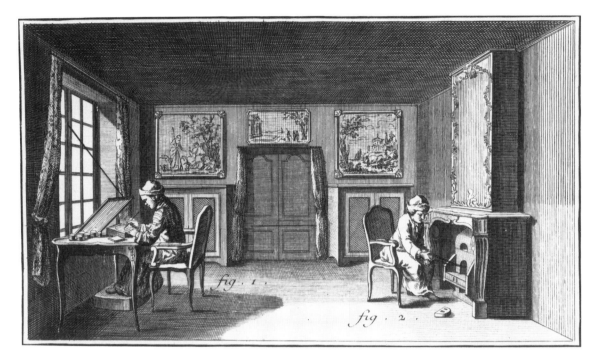

36 *An enameller's workshop,
a plate from Diderot and
d'Alembert's Encyclopédie
(Paris, 1755). On the left the
painter works at the window,
while his assistant fires work in
the muffle kiln*

Paul Kolbe of Vienna survive in the Kunstbibliothek, Berlin[3] and in the collection of Messrs
S. J. Phillips, London (fig 2, cat. no. 108) and thirteen designs by Jean Guillaume George Krüger
for the Fabrique Royale in Berlin are to be found in the Kupferstich Kabinett in that city.[4]
Several loose drawings for watches, boxes and a chatelaine by George Michael Moser, first
Keeper of the Royal Academy, London, are known. It is, however, one of the curiosities of
eighteenth-century studies that few if any of the French designs can be directly associated with
extant boxes. A possible explanation for this is that the drawings, commissioned either by the
marchands-merciers or the goldsmiths themselves, which were used in production passed
through so many hands that they became too damaged to preserve or were deliberately
destroyed as being of no further use to the workshops.

Coloured gold

It is not clear from contemporary records whether the application of coloured gold decoration
was undertaken in the workshops of the manufacturing goldsmiths or in that of a specialist.
This form of embellishment *en quatre couleurs*, of which the most usual colours were red, green,
blue, yellow and white, became popular in the mid 1750s. The different colours were obtained
by varying the alloys of the gold and several recipes survive from the eighteenth century. Mrs
Le Corbeiller gives those from the *Secrets concernant les arts et metiers* of 1790 which were
probably typical of the current practice. These indicate that the addition of copper gave red
gold; arsenic or steel filings gave blue or grey gold; silver could produce green gold and the same
metal in different proportions was used for white gold until the predominant use of platinum
just before the Revolution. Yellow could be obtained with an alloy of gold and a compound of
iron. Having cast and chased the individual coloured elements, these were soldered to the body
of the box before the final chasing and burnishing. In addition, the gold could be tinted with
various chemicals. These were either applied by dipping the gold into a boiled solution
containing substances such as turmeric and subsequent firing, or by the use of wax containing
colouring agents which could be applied with a brush and fired. Both techniques only affect the
surface of the gold and are consequently less durable than gold coloured in alloy.[5]

Enamel

The author of the section of the *Encyclopédie* devoted to enamel makes reference to three types of enamel used in the eighteenth century.[6] The first is the translucent coloured glass used in imitation of precious stones, and known in England as 'paste'. His second category is that used for painting, and his third is the enamel glass, often opaque, used by the lampworks of Nevers in the production of figures. The recipes which are given are largely derived from those in Antonio Neri's *L'Arte Vetraria*, first published in Florence in 1612, and Johann Kunckel's *Ars Vetraria Experimentalis* (Jena, 1679), both of which had several subsequent editions. An English translation of Neri was issued by Christopher Merret in 1662 and this was probably used by Robert Dossie in his *Handmaid to the Arts*, published in 1758, which gives recipes for different colours of enamel as well as guidelines for constructing a muffle kiln and for painting in enamel colours (figs 36 and 37). Enamel is glass coloured by the inclusion of metallic compounds. These colours could be bought ready prepared in cakes from Venice, or, following the establishment of the porcelain factory at Meissen, from Dresden, or they could be made up by the enameller

37 *Firing enamels at the muffle kiln in Fabergé's workshop. The craftsman on the right has been identified as Nicolai Petroff (A. K. Snowman Collection, London)*

himself. Dossie recommends that the body of the enamel should be prepared from powdered fine white sand or calcined flints with the addition of red lead, alkaline vegetable salts, borax or even common salt to which were added colouring agents. White was obtained with tin oxide or arsenic; scarlet, crimson or purple with gold, or crimson with manganese and copper; yellow with silver, sulphur and antimony or iron; and blue with ultramarine (calcined lapis lazuli) or zaffer (calcined cobalt). Other colours could be obtained by mixing these. Black was the result of mixing zaffer, manganese, scarlet ochre and antimony in equal parts. Dossie goes on to suggest that these colours should be mixed with oil of spike thinned with turpentine since other oils burnt black in the kiln. To avoid cracking the enamel, both sides of the metal plate must be painted to reduce tension, and Dossie recommends that the work should be warmed before firing and cooled slowly afterwards. Since the colours fused at different temperatures it was necessary to begin with those which melted at the highest temperature and to add other colours with a lower melting point at subsequent firings. The furnaces should be fired with pit coal or charcoal, but they must also be fitted with a muffle, a metal screen to prevent fumes colouring the molten enamel. Alternatively the enamels could be protected by metal boxes, called 'coffins', during firing. When cooled the enamel was polished to give it the even sheen required.

The enamel was applied to boxes either *en plein* or *en basse-taille*. The former term indicates that the enamel has been applied directly to the surface of the box (cat. no. 67), rather than to separate panels which were subsequently mounted *à cage*. *Basse-taille* enamelling, the use of translucent enamel over an engraved ground so well described by Cellini, was frequently used on gold boxes in the eighteenth century. However, a refinement was the use of translucent enamel over engine-turning. This technique of producing a continuous pattern by machine, used on wood and ivory since the sixteenth century, does not seem to have been used on gold until about 1745. In that year the *marchand-mercier* Hébert supplied 'Trois boîtes d'or tournées, emaillées en bleu, 3,990 livres' for the *corbeille de marriage* of Marie-Thérèse-Antoinette.[7] Its use under enamel is first thought to have been practised by Genevan goldsmiths, but was brought to perfection in the workshops of Carl Fabergé in the late nineteenth century.

Notes

1 Inv. nos E 51–1729–1938
2 Snowman (1966), figs 26–29, 79–92 and 49
3 Snowman (1966), figs 523–34
4 Le Corbeiller, p 24
5 N. Goodison, *Ormolu: the work of Mathew Boulton* (London, 1974), p 71 ff gives several preparations used in the eighteenth century
6 *Encyclopédie*, pp 533–45
7 Maze-Sencier, p 152

The collecting of jewellery

Only six of the great sixteenth-century collections of jewels and jewelled objects have come down to us today even partially intact. The imperial jewels and mounted vessels, accumulated for the most part by Rudolph II, are in the Kunsthistorisches Museum, and the Secular and Religious Treasuries, in Vienna. The Residenz in Munich houses the Dukes of Bavaria's pieces including eight of the ones originally declared heirlooms by the Disposition of 1565, and in Dresden the astonishing Green Vaults hold some of the sixteenth-century Electors' jewels as well as the later virtuoso productions of the Dinglinger workshop. The French royal collections have not had such an effortless descent to modern times, partly because of the Religious Wars of the sixteenth century during which most of the royal treasures and crown jewels were dispersed, and partly because of the Revolution. But the Gallerie d'Apollon at the Louvre still contains a large number of the sixteenth- and seventeenth-century mounted vessels which belonged to Louis XIV, while the Cabinet des Médailles at the Bibliothèque Nationale houses mounted cameos and intaglios which can be traced back to the French royal collections at least since the time of Henri IV (1589–1610). In Madrid, the Prado has six cases full of wonderful mounted semi-precious stone vessels dating from the later part of the sixteenth century, and the seventeenth, but none of these can be proven to have belonged to Philip II of Spain (1527–98), great collector of such things as he was: rather they came to France as an inheritance from Louis XIV's son, the Grand Dauphin, Louis de Bourbon who died in 1711. Living in his small Palais de Meudon, he had spent his life enthusiastically amassing works of art, often almost in competition with his father, with whom he shared a great love for coloured stones mounted in enamel and jewels. At least one of his pieces, a crystal covered vase with a distinctive black and gold moresque with white interlace enamelled mount can be proven to stem from a French royal workshop of the 1560s.[1] The big stones have been prized out of the gold at some stage in the cup's history, making one realise how close it too came to total destruction.

In Florence, the Palazzo Pitti houses a good number of the mounted vessels made for the Grand Dukes, but of the important sixteenth-century jewellery not one piece survives. Instead, there is a small group of cheerful little pendants, all made around 1600, and shaped as mermaids, frogs, goats, elephants and so on, which belonged to Anna Maria Luisa, daughter of Cosimo III, who married the Elector Palatine. His court was at Düsseldorf, and when he died in 1717 she returned to Florence with all her possessions which included these little jewels, too insignificant to appear in detail in any inventory, and possibly acquired in Germany, or perhaps brought with her to her marriage. Whether she was an early collector of Renaissance jewels is therefore hard to prove. The significance of her little group of objects is that it dates from well before the time when anyone would have dreamt of faking such pieces, and so is highly instructive.

In general one has little reason to suppose that Renaissance jewels, as opposed to the mounted vessels of that period, were much esteemed during the eighteenth century except as antiquarian curiosities or historical relics. Horace Walpole, for example, owned the Darnley jewel, made for Lady Margaret Douglas, mother of Henry, Lord Darnley, in memory of her husband, Mathew Stuart, Regent of Scotland.[2] This extraordinary heart-shaped locket is both crude and complex

in its appearance, enamelled all over, as it is, with emblems relating to the dramatic events of her life. He also owned a *Gnadenpfennig* with a medal of Maximilian II[3] and three 'ancient' watches, possibly sixteenth or early seventeenth century in date. But these were all in keeping with the hairs of Edward IV, cut from his head when the tomb in St George's chapel was opened, and the Stuart memorial jewellery – they were all relics, and their romantic and historical associations were their principal attractions.

The collector who is often mentioned in the same breath as Walpole, William Beckford (1759–1844), did not collect Renaissance jewellery at all, but he did have a passion for mounted hardstone vessels, commissioning pieces for himself, and buying for £285 in 1819 the extraordinary smoky topaz vase with early seventeenth-century enamelled dragon mounts from E. H. Baldock, the grandest London dealer of the day. Beckford must have been drawn to this brilliant object, now in the Linsky Collection, and still in almost perfect condition, by the story that it had belonged to Caterina Cornaro, last queen of Cyprus.[4] It was also supposed to have been made by Benvenuto Cellini, the sculptor and goldsmith whose memory, like that of Michelangelo and Giambologna, had remained vivid, if distorted, throughout the eighteenth century. He had, of course, been a consummate self-publicist, and his *Life* was published in Naples in 1728, well before the Romantic movement. Then in 1771 there was a London edition entitled *The Life of Benvenuto Cellini: a Florentine artist . . .*, which shows that he was supposed, in some way, to typify the species, and the translation by the great Goethe himself appeared in Braunschweig in 1798, with the title, *Benvenuto Cellini: a story from the sixteenth century*.[5] Berlioz's opera *Benvenuto Cellini* produced in Paris in 1838 (Weimar 1851, London 1853) is a tale of love, elopement and murder which bears no relationship to Cellini's account of his own life, but does include the detail of his sacrificing the household pewter to the melting pot in the triumphant process of casting his Perseus.[6]

There were to be no fewer than eight more operas involving Cellini during the course of the nineteenth century, so everyone who had anything at all to do with art fancied they knew the man; his own estimate of his technical virtuosity was believed, and every piece of sixteenth-century jewellery or goldsmiths' work which was particularly elaborate or sculptural was at once attributed to him. For example, in 1847 Jules Labarte, that considerable scholar, gave three of the fifty-one pieces of Renaissance jewellery collected by Debruge Dumenil in the fifteen years earlier, to Cellini, and that shows relative restraint on his part.[7]

All sixteenth-century jewellery,[8] however trumpery, shared in the reflected glory of his craft which was identified as being the precise, densely scrolling elaboration of Mannerist goldsmiths' work in reality, the style of a decade or so after Cellini's death, and more Northern European than Italian. And if Debruge Dumenil was, as in all fields of the decorative arts, one of the first collectors (two of his pieces are cat. nos 2 and 16), he was swiftly followed by many others, and the prices rose accordingly. For example, an Augsburg pendant of about 1580 (now at Waddesdon Manor, Berkshire), with two figures symbolising the Sciences, then also attributed to Cellini, fetched £66.8s at the Debruge Dumenil sale in 1850, while the Canning jewel, a famous baroque pearl pendant in the shape of a merman, now in the Victoria and Albert Museum, cost £300 at Christie's only thirteen years later; in 1881, Baron Ferdinand de Rothschild paid £2121 for the Lyte jewel,[9] a diamond-set English piece then thought to be Italian, and now in the British Museum.

The Rothschilds in England, France and Germany were one of the forces pushing up the prices as this jewellery fitted perfectly into their collecting taste; there was Baron Adolphe (d. 1900) who bequeathed thirteen pieces, including fig 1, cat. no. 16, to the Louvre.[10] Freiherr

Karl von Rothschild who lived in Frankfurt-am-Main assembled around 3000 works of art from the 1850s onwards, and among them were over 200 pieces of jewellery, mostly of the Renaissance;[11] and Baron Ferdinand de Rothschild (d. 1898) left 199 pieces to the British Museum.[12]

As demand outstripped supply, skilled goldsmiths began to fill the market's need, assisted by the fact that the great princely collections of Renaissance jewels were now open to the public (for example, the Green Vaults, Dresden from 1831 onwards; the imperial collections, Vienna from 1870 onwards) so that outstanding examples of the craft could be studied in detail. In all branches of the visual arts the Renaissance was admired as much if not more than the Gothic, and it was affecting contemporary jewellery design as much as was the archaeological movement. In Vienna, firms like Markowitsch and Scheid (founded 1848), Kleeberg, August and Huck (founded before 1871) and Herman Ratzersdorfer (founded before 1845), specialised in particularly accurate versions of the Renaissance revival especially during the 1870s.[13] That the last firm deviated from mere imitation to faking, or purveying of fakes, is revealed by a letter in the Victoria and Albert Museum Archives which rebukes them for having 'impudently' offered the new museum spurious enamelled work. And, of course, there was Reinhold Vasters of Aachen,[14] faking away busily around the same time, for the *marchand-amateur*, Frederic Spitzer, in Paris, and for who knows what other clients, both witting and unwitting. The posthumous Spitzer sale in 1893 included 266 pieces of jewellery, most of them Renaissance in style, and with a good sprinkling of Vasters's creations.[15]

By the 1890s, together with a host of other, smaller collectors, Pierpont Morgan had entered the market for Renaissance jewels as well as everything from Fragonards to Byzantine art. As *The Burlington Magazine* said in its obituary of him when he died in 1913, his collecting methods were Napoleonic, and his huge prices unsettled the market. For example, in 1902, that most insinuating of dealers, Duveen, challenged him into paying the vast sum of £5250 for the Armada jewel,[16] a sixteenth-century pendant with multiple portraits of Queen Elizabeth I, now in the Victoria and Albert Museum; thirty years later it was to fetch half that amount. By no means everything that Morgan bought was authentic, for as *The Burlington Magazine* also said, 'He was a great collector, he was not a connoisseur',[17] and the Metropolitan Museum, New York, has had to enjoy the greater part of his collection, both good and bad, ever since.

By comparison with the previous years, the twentieth century saw a decline in the admiration for jewels of the Renaissance period, just as baroque and mannerist plate went out of fashion between the wars, and was replaced in people's esteem by the more austere creations of the Queen Anne period. Collections were still being assembled, however: Max von Goldschmidt-Rothschild's was sold at the Parke-Bernet Galleries, New York, in 1950, J.Desmoni's at Sotheby's in 1960, a private one at Christie's in 1961, the jewellery dealer, Melvin Gutman's at Sotheby's, New York, in 1969, and Arturo Lopez-Willshaw's at Sotheby's, London, in 1979.

Fashions in art come and go, and since the 1950s there has been a steady rise in the price of Renaissance jewellery: cat. no. 1, sold at the Goldschmidt-Rothschild sale in 1950 for $500, and at the Melvin Gutman sale in 1969 for $23,000, to give just one dramatic example.

A few pieces in the Thyssen-Bornemisza Collection were acquired before the last war, at unspecified times, by the present Baron's father: the rock crystal vessels, with the exception of cat. no. 37, and the Spanish pendant with St James defeating the Moor (cat. no. 10). A few more pieces were gifts to the present Baron, and everything else was bought during the 1960s, and to a lesser extent, the 1970s, mostly from the sales mentioned earlier.

Notes

1 Inv. no. cat. 1947 no. 54; E. Steingräber, *I Tesori Profani d'Europa* (Milan, 1968) p 36. The documented comparative piece is the onyx ewer dating from the 1560s given in 1570 by Charles IX of France to Archduke Ferdinand II (fig 1, cat. no. 2, Inv. no. 1096)

2 *Catalogue of the Classic Contents of Strawberry Hill collected by Horace Walpole*, sold 11 May 1842, no. 59

3 *ibid*, no. 86

4 Reitlinger, p 375

5 In the nineteenth century there was a flood of editions of the *Life* and the *Treatises*; for an account of all publications before 1907, see S. J. Churchill, *Bibliografia Celliniana* (London, 1907)

6 This detail obviously appealed to the Romantic feeling for the dream of artistic creation because it closely resembles the contemporary legend about the potter, Bernard Palissy, burning all his household furniture in an attempt to discover a new firing technique

7 Labarte, nos 992–94

8 eg, in 1858, C. Arneth published *Die Cinque-Cento Cameen und Arbeiten des Benvenuto Cellini und seiner Zeitgenossen im K. K. Münz- und Antiken-Cabinett zu Wien*, showing where his priorities lay; in fact, the imperial collections in Vienna do contain the one and only piece of goldsmiths' work by the master, the famous salt

9 Reitlinger, p 390

10 E. Molinier and G. Migeon, *Le legs de Adolphe de Rothschild aux Musées du Louvre et de Cluny* (Paris, 1902)

11 F. Luthmer, *Der Schatz des Freiherrn Karl von Rothschild. Meisterwerke alter Goldschmiedekunst aus dem 14.–19. Jahrhundert* (Frankfurt, 1885) vol. 2 illustrates some of the jewellery

12 C. H. Read, *The Waddesdon Bequest. Catalogue of the Works of Art bequeathed to the British Museum by Baron Ferdinand de Rothschild* (London, 1902)

13 see W. Neuwirth, *Wiener Gold- und Silberschmiede und ihre Punzen 1867–1922* (Vienna, 1977). Plate 17, vol. I, shows a pendant made exactly after the Holbein design in the British Museum (fig 25)

14 see C. Truman, 'Reinhold Vasters: the last of the goldsmiths', *Connoisseur* CC (March 1979)

15 C. Mannheim and P. Chevalier, *Catalogue des Objets d'Art et de Haut Curiosité Antique, du Moyen Age, et de Renaissance composant l'importante et précieuse Collection Spitzer*, sold Paris, 17 April–16 June 1893. For example, lots 1827, 1865, 1819, 1813, 1840

16 Reitlinger II, pp 391–92

17 'Mr John Pierpont Morgan', *The Burlington Magazine* XXIII (March 1913) pp 65–67. For the best account of Pierpont Morgan's life, see H. L. Satterlee, *J. Pierpont Morgan: an intimate portrait* (New York, 1939)

The collecting of gold boxes

Unlike the collecting of jewels, the collecting of gold boxes brought with it no patriotic, dynastic or magical benefits. However, even in the eighteenth century several men and women could be said to be collectors of such things, in that they possessed a number of boxes far in excess of their needs, and even beyond the number dictated by rapidly changing fashions. Reputed to be amongst the largest of eighteenth-century collections was that of the Prince de Conti who was rumoured to own 800 snuff-boxes at his death in 1777, but Sir Francis Watson has pointed out that only thirty-four were included in the two subsequent sales of his estate.[1] However, smaller collections were not uncommon. In 1723, for example, the duchesse d'Orleans was said to

have owned eighty-seven boxes,[2] and at the sale of the property of the Comtesse de Verrue in 1737 some 200 were listed.[3] According to Boswell the extravagant Count Bruhl, director of the Meissen porcelain factory, possessed 'upwards of seven hundred snuff-boxes' when he died in 1764.[4] In the same year, the inventory taken following the death of Madame de Pompadour contained details of sixty-seven gold or gold mounted boxes, including two by the enameller Aubert (see cat. nos 47–49).[5] Three years later, the posthumous inventory of the Dauphine Marie-Josèphe de Saxe contained about seventy boxes of gold, enamel, stone, lacquer and 'vernis' many of which were subsequently bequeathed to her ladies in waiting.[6] At the sale of Jean-Louis Gaignat in 1769, the twenty-two boxes were illustrated in the margin of a copy of the catalogue by Gabriel de St Aubin, who also supplied designs for snuff-boxes.[7]

In England such collecting was not unknown. Horace Walpole credited the Duchess of Portland with the possession of 'hundreds of old-fashioned snuff-boxes that were her mother's, who wore three different every week'.[8] However, Sir Francis Watson has again pointed to the probable exaggeration of this statement since her sale contained less than fifty examples.[9] Walpole himself included snuff-boxes amongst his collection. In the Tribune at Strawberry Hill in 1774 was 'a red snuff-box with enamelled top and bottom, given to Mr W by Francis, Earl of Hertford' (cat. no. 66).

The nineteenth century saw the birth of collecting boxes solely as objects of beauty rather than as of function, since the habit of snuff-taking was surpassed by that of cigar and cigarette smoking from the earliest years of the century. Admiration for the arts of the *ancien régime* was particularly strong in countries which had been uneffected by the French Revolution and, in England, George IV and the Marquises of Hertford were amongst the keenest collectors of boxes both of whom would have regarded these small and precious items as epitomes of eighteenth-century taste. The King's collection was dispersed or destroyed following his death, but the Hertford boxes, added to by Sir Richard Wallace, are now contained in the Wallace Collection, London.

It would be impossible to survey the collecting of gold boxes in the nineteenth century without reference to the Rothschild family. The acquisitions of five members of the family are represented at Waddesdon Manor. Baron Ferdinand, who built and furnished the house, bought gold boxes on the London art market and inherited a fine group of miniatures by the van Blarenberghes from his father, Baron Anselm of Vienna. Baron Ferdinand's sister, Miss Alice de Rothschild inherited Waddesdon in 1898 and the collection subsequently passed to her great-nephew, Mr James de Rothschild who also inherited some boxes from his father Baron Edmond de Rothschild of Paris. Anthony Blunt has demonstrated that Baron Ferdinand's overriding interest was in all aspects of French life under the *ancien régime* and in consequence his collection included snuff-boxes, themselves inextricably bound up with French eighteenth-century custom, decorated with miniatures depicting both grand and common-place events by the van Blarenberghes, a taste shared by Meyer Rothschild at neighbouring Mentmore Towers.[10] It was a collection intended to harmonise with the French furnishings of the house and was clearly not considered to be of the same importance as the collection of goldsmiths' work which Baron Ferdinand bequeathed to the British Museum. Miss Alice's taste was remarkably close to that of her brother and she added to the miniature collection but her devotion to pug-dogs led her to acquire three boxes formed as pugs in Meissen porcelain and amethystine quartz (see cat. no. 92). After 1945 a collection of boxes bequeathed by Baron Edmond de Rothschild in 1934 to his son James joined those already at Waddesdon, but unlike them this collection concentrated more on goldsmith's work than on miniatures.

In Frankfurt, Freiherr Karl von Rothschild also collected gold boxes but unlike his English relatives he collected very few boxes with miniatures. Indeed he does not appear to have suffered from the preoccupation with all things French which characterised Rothschild collecting when it turned towards the eighteenth century. Freiherr Karl acquired several fine German boxes including one by Heinrich Taddel and another by J. P. Kolbe of Vienna.[11]

Another of the great English collectors was Charles Goding, whose collection of sixty-four boxes was exhibited at the South Kensington Museum (now the Victoria and Albert Museum) in 1862 and again from 1880 until 1884 when it was acquired by the dealer Samson Wertheimer. The *Special Exhibition of Works of Art* at South Kensington in 1862 where the collection was first shown is an extraordinary document of the collecting taste at that time. Nearly 400 gold boxes and related items were displayed. They were the property of a strange variety of collectors including a Royal Duke, two peers of the realm, two members of Parliament, two Rothschilds and a priest. Sadly, however, the descriptions of the boxes are frequently too brief to enable subsequent identification. For example, the very fine circular box by Barnabé Sageret (cat. no. 55) in the collection of His Royal Highness the Duke of Cambridge is described as 'No. 4,176. Circular gold box; chequered ground with translucent enamel flowers'. The same brevity was used in auction sales until comparatively recently and therefore, unlike pictures, it is often impossible to trace a gold box from collection to collection. An exception is possible when a particularly distinctive feature such as a signature, though not a hall-mark, is mentioned. One such piece is the steel and gold box signed 'Kolbe à St Petersburg' (cat. no. 108), which was part of the huge collection of boxes formed by C. H. T. Hawkins and offered at auction by Messrs Christies in six large sales between 1896 and 1936.

From sales such as this, French collectors were able to once again acquire the gold boxes which had been dispersed abroad at the sales following the Revolution of 1789. Serge Grandjean has noted that Basile de Schlichting included amongst his bequest to the Louvre in 1914 of 114 boxes, one from the collection of George IV, offered at the sale of the Earl of Harrington's boxes in 1851, as well as several from Charles Goding and C. H. T. Hawkins.[12] Eight years later another Rothschild, Baron Salomon, bequeathed a further 107 boxes to the Louvre, thereby ensuring the supremacy of the French national collection amongst European and American museums.

The twentieth century has seen the formation and dispersal of several remarkable collections, not least amongst these being Charles and Emile Wertheimer's sold in 1912 and 1953, and that formed by the late King Farouk of Egypt (see cat. no. 125) and sold, following his downfall, in 1954. More recently the collections of Chester Beatty, René Fribourg and J. Ortiz-Patiño (see cat. nos 46, 47, 50, 53, 60, 65, 83, 85 and 86) have passed through the salerooms and have demonstrated that collectors have moved away from regarding gold boxes as mere adjuncts to the creation of a French interior towards an appreciation of quality of design and manufacture.

It is this same concern with quality, combined no doubt with a tinge of romanticism, which is found amongst collectors of Fabergé today. However, this has not always been the case. Amongst the largest collections of the Russian goldsmith's work is that created by Queen Alexandra, and formerly displayed at Sandringham. Not only did the King and Queen commission pieces from St Petersburg, through the offices of Henry Bainbridge in London, but visitors to Sandringham would frequently take a piece as a present for their royal hostess. The most usual candidates for this gift were the hardstone animals which were considered neither too cheap nor too expensive to be embarrassing. For example, the Hon. Mrs Ronald Greville bought

the model of King Edward VII's Norfolk terrier Caesar on 29 November 1910 which is still in the Royal Collection. The little onyx carving with a collar enamelled with the inscription 'I belong to the King' cost thirty-five pounds.[13] Viscount Knutsford, who visited Sandringham in 1909, recorded his impression of the Queen's collection. 'The Queen likes most agate animals, of which she has a magnificent collection in two large glass cabinets, which every evening are lit by electricity. There is a Russian in Dover Street who makes them, and a man in Paris makes the flowers of the same stone. Some are cut out of jade. . . . There were quite forty different agate animals, monkeys, penguins, dogs, birds, chinchillas, all exquisitely modelled by this Russian, and all made to order.'[14] The Royal Collection was by no means unique. Several families such as the Nobels and the Kelchs or the Rothschilds at Gunnersbury Park formed their own private treasuries.

Following the Russian Revolution, the interest in the work of Fabergé was stimulated by Jacques Zolotnitsky in Paris, by Emmanuel Snowman of Messrs Wartski in London and by Dr Armand Hammer in the United States. From 1924, Wartski held a series of exhibitions to display the works of art that had been acquired in Russia. Dr Hammer who had been paid in kind for his Russian business interests, arranged an exhibition of the pieces that he had acquired which travelled around the United States from 1929 until 1935. This attracted the interest of a formidable group of American ladies who themselves built up substantial collections of Fabergé and Russian works of art. Amongst these must be numbered Marjorie Merriweather Post, India Early Marshall, Matilda Geddings Grey and Lillian Thomas Pratt, each of whose collection is on public display in America.[15]

That interest in collecting the work of Carl Fabergé is still strong is admirably demonstrated by the success of the exhibition *Fabergé, goldsmith to the Imperial court of Russia*, organised by A. Kenneth Snowman at the Victoria and Albert Museum in 1977, and by the numerous sales of his work held in London, Geneva and New York.

Notes

1 Watson, p 110
2 Watson, p 110
3 Watson, p 109
4 Le Corbeiller, p 15
5 Cordey, p 197
6 Bapst, p 135
7 Emile Dacier, *Catalogue de ventes et livrets de Salons illustrés par Gabriel de Saint-Aubin* XI (Paris, 1921)
8 Le Corbeiller, p 14
9 Watson, p 110
10 Waddesdon catalogue, pp 15–17
11 Christie's, London, 30 June 1982
12 Grandjean, p 18
13 Alexander von Solodkoff, *Fabergé's London Branch*, Connoisseur CCLX (February 1982) p 108
14 Viscount Knutsford, *In Black and White* (London, 1926), quoted by J. Bannister in *Connoisseur* CXCVI (September, 1977) p 70
15 Habsburg, pp 126–31

CATALOGUE

The descriptions of the objects are not intended to do the work which photographs can do much better, but the enamel colours have been listed in some detail as colour illustrations can be deceptive in their tonalities; the reverses and parts which cannot be seen in the illustrations are also described.

Attribution to a country of origin has been left imprecise, i.e.: 'Western European', unless there is some evidence which points to one country rather than another; this is to avoid the capricious apparent precision of much writing on the subject.

With very rare exceptions (cat. nos 20 and 21), jewellery of this period is unmarked.

Jewellery and treasury pieces

1 Pendant

A wreath of laurel framing a bloodstone backplate to which are attached the figures of an amorous couple, probably Pluto and Proserpine. The bodies of each formed of baroque pearls, the limbs and heads enamelled white. The rock on which they sit enamelled translucent green and brown. Two cabochon rubies, an emerald and a sapphire, set into fringes of grass. The strapwork on the wreath enamelled translucent red and green. Hung with a pearl.

Dimensions
Height: 9.6 cm; width: 5 cm

The original reverse missing and replaced by a plain silver plate.

Provenance
Charles Stein Collection, sold Gallerie George Petit, Paris, 8–9 March 1866, no. 155
Baron Max von Goldschmidt-Rothschild Collection, sold Parke-Bernet, 11, 13–14 April 1950, lot 99
Melvin Gutman Collection, sold Sotheby's, New York, 24 April 1969, lot 93
K I 34 E

Western European, possibly French, mid sixteenth century

Exhibitions
Chicago, Art Institute, 1961–62
Baltimore, Museum of Art, 1962–68 (for catalogue reference, see Lesley below)

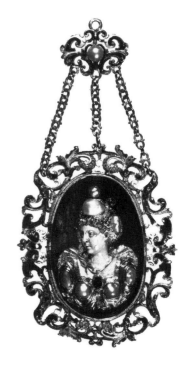

ILLUSTRATION
1 *Pendant, enamelled gold, the relief on a lapis lazuli ground, mid sixteenth century (Mr and Mrs J. W. Alsdorf Collection, Chicago)*

Pluto, king of the Underworld, abducted Proserpine, daughter of Flora, and took her down to Hades to be his wife. Here she was surrounded by jewels and all the riches of the earth, but also by darkness. It is possible that this is what is represented on this pendant.

The French did not have the monopoly of those jewels where a hardstone forms the backplate, and a relief scene or portrait of mixed materials is attached to the front. But judging by the 1560 inventory of the jewels of the French crown, court taste did especially favour jewels of this type, as these entries suggest: 'no. 440 Une enseigne sur uns fons de lappis ou il y a apliqué dessus une teste de femme et a l'endroict de l'oreille une petite poincte de diamant' . . . ; 'no. 432 Une enseigne sur ung fons de jeayet ou il y a ung visage d'agathe, garnie d'or, et une poincte de diamant sur l'espaulle . . . '; and, most relevant of all, 'no. 454 Une grande enseigne d'une figure ayant le corps de perle, la teste, les bras et les jambes d'agathe, accollant une femme et garnie d'un grand feuillage, emaillee de plusieurs couleurs'.[1]

A plaque on a lapis ground, which may well come from the same workshop (fig 1), shows a woman whose face and neck are enamelled white, with gold hair and drapery finely chased with dense swirling lines very similar to those on the pendant under discussion; also like this pendant, parts of the composition are made up of pearls, and two cabochon stones add colour.[2]

Notes
1 'no. 440, A badge or pendant on a lapis lazuli ground to which is applied the head of a woman with a small pointed diamond in her ear . . . no. 432, A badge or pendant on a jet ground with a face of agate, mounted in gold with a diamond on the shoulder . . . no. 454, A large badge of a figure with a pearl body, the arms and legs of agate, embracing a woman, and decorated with much foliage, enamelled in many colours'. . . . Published by Lacroix
2 Mr and Mrs J. W. Alsdorf Collection, Chicago; height 11.4 cm. I have not handled this piece so cannot be certain whether the setting around the plaque is original to it

Additional bibliography
M. L. D'Otrange-Mastai, 'Jewels of the xvth and xvith centuries', *Connoisseur* cxxxii (November 1953) ill. p 69
Y. Hackenbroch, 'Jewellery', *The Concise Encyclopedia of Antiques* (London, 1954) pl. 94 c
Lesley, no. 31

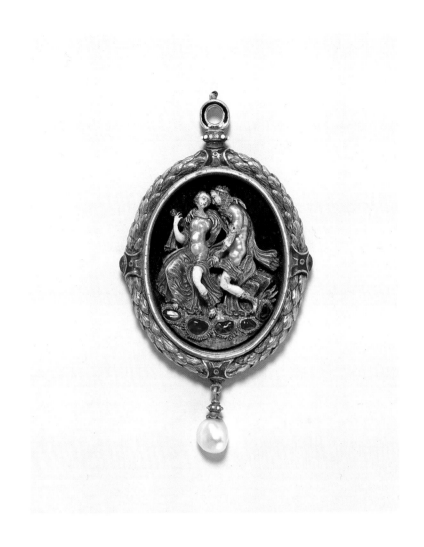

2 Pendant

Enamelled gold frame set with four table-cut rubies and four rose-cut diamonds. A *commesso* (a composition of hardstone parts giving the effect of a cameo) agate head of a Moor in the centre, the turban, quiver and garments of enamelled gold, the backplate also of agate. The reverse plain with a bevelled edge.

Dimensions
Height without suspension chains or pendent jewels: 4.5 cm; width: 3.8 cm; visible surface of cameo: 3.6 cm; width: 3 cm

Originally a badge or pendant, but altered in the eighteenth century to make a slide, and the diamonds with their dentellated settings added then. The bottom left-hand ruby also a replacement. The suspension chains and dependent jewels recent.

Provenance
Debruge Dumenil Collection, sold Bonnefons de Lavialle, Paris, 23–26, 28 January; 2, 4–9 February; 4–9, 11, 12 March 1850
Simon de Monbrison, Paris, 1966
K128A

Probably French, mid sixteenth century

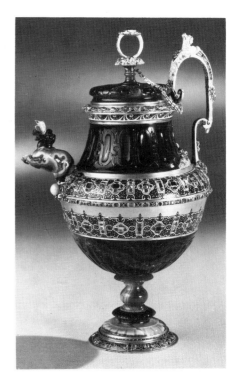

Cameos of Moors appealed particularly strongly to Mannerist taste. They displayed the natural striations of the stones to good advantage and they showed a pleasing exoticism in contrast with the serenity of the more conventional portrait cameos in the classical style, as the setting around a Moor cameo in the Bibliothèque Nationale, Paris, proclaims: 'E PER TAL VARIAR NÀTVRA E BELA'.[1] There are nine cameos with this subject in the imperial collections, Kunsthistorisches Museum, Vienna.

Unfortunately, the entry in the 1560 inventory of the jewels of the French crown, 'Une autre enseigne d'agathe rapportee sur ung fons, d'une teste de More avec son turban',[2] cannot be proven to apply to this piece. But as the many entries describing jewels with reliefs of mixed materials show, the inventory does prove that they were very popular in France.

This is not enough, however, to prove that it is French since these jewels were also being made elsewhere, notably Milan and, later, Prague. Indeed, it is probable that the hardstone carving is in fact Italian since relatively large numbers of Moor cameos and *commessi* were executed in Italy in the second half of the sixteenth century. The setting may, however, indeed be French as the border of black enamel with very fine pointed moresque leaves in reserve and white bandwork snaking through it can be found on a provably French group of objects and jewels of which the mounted onyx ewer (fig 1) in the Kunsthistorisches Museum, Vienna, is the most prominent example.[3]

ILLUSTRATION
1 *Onyx ewer, mounted in enamelled and gem-set gold, given by Charles IX of France to Archduke Ferdinand in 1570 (Kunsthistorisches Museum, Vienna)*

Notes
1 'Because of this variety Nature is beautiful'; Babelon, no. 596
2 'Another agate badge with the head of a Moor in a turban mounted on a background', no. 359 in the inventory published by Lacroix
3 Inv. no. 1096

Additional bibliography
Y. Hackenbroch, 'Commessi', *Metropolitan Museum Bulletin* XXIV (March 1966) p 222
Hackenbroch (1979) p 90, ill. 234
Labarte, no. 1000

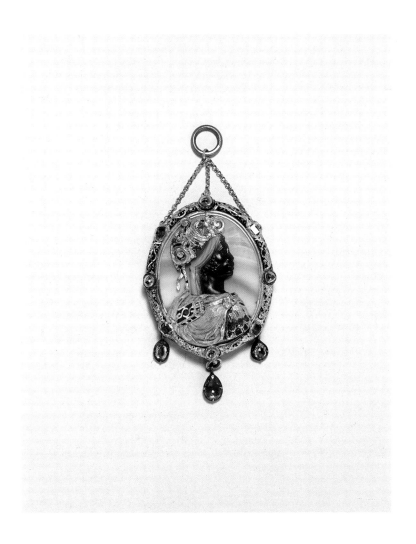

3 Marten's head

Crystal, with a collar and muzzle of *champlevé* enamelled gold set with table-cut rubies; the eyes of cabochon rubies, the stone settings with mid-blue enamelled lobes emerging from them. Eight attachment rings inside the collar and one big one outside.

Dimensions
Length: 6.6 cm; diameter of neck: 3 cm

Provenance
A la Vieille Russie, New York, 6 December 1974
K 141 C

Probably French, *circa* 1560–70

This was designed to replace the head of a marten or sable fur which would have been worn draped around the shoulder, as in the portrait of Madame de Buisseret (fig 1). The fur would probably have had crystal or gold claws as well. The nine-teenth century christened such furs *Flöhpelze*, that is, vermin attractors, but there is no mention in fifteenth- and sixteenth-century inventories of this supposed function.

The earliest surviving head of this type is in the Musée de Cluny, Paris; it is of gilt copper, still contains the skull of the animal and is described as fifteenth-century Italian. The great majority of portraits showing women wearing these jewelled furs date from the first half of the sixteenth century and are Italian.[1] The fashion spread northwards, and Anna of Bavaria had one which is illustrated in the Hans Mielich pictorial inventory of her jewels of *circa* 1550–55 (Bayerisches Nationalmuseum), and which she wears in her portrait of 1565 by the same artist. Crystal marten's heads were being made in Milan, the great centre for crystal carving, as is shown by the list of objects on offer included by the Sarachi brothers when writing to Albrecht V of Bavaria about their terms of service with him, 'E piú faro de le cose menute come saria pendentini, pini, giande, cinte, teste de sibilino, pontali et altre cose come sono le mostre che ho dato'.[2]

Mary Queen of Scots owned and gave away no less than fifteen, which are recorded in the inventory of her jewels made in 1561 when she left France on the death of her husband, the Dauphin. One of these was also of crystal: 'Une teste de martre garnie de deux perles et de plusiers petits rubiz et saphiz, les quatre pattes de mesme . . . une teste de martre de crystal garnie de turquoyse, le quatre pattes de mesmes'.[3] In 1566 she gave Madame de Martigues 'Ung loup sernier garny d'une teste de martre de crystal acoustree dor esmaillee de rouge garnye de xxj turquoises quatre pattes aussy de crystal garnyes chacune patte de trois turquoyses et une chesne contenante quatre vingt xiiii pastenostres. La chesne est donne au Roy'.[4]

The fashion survived into the early seventeenth century and then died out. As the small jewelled heads and claws were therefore useless, they were broken up for their materials and they are now very rare.

This one may be French, *circa* 1560–70, because of the resemblance of its moresque enamelling, with its white bandwork over a black field with gold saracenic leaves in reserve, to the enamelled mounts on the onyx ewer given by King Charles IX of France to Archduke Ferdinand of Tirol in 1570 (fig 1, cat. no. 2).[5]

OTHER EXAMPLES
A crystal set in the possession of a Bavarian ducal family shown at an exhibition
 of *Flöhpelzchen* (Germanisches Nationalmuseum, Nürnberg, spring 1969)[6]
A very fine enamelled gold marten's head (Walters Art Gallery, Baltimore)[7]

ILLUSTRATIONS
1 *Madame de Buisseret, née Daman, of Antwerp circa 1560, attributed to Antonio Mor (Richard Philp Collection, London)*
2 *Detail of fig 1*

Notes
1 eg, Titian, Eleonora Gonzaga, Duchess of Urbino, 1537–38 (Uffizi, Florence); Parmigianino, Camilla Gonzaga, Countess of San Secondo, *circa* 1538 (Prado, Madrid)
2 'And I will also make small things such as pendants, pine cones, acorns [beads], belts, marten's head, aglets and other things like the samples I sent you.' Quoted by R. Distelberger, 'Die Sarachi-Werkstatt und Annibale Fontana. *Jahrbuch der Kunsthistorischen Sammlungen* LXXI (1975) p 162
3 'A marten's head decorated with two pearls and numerous small rubies and sapphires, the four paws the same . . . a crystal marten's head decorated with turquoises, the four paws of the same.' *Inventaires de la Royne Descosse Douarière de France* (Bannatyne Club, Edinburgh, 1863) pp 12 and 85
4 'A curved (?) wolf skin decorated with a marten's head mounted in red enamelled gold decorated with xxj turquoises, four paws also of crystal each paw decorated with three turquoises and a chain consisting of eighty xiiii paternoster beads. The chain has been given to the King'. *Ibid*, p 108
5 This vessel, in the Kunsthistorisches Museum, Vienna, is listed in the 1560 inventory of the jewels of the French crown, and must therefore have been made in the decade between 1560 and 1570. See M. Leithe-Jasper, 'Der Bergkristallpokal Herzog Philipps des Guten von Burgund – das ''Vierte Stück'' der Geschenke König Karls IX von Frankreich an Erzherzog Ferdinand II', *Jahrbuch der Kunsthistorischen Sammlungen* LXVI (1970) pp 227–41
6 Illustrated in F. Weiss, 'Bejewelled Fur Tippets and the Palatine Fashion', *Costume: the Journal of the Costume Society* IV (1970) pp 37–43
7 *Jewellery Ancient and Modern* (New York, 1979) no. 540

Additional bibliography
J. Hunt, 'Jewelled Neck Furs and Flöhpelze', *Pantheon* XXI (May 1963), pp 151–57

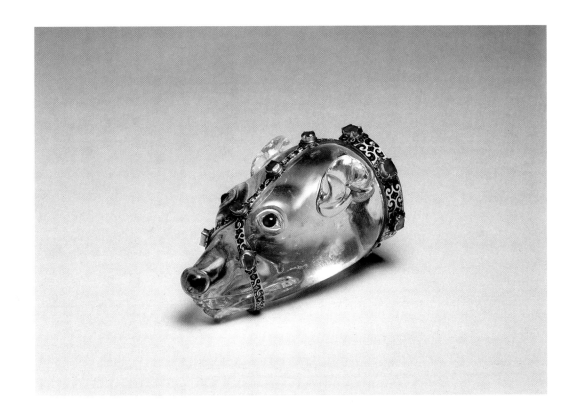

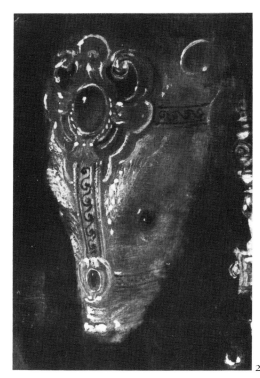

1

2

4 Religious pendant

Agate sphere, mounted in gold and set with table-cut rubies. The sphere opens to reveal the Adoration of the Shepherds and the Annunciation enamelled in *ronde-bosse*, opaque white, translucent red, mid-blue and green. The borders *champlevé* enamelled black and mid-blue. The fronts and backs of the s-scroll elements of the suspension chain opaque white, the backs of the stone settings translucent green. Hung with a baroque pearl.

Dimensions
Height including chains: 10.1 cm; diameter: 3.1 cm

Some of the stones on the chain and the heart-shaped stone in the suspension element recent replacements.

Provenance
Eugen Gutman Collection
Christie's, 28 November 1961, lot 22
K 134 S

North-West European, mid sixteenth century

Hugh Tait, in his article on historiated Tudor jewellery,[1] links this to a group of hat badges made in England during the second quarter of the sixteenth century. In particular he regards the figurative style as being like that of the provably English hat badge depicting Christ and the woman of Samaria,[2] and another with Judith and Holophernes;[3] nonetheless, it is closest to the less certainly English pendant with Jacob in the well (fig 1).[4] The similarity is, however, not compelling, and it is dangerous to say that the slight crudity of execution, which they all share, proves a common origin. Unfortunately, the black and gold rosettes of the border do not provide sufficiently distinctive additional evidence to suggest a workshop of origin.

All that can be added is that the piece does not resemble the work produced by any South German centre at that time, and that the 1560 inventory of the jewels of the French crown includes two very similar sounding pieces: 'Une autre pomme d'agate qui s'ouvre dans laquelle y a ung Trepassement et une Assumption Nostre Dame, estimee XXX.

Une autre demye pomme d'agatte qui s'ouvre, dans laquelle y a ung Crucifiement, estimee XII.'[5]

The dating is based on the style of the strapwork combined with fruit at the attachment points of the chain.

ILLUSTRATION
1 *Enamelled gold pendant with Jacob in the well, circa 1540–50 (British Museum, London)*

Notes
1 H. Tait, 'Historiated Tudor Jewellery', *The Antiquaries' Journal* XLII (1962) p 240
2 British Museum, London, Inv. no. 1955, 5–7, 1
3 Wallace Collection, London
4 British Museum, London, Inv. no. 1956, 10–7, 1
5 'An apple of agate which opens and in which there is a Death and Assumption of Our Lady estimated at XXX.

 Another half apple of agate which opens, in which there is a Crucifixion, estimated at XII.' Published by Lacroix

Additional bibliography
von Falke
Hackenbroch (1979) p 279, ill. 757 and pl XXXIV

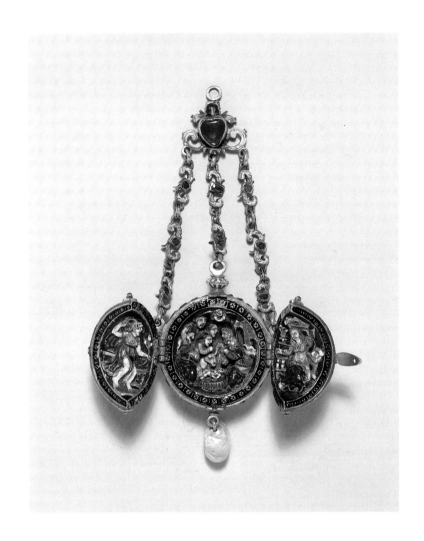

5 Boat pendant

Enamelled gold set with a table-cut topaz, a pale emerald, fifteen rubies, six seed pearls, and hung with a pearl. The sides of the boat *champlevé* enamelled black with gold arabesques in reserve, whose leaves have been hollowed out and filled with opaque pale blue and pale green enamel. The moulding beneath the row of rubies *sablé* matted. The man and woman emerge from a translucent green enamelled surface. The mast *ronde-bosse* enamelled pinkish-blue. The reverse of the figures flat and enamelled mid-blue with gold fleurs de lis in reserve. The matting and enamel colours on the suspension element the same as on the boat.

Dimensions
Height excluding suspension ring and pearl: 6.5 cm

Much enamel lost from the mast and the upper edge of the boat.

Provenance
Madame de x sale, Hotel Drouot, Paris, 21 March 1912
Baron Max von Goldschmidt-Rothschild Collection, sold Parke-Bernet, 11, 13–14 April 1950, lot 94
Melvin Gutman Collection, sold Sotheby's, New York, 24 April 1969, lot 95
K134F

French, third quarter of sixteenth century

Exhibitions
Chicago, Art Institute, 1951–62

ILLUSTRATIONS
1 *Detail of enamelled gold frame to classical cameo of Claudius (?), French, last quarter of sixteenth century (Kunsthistorisches Museum, Vienna)*
2 *Italian cameo of Bellona, mid sixteenth century, in enamelled gold French mounts of third quarter of sixteenth century (Kunsthistorisches Museum, Vienna)*

The fleurs de lis on the reverse must be used heraldically here as they are not part of the decorative idiom of the Renaissance. This automatically associates the piece with a member of the French royal family or at least the French court. The decoration on the hull supports this: the black enamelling with gold leaves in reserve and the opaque blue, green and white enamel in some of the leaves, is similar in technique and palette to that on the frame of a cameo of Claudius (?) (fig 1),[1] although the actual ornament is different, being conventional moresques rather than broken c-scrolls. This may mean that the locket case is a decade or so later in the century. In the 1619 inventory of the imperial collections it is described as being 'French work', which reinforces the suggestion that the piece under discussion is indeed French. The enamelling is also especially close to that around a mid sixteenth-century cameo of Bellona (fig 2).[2]

The sailor with his conical hat and the woman with her shaped bodice, large sleeves and neat headdress are remarkably realistically depicted, and also fit the attribution to France or the Netherlands.[3]

None of the decoration on the piece has anything to do with that on the two, probably South German, gondola pendants in the Museo degli Argenti,[4] and neither they nor this one are related to the numerous surviving pendants (for example, cat. no. 11) made on the Eastern Mediterranean coast.

Notes
1 Kunsthistorisches Museum, Vienna, Inv. no. IVa 98; Eichler and Kris no. 21; *Princely Magnificence*, no. 22
2 Kunsthistorisches Museum, Vienna, Inv. no. XI132; Eichler and Kris, no. 181 where the setting is called 'Florentine' on the basis of erroneous comparison with the 1581–84 mounts by Jaques Bylivelt on the large lapis lazuli vase (Museo degli Argenti, Florence)
3 I am indepted to Mrs Madeleine Ginsburg of the Victoria and Albert Museum for this opinion
4 From the collection of the Electress Palatine: Inv. nos 2500 and 2525; K. Aschengreen Piacenti, *Il Museo degli Argenti* (Milan, 1968) nos 1971 and 1997 and ill.

Additional Bibliography
D'Otrange, p66
Y. Hackenbroch, 'Jewellery', *The Concise Encyclopedia of Antiques* (London, 1954) pp168–72, pl. 94F
Hackenbroch (1979) p146, ill. 378

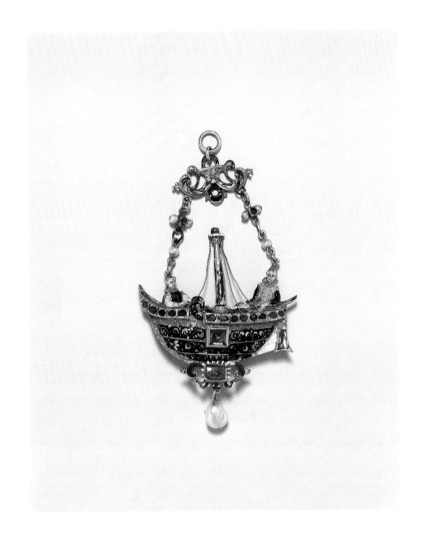

6 Portrait pendant

The openwork gold backplate stamped-out, with filigree enamel in black, white and opaque blue attached to the front. Bolted through each decorative element is a box setting holding a table-cut green doublet. The portrait is in oils on silver or silvered copper.

Dimensions
Height: 8.4 cm; width: 6.2 cm; height of painting: 5.2 cm; width: 3.9 cm

The mounting immediately around the miniature a replacement; the enamelled frame not original to it. The suspension loop repaired, and the uppermost suspension loop modern.

Provenance
Peter Bodmer Collection, Zurich
Julius Böhler, Munich, 8 September 1975, catalogue October–November, no 7
K 1 2 2 B

The miniature Italian, probably Florentine, *circa* 1570; the frame Mediterranean, perhaps Spanish, early seventeenth century

It is clear that miniature and frame do not belong together from the fact that they do not fit, that the reverse of the frame is undecorated while the miniature is intended to be seen from both sides, and that the goldsmith's work is rough, almost peasant-like, and in any case later than the miniature, which is obviously court art.

Various suggestions have been made as to the identification of the lady. One is, that with minor variations, she repeats the portrait by the Florentine court artist, Alessandro Allori, of Lucrezia de Medici (Uffizi Gallery, Florence), daughter of Grand Duke Cosimo I, who married Alfonso d'Este in 1558 and moved to Ferrara in 1560.[1] Another suggestion, by Dr Hackenbroch,[2] is that she is Virginia de Medici, half-sister of Francesco I, Grand Duke of Florence. In 1586 she married Cesare d'Este, duke of Ferrara, and the wedding was celebrated with the performance of *L'Amico Fido* by Giovanni Bardi who also wrote the *intermezzi*. The fifth *intermezzo* showed Juno, patroness of brides, who appeared in a chariot accompanied by Iris with a bird as an attribute, and by nymphs representing the Seasons, Day and Night. Dr Hackenbroch regards the allegorical scene on the reverse of the miniature as depicting this *intermezzo* and therefore confirming her identification of the sitter.

There are, however, problems in this interpretation. If one turns to the 1603 edition of Ripa's *Iconologia* one gets a very precise identification of the figures surrounding Juno: they are the nymphs of the air. The first on the left is a Comet, with her red skin, red dress, flowing red hair, a star on her head and a piece of sulphur in one hand; she lacks only the branch of laurel and 'verminaca' mentioned by Ripa, in the other hand, but this is probably for reasons of space. The figure immediately to the right of Juno is Rain, according to Ripa a woman dressed in grey with, on her head, a garland of seven stars, one of them dark, and on her chest, another seventeen, of which seven are dark; in her hand is a spider weaving its web. This also fits, as she lacks only the stars on her breast. The fourth figure is the Dew, who in Ripa is dressed in green, with, on her head, a wreath of branches covered with dew and surmounted by a full moon. The floating women in front is probably maidenly modesty ('Pudicitia'), who wears a transparent veil covering her face and a flowing dress, and in her left hand holds the hem of her garment while with her right she reaches towards a dove which is flying towards her; beneath her is a tortoise.[3] This figure lacks the tortoise, but that may be because of the inherent absurdity of flying tortoises, and the dove is over her head, perhaps for reasons of composition.

Notes
1 Suggestion by Detlef Heicamp in the Julius Böhler sale catalogue, Munich, October–November 1975, no. 7
2 Y. Hackenbroch, 'Un gioiello Mediceo inedito', *Antichità Viva* XIV (1975) pp 31–35; also Hackenbroch (1979) pp 35–36, ills 64 a & b and pl II
3 C. Ripa, *Iconologia* (Padua, 1611) pp 71, 80, 378–79, 380–81

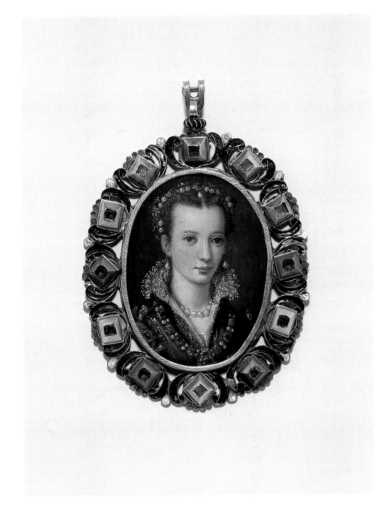

Notes

4 See I. B. Supino, *I Ricordi di Alessandro Allori* (Florence, 1908) p 23, quoted by Y. Hackenbroch, 'Un gioiello Mediceo inedito', *Antichità Viva* XIV (1975) p 32

Now, the presence of 'Pudicitia' is very suitable to a marriage allegory, and the central figure most probably is indeed Juno, shown here with her husband's attribute, the thunderbolt, but the surrounding nymphs certainly are not Day and Night and the Seasons. This might be explained away by artist's licence, but there is also some doubt raised by the portrait itself. She is not so striking in her features or dress that she conclusively recalls a well-identified full-scale portrait, and her costume suggests that she dates from the late 1560s or about 1570, not 1558, nor 1586. Thus, for the moment she remains unattributed.

Alessandro Allori did indeed paint miniatures, as well as full-scale portraits, for in his memoirs of 1579–84 he records painting the heads of the Virgin of the Annunciation and the Angel to go inside a small gold box,[4] but in the absence of documented examples of his miniature style, it is again very difficult to attribute the painting of this particular miniature to him.

7 Cross pendant

Enamelled gold, set with thirteen table-cut diamonds and hung with pearls. The front of the cross composed of two parts: the scrollwork projecting around the sides of the central core, which is cast and chased; and the central 'core' itself, which holds the stones. The scrollwork, which is partly pierced, is finely matted on all its plain gold surfaces. The enamel palette includes white, black, opaque mid-blue, turquoise blue, translucent green, blue and red. The strongly projecting 'core' is *champlevé* enamelled down the sides in red, white and translucent green, on a black ground. The reverse is covered by a backplate which is screwed on, with only the outermost parts of the side scrolls projecting beyond it. These are enamelled translucent red, green, royal blue and white. This gently convex backplate is dotted all over with a chasing tool, *basse-taille* enamelled with a trophy of arms at the top, sea horses and c-scrolls in the arms, a basket of fruit on the stem, surrounded by strapwork, with crossed viols below, and, in the lower lobe, dolphin scrolls with interlaced tails. The palette of enamel colours is black, white, translucent pale green, red, yellow and royal blue.

Detail of the side of the gem-setting

Dimensions
Height excluding dependent pearl: 7 cm; width: 4.9 cm; height of backplate: 5.9 cm

Some enamel missing from the side scrolls, especially from the clusters of stylised fruit. The backplate loose, and with much enamel missing.

Provenance
Mrs Huddleston Rogers Collection
Joseph Brummer Collection, sold Parke-Bernet, I, 20–23 April 1949, lot 687 and ill.
Melvin Gutman Collection, sold Sotheby's, New York, 24 April 1969, lot 46
K I 34 B

Probably South German, third quarter of sixteenth century

Exhibitions
Chicago, Art Institute, 1951–62
Baltimore, Museum of Art, 1962–68 (for catalogue reference, see Lesley below)

This is constructed in a way which seems to have evolved in the South German centres of production, Munich and Augsburg, and which was in use between about 1550 and 1580. The typical features are cast strapwork or scrollwork, usually incorporating figures or clusters of fruit or masks; the gemstones are applied as a separate unit, often with moresque enamelling on the sides of the deep box settings, and the back is covered by a separately applied, very gently convex backplate, usually with *basse-taille* enamelling.

A slightly earlier example of this type (earlier because of the curved lobes to the unenamelled gem-settings which antedate the enamelled and square box settings)

is illustrated on f. 32r (fig 1) of the Hans Mielich illuminated inventory of the jewels of Duchess Anna of Bavaria, executed between 1552 and 1555.[1] Cast and enamelled strapwork (fig 2) which is very similar to that on the cross under discussion, constitutes the large bosses holding sapphires on the body of the enamelled gold cup made in 1563 by Hans Reimer (master 1555, d. 1604), who worked in Munich for the Bavarian court.[2] It is one of the very rare pieces of sixteenth-century goldsmiths' work (as opposed to silver plate), to be signed and dated, and by comparison with it, other works can be attributed to him, in particular, an altar cross which came to the Residenz Treasury from the monastery of Andechs. This shares goldsmithing features, as well as decorative motifs, with the sapphire cup, but, for the purposes of this argument, the elements at the ends of the arms are the most interesting (figs 3 and 4). These have the same construction as the piece under discussion, with cast scrollwork, prominent detached stones, and a gently curved, *basse-taille* enamelled backplate.[3] The altar cross can be dated between the sapphire cup and a tankard of 1572 in Reimer's oeuvre, and since his style of the 1570s seems to abandon the strapwork in favour of more abstract scrollwork, one is inclined to say by analogy with his work, that the pendent cross is a work of the 1560s. There is no doubt that it is a piece produced in a leading workshop, because of its massiveness, combined with fine and varied enamelling, and the quality of its stones.

Despite the resemblance to pieces made in Munich, which has just been described, caution must be exercised in suggesting that the cross was definitely made there or in Augsburg, as the technique and style common to these pieces were quickly adopted by goldsmiths in other parts of Germany and Europe. A striking and well-documented example of this is the pectoral cross of the Abbot of Averbode near Malines (figs 5 and 6) which was made in Antwerp in 1562 to a design by Hans Collaert the Elder by the Frankfurt born goldsmith, Hieronimus Jakobs.[4]

Notes
1 *Das Kleinodienbuch der Herzogin Anna* (Bayerische Staatsbibliothek, Cod. icon. 429)
2 Schatzkammer, Residenz, Munich. Signed on the footrim 1.5.HR.F.6.3; height 48.6 cm
3 See the discussion of these pieces in the excellent article by Krempel, pp 111–86
4 Staatliche Museen Preussischer Kulturbesitz, Inv. no. F 3783; see K. Pechstein, *Goldschmiedewerke der Renaissance. Kataloge des Kunstgewerbemuseum Berlin* V (Berlin, 1971) no. 92, colour plate V and ill.

Additional bibliography
Lesley, no. 6
Y. Hackenbroch, 'Jewellery at the Court of Albrecht V at Munich', *Connoisseur* CLXV (June 1967) pp 74–82

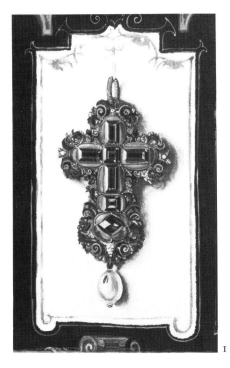

3

4

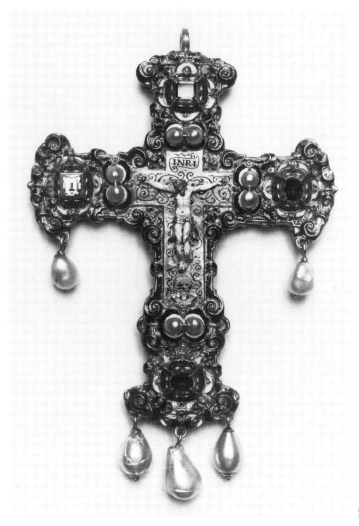

5

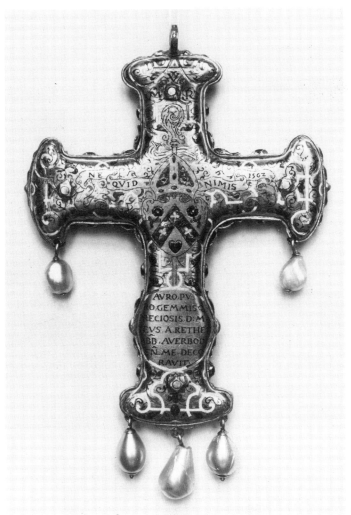

6

8 Pendant

Enamelled gold, set with five table-cut diamonds and ten table-cut rubies, and hung with a
pearl. Constructed of three cast parts: the outer scrollwork with figures; the circle of rubies;
and the central scrolls and diamond setting, all held together by a cross-strut and bolts at the
back. The four outer diamond settings also cast and bolted through the scrollwork. The
enamel palette black, white, opaque mid-blue, translucent green and red. The lower sides of
the outer diamond settings with strapwork and gold moresques against a *champlevé* enamelled
black ground. The reverse of the projecting scrolls on the back enamelled green and black.

Dimensions
Height: 6.8 cm; width: 5.4 cm

The backplate missing; the front much worn and with heavy enamel loss.

Provenance
Baron Nathaniel von Rothschild Collection
Melvin Gutman Collection, sold Sotheby's, New York, 24 April 1969, lot 87
K 1340

Probably South German, *circa* 1570–80

Exhibitions
Detroit, Institute of the Arts, *Decorative Arts of the Italian Renaissance, 1400–1600*, 1958–59,
 no. 371 and ill.

This must once have had a gently convex enamelled backplate like cat. no. 7 with
which it shares many technical features. It is probably slightly later in date, how-
ever, as it makes use of tight abstract scrolls instead of clearly defined strapwork. It
is, for example, less comparable to the enamelled gold bosses holding the sapphires
on the covered cup made by Hans Reimer in 1563 (fig 2, cat. no. 7) than the
enamelled scrollwork on the ebony house altar of Albrecht v made around 1574
by the Augsburg goldsmith, Abraham Lotter the Elder. It is especially close to the
decoration on the small ebony house altar (fig 1)[1] also in the Schatzkammer of the
Residenz, Munich, which, although undocumented, has so many features in com-
mon with the Lotter piece that it must also be by him.

ILLUSTRATION
1 *Detail of the centre of the small ebony house
altar, enamelled gold, set with gemstones,
probably by Abraham Lotter the Elder,
Augsburg, circa 1575 (Schatzkammer,
Residenz, Munich)*

Notes
1 For a discussion of this and the Lotter
altarpiece, see Krempel, pp 137–44 and
nos 17 and 19

Additional bibliography
Lesley, no.51

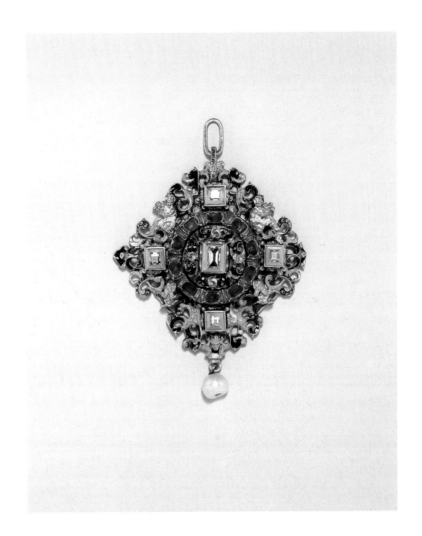

9 Hind pendant

Enamelled gold, the body of the couchant hind composed of a baroque pearl and translucent green and brown enamelling. The forehead set with a table-cut ruby with faceted edges. The animal resting on a gold ground covered with enamelled flowers and fruit, and with table-cut rubies in box settings on either side. The curved edges of the 'platform' composed of openwork strapwork, *champlevé* enamelled white with gold dots in reverse; bosses of translucent green enamel project, and translucent red strapwork runs beneath it. The underside of the 'platform' made up of scrolling and truncated strapwork enamelled translucent red and blue, and opaque mid-blue and white. The chains and suspension element enamelled white, black and translucent red. A table-cut emerald set in one side of the suspension element.

Dimensions
Height excluding suspension ring: 8.5 cm; width of 'platform': 4.6 cm

Provenance
Simon de Monbrison, Paris, 1966
K 129 A

Spanish, *circa* 1570

Volume II of the *Llibres de Passanties*, the album in which the designs submitted by aspirant masters to the Barcelona goldsmiths' guild were bound, includes a number of drawings for pendants, which, like this one, have an animal resting on a cushion or 'platform'. These include a dog, a cat, an Agnus Dei and a monkey, and they all date from the 1590s and the first decade of the seventeenth century.[1] All the surviving examples seem to bear out that this is a peculiarly Spanish design.

This example has been dated on the basis of its strapwork ornamentation, which is closest to designs in the same book which date from the 1560s and 70s.[2]

OTHER EXAMPLES
A deer pendant, the body of enamelled gold and a baroque pearl, the 'platform' of gold set with pearls and rubies (Waddesdon Bequest, British Museum, London)[3]
A centaur pendant, the body of enamelled gold and a baroque pearl, the 'platform' of enamelled strapwork (Mr and Mrs J. W. Alsdorf Collection, Chicago)

Notes
1 Museu de Historia de la Ciudad, Barcelona, Inv. no. 657, f.317 dated 1593; f.344 dated 1599 and f.385 dated 1604; see Muller, ills 148–51
2 Museu de Historia de la Ciudad, Barcelona, Inv. no. 657, f.365 showing a link of a necklace, dated 1565; Muller, ill. 58
3 Waddesdon Bequest, no. 162

Additional bibliography
Hackenbroch (1979) ill. 902

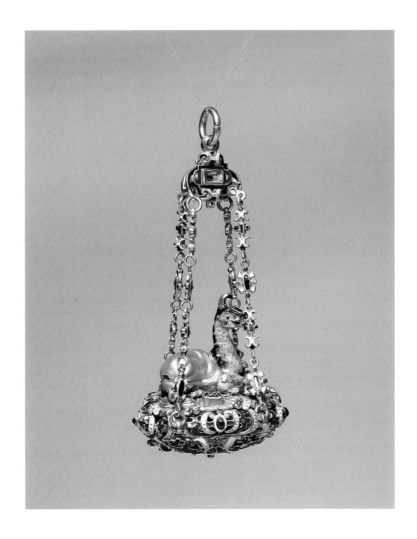

10 Pendant

Carved agate set with an enamelled gold relief of St James riding over three Moorish heads, the border *champlevé* enamelled. At the quarter-points, interlacing bandwork *champlevé* enamelled pale blue and black with gold dots in reserve. The lesser strapwork translucent red and green, and the protruding ball flowers with traces of red enamel. The reverse plain.

Dimensions
Diameter: 4.8 cm

Some enamel loss.

Provenance
bought by Baron Heinrich Thyssen-Bornemisza (1875–1947) before 1938
K 134T

Spanish, *circa* 1575

The scene alludes to the miraculous apparition of St James at the battle of Xeres in 1243. He rode a white horse and flashed a lightning blade, and with this advantage on their side the Christians easily defeated the vast army of the Moorish king of Seville.[1] St James was, of course, especially venerated in Spain, and the senior order of chivalry there was dedicated to him, so this iconography effectively guarantees a Spanish origin for the piece. Its form reinforces this supposition, since capsule-shaped pendants, usually oval, and often of crystal or agate with a scene in the centre, are a characteristically Spanish type.[2] The dating is based on the style of the strapwork at the quarter-points.

Notes
1 The Revd S. Baring Gould, *The Lives of the Saints* v (Edinburgh, 1914) p424
2 See *Princely Magnificence*, nos 96, 99, 101, 108, all from the Treasury of the Cathedral of the Virgin of the Pillar, Saragossa

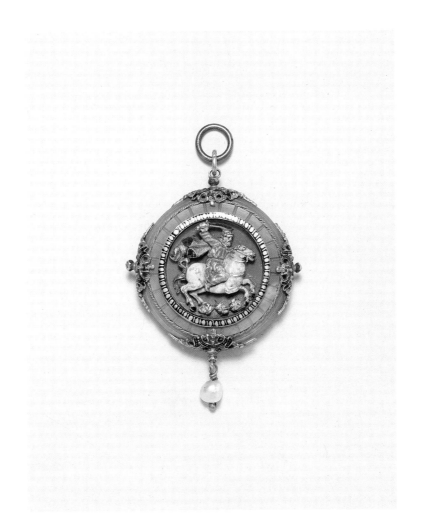

11 Ship pendant

Filigree enamel on gold in opaque turquoise, translucent blue, green; the hull orange and red. The sail engraved, the lines enamelled black, with the Virgin and Child. Set with pearls.

Dimensions
Height excluding suspension ring: 7.5 cm; length: 7 cm

The main mast broken, eight cannon balls missing, the hull replaced in the eighteenth century, possibly by a gold box maker, as shown by the translucent enamelling on a very evenly hatched ground with gold tritons in reserve.

Provenance
Bachstiz Collection, Amsterdam
Martin J. Desmoni Collection, sold Sotheby's, 17 May 1960, lot 123
Karl von Rothschild Collection
K127H

Mediterranean, second half of sixteenth century

Exhibitions
San Francisco, De Young Memorial Museum, and Kansas City, William Rockhill Nelson
Gallery, 1959, no. 24

Although this pendant is obviously not intended to be a realistic ship of the period, it has enough accurately observed characteristics for one to be able to say that it dates from the second half of the sixteenth century in as much as it is more like a galleon than a carrack: the forecastle is withdrawn into the the hull within the stempost, whereas with a carrack it would be built out onto the bulkhead.[1] The original hull may have been of crystal lined with varnish like fig 1, or of hardstone.

It is impossible to suggest a country of origin for this pendant as filigree enamel was made in a large number of places including Spain, Italy, especially Venice and its dependencies in the Aegean and the Adriatic, and in Central Europe, especially Hungary. All that can be deduced from the enamelling (excluding the hull, of course) is that the palette of pale blue, dark blue and green suggests the Eastern rather than the Western Mediterranean.

Ship pendants, usually much cruder and less realistic than this, continued to be popular around the Aegean until the eighteenth century, and the Benaki Museum, Athens, owns a large collection of these later examples, all executed in filigree enamel.

OTHER EXAMPLES
Ship pendant, enamelled gold, the hull of crystal lined with varnish (Michael Friedsam Collection, Metropolitan Museum, New York) (fig 1)
Ship pendant, gold and filigree enamel, probably Aegean, seventeenth century (Victoria and Albert Museum, London, Inv. no. 696–1893) (fig 2)

Notes
1 Information gratefully received from Dr A. P. McGowan, National Maritime Museum, London

Additional bibliography
F. Luthmer, *Der Schatz des Freiherrn Karl von Rothschild. Meisterwerke alter Goldschmiedekunst, aus dem 14.–18. Jahrhundert* II (Frankfurt, 1885) ill. 48
D'Otrange-Mastai, pl. IA
Hackenbroch (1979) ill. 922

ILLUSTRATIONS
1 *Ship pendant, enamelled gold, the hull of crystal painted inside with varnish, Mediterranean, second half of sixteenth century (Metropolitan Museum, New York)*
2 *Ship pendant, enamelled gold, probably Aegean, seventeenth century (Victoria and Albert Museum, London)*

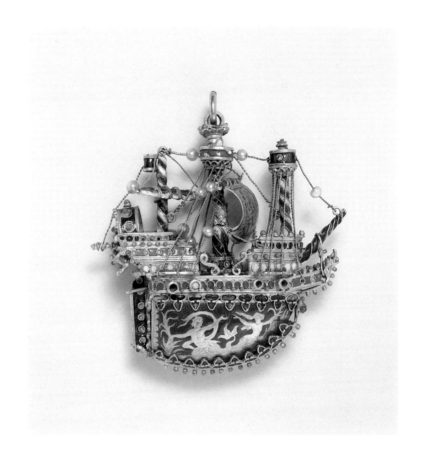

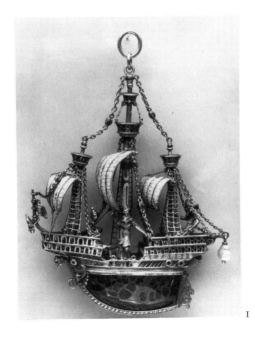

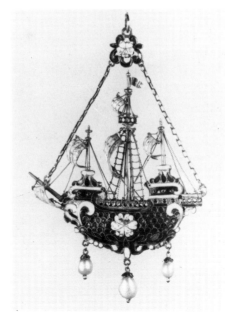

1

2

12 Talismanic pendant

Ivory mounted in gold and set with pearls and a turquoise. The decoration of filigree enamel in translucent red and green.

Dimensions
Height: 5.2 cm

The chain modern.

Provenance
Martin J. Desmoni Collection, New York
Sotheby's, 17 May 1960, lot 51
K 127D

Spanish, second half of sixteenth century

Exhibitions
San Francisco, De Young Memorial Museum, and Kansas City, William Rockhill Nelson
 Gallery, 1959, no. 27

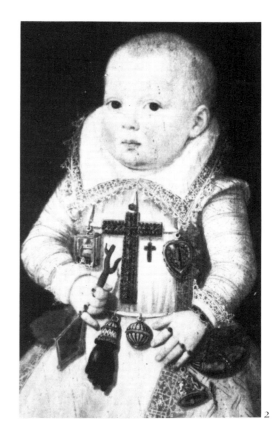

The fingers are making an obscene gesture of great antiquity dating back to at least Roman times and still used insultingly all over the Mediterranean area. By extension, it was also used to drive away the evil eye, and in Spain it was called the 'Higa per no ser viadas'.[1] Hand pendants in the 'mano cornuta' position, that is, with the thumb and forefinger conjoined (fig 1) were also worn with the same talismanic purpose, and, to make assurance doubly sure, an accumulation of protective pendants were worn at the same time, especially by children (fig 2). The inventories show that in 1589 Philip II of Spain had coral 'higas', and in 1589 the jewellers of Badajoz were making ivory and jet ones;[2] so also were the goldsmiths of Barcelona, because the *Llibres de Passanties*, the book in which the designs submitted by apprentices aspiring to be masters were bound, includes one in the 'mano cornuta' position dated 1586.[3]

The power of this pendant is reinforced by the turquoise ring on the third finger. De Boodt, writing in the first years of the seventeenth century warmly recommends this stone for its power to reduce pains in the eye and head aches, and its quality of reducing enmity between men and reconciling men and women.[4]

OTHER EXAMPLES
Rock crystal 'higa' with filigree enamelled cuff, second half of sixteenth century
 (Museo de la Fundacion Lazaro Galdiano, Madrid)[5]
'Mano cornuta' with filigree enamelled cuff, second half of sixteenth century
 (British Museum, London) (fig 1)
Ivory 'mano cornuta' holding ring, with enamelled gem-set cuff, and ambergris
 ringed 'mano cornuta' with enamelled cuff, both late sixteenth century
 (Württembergisches Landesmuseum, Stuttgart)[6]

ILLUSTRATIONS
1 'Mano cornuta' pendant, ivory and enamelled gold, Spanish, second half of sixteenth century (British Museum, London)
2 Juan Pantoja de la Cruz. Detail of Infanta Anna, 1602. Note among the amuletic pendants the 'higa' and the crystal heart reliquary (Convent of the Descalzas Reales, Madrid)

Notes
1 Hansmann and Kriss-Rettenbeck, pp 203–205
2 Muller, pp 68–69
3 *Llibres de Passanties* II, f. 289. Design by Pera Estivill (Museu de Historia de la Ciudad, Barcelona); Muller, ill. 95
4 de Boodt, pp 340–46
5 Muller, ill. 94
6 Hackenbroch (1979) ill. 887

Additional bibliography
D'Otrange-Mastai, ill. 17
Hackenbroch (1979) ill. 890 where it is given to the British Museum
W. L. Hildburgh, 'Images of the Human Hand as Amulets in Spain', *Journal of the Warburg and Courtauld Institutes* XVIII (1955) pp 67–80

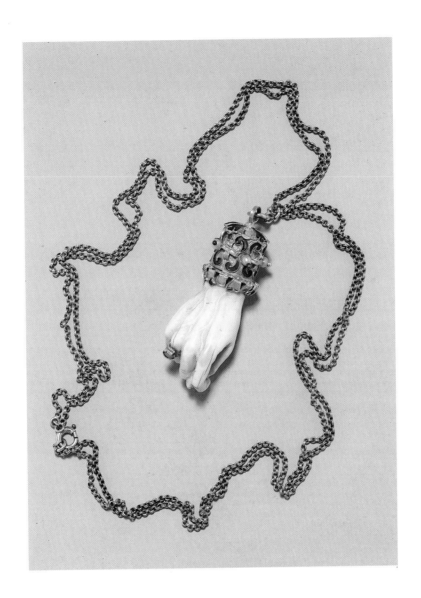

13 Pomander

Enamelled gold set with six table-cut rubies and nine diamonds. The spool-shaped top unscrews to release six segmental compartments with sliding lids, inscribed in Roman capitals, 'AMBRE, MYRRHE, GIROFLE, MUSQ, CANELLE, BENIOVIN'. The central stem is *champlevé* enamelled with two patterns alternating on the sides, articulated by white bandwork and a black and gold pattern around a central motif, either green or scarlet. The sides of the segments also decorated with alternating scrolling patterns, one with acanthus sprays ending in dolphins curling out of a central cup, the other with leafy scrolls tied together by a dotted band; colours and white, black, translucent royal blue, red, green and bright yellow. The edges of the segments enamelled black with a double bead-and-reel pattern.

The upper surface of the top spool-shaped element with red and blue strapwork bent back on itself, while white strapwork runs around the edge and hangs over it. The 'shoulders' are arabesque scrolling leaves in black and white over a 'dashed' ground.

The outer surface of the globe articulated by roll-mouldings in spiralling white and black, with gold dots in reserve. The outsides of the segments inset with curved panels of turquoise blue *émail en résille sur verre*, with symmetrical floral scrolling patterns in white, opaque pale green, translucent royal blue, red, green and yellow. Two different patterns alternate on the segments all the way round. Through the middle of each is pinned a strapwork quatrefoil element set with a diamond. The stem decorated with double staves and dots in black and white enamel. The foot set with further *émail en résille* plaques while the outer rim of the foot repeats the black and white arabesques of the shoulders and is set alternately with rubies and diamonds.

Dimensions
Height excluding suspension ring: 10.7 cm; diameter of base: 4.2 cm

Provenance
Mrs Henry Walters Collection, sold Parke-Bernet, 30 November and 1–4 December 1943, lot 998
Melvin Gutman Collection, sold Sotheby's, New York, 24 April 1969, lot 120
K 134 L

French, *circa* 1570–80

Exhibitions
Baltimore, Walters Art Gallery, 1948

The enamel segments of this pomander are of the type known as *émail en résille sur verre*. Joan Evans says of this technique that it was so difficult that, 'it was only practised for a decade or so, and probably only by one or two exceptionally skilled enamellers, who seemed to have worked in France'.[1] Since this was written it has, however, become clear that it was probably made in two quite distinct centres, one being French, and the other Central European, possibly South Germany or Prague. The latter group most frequently uses figurative compositions with flat spiky elongated outlines, and broken scrollwork very close to that found, for example, on the *champlevé* enamelled gold bowls made for Wolf Dietrich von Raitenau, Bishop of Salzburg, especially the one of 1604.[2] To this group belong a number of girdles composed of narrow oblong plaques in silver-gilt settings;[3] two pendent plaques with a Nativity[4] after the 1623 design by Valentin Sezenius, an engraver about whom nothing is known; and a large group of plaques attached to a tabernacle of *circa* 1740 in an unidentified Polish monastery[5] with cycles of allegories, mythological and hunting scenes. Stylistically closely related to these is a pendent plaque with Apollo and Daphne in the British Museum (Waddesdon Bequest).[6] This whole group dates from *circa* 1590–1625, its decorative elements suggesting the earlier date in most cases, but the Sezenius engraving presumably providing the *terminus post quem* for the Nativity plaques.

The other group of *émail en résille* pieces, to which this pomander belongs, includes watches with French movements, locket cases, mounts for oval pendants

Notes
1 Evans (1970) p 127
2 Museo degli Argenti, Florence, Inv. no. 2; see R. Pittioni, 'Studien zur Industrie-Archäologie III: die Goldene Trinkschalen des Salzburger Fürsterbischofs Wolf-Dietrich von Raitenau', *Sitzungsberichte der Österreichischen Akademie der Wissenschaften* CCLXVI (1970). These were almost certainly all made in Salzburg by the Bishop's own court goldsmiths
3 eg. Victoria and Albert Museum, London, Inv. no. 484–1873; Wallace Collection, London, Inv. no. XXIII A40; Kunstgewerbemuseum, Berlin, Inv. no. F 1215
4 Victoria and Albert Museum, London, Inv. no. 6996–1860, and one in the Museo Civico Pavia
5 See M. Kalamajska-Saeed, '*Emaux sur verre* recently discovered in Poland', *Pantheon* XXXV (June 1977) pp 126–30
6 Illustrated in Evans (1970) pl. 107b

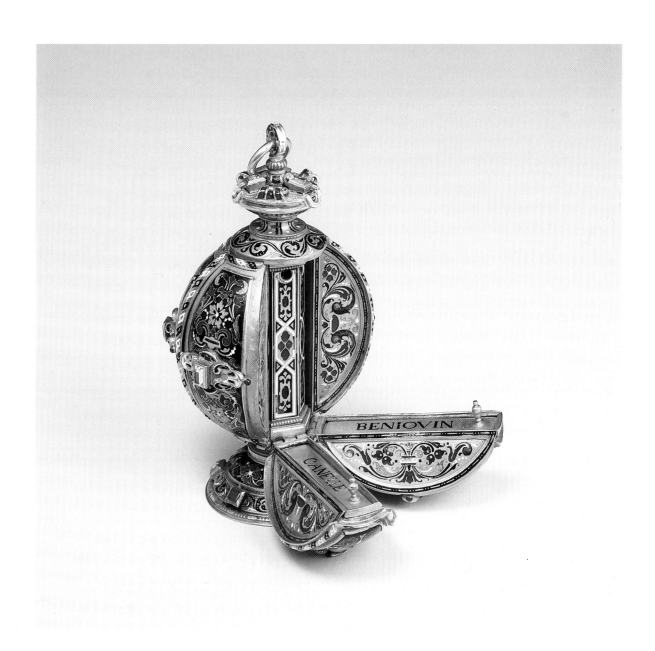

and some unmounted plaques. Both groups use a vivid translucent blue and a white ground, and the French ones also use green and dark purple. The watches are all early seventeenth century and have French mechanisms such as the one signed 'A Bloys' in the Victoria and Albert Museum,[7] and in the same museum is a miniature case with a painting of Henri III which is enamelled with naturalistic flowers and a pale blue 'snaking ribbon' suspension ring which cannot date from before 1625. Thus the technique has traditionally been dated to the first two decades of the seventeenth century.

This pomander, however, must be earlier because of its strapwork, the addorsed scrolling decoration on the sides of the compartments, and the bold geometric *champlevé* ornament on the central stem, paralleled by one of the grandest surviving examples of Renaissance goldsmiths' work, the mounts made between 1576 and 1581 by Bylivelt for a lapis lazuli swing bucket produced by the Florentine grand ducal workshops (fig 1).[8] Another piece exists which, in its enamel colours and stylised floral motifs, also parallels the plaques on the pomander: this is a pendent portrait in crystal of Anna Maria of Austria, the frame being of blue-ground *émail en résille* (fig 2).[9] She is identified by a bungled French inscription 'D. ANNA MARLE D'AUSTRICE: R.D 'SPAGNE', and she was the third wife of Philip II of Spain, married in 1570, and dead by 1580. As the portrait is unlikely to be much later than her date of death, it is reasonable to assume that the pendant therefore dates from *circa 1570–circa 1580*. The connection between it and the pomander is reinforced by the fact that both pin the enamel to the main structure by separate strapwork elements (fig 3).

Of slightly greater size[10] and using a white glass ground instead of blue, and more stylised floral motifs, is the frame of a jasper cameo of a Byzantine emperor (figs 4 and 5).[11]

Another pomander, with similarly enamelled sides to its spice compartments, inscribed with the same French names, similarly spelt, but with a silver-gilt case ornamented with the Mannerist strapwork of the same period (fig 6) is in the collection of A la Vieille Russie, New York.[12]

Thus one is led to conclude that the technique of *émail en résille* was being practised in a French workshop some twenty years earlier than has been thought hitherto, and that this pomander, unique in its quality, design and combination of various enamelling techniques, is an outstanding product of this workshop. But, in the absence of documentation, such as exists for Bylivelt's work on the lapis bucket, one is thrown back on one's art historical prejudices and on the evidence of one's own senses of sight and touch when confronted with such an exceptional piece, and the question undoubtedly is raised as to why more obviously sixteenth-century examples have not survived.

The names of the spices and aromatic resins are: ambergris, myrrh, cloves, musk, cinnamon and gum benzoin, three used purely for perfuming, and three also used for food.

Notes
7 Inv. no. 2353–1855
8 Kunsthistorisches Museum, Vienna, Inv. no. 1655
9 Mr and Mrs J. W. Alsdorf Collection, Chicago
10 Height: 11.5 cm as against 9.2 cm
11 A. von Solodkoff Collection, London
12 Height: 9 cm

Additional bibliography
Y. Hackenbroch, 'Jewellery', *The Concise Encyclopedia of Antiques* (London, 1954) pp 168–72, ill. 96
Lesley, no. 69

1

2

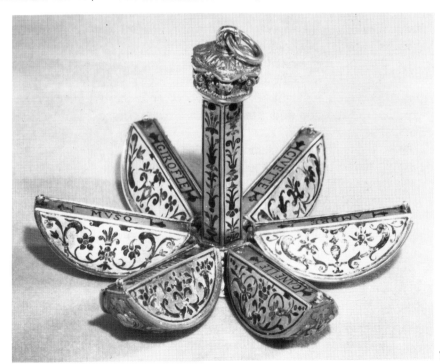

3

4

5

6

7

14 Cimon and Pero pendant

Enamelled gold set with four table-cut rubies, three table-cut diamonds, and hung with pearls. The pendant built up on a cast and fretted backplate, *champlevé* enamelled white with attenuated scrolls in reserve. Most of the plain gold areas finely matted, and some small projecting scrolls enamelled apple-green and turquoise blue. Another layer of scrolls screwed to the backplate by the deep gem-settings and enamelled white, opaque apple-green, translucent red and royal blue. The deep tapering sides of the biggest stone settings *champlevé* enamelled white, in the case of the two rubies, and black, in the case of the diamond. The underside of the ground on which the figures rest enamelled royal blue with gold scrolls in reserve. The reverse enamelled white with gold scrolls in reserve, translucent red and blue, and with fine, diapered matting on the gold.

Dimensions
Height without suspension ring and pearls: 6.5 cm; width: 5.2 cm

Much of the enamel lost from the reverse.

Provenance
Countess Livia Zichy Collection
Joseph Brunner Collection, sold Parke-Bernet, I, 20–23 April 1949, lot 670
Melvin Gutman Collection, sold Sotheby's, New York, 24 April 1969, lot 106
K134G

South German, *circa* 1590–1600

Exhibitions
Budapest, the Great Exhibition, 1884 (for catalogue reference, see Pulszky, Radisics and
 Molinier below)
Baltimore, Museum of Art, 1962–68 (for catalogue reference, see Lesley below)

ILLUSTRATION
1 *Engraved design for the frame of an openwork badge or pendant, by Daniel Mignot, Augsburg, 1596 (Victoria and Albert Museum, London)*

Cimon and Pero, also known as 'Roman Charity', is the story of how a devoted daughter kept her unjustly imprisoned father alive by suckling him, and it was already a popular artistic theme before the end of the sixteenth century. The story is told by the first-century AD historian, Valerius Maximus, whose work appears in printed form in 1530, published by Aldus Manutius, but the subject had already been depicted on plaquettes made in the Venetian/Paduan area in the early sixteenth century. It is shown in the Gallerie François I at Fontainebleu, and was adopted quite early by German graphic artists including Barthel Behaim, Hans Sebald Behaim, Peter Flötner and Jost Amman.[1] Thus the goldsmith who made this had ample opportunity to be familiar with the iconography.

Stylistically the pendant represents the next stage in evolution after the South German styles of cat. nos 7 and 8: the strapwork and tight scrollwork have become bold, open c-scrolls, with assymetrical scrolls in reserve on the white enamel. The construction still lends itself to 'mass production', being modular in type, as the backplate is cast from a model, the details added by chasing, and then enamelled, while the stones and central group are bolted through separately. It is the style displayed in a number of designs dated 1596 by Daniel Mignot the French, presumably Huguenot, immigrant to Augsburg. Fig 1[2] shows one in which the backplate has the holes through which the extra decoration is bolted.

This openwork scroll style spread to Prague, to lesser centres in Central Europe such as the Transylvanian ones, and dominated the first twenty years of seventeenth-century jewellery design, there becoming more and more attenuated and sophisticated. There is, for example, a pendant with St George and the inscription 'HONORA REGEM' in the Historical Museum, Budapest,[3] which is early seventeenth century, and probably Hungarian, although much damaged and altered.

Notes
1 See A. Pigler, *Barockthemen: eine Auswahl von Verzeichnissen zur Ikonographie des 17. und 18. Jahrhunderts* II (Budapest, 1956) pp 284–92
2 Victoria and Albert Museum, London, Inv. no. E.2129–1911. One of a set numbered I–XIII
3 Hackenbroch (1979) ill. 599 A and B

Additional bibliography
Pulszky, Radisics and Molinier, pp 20–21
D'Otrange, p 32, ill. XVIII
Y. Hackenbroch, 'Jewellery' *The Concise Encyclopedia of Antiques* (London, 1954) pl. 96
Lesley, pp 20–21, ill. 92

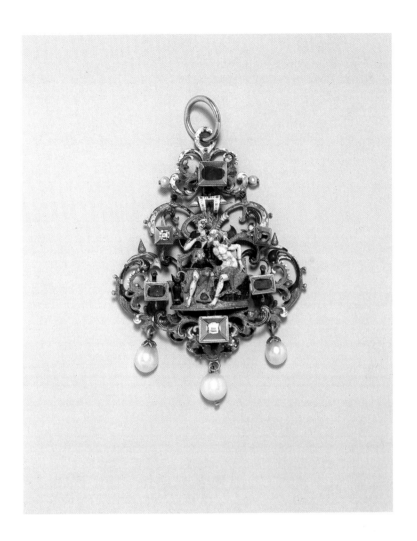

Notes

4 D'Otrange-Mastai, pp 131, ill. M;
 formerly in the Alfred de Rothschild
 Collection
5 See *Uit de Schatkamer* I (Rijksmuseum,
 Amsterdam, 1967) no. 27 and ill.

OTHER EXAMPLES

Cimon and Pero pendant with identical scrollwork and figure group, coarser in execution, with garish enamelling and minor differences of detail, but dependent on the example under discussion, or a model in common, formerly Martin J. Desmoni Collection, New York[4]

Cimon and Pero pendant in an architectural setting, with gem-set obelisks on either side, the figures not cast from the same model as those on the piece under discussion, and the whole probably nineteenth century; height: 12 cm (Rijksmuseum, Amsterdam)[5]

15 Venus and Cupid pendant

Enamelled gold, set with nine table-cut garnets, four emeralds, and three diamonds, and hung with a pearl. The oval backplate cast, chiselled and matted, the c-scrolls at the quarter-points and the protruding florets being cast with it. The florets decorated with dots of painted enamel on yellow and white *champlevé* enamel. The gem-settings bolted to the backplate on square stems and with nuts on the reverse. The figure of Venus with a *sablé* matted robe and pounced scrollwork on the skirt. The reverse enamelled on all its scrolling parts, the florets being the same, front and back, as also the protruding c-scrolls, while the central scrolls are translucent red, royal blue and opaque mid-blue around a white stylised flower and black ovals.

Dimensions
Height: 6.5 cm; width: 4.5 cm

The bottom gem-set element missing and some enamel loss from the backplate.

Provenance
Simon de Monbrison, Paris, 1966
K 127 A

Probably South German, late sixteenth century

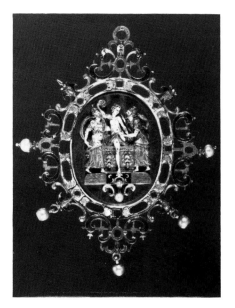

This is a technically skilful piece, with its fine matting, enamelling and gem-setting, which makes the most economical and appealing use of the minimum of materials. It is assembled on the cast and chiselled openwork oval backplate with the extra elements bolted or soldered onto it. Alternative use of a very similar oval backplate[1] is shown by a now very incomplete and much altered piece in the Musée de Cluny, Paris (fig 1).

Such a method of assembly would only be developed in a centre with a high rate of production, and the style of the piece under discussion, with its combination of c-scrolls and rosettes with an attenuated late Mannerist figurative composition, suggests South Germany. Augsburg being the most flourishing town of jeweller–goldsmiths in South Germany during the second half of the sixteenth century, it therefore also seems the most likely town of origin for this piece.

ILLUSTRATION
1 *Pendant with Susannah and the Elders against a lapis lazuli backplate, late sixteenth century (Musée de Cluny, Paris)*

Notes
1 Inv. no. CL 20699; height without pearl: 7.06 cm; width without pearls: 6.12 cm. The lapis plaque and the enamelled gold backplate probably later additions according to Elisabeth Taburet of the Musée de Cluny

Additional bibliography
Hackenbroch (1979) p 104, ill. 265

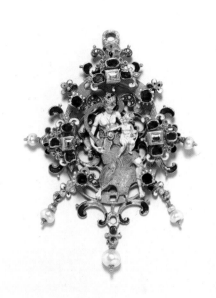

16 Faith pendant

The enamelled gold set with twenty-eight table-cut diamonds, and two faceted point-cut diamonds in the figure's chest. The helmet with a crouching animal crest, and a blue enamelled feather curving from it. The underside of the base of scrolling openwork. The c-scroll pattern on her dress hatched vertically. The reverse of the figure and base set with diamonds and the back of the cross enamelled black in imitation of wood. The reverse of the shield with a translucent red rosette in a mid-blue border.

Dimensions
Height: 8 cm; width of base: 2.8 cm

Provenance
Debruge Dumenil Collection, sold Bonnefons de Lavialle, Paris, 23–26, 28 January;
 2, 4–9 February; 4–9, 11, 12 March 1850
Arturo Lopez-Willshaw Collection, sold Sotheby's, London, 10 June 1979, lot 10
K 1 34 Y

Spanish, *circa* 1600

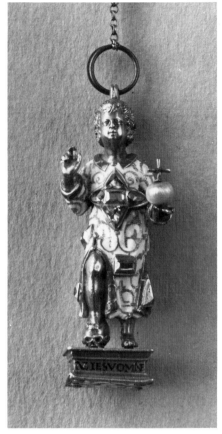

ILLUSTRATION
1 *Christ Child pendant, Spanish, circa 1600*
 (Musée du Louvre, Paris)

The heavy c-scrolls in reserve against dense white enamel are typically Spanish, as shown by comparison with two reliquary crosses with multiple receptacles, one in the Pierpont Morgan gift to the Metropolitan Museum, New York,[1] another in the Hispanic Society of America, New York.[2] A pendant with the Christ Child (Musée du Louvre, Paris) is so similar in its scrollwork, chasing and gem-setting that it could almost come from the same workshops (fig 1).

A pendant with the personification of Faith, one of the three theological Virtues, was also among the jewels at Schloss Ambras near Innsbruck when they were inventoried in 1596, 'Ein clainatt mit der figur Fides, das creux mit zehen diamant und ein klain robintafelen, drei perlen und ein hangperlen . . .'[3]

Notes
1 Hackenbroch (1979) illus. 874 a & b
2 Muller, ill. 72
3 'A jewel with the figure of Faith, the Cross with ten diamonds, a small table-cut ruby, three pearls and a dependent pearl . . .' Quoted in *Jahrbuch der Kunsthistorichen Sammlungen* VII (1888) pp CLXIX–CLXXII

Additional bibliography
Labarte, no. 1042

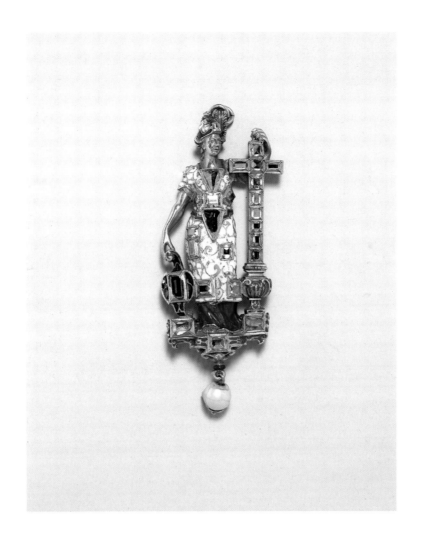

17 Female bust pendant

The bust of chalcedony, mounted in enamelled gold set with four table-cut and one point-cut diamond. A cabochon stone in her necklace.

Dimensions
Height excluding suspension ring: 9.7 cm; width: 2.9 cm

Provenance
Eugen Gutman Collection
Martin J. Desmoni Collection, sold Sotheby's, 17 May 1960, lot 45
K 127 C

The mount Spanish, *circa* 1600; the contemporary bust Italian or Spanish

Exhibitions
Berlin, Kaiser Friedrich Museum, 1906, no. 359
San Francisco, De Young Memorial Museum, and Kansas City, William Rockhill Nelson
 Gallery, 1959, no. 15

Although this bust does not have the upturned eyes and attitude of pathos often associated with representations of Lucretia and Cleopatra at the moment of their suicides, she is probably intended to represent one of these tragic heroines, most probably Cleopatra because of her exotic headdress.

These two subjects became popular around 1500 in Italy, and they appear in gem, plaquette, and graphic form. In some cases the plaquette makers and gem-carvers may have been one and the same, as in the case of Valerio Belli and, later in the century, Annibale Fontana. The appeal of the subject must have been the opportunity for combining pleasing pathos with the depiction of a naked breast. Ernst Kris attributes most of the surviving cameos to the Paduan-Venetian circle, and dates them around 1500.[1] There is no reason however to date this one so early, as the miniature female hardstone nude bust was obviously something which continued in popularity well beyond the sixteenth century,[2] and the setting on it must date from the end of that century because of the gold scrolls on the dress and the hanging element and scrolls beneath. The heaviness and slight crudity of the gold and its chasing, combined with the brilliant enamel colours, are characteristically Spanish, reminiscent of the Faith pendant (cat. no. 16). The Spanish court had hardstone cutting craftsmen working for it in the latter part of the sixteenth century[3] so the bust may, therefore, also be Spanish.

Notes
1 E. Kris, *Meister und Meisterwerke der Steinschneidekunst* (Vienna, 1929) I, pp 42–43; II, ills 130–36
2 eg, a jacinth bust of a woman mounted in gold and stones, mid eighteenth century, and representing an Indian (Victoria and Albert Museum, London, Inv. no. M.62–1975)
3 eg, Giulio Miseroni, a member of the famous Milanese hardstone carving family, who went to Spain in 1582

Additional bibliography
von Falke, no. 24, pl. 8
D'Otrange-Mastai, pl. II, no. N

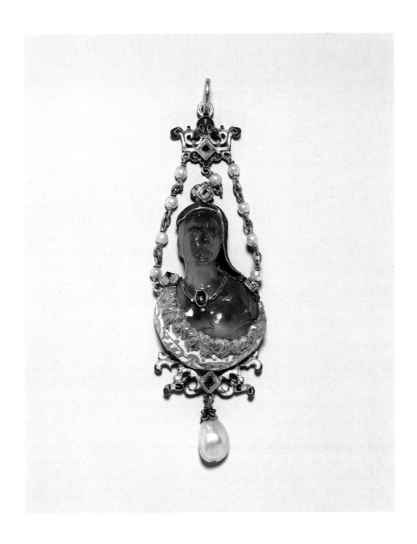

18 Christ Child pendant

Enamelled gold set with emerald. The Christ Child depicted as Salvator Mundi standing on
the serpent; the reverse of the figure the Infant John the Baptist in a yellow enamelled
hairshirt. The reverse of the frame enamelled white and opaque mid-blue, and translucent
red and green.

Dimensions
Height without pearl: 5.2 cm; width: 3.2 cm

The dependent pearl a later replacement.

Provenance
Martin J. Desmoni Collection, sold Sotheby's, 17 May 1960, lot 88
K 127G

Spanish, late sixteenth century

Exhibitions
San Francisco, De Young Memorial Museum, and Kansas City, William Rockhill Nelson
 Gallery, 1959, no. 78

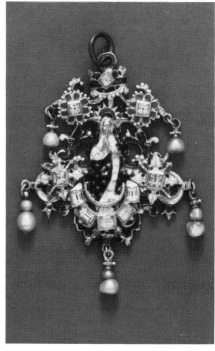

ILLUSTRATION
1 *Pendant with the Virgin of the Pillar,
 enamelled gold, set with crystals, Spanish,
 circa 1610 (Victoria and Albert Museum,
 London)*

The heavy, slightly unstructured scrolling, the coarse chasing and the brilliant
enamel colours are characteristically Spanish. The piece should be compared with
cat. nos 16 and 17, also made in Spain. The emeralds, as might be expected of a
Spanish piece, are very fine, and they are in quadrilobed settings, which had been
abandoned by the second half of the sixteenth century in the main German centres
of goldsmithing; another appears, however, on the shoulder of the Cleopatra pen-
dant (cat. no. 17). The same starred blue enamel as on the dress is on numerous
Spanish pendants such as, for example, fig 1 from the Treasury of the Cathedral
of the Virgin of the Pillar, Saragossa.[1]

Notes
1 Victoria and Albert Museum, London,
 Inv. no. 341–1870

Additional bibliography
D'Otrange-Mastai, p 127, ill. 7
Hackenbroch (1979) ill. 915

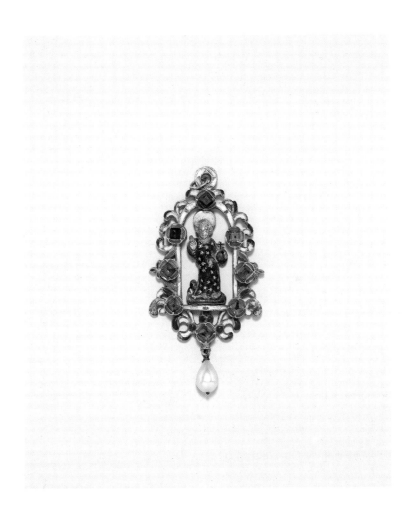

19 Parrot pendant

Enamelled gold set with table-cut rubies, an emerald, two faceted point-cut and one table-cut diamond. Hung and set with pearls. The reverse of the circular frame *champlevé* enamelled black with an egg-and-dart pattern in reserve. Rectangles of translucent green enamel punctuate it, and the backs of the projecting side scrolls are translucent blue. The parrot bolted to matted gold and black enamelled scrollwork which spans the circle.

Dimensions
Height excluding suspension ring: 9.6 cm

The condition very good, the details of the chasing still being very crisp.

Provenance
given by the Countess Batthyany
K I 34 R

Germanic, possibly Central European, late sixteenth century

This is related to a whole group of pendants with the same circle of closely set table-cut rubies forming the frame to the subject. The finest of these is in the British Museum, and is of a hawking couple on horseback (fig 1); on the grounds of their costume one can tell that this comes from Germany or Central Europe and dates from about 1580–90. The similarities between the shapes of the scrolls projecting at the quarter-points, and the suspension chain ornaments, are so close to those on the Thyssen pendant that it is probable that they come from the same workshop.[1]

Three closely related pendants were also shown at the Budapest Great Exhibition of 1884, one with a Pelican in her Piety in the centre, the second and third with parrots. This last is again so close in its outlines to the piece under discussion that it may well come from the same workshop (fig 2).[2]

Notes
1 Waddesdon Bequest, no. 177. This piece has a good provenance, having been in Lord Londesborough's collection when it was published in F. W. Fairholt and T. Wright, *Miscellanea Graphica: Representations of ancient, medieval and renaissance remains in the possession of Lord Londesborough* (London, 1857)
2 Pulszky, Radisics and Molinier, pp 17–18 and ill. The Pelican in her Piety and the first parrot were in the collection of Ghéza Karasz, the second parrot unlocated

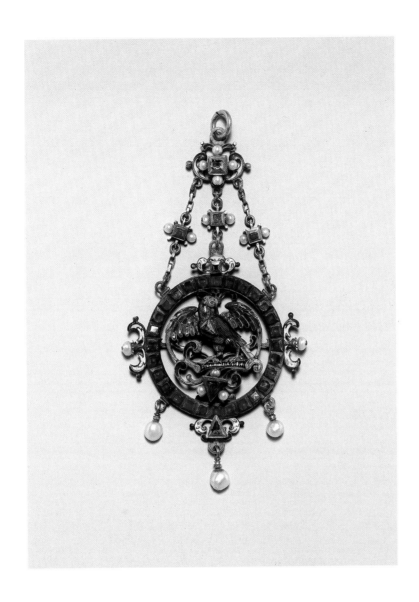

Similar superimposition of a totally disparate front part of a jewel on an assymmetrical openwork scrolling backplate can be seen in the designs by the Frenchman, Daniel Mignot, who published numerous engravings for jewellery in Augsburg between 1593 and 1596 (fig 3).

As to the meaning, if any, of these parrot pendants, one must be cautious before attributing any elaborate symbolism to them: it may well be that the bird's exoticism is enough explanation of its popularity. However, if some allusion was intended, it was probably not a precise one, such as that the parrot represents the Virgin Mary, but a vaguer, more sentimental one, more in keeping with the courtly commonplaces of the day, to do with the sweet enslavement of love. One emblem book, for example, published in 1627, has the following verse next to the picture of a captive parrot:

> Gefangen: Mit Verlangen.
> Als ich mein eigen war / und frey umher zu schweben /
> Da führt ich jederzeit ein still und traurigs Leben:
> Doch wie die Liebe mich bracht unter ihren Zwang /
> Ward meine Zunge loss / und lustig mit Gesang.
> Ich lacht / ich hüpfft und sprung / ob ich schon eingeschlossen /
> So hat mein Zustand mir jedoch nicht verdrossen.
> O süsse Sclaverey! Wann einer ist verliebt /
> Verliert die Freyheit er / ist aber nicht betrübt.[3]

OTHER EXAMPLES

A parrot pendant in a ruby-set circular frame with addorsed scrolls at the quarter-points, similar in type, but not closely connected to the group described above, formerly Astor Collection (sold Christie's, London, 27 November 1979, lot 173)

A parrot pendant in a ruby and diamond-set circular frame with addorsed scrolls at the quarter-points, similar to the group described above (Taft Museum, Cincinnati, Ohio)

Notes

3 'Willingly Captive.
When I was my own master / and free to fly around as I wished / Then I constantly led a still and sad life: But when Love brought me under its yoke / My tongue was loosed / and became merry with song. I laughed / hopped about / so, though I be now locked up here / my condition has not depressed me. O sweet enslavement! Whoever is in love / loses his freedom / yet is not saddened.' J. Cats, *Proteus/ofte/ Minne-beelden/verander/in Sinnebeelden* (Rotterdam, 1627), with verses in Dutch and German, quoted in A. Henkel and A. Schöne, *Emblemata: Handbuch zur Sinnbildkunst des XVI und XVII Jahrhunderts* (Stuttgart, 1967) pp 802–803

ILLUSTRATIONS

1 *Pendant with a hawking couple, late sixteenth century (British Museum, London, Waddesdon Bequest)*
2 *Illustration of a pendant shown at the Budapest Great Exhibition of 1884, from the catalogue*
3 *Design for an aigrette by Daniel Mignot, 1596, showing the front section separate from the body*

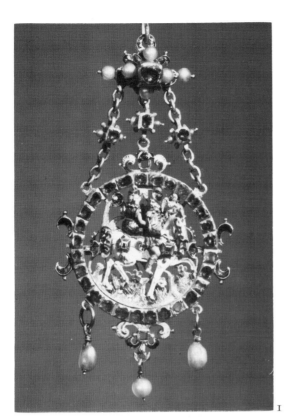

20 Necklace with pendant

Enamelled gold, set with pearls. The fifteen rosettes made up of stamped-out backplates to which the filigree enamel in black, white and opaque dark and light blue is attached. All the rosettes display a wide range of filigree techniques including granulation, spiralling gold wire and plain gold surfaces densely matted with small holes. The pendant which is en suite depicts Juno with her peacock and Jupiter with his eagle.

Dimensions
Length: 41.2 cm; height of pendant: 2.9 cm; diameter of rosettes: 2.7 cm; 2.9 cm; 2.3 cm; 1.5 cm variously

Heavy enamel loss from the border of the pendant. The enamel matte and brittle. The back of the pendant incomplete and some of the pearls later replacements.

Provenance
Eugen Gutman Collection
R. W. M. Walker Collection, sold Christie's, 17 July 1945, lot 88
K 1 34 W

Marks
1 On four of the links, on a gold plaque and soldered to the back, the initials GK

Probably South German, *circa* 1600

1

This necklace and the pomander (cat. no. 21) are part of a group of jewels made around the same time and most probably in a South German centre, whether Augsburg, Vienna or Munich or perhaps a minor town.

 They share the same technique of manufacture: the stamped-out backplate, the various forms of filigree, the pitted matting on the gold surfaces and the same palette of enamel colours, mostly opaque. Above all, and exceptionally for the period, they are often marked with initials stamped on a small square of gold which is soldered to the back.

 The documented core collection in the group is the 213 dress jewels given by the Archduchesses Maria Christierna and Eleonora to the Imperial Convent at

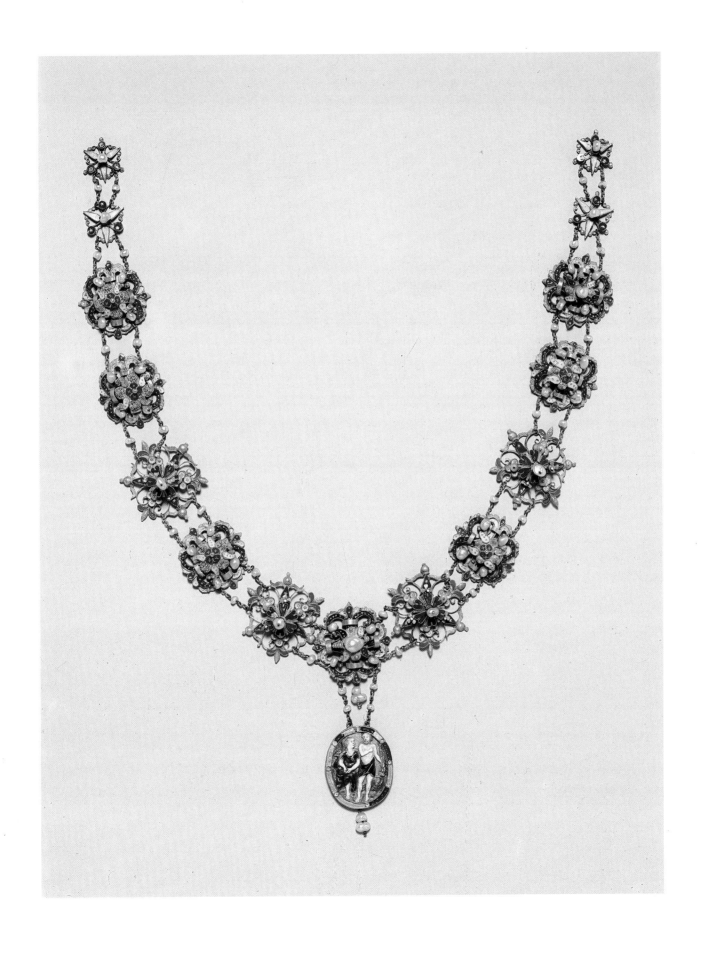

Hall near Innsbruck when they joined it in 1607, and now in the Museum für Angewandte Kunst, Vienna. These jewels fall into a number of groups of varying quality, none, however, dating from before about 1590. The marks which some of them bear are variously AB, CK, BS with a diagonal line, and MC in monogram. Figs 1 and 2 show a small star-shaped jewel set with a pearl which somewhat resembles the end links of the necklace, and a larger jewel, also unmarked, which demonstrates the technical similarity between the two groups.[1]

These jewels, which must have been relatively cheap to produce because they use the minimum of metal, were exported all over the Germanic area, as the burial jewels of Duke Francis I of Pommern-Stettin (d. 1620) include two unmarked ones (fig 3) which closely resemble the intermediate size links of this necklace. All the jewellery from his tomb is now in the National Museum, Szczecin.[2]

The Victoria and Albert Museum, London, also owns a necklace,[3] with a pendant of greater quality, probably made in Prague, which is in the same technique, and marked RV in monogram (fig 4). This is said to have come from the Archducal castle of Ambras near Innsbruck and, although unproven, the story is compatible with the rest of the evidence about the group.

This style of filigree-enamelled jewellery survived into the seventeenth century and was adopted by at least one other goldsmith working far from South Germany, as shown by the burial crown of King Charles IX of Sweden (fig 5), made for his State funeral of 1613 by Antonius Groth, the Fleming, who was active in Stockholm as goldsmith and mint master, 1599–1613.[4]

Notes
1 For the history of the Hall jewels, see *Princely Magnificence*, no. 73 and ills
2 For the history of the Szczecin jewels, see *Princely Magnificence*, no. 125 and ill.
3 Inv. no. 696–1898
4 For the history of Charles IX's burial regalia, see *Princely Magnificence*, no. 126

Additional bibliography
von Falke, no. 38, pl. 11

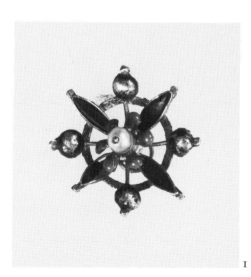

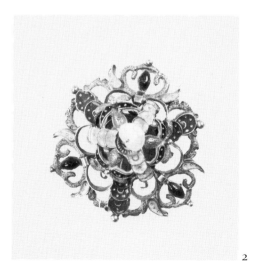

1

2

ILLUSTRATIONS
1 *Dress jewel from the Hall jewellery, South German, circa 1600 (Museum für Angewandte Kunst, Vienna, Inv. no. BI 958)*
2 *Dress jewel from the Hall jewellery, South German, circa 1600 (Museum für Angewandte Kunst, Vienna, Inv. no. BI 954)*
3 *Dress jewel from the tomb of Duke Francis of Pommern-Stettin (National Museum, Szczecin)*
4 *Detail of a necklace, enamelled gold, set with pearls, South German, circa 1600 (Victoria and Albert Museum, London)*
5 *Detail of the burial crown of King Charles IX of Sweden by Antonius Groth, circa 1613 (Strängnäs Cathedral, Sweden)*

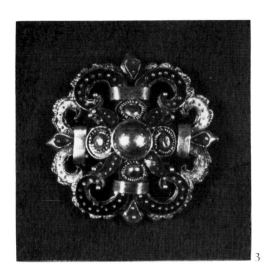

3

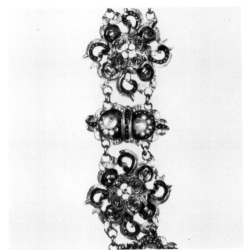

4

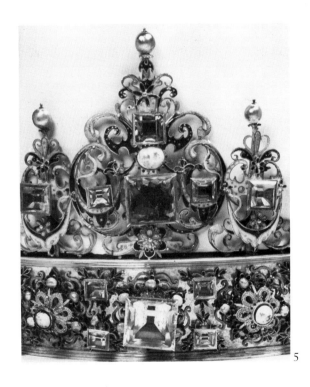

5

21 Pomander

The piece unscrews in the middle. The gold openwork is cast in sections, the flowers filigree-enamelled turquoise blue and yellow, the c-scrolls and strapwork white with gold dots and scrolls set in the enamel. The gold surfaces densely matted with small holes. The small projecting naturalistic flowers *ronde-bosse* enamelled white, yellow and mid-blue with some painted enamel details. The inner edge of the lower half enamelled translucent dark red, as also the foliage coming down from the suspension ring. White and pale blue enamel beading overall, and the strawberry-like elements on the upper part dotted with white enamel. A swivelling suspension ring on the top.

Dimensions
Height: 8.3 cm; diameter: 4.2 cm

The dependent pearl at the bottom missing, and some damage to the enamel.

Provenance
Duke of Norfolk Collection, Arundel Castle, sold Christie's, 28 November 1961, lot 50
K I 35 B

Marks
1 Stamped in gold and soldered to the inner rim, AT in monogram

Probably South German, *circa* 1600

ILLUSTRATIONS
1 *Dress jewel, enamelled gold, set with a diamond, South German, circa 1600, from the Hall jewellery (Museum für Angewandte Kunst, Vienna, Inv. no. BI 1455)*
2 *Cornelis Ketel. Griete van Rhijn, 1605 (Rijksmuseum, Amersterdam)*
3 *Detail of the pomander in fig 2*
4 *Pomander of enamelled gold, set with pearls, South German, circa 1600 (Victoria and Albert Museum, London)*

1

1

2

3

This, like cat. no. 20, belongs to the same group of jewels made, probably in Augsburg, Vienna or Munich, at the turn of the sixteenth and seventeenth centuries. Part of this group is constituted by the dress jewels in the Hall treasure, which includes some pieces with the same white dotted strawberry motif (fig 1).[1]

This will have been made to hold an aromatic substance such as ambergris, and to be worn on a long chain hanging from the waist (figs 2 and 3).

OTHER EXAMPLES
A very similar pendant, enamelled white and pale blue, and set with pearls (Victoria and Albert Museum, London, Inv. no. 298–1854) (fig 4)
A pendant decorated with enamel, hung with pearls and set with gemstones, with similar florets and 'strawberries', formerly Martin J. Desmoni Collection (sold Sotheby's, 17 May 1960, lot 58, present whereabouts unknown)[2]

Notes
1 A small floral ornament in the Victoria and Albert Museum, London, Inv. no. 610–1872, also has this strawberry motif
2 Hackenbroch (1979) p185, ill. 511A lists it as being in the Smithsonian Institution, Washington DC, but this is not so

Additional bibliography
Hackenbroch (1979) p185, ill. 509

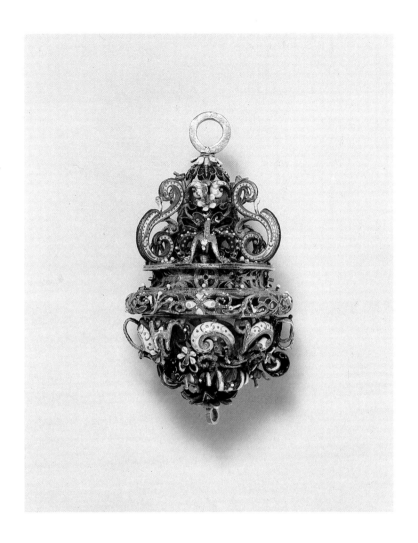

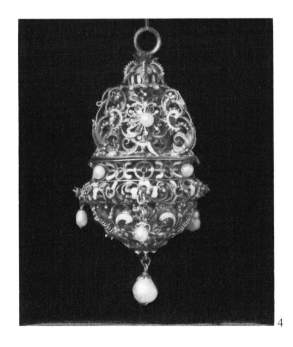

4

22 Reliquary pendant

Gold, *champlevé* enamelled white and pale green; *ronde-bosse* enamelled translucent red, blue and green. The rock crystal 'window' framed by black and white enamelling and twelve table-cut Burmese rubies; the crown set with table- and hog-back cut diamonds. The pendant hinged. The reverse of the front *champlevé* enamelled with black scrolls; the closed backs of the stones similarly enamelled white with gold scrolls in reserve. The inside of the pendant with an oval receptacle for a relic, the border *champlevé* enamelled black with a scrolling leafy pattern. The reverse of the heart decorated with a symmetrical pattern of c-scrolls around a cartouche with IHS surmounted by a cross and with three nails beneath. The scrolls *champlevé* enamelled white, opaque green, and mid-blue; the background *basse-taille* enamelled translucent red. Hung with a pearl.

Dimensions
Height: 9.5 cm; length: 5.4 cm

Provenance
Loria Collection, sold Sotheby's, 7 July 1953, lot 86
Martin J. Desmoni Collection, New York, sold Sotheby's, London, 17 May 1969, lot 76
K127F

Spanish, *circa* 1600

Exhibitions
San Francisco, De Young Memorial Museum, and Kansas City, William Rockhill Nelson
 Gallery, 1959, *Renaissance Jewels selected from the Collection of Martin J. Desmoni*, no. 75

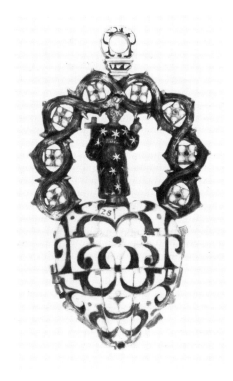

Large pendent religious jewels were very popular in Spain during the first half of the seventeenth century. The crowned heart form is probably intended to refer to the Sacred Heart of Jesus, although this particular cult was many years from being established canonically. The front of the heart is pierced so that contact with the relic contained within should be more immediate and the crystal window makes it more visible. The Sacred Monogram, IHS, on the reverse, confirms and reinforces the devotional function of the piece.

The c-scrolls on both front and back with their gold patterns in reserve are typical of jewellery made at this date in a number of major centres such as Prague and Augsburg; so is the palette of the translucent enamels, and the black scrolls on the inside are very similar to some pieces made in Munich,[1] but the heavy black and white around the crystal window in the centre is characteristically Spanish, as is the massiveness of the whole design.

A similar pattern of enamelling can be seen on the reverse of a reliquary pendant in the British Museum, London (fig 1).[2] This also is Spanish and of the same date.

ILLUSTRATION
1 *Reverse of a reliquary pendant, enamelled gold, the converse set with diamonds and a jacinth cameo bust of a woman, Spanish, circa 1600–10 (British Museum, London)*

Notes
1 eg, the heart-shaped gold pendant enamelled with a cross and drops of blood (Schatzkammer, Residenz, Munich). See Krempel, ills 53 and 54
2 Inv. no. M&L AF 2651; height: 5.7 cm

Additional bibliography
D'Otrange-Mastai, p131

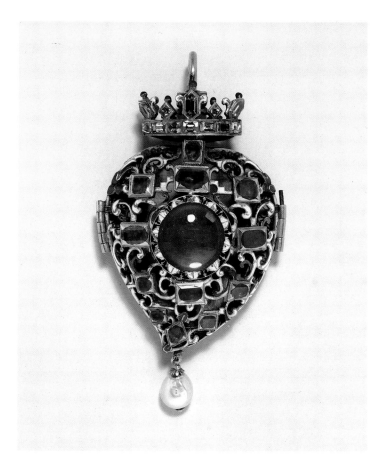

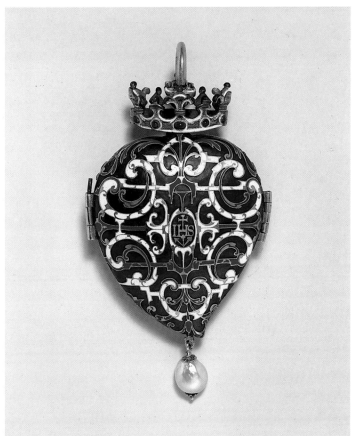

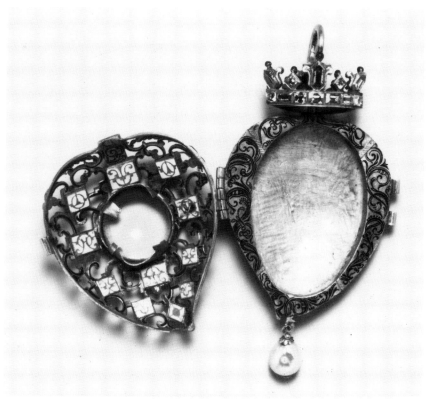

23 Chain of twelve rosettes

Enamelled gold, six of the rosettes set with small table-cut rubies in simple rectangular cut-down settings, three with large table-cut rubies in deep rectangular enamelled settings, and three with large table-cut diamonds in similar settings. The first group and the second two groups cast from the same models as each other. All have the central gem-set bosses screwed through the middle. The enamel colours white, mid-blue, pale green, translucent green, turquoise blue. A translucent red used on one rosette alone – the second from the top on the left. All unenamelled surfaces on the scrolls *sablé* matted. The reverses undecorated.

Dimensions
Overall length: 41.5 cm; height of the rosettes set with small rubies: 3.3 cm; height of the rosettes set with diamonds: 3.5 cm; height of the rosettes set with large rubies: 3.5 cm

The four pearls which would have been on the bare spikes of the rosettes set with small rubies all missing.

Provenance
Probably excavated from the vault of the Sophienkirche, Dresden
Saxe-Coburg-Gotha Collection (until the 1930s?)
Melvin Gutman Collection, sold Sotheby's, New York, 24 April 1969, lot 114
K 1341

German, *circa* 1600

Exhibitions
San Francisco, California Palace of the Legion of Honor, 1942, no. 207, ill. p 30
Baltimore, Museum of Art, 1962–68 (for catalogue reference, see Lesley below)

There are two links in the Museum für Geschichte der Stadt Dresden[1] which are identical with the rosettes set with diamonds and rubies in large enamelled box settings (fig 1).

The next closest group of links are those from the tomb of Duke Francis I of Szczecin and west Pomerania (1577–1620), now in the National Museum, Szczecin.[2] These are probably hat jewels, from the position in which they were found on the corpse, and are similar in general type. Fig 2 shows two of them; it is not known for certain who made them, but when Sophia of Saxony married Duke Francis in 1610, her brother, Elector Augustus of Saxony, bought ninety-five diamond rosettes at three different prices from his court jeweller Gabriel Gipfel, and it may be that these are some of them.

The design book executed between 1593 and 1602 in the workshop of the very successful Hamburg jeweller and merchant, Jakob Mores,[3] who supplied most of

Notes
1 J. L. Sponsel, *Das Grüne Gewölbe* III (Leipzig, 1929) p 178, pl. 6, no. 9. I am very grateful to Dr U. Arnold of the Green Vaults, Dresden, for giving me the background information to these pieces. Together with sixty-nine rings, eight individual pendants and jewels, twenty-eight bracelets, twenty-one chains and a number of rosettes and chain links, they were found in the vaults of the Sophienkirche, Dresden when it was being plumbed for central heating in 1910; see R. Bruck, *Die Sophienkirche in Dresden, ihre Geschichte und ihre Kunstschätze* (Dresden, 1912). It was not possible to establish from which tombs they came as the vaults had already collapsed in on each other. The jewellery is now all in the Stadtmuseum, Dresden. Bruck suggests that isolated rosettes such as these were not parts of chains, nor dress jewels, but parts of burial wreaths for women and children. It is possible that the rosettes under discussion were part of the same find.
2 Inv. nos MNS/RZ 2567 and MNS/RZ 2568, both 4.2 cm wide; see *Princely Magnificence*, no. 125 l, m
3 Staats- und Universitätsbibliothek, Hamburg, Cod. Ia *in scrin.*; see R. Stettiner, *Das Kleinodienbuch des Jakob Mores* (Hamburg, 1915) pl. 15, no. 1

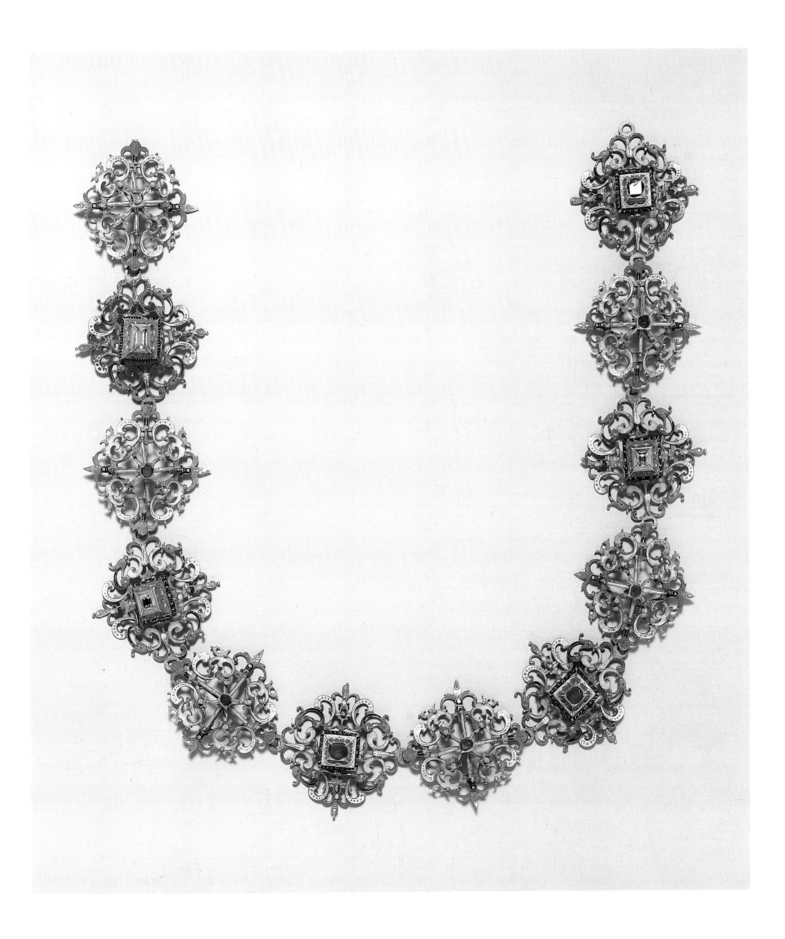

the North German and Scandinavian courts, includes six such chains of rosettes, none of them identical to the present example, but one including a link which, with its pearls around a table diamond, resembles the links here, whose pearls have disappeared, sufficiently for Mores also to be among the possible makers of the chain under discussion (fig 3).

Chains of large enamelled and jewelled rosettes were worn around the shoulders, sewn individually to the clothing, and around the crowns of the tall hats popular in the late sixteenth and early seventeenth century, so these rosettes may not always have been joined together as they are now. The portrait of the Archduke Matthias painted by Lucas van Valckenborch in 1579 shows two of these ways of wearing rosettes (fig 4).

Given the Saxe-Coburg-Gotha provenance for this chain, the presence in Dresden of a piece from the same workshop (the Dukes of Saxony and the Saxe-Coburg-Gotha line being linked dynastically), and the resemblance to the Szczecin pieces, it is also tempting to suggest that it may have been made in Dresden, although Hamburg remains a possibility.

Additional bibliography
Lesley, no. 59

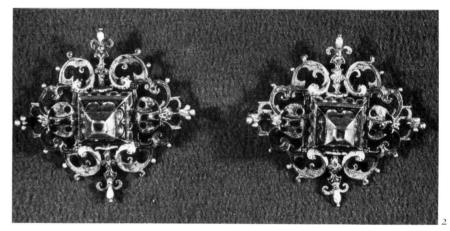

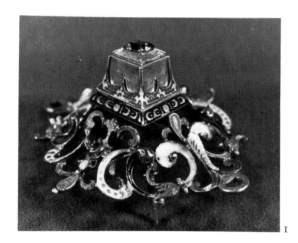

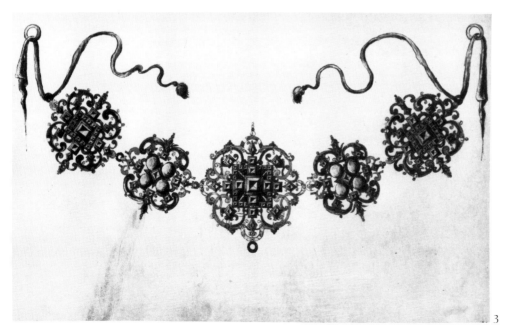

ILLUSTRATIONS
1 *Rosette, enamelled gold, set with a diamond, German, circa 1600 (Stadtmuseum, Dresden)*
2 *Two rosettes, enamelled gold, set with diamonds, German, circa 1600–10 (National Museum, Szczecin)*
3 *Elements of a chain, pen, ink and watercolour on vellum, f. 32 from the Jakob Mores design book, Hamburg, 1593–1602 (Staats- und Universitätsbibliothek, Hamburg)*
4 *Lucas van Valckenborch. Archduke Matthias, 1579 (Kunsthistorisches Museum, Vienna, Inv. no. 6437)*

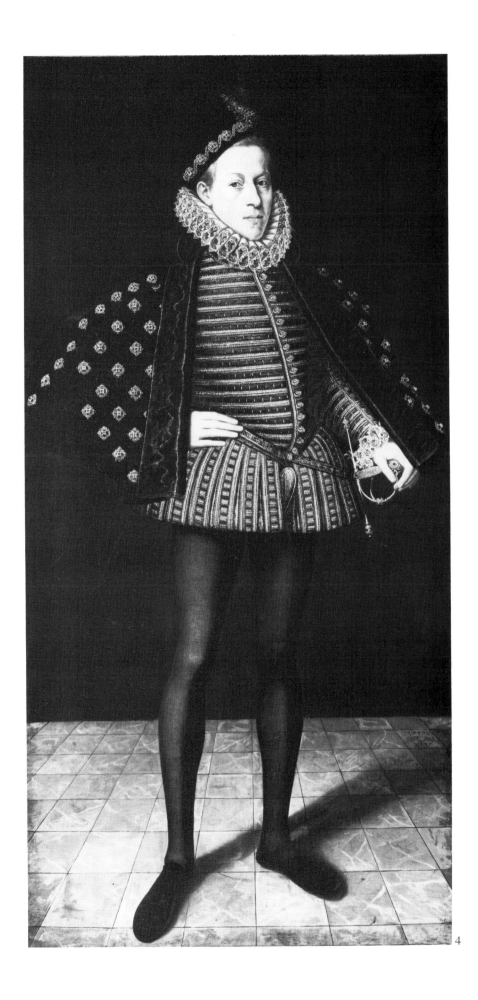

4

24 Pair of earrings

Enamelled gold set with two emeralds and hung with pearls. The three separate elements cast and enamelled. The backs plain.

Dimensions
Height: 5.8 cm; width: 1.6 cm

Provenance
Melvin Gutman Collection, sold Sotheby's, New York, 24 April 1969, lot 108
K I 34 H

Western European, *circa* 1600

Exhibitions
Norfolk, Virginia, Museum of Arts and Sciences, 1964–68, no. 15

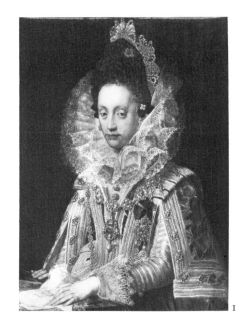

1

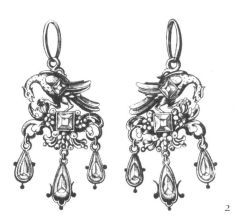

2

Earrings became popular as fashion focused on the head and neck towards the turn of the sixteenth and seventeenth centuries. Women wore large ruffs, jewels and aigrettes in their hair, earrings, and often yet more jewels scattered over the ruff. The portrait by Peter Candid of Duchess Magdalena of Bavaria on her wedding day in 1613 (fig 1)[1] shows the cumulative effect, and also shows how the earrings were often worn: not from the ear itself, but attached by a bow to the hair next to the ear. The earrings under discussion do, in fact, have hooks for pierced ear lobes, but sometimes, as in the design by the anonymous, probably German, engraver of *circa* 1610, they merely have a loop for the ribbon (fig 2).[2]

A good idea of the different kinds of earrings worn in the early seventeenth century is given by the inventory made in 1611 of the jewels belonging to Sophia Hedwig of Brunswick: after 'Hauptgeschmuck' (head ornaments), and 'Roosen uffs Heupt' (rosette jewels for the head), there are:

> Zwei ohrgehenge in jedem achzehn demanten und drei perlen, ein davon
> verloren (400 gulden).
> Zwei ohrgehenge in jedem sieben demantschilde und drei perlen (220 gulden).
> Zwei ohrgehenge wie birnen gemacht in jedem ein und vierzig demanten.
> Zwei ohrgehenge jedes mit sieben demanten und ein hangperle.
> Zwei ohrgehenge jedes mit ein smaragd und zwolff rubintges.
> Zwei lange ohrgehenge von smaragden.
> Zwei ohrgehenge von perlen omher mit elff rubinen.
> Zwei ohrgehenge von balais rubinen.[3]

The surviving earrings are, of course, of much less intrinsic value than those on this list; many have a similar outline to those under discussion, being quite small, with linked elements and dependent pearls.

Similar heavy cast elements and bright, simple enamelling appear on a necklace of about 1600, which is probably Spanish (fig 3).[4]

ILLUSTRATIONS
1 *Peter Candid. Duchess Magdalena of
 Bavaria, 1613 (Alte Pinakothek, Munich)*
2 *Engraved design for earrings, German (?),
 circa 1610 (Victoria and Albert Museum,
 London)*
3 *Necklace, enamelled gold, set with emeralds
 and hung with pearls, Spanish, early
 seventeenth century (Victoria and Albert
 Museum, London)*

Notes
1 Alte Pinakothek, Munich, Inv. no. 2471
2 Victoria and Albert Museum, London,
 Inv. no. 25548.2
3 'Two earrings, in each eighteen
 diamonds and three pearls, one of
 these lost (400 guilders).
 Two earrings, in each seven table
 diamonds and three pearls
 (220 guilders).
 Two earrings made like pears, in each
 forty-one diamonds.
 Two earrings, each with seven diamonds
 and a dependent pearl.
 Two earrings, each with an emerald and
 twelve rubies.
 Two long earrings of emeralds.
 Two earrings of pearls set about with
 eleven rubies.
 Two earrings of balas rubies.'
 Quoted in M. H. Gans, *Juwelen en Mensen*
 (Amsterdam, 1961) p401
4 Victoria and Albert Museum, London,
 Inv. no. M291–1910

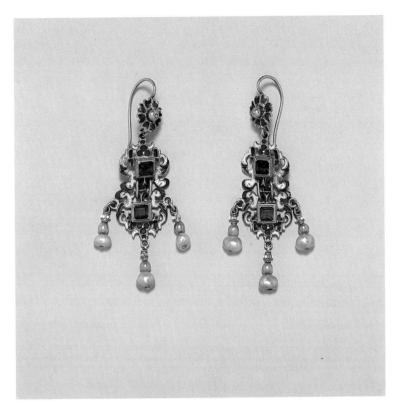

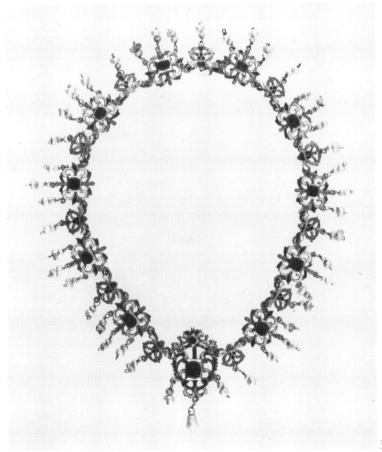

3

25 Eagle pendant

Enamelled gold set with five table-cut emeralds, ten table-cut and seven cabochon rubies, and hung with pearls. The eagle *champlevé* enamelled black, front and back, the crown and rosette between the legs white, the perch white and translucent green.

Dimensions
Height: 6.4 cm; width: 4.9 cm

The wings and tail broken and resoldered; an emerald surrounded by rubies missing from the right wing; much enamel loss from the eagle. The chain modern.

Provenance
Prince Radziwill Collection
Mrs Staceff Collection
Melvin Gutman Collection, sold Sotheby's, New York, 24 April 1969, lot 84
K 1340

Spanish or Central European, *circa* 1600

Although basically of an heraldic type, this eagle makes no precise heraldic allusions: like the lion in its various postures, the eagle was absorbed into the commonplaces of the decorative repertory, and anyone could wear a pendant of this sort. For example, Margareta Bronsen, a citizen of Lübeck, was painted by Michael Conrad Hirt in 1641, probably in her wedding garments, wearing marvellous lace, heavy early sixteenth-century gold chains, and a probably contemporary eagle pendant with spread wings (fig 1).[1] Similarly, an inventory of the jewels of the Spanish poet, Juan de Arguja, shows that in 1600 he owned an eagle pendant set with emeralds, and another small one set with diamonds and with a pearl at its feet.[2]

That being said, an eagle jewel was obviously one of the forms favoured by the princely families of Europe: Costanza, wife of Sigismund of Poland, was painted around 1610 wearing, on her breast, a large gem-studded enamel eagle with spread wings and an orb between its talons, and, in her hair, a similar eagle.[3] In 1605, Queen Anne, consort of James I of England, sent an eagle set with diamonds to Queen Margaret of Spain on the occasion of the baptism of the Infante Philip,[4] and a portrait of Philip II and his children shows the two Infantas wearing apparently identical eagle pendants rather similar to this one (fig 2). The symbolic qualities of the bird were considered to be clarity of vision, quickness and nobility of thought, pride, virtue and rejuvenescence – all, of course, highly suitable to the nobility.[5]

Eagle pendants seem to have been particularly popular in Spain, and although one can only be tentative about it, that is probably where this piece was made: the relatively fine stones, rather simply cut (for example, the six rubies left *en cabochon*), combined with the slightly crude construction and heavy coarse enamelling, are all compatible with production in a prosperous centre which, nonetheless (unlike, say, Augsburg or Antwerp), was not leading the market. One must not, therefore, exclude the less well-known areas of production in Central Europe such as Transylvania.

Notes
1 St Anna church, Lübeck
2 Muller, p 77
3 German School, Bayerische Staatsgemäldesammlung, Inv. no. 7009
4 Muller, p 75
5 A. Henkel and A. Schöne, *Emblemata: Handbuch zur Sinnbildkunst des XVI und XVII Jahrhunderts* (Stuttgart, 1967) pp 757–80

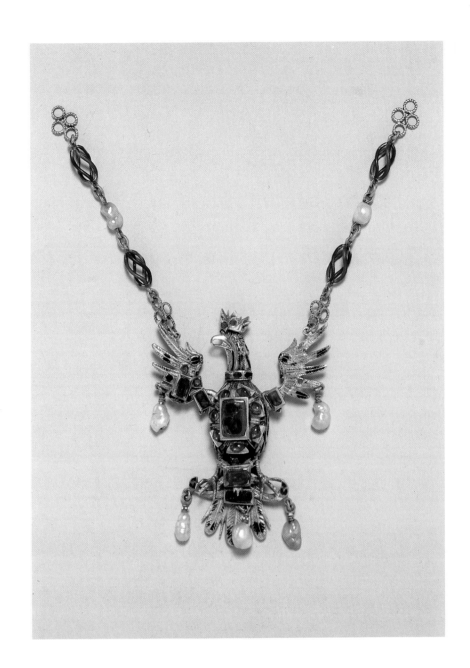

OTHER EXAMPLES

Eagle pendant, enamelled gold, set with table-cut and cabochon stones, Spanish, late sixteenth century (Fitzwilliam Museum, Cambridge)

Design for a crowned pendent spread eagle by Puig, dated 1561[6]

Gold pendant of crowned spread eagle ornamented with painted enamel and set with emeralds; from the wings two emerald drops, at the bottom a pearl, the back likewise covered with painted enamel, seventeenth century (J. Ford Collection)

Pendent jewel in enamelled gold in the form of an eagle surmounted by an imperial crown; the whole richly set with emeralds and terminated by a pearl; the jewel said to have belonged to Emperor Charles v (Mrs Ford Collection)[7]

Crowned eagle with spread wings, enamelled gold set with rubies, emeralds and pearls, European, *circa* 1600 (private collection)[8]

Notes

6 *Llibres de Passanties* II (Museu de Historia de la Ciudad, Barcelona) f. 201
7 Both exhibited, London, South Kensington Museum, *Art Treasures Exhibition*, 1862, nos 7265 and 7390
8 Hackenbroch (1979) ill. 533

ILLUSTRATIONS

1 *Michael Conrad Hirt. Detail of Margareta Bronsen, 1641 (St Anna Church, Lübeck)*
2 *Spanish School. Two Infantas of Spain, daughters of Philip II, circa 1583–85 (Hispanic Society of America, New York)*

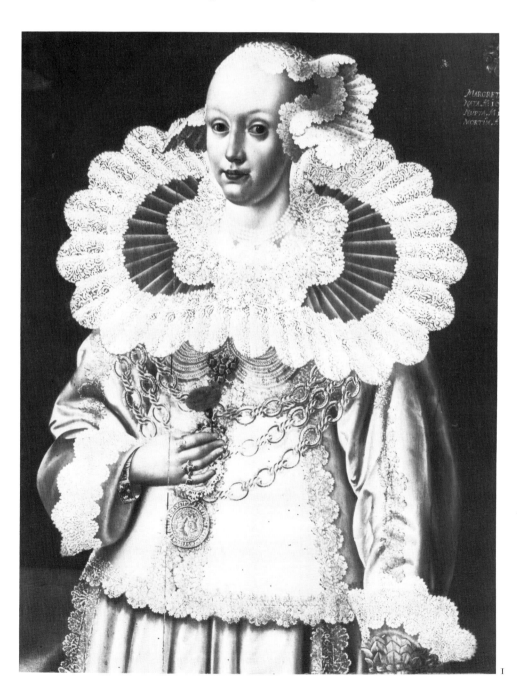

1

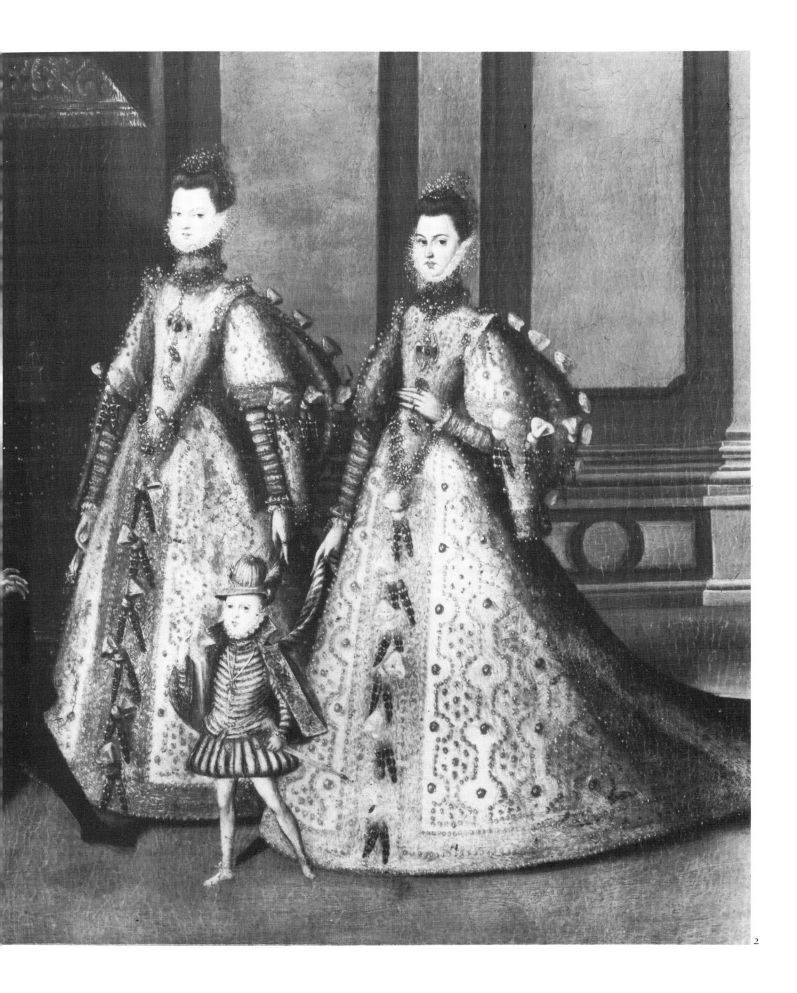

2

26 Cameo pendant

Enamelled gold, set with twenty-three table-cut diamonds and two table-cut rubies with faceted edges. The heavy scrollwork cast and enamelled white on one side and translucent green on the other, with scrolls of translucent red at the quarter-points. The putto heads rivetted to the scrolls. The isolated stones bolted through with rectangular gadrooned gold nuts on the reverse. The backplate behind the cameo *champlevé* enamelled in colours which match the front with interlacing bandwork strewn with small flowers in the interstices. Hung with pearls.

Dimensions
Height excluding suspension ring and pearl: 8.1 cm; width: 6.1 cm; height of cameo: 2.8 cm; width: 2 cm

The rubies later replacements, the diamonds either later replacements, or refoiled; the plate over the reverse lifts out to reveal a later golden border soldered to it; heavy enamel loss. The suspension ring modern.

Provenance
Ruth, Viscountess Lee of Fareham Collection, sold Christie's, 22 November 1966, lot 22
KI38A

The cameo Italian, late sixteenth century; the setting possibly Italian, *circa* 1600

2

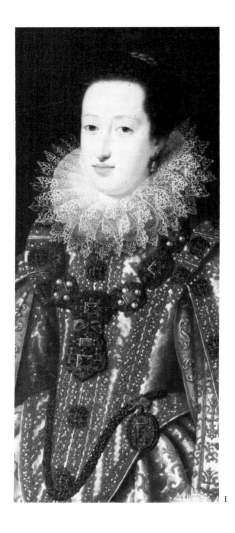

I

This piece, which has been much damaged and repaired, has been attributed and dated on, for the most part, rather negative grounds. It looks nothing like well-documented pieces known to have been made in Spain, South and North Germany, Prague, Paris, Sweden or Denmark. Furthermore, there are no well-documented pieces of around 1600 from Italy with which to compare it; indeed the shortage of surviving Italian jewellery of the sixteenth and seventeenth century in general is well known. The pendant has therefore been called Italian partly by default, and partly because of the boldness of its scrollwork and of the putto heads, on analogy with some picture frames of the period, and the jewellery depicted, for example in the portrait of Eleonora Gonzaga, bride of Emperor Ferdinand. This was painted by Justus Sustermans in Mantua, *circa* 1621, with Eleonora wearing what may well be her wedding dress and a lavish jewelled chain and pendant of presumably Italian manufacture as it does not appear among the jewellery sent to her by the Emperor (fig 1).[1] The scrolls of this pendant closely resemble those of a boldly scrolling cross in the Alsdorf Collection (fig 2).

OTHER EXAMPLES
Agate cameo of the same subject, formerly Blacas Collection (British Museum, London)[2]

ILLUSTRATIONS
1 *Justus Sustermans. Detail of Eleonora Gonzaga, dated 1621 (Kunsthistoriches Museum, Vienna)*
2 *Pendent cross, enamelled gold, set with emeralds and pearls, Italian (?), circa 1600 (Mr and Mrs J. W. Alsdorf Collection, Chicago)*

Notes
1 The Sustermans version in the Kunsthistorisches Museum, Vienna, Inv. no. 7146; a copy by Lucrina Fetti dated 1622 in the Palazzo Ducale, Mantua, Inv. no. 6832
2 Dalton (1915) no. 134, where it is called late eighteenth century

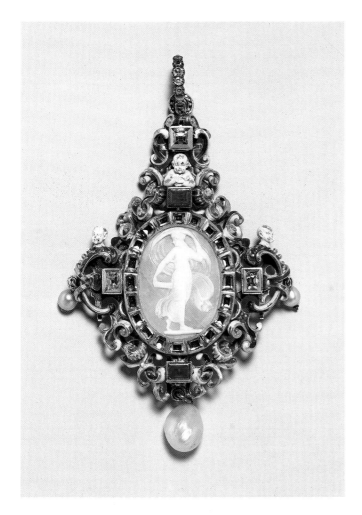

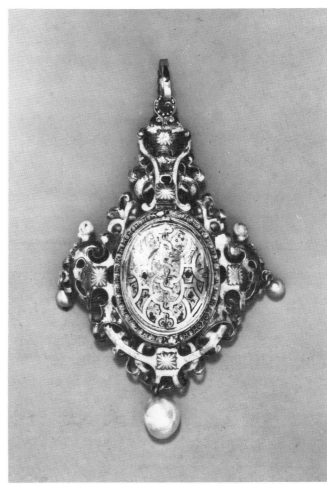

27 Putto pendant

A chalcedony head of Eros carved in deep relief to just behind the ears which are covered by an 'ear-phone' hairdo. The face slightly undercut at the junction with the backplate. The exposed area of the reverse flat with a slightly bevelled edge. The gold frame enamelled in translucent opaque colours, and set with a faceted diamond in a protruding box setting; set and hung with a pearl. The reverse of the open frame enamelled black with staves and ovals.

Dimensions
Height without dependent pearl and suspension ring: 6.1 cm; width: 4.8 cm; height of visible surface of head: 3.4 cm; width: 2.2 cm

The diamond, and the pearl set in the base, later additions.

Provenance
Bulgari, Rome, 1970
K 147

The head Roman, second half second century AD; the setting probably Prague, *circa* 1600–10

This carving belongs to quite an extensive group of chalcedony heads of boys, nearly all with the same characteristic plait down the central parting and carved in deep relief, emerging from a flat backplate. Nearly all the other examples are bored through horizontally, or horizontally and vertically, to provide a fixing.[1] It is possible that they were made to be let into *phalerae*, the disc-shaped medallions which served either as horse trappings, or in the finer cases, as decorations distributed to the soldiers as military rewards to wear on the shoulder straps of their breastplates. Bronze examples with imperial busts projecting from the centres are quite common,[2] and other subjects which occur are Medusa heads, lions, horses, eagles and rosettes.[3] Slightly more lavish types were set with glass-paste cameos of the emperor or imperial family, such as an example with what may be the portrait of Germanicus with three of his children (fig 1), which still retains its bronze disk.[4] Its diameter is 3.8 cm, and this is similar to the average measurement of the surviving hardstone heads, although its manner of fixing into the disk is not the same, lacking the boreholes.

This head almost certainly represents a prince of the imperial house who has been assimilated to Eros. It has even been suggested that Cleopatra may have sent such heads to Mark Antony to announce the birth of twins in 41 BC, as it is recorded that she sent 'billets' of precious stones.[5] On the other hand, the fact that most of the surviving heads are bored through suggests that they must have been set into or onto something, and ultimately, this is most likely simply to have been jewellery, such as large pendants.[6]

The head has been dated to the second half of the second century AD on the basis of its remarkable similarity to a chalcedony bust of Faustina the Younger (married Marcus Aurelius 145 AD, d. 175 AD) in the Bibliothèque Nationale, Paris (fig 2).[7] This has the same rounded smooth well-finished surface, the same convention of eye and eyelid, very similar, carefully striated hair, and a similar mouth.

The example under discussion is of outstanding quality by comparison with all the others.

The setting is closest in the palette of enamel colours and its stylised clusters of fruit to gem-settings executed by the Court goldsmiths working for Rudolph II around 1600–10 when the imperial crown (Schatzkammer, Vienna) was being made. The addition of the wings has, of course, transformed the head into a putto.

ILLUSTRATIONS
1 *Phalera of the Julian-Claudian period set with a glass-paste cameo (British Museum, London)*
2 *Chalcedony three-quarter bust of Faustina the Younger, Roman, second half of second century AD (Bibliothèque Nationale, Paris)*

Notes
1 H. B. Walters, *Catalogue of the Engraved Gems and Cameos, Greek, Etruscan and Roman in the British Museum* (London, 1926) no. 3658, agate, with shield shaped backplate, pierced horizontally 3.9 × 3.4 cm; nos 3662–3665, chalcedony, 4.4 × 4 cm, 4.3 × 3.6 cm, 3.6 × 2.7 cm, 5.4 × 4.3 cm respectively; Eichler and Kris, nos 105–107, chalcedony, pierced horizontally and vertically, heights: 5.7 cm, 5.3 cm, 4.2 cm respectively; Babelon, nos 167, 171, 172, the last two pierced vertically and horizontally, diameters: 2.1 cm, 3.8 cm, 4.1 cm respectively. Also two coarse late examples of cornelian, third century AD, in Munich, without a backplate but with a groove running around the outer edge, heights: 7.6 cm, 7.2 cm respectively, see *Antike Gemmen in Deutschen Sammlungen: Staatliche Münzsammlung, München* I (Munich, 1975) pt 3, nos 2823 and 2824
2 See the bronze and niello *phalera* in the British Museum found at Xanten on the Rhine, datable from its inscription to *circa* 57 AD and 10.5 cm in diameter
3 See Paulys, *Real-Encyclopedie der Klassischen Altertumswissenschaft* XXXVIII (Stuttgart, 1894–1967) pp 1659–62, for further information on *phalerae*
4 Overall diameter of disc 5.6 cm; Inv. no. 70.2–24.2. For a detailed discussion of this piece, see D. B. Harden, 'A Julio-Claudian Glass *phalera*', *The Antiquaries' Journal* LII (1972) pp 350–53
5 See J. Boardman and M.-L. Vollenweider, *Catalogue of Engraved Gems and Finger Rings in the Ashmolean Museum* I (Greek and Etruscan) (Oxford, 1978) no. 358
6 I am most grateful to Dr R. Higgins for confirming the suggestion that this was intended for a piece of jewellery
7 Babelon no. 297. Height: 7.2 cm; width: 5.8 cm

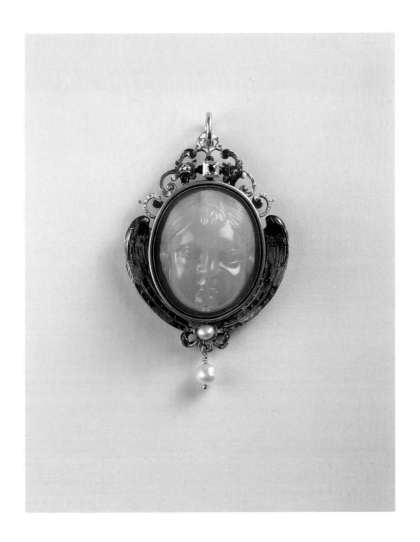

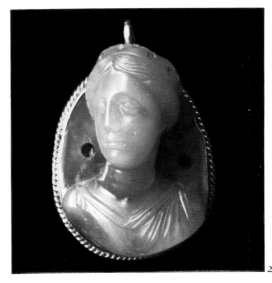

1

2

28 Gimmel fede ring

Enamelled gold set with a table-cut diamond and a table-cut ruby, the hands enamelled opaque white, the heart and cuffs translucent red, the rosettes and sides of the cuffs opaque blue. The hoops *champlevé* enamelled black. The ring takes apart into two halves, the insides of the hoops inscribed in Roman capitals 'QVOD DEVS CONIVNXIT' (What God has joined together) and 'HOMO NON SEPARET 1615' (let no man put asunder) respectively. The compartments behind the two halves of the bezel contain an enamelled baby and skeleton.

Dimensions
Height from top of bezel to base of hoop: 2.7 cm

The fingers missing from the right hand.

Provenance
traditionally thought to have been given by Catherine of Brandenburg to her husband, Gabor Bethlen, but this cannot be so as his first wife, Susannah Karolyi, did not die until 1622
J. Kugel, Paris, 1964
K I 32 A

Marks
1 French import mark for gold imported from countries without customs conventions, since 1 June 1839

German, dated 1615

This combines two of the most common features associated with betrothal and wedding rings in the sixteenth and seventeenth centuries: the clasped hands (*mani in fede*, hence 'fede') stem back to ancient Roman betrothal rings, while the double form (*gemellus*, hence 'gimmel') can be found from the fourteenth century onwards. The symbolism of both is obvious, with their allusion to the union of the bride and groom in marriage, reinforced by the traditional use of the diamond and ruby. Belief in the magical and prophylactic power of gemstones was still current at this time, and the powers of these two stones are described in one of the most important treatises on the subject, first published in 1609. Its author, Anselm Boetius de Boodt,[1] court physician to Emperor Rudolph II, says that, among other qualities, the diamond 'calms fury, and nourishes and increases the love of married people for each other, for which reason it is called the precious stone of reconciliation'. On the other hand, he doubts that it can prove whether a wife is faithful or not. Of the ruby, which he values on a par with the diamond, he says that, 'it resists poisons, repels the plague, banishes sadness, represses licentiousness . . . and restores the spirit'. White was, however, also the colour associated in the liturgy with purity, and red with charity, so this religious symbolism, reinforcing the magical power of the two stones, made them highly suitable for marriage rings, and indeed, this combination is found quite often.

Notes
1 de Boodt, pp 152–60, pp 183–84

Notes
2 Oman, nos 662 and 663
3 Taylor and Scarisbrick, nos 712–16
4 Dalton (1912) no. 991

The baby and the skeleton make additional reference to the brevity of life, its beginning and end.

Rings of this type survive in quite large numbers, and one can be certain of their German origin because so many of them bear German inscriptions.

OTHER EXAMPLES

Cat. no. 29

Inv. no. M.224–1975, which is tripartite, inscribed 'MEIN ANFANGK VND ENDE/WAS GOTT. ZUSAMEN FVGET', thus combining the marriage theme with the memento mori; Inv. nos 851–1871 and 854–1871 are inscribed, 'QVOD DEVS CONIVNSIT/HOMO NON SEPARET', the second with, 'CLEMEN KESSELER DEN 25 AUG Aº 1605'[2] (Victoria and Albert Museum, London)

Diamond and ruby ring set with a baby within the bezel, inscribed 'QVOD DEVS . . .' etc, said to have been Sir Thomas Gresham's wedding ring (Leveson Gower Collection, Surrey)

Five examples,[3] one with two Dutch names, two with German inscriptions, the latter in the same dialect as an example[4] in the British Museum, London, inscribed 'WAS GOT ZV SAMEN FIEGT DAS/SOL DER MENSCH NIT SCHAIDEN' (Ashmolean Museum, Oxford)

29 Gimmel fede ring

Gold set with a red paste and pale emerald. The setting *champlevé* enamelled with black moresques on a white ground, the shoulders opaque mid-blue, white and black. The ring separates to show black enamelled foliage around a small cross on the inside of each half bezel, and the inscription 'WAS. GOTT. ZU.SAMEN. FUEGET. SOL DER. MENSCH NIGHT. SCHEIDEN'.

Dimensions
Height from top of bezel to base of hoop: 2.7 cm

The stones a later replacement.

Provenance
J. Kugel, Paris, 30 January 1969
K I 30C

German, probably early seventeenth century

ILLUSTRATION
1 *Gimmel fede ring, enamelled gold, set with stones (British Museum, London)*

For a discussion of the significance of gimmel marriage rings, and for other examples, see cat. no. 28. This ring is very similar in everything but the text of the inscription to one in the British Museum (fig 1)[1] which bears the Latin legend 'QUOD DEUS CONJUNXIT HOMO NON SEPARET'. The differences are that the British Museum example has scrolls of turquoise blue enamel inside the bezel instead of black; that its enamel stands slightly proud of the gold instead of being flush with it; that the moresques on the lobed setting differ in proportion; and that the black and gold enamelled escutcheons at the ends of the shoulders are of another design.

A third example, with the German inscription, and set with a garnet and chrysoprase (?) is the Fortnum Collection, Ashmolean Museum, Oxford.[2] Versions of this ring, again with the German inscription, were being made as late as 1906 when they appear in the catalogue of Messrs Watherston and Son of 6 Vigo Street, London, to be set 'with various gems'.[3]

Notes
1 Dalton (1912) no. 992; set with a ruby and aquamarine (?); height: 2.9 cm. Formerly Lord Braybrooke Collection. Bought by Lord Braybrooke from Mr Durlacher, New Bond St, May 1856. The latter had acquired it in Paris from a person who 'obtained it in Florence', according to the privately printed, undated catalogue of the collection (in which it is no. 158). It bears the French restricted warranty mark in use between 1819 and 1838 and the small census mark in use between 1838 and 1912. It is possible that it is a nineteenth-century copy of the ring under discussion; significantly, it is even set with gems in the same anachronistic combination of colours.
 Yet another version of this ring with blue enamel scrolls inside the bezel, inscribed 'WAS GOTT ZU SAMEN FUEGET SOLL. DER MENSCH NICHT SCHEIDEN', and set with two small rubies and one long emerald, apparently in their original settings, is in the Metropolitan Museum, New York, Inv. no. 1974. 356.649
2 Inv. no. F 218, Taylor and Scarisbrick, no. 712 and ill.
3 I am very grateful to Mr Geoffrey Munn of Wartski's for this information

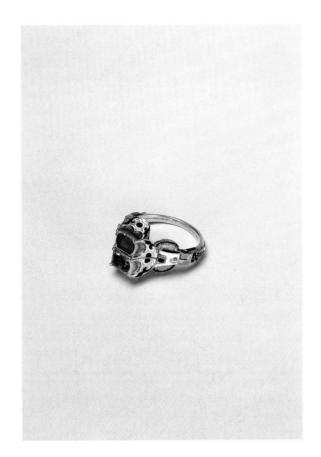

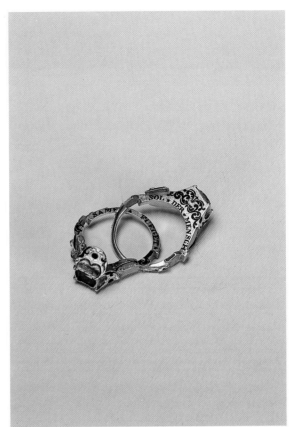

30 Necklace

Enamelled gold, set with table-cut rubies and pearls. The chain consisting of twenty links, ten links of which can be detached by means of slide clasp to form a loose bracelet. Pale blue and mid-blue enamelling on the fronts while the reverses are dark translucent blue. The reverse of the pendant with a crown, the points and florets of which are alternately blue and red, the monogram beneath of F (white enamel) B (green enamel) and probably I. The cross bar of the anchor inscribed 'HOUP.FEIDIS.ME'. A line of black enamel around the edge of the pendant.

Dimensions
Length: 44.2 cm

Heavy enamel loss, particularly from the reverse.

Provenance
S. J. Phillips Ltd, London
R. W. M. Walker Collection
Melvin Gutman Collection, sold Sotheby's, New York, 24 April 1969, lot 115
K 134 J

English or Scottish, first quarter of seventeenth century

Exhibitions
London, Victoria and Albert Museum, *Princely Magnificence: Court Jewels of the Renaissance 1500–1630*, 1980–81, no. 119

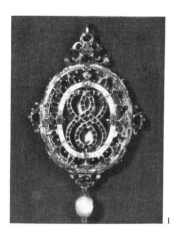

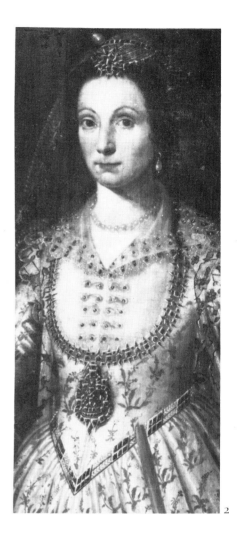

The links are made up of addorsed sickle moons and knots which are doubtless intended to be emblematic and personal to the owner, as also the motto 'Hope feeds me'. This is reinforced by the anchor which also symbolises Hope.

The fact that the inscription is in Scottish does not necessarily mean that the piece was made in Scotland, since with James VI of Scotland's accession to the throne of England in 1603 as James I numerous Scottish courtiers settled in London.

The most closely related piece to survive is the locket in the Fitzwilliam Museum, Cambridge (fig 1). This has an immediate generic similarity to it because of the knot emblem on the front, peculiar to the Heneage family, but, more tellingly, it makes use of the same combination of closely set table-cut rubies with dots of pale blue opaque enamel on the front, and the same translucent dark blue on the reverse.

Personal monogram pendants were popular at this time, and numerous examples are illustrated in the contemporary design book of the Hamburg jeweller and merchant, Jakob Mores (Staats- und Universitätsbibliothek, Hamburg). There is a portrait of Teresia, Lady Shirley, painted between 1624 and 1627, at Berkely Castle (fig 2), which shows her wearing a somewhat similar necklace to this, the pendant being made up of her own and her husband's monogram.

ILLUSTRATIONS
1 *Miniature case, enamelled gold set with rubies and diamonds, English, first quarter of seventeenth century (Fitzwilliam Museum, Cambridge)*
2 *Detail of Teresia, Lady Shirley. English School, 1624–27 (The Trustees of the will of the late Earl Berkely)*

Additional bibliography
D'Otrange-Mastai, p 69, ill. p 71
Lesley, no. 52

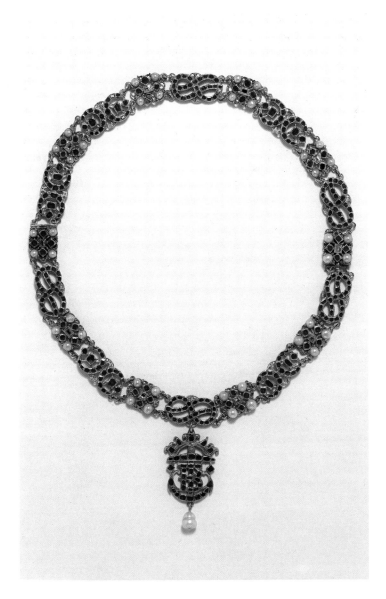

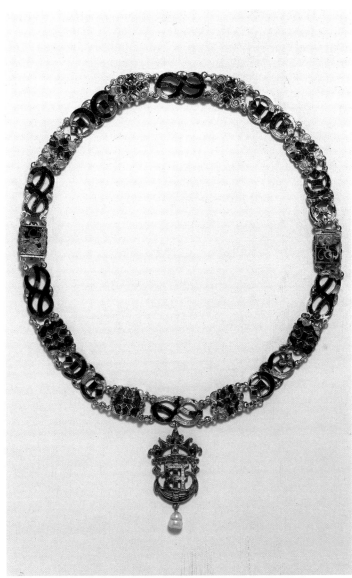

31 Gnadenpfennig

Obverse: Duke Johann zu Sachsen-Weimar (d. 1605); inscribed 'D.G. IOHANNES. DUX.SAXONIAE 1604'. Reverse: Dorothea Maria of Anhalt (d. 1617); inscribed 'D.G.DORO MARIA DVCI: SAX: NATA. PRIN: ANHA'. The cast and chased frame finely matted and enamelled. The coats-of-arms are: obverse: below the suspension ring, *Barry of ten or and sable, a crown of rue in bend*; top, *Azure a lion rampant argent*; right, *Or a lion rampant sable*; below, *or a hen sable*; reverse: below the suspension ring, *1 Argent an eagle displayed gules*, *2 Barry of ᵗen or and sable, a crown or rue in bend*; top, *Argent, a bear azure climbing a sloping wall with an open gate, or*; left, *Quarterly, gules and or*; right, *Chequy argent and sable*; below, *Azure, an eagle wings displayed argent*. Hung with a pearl.

Dimensions
Height: 10.3 cm; width: 4.7 cm; height of medal: 3.5 cm; width: 2.7 cm

Some enamel loss.

Provenance
Melvin Gutman Collection, sold Sotheby's, New York, 24 April 1969, lot 64
S. J. Phillips, London, 16 June 1969
K 138

German (Saxony), dated 1604

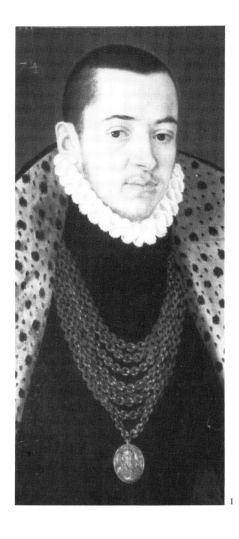

1

The coats-of-arms show the territories associated with the Saxon and Anhalt lines. The arms below the suspension rings are the main ones, while on the obverse the others represent Thuringia and Pfalz-Saxony, Meissen, and, at the bottom, Henneberg, which came to Saxony in 1583.[1] On the reverse the arms show Bernberg, Waldersee, Askania and Mühlingen.[2]

The maker of this medal is unknown. It was coined in 1603 to celebrate the division of Saxony between Duke Johann zu Sachsen-Weimar and the children of his older brother, Friedrich Wilhelm in Sachsen-Weimar and Sachsen-Altenburg. Duke Johann was born in Weimar in 1570 and ruled over Saxony between 1586 and 1603 in conjunction with his brother Friedrich Wilhelm. He died in Weimar in 1605.

It is mounted as a *Gnadenpfennig* or *Ehrenpfennig* (literally, a 'grace', or 'honour coin') which is a peculiarly German creation. This is a medal of a ruler or dignitary, which has been made into a pendant (the splendour of the setting depending on the rank of the recipient and the degree of honour being done him), in order to be distributed as part of the diplomatic merry-go-round of gift exchanges, and to reward loyal retainers and notabilities (fig 1). For example, in 1612 Peter Paul Rubens was given a gold *Gnadenpfennig*, set with two rubies and with the Bavarian coat-of-arms in enamel, by Duke Maximilian I, and in 1622 a court official was given five simple *Gnadenpfennigs*, to distribute to deserving persons as he saw fit. Sometimes a military victory or a major political achievement was celebrated by the distribution of these jewels, as when the Emperor elevated Maximilian I to an Electorship of 6 March 1623, and the Duke then had fifty valuable *Gnadenpfennigs* made for distribution.[3]

The making of such jewels was the routine work of goldsmiths employed by the court: Hans Reimer in Munich made a large number from the 1550s onwards,[4] and so did Gabriel Gipfel at the Electoral court of Saxony in the period between *circa* 1590 and 1617.[5]

The cast and enamelled setting is similar in type to that found around some medals of Archduke Maximilian III of Austria, dated 1612 (fig 2),[6] although one cannot imagine that Saxon and Bavarian medals would have been mounted in the same centre.

Notes
1 Siebmacher I, pt I, pp 18–20
2 Siebmacher I, pt III, pp 21–22
3 Frankenburger, p 128
4 Frankenburger, p 249
5 E. von Watzdorf, 'Gesellschaftsketten und Kleinöde vom Anfang des XVII Jahrhunderts', *Jahrbuch der Preussischen Kunstsammlungen* LIV (1933) pp 178–79
6 eg. Victoria and Albert Museum, Inv. no. M.547–1910; British Museum, Waddesdon Bequest (Read, no. 180); Metropolitan Museum, New York, Pierpont Morgan Bequest (G. C. Williamson, *Catalogue of the Collection of Jewels and precious Works of Art, the Property of J. Pierpont Morgan* (London, 1910) no. 10)
7 I am most grateful to Dr P. Arnold of the Münzkabinett, Dresden for information about this medal, and for the bibliographical references

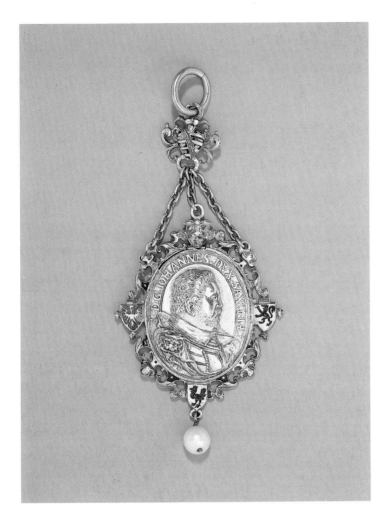

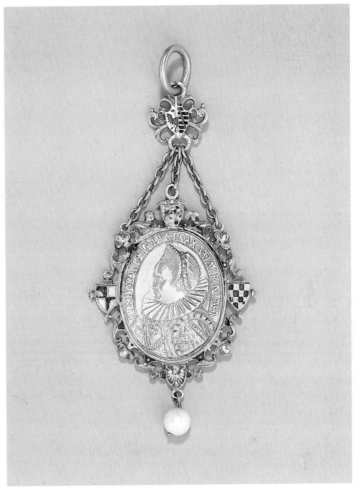

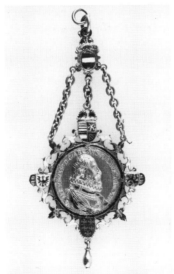

ILLUSTRATIONS
1 *Detail of Johann I of the Pfalz (d. 1604)
 wearing a Gnadenpfennig of Frederick III of
 the Pfalz dated 1563. German School,
 dated 1574 (Bayerische
 Staatsgemäldesammlungen, Inv. no. 6924)*
2 *Gnadenpfennig of Archduke Maximilian III
 (1557–1618), enamelled gold, dated
 1612 (Victoria and Albert Museum,
 London)*

Additional bibliography
W. E. Tentzel, *Saxonia Numismatica oder
 Medaillencabinet von Gedächniss-Müntzen
 und Schau-Pfennigen, Welche die
 Durchlauchtigsten Chur-und Fürsten zu
 Sachsen Ernestinischer Haupt-Linie prägen
 und verfertigen lassen, . . .* (Dresden,
 1705) p478, no. 7 pl. 33
J. Mann *Anhaltinische Münzen und Medaillen*
 (Hannover, 1907) no. 97

2

OTHER EXAMPLES OF THE SAME MEDAL
Staatliche Kunstsammlungen, Dresden, Münzkabinett, Inv. no. 4179
Examples in the Münzkabinetts of Weimar and Dessau before the Second
 World War[7]

32 Watch on a stand

The base and watchcase of rock crystal, the stem of glass. The movement with a verge escapement with a ratchet 'set-up'. The watch face of gilt brass, densely engraved with naturalistic foliage against a hatched ground. The dials of silver, showing the hour, the age and phase of the moon, the day of the week and the deity connected with it, and the date in the month. The gold frame of the crystal case enamelled translucent green with white scalloping dotted black. The case interior enamelled white with painted enamel flowers.

Dimensions
Height of cross excluding suspension ring: 7.2 cm; height including stand: 18.2 cm; width of stand: 7.5 cm

This object is much restored and possibly a 'marriage' of the watch to the stand. The enamel on the cross has been heavily repaired with resin. The join with the domed enamelled top of the stem includes a modern screw and screw thread, although it is not clear whether these are over a previous, similar means of attachment. The stem, which is a later replacement, is hard-edged, too hefty in its proportions, and merely stuck, not fitted, into its base. The gold rim of the base is distressed for enamelling, but none survives.

Provenance
Bulgari, Rome, 1969
K127B

The watch probably French, *circa* 1630–40; the stand probably contemporary; the stem of recent manufacture

While crucifix watches are quite common at this period, this one seems unique in having a stand. It must not be rejected out of hand as a 'marriage', however, as the green enamel on the stand, especially the pattern on the rim at the base of the stem, and that on the watchcase appear to match exactly.

It has been attributed tentatively to France on grounds of its 'pea-pod' enamelling which was particularly popular there. The dating is on the basis of the mechanism.[1]

Notes
1 I am much indebted to Mr Richard Good, Department of Medieval and Later Antiquities, British Museum, for his opinion of the mechanism

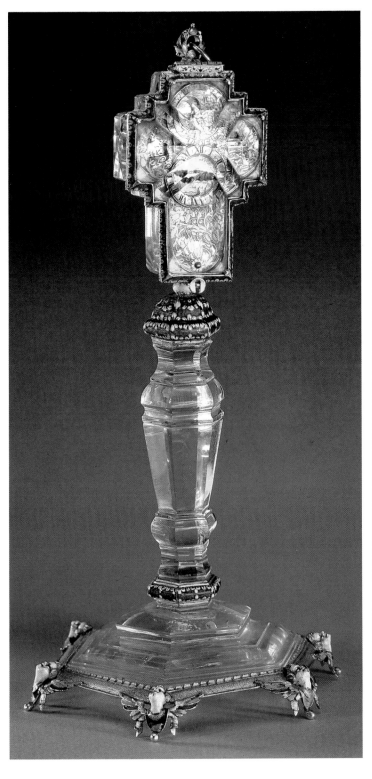

33 Blind Cupid

Enamelled gold, set with cabochon and table-cut rubies, table-cut and rose-cut diamonds and table-cut emeralds. The reverse of the wings decorated with painted enamel in pale blue, pink, yellow and green. The reverse of the quiver and bow enamelled pale blue with black painted enamel details. The body enamelled white *en ronde-bosse* with rosy touches, especially on the bottom. Four attachment rings on the reverse of the wings. A gold double bow, formerly enamelled, on the back of the cupid's head.

Dimensions
Height: 3.8 cm; width: 3.9 cm

Provenance
K I 3 I D

Western European, third quarter of seventeenth century

It is not clear how this would have been worn but it must have been sewn to a garment because of the attachment rings on the reverse. Sculptural jewels had become relatively rare by the time this was made: its dating is based on the type of enamelling, especially the sugary painted enamel colours on the wings, and the bright blue of the quiver and *cache-sexe*. This pale blue first found favour in France and Holland around 1625 but soon spread to the other neighbouring countries. The double bow is found everywhere in jewellery from the 1660s onwards.

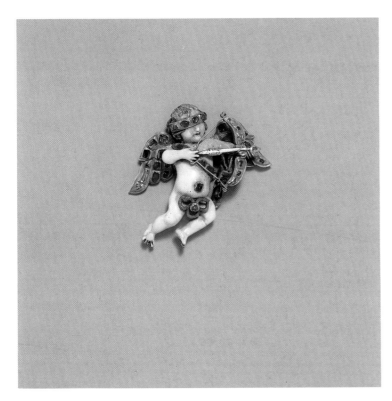

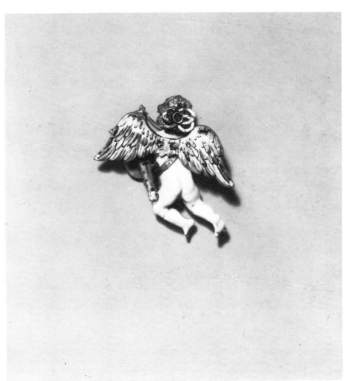

34 Ring of a knight of the Order of St John of Jerusalem

Cast gold, the bezel with white enamel, the underside of the bezel tapering in four steps. The seven-sided hoop *champlevé* enamelled with a white star shape within black hatched lozenges.

Dimensions
Height: 2.9 cm

Slight enamel loss, especially from the border of the bezel.

Provenance
Arturo Lopez-Willshaw Collection, sold Sotheby's, London, 10 June 1974, lot 19
K 140W

Marks
1 Possibly an almost totally illegible mark within a rectangle

Maltese, late seventeenth century, or early eighteenth century

1

2

Rings were not part of the official insignia of a knight of the Order of St John but, judging by the large number and size of those which survive, they were worn not only by the knights themselves but also by their female relations and pages.[1] Most of these are late eighteenth century in date and bear Maltese marks, but a few more robust ones are obviously slightly earlier. There is a silver ring (height: 2.7 cm) very similar to this one in the collection of the Order of St John, St John's Gate, London (fig 1), where there is also a black and white enamelled gold ring related to yet a third in the Victoria and Albert Museum (fig 2).[2] This has the same brilliant black slashes and coarse-grained white enamel as the ring under discussion.

All these are difficult to date as their form is not typical but the presence of a maker's mark on at least one of them suggests a later rather than earlier date, since jewellery was very rarely marked before the eighteenth century, and even then only in a few centres of production.

Another gold ring, of the same shape as that under discussion, with, on the bezel, a Maltese cross and jagged star shapes in the corners, enamelled white, with dark green border, is in the Fortnum Collection, Ashmolean Museum, Oxford. This bears the mark IX on the bezel, and was bought in Rome.[3]

ILLUSTRATIONS
1 *Silver ring, Maltese, late seventeenth or eighteenth century (Order of St John, London, Inv. no. 3193)*
2 *Enamelled gold ring, Maltese, late seventeenth or eighteenth century (Victoria and Albert Museum, London)*

Notes
1 eg, Victoria and Albert Museum, London, Inv. nos 1059–1905 and 1060–1905, both bright-cut, pierced and enamelled
2 Inv. no. M282–1962. Maker's mark in a rectangular field PH/M?
3 Taylor and Scarisbrick, no. 733 and ill. Another silver example of this shape, formerly enamelled (height: 2.9cm), is in the Kunstgewerbemuseum, Cologne, Inv. no. G 865

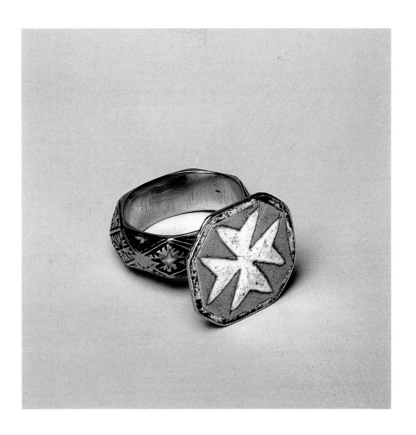

35 Salt

Lapis lazuli. The bowl and stem separate. The narrow end of the shell carved as a frowning bearded face, the beard radiating out with the flutes of the shell. The underside of the foot flat.

Dimensions
Height: 10.5 cm; diameter of foot: 5.3 cm; width: 12 cm

A possible foot mount missing.

Provenance
Edwin J. Berwind Collection, sold Parke-Bernet, 9–11 November 1939, lot 382
Melvin Gutman Collection, sold Sotheby's, New York, 24 April 1969, lot 131
K 1 34 M

Italian, probably Florence, last third of sixteenth century

Exhibitions
Detroit, Institute of Arts, 1958–59
Baltimore, Museum of Art, 1962–68

Lapis, unlike rock crystal and the other hardstones, was adopted relatively late by the princely collectors. This may be because the craftsmen were slow to use a material which presented such technical difficulties, being brittle and of variable hardness.

As with the other hardstones, Milan was the prime centre of manufacture and in 1537, François I bought two vases of lapis from the Milanese merchant, Ambrogio Casal.[1] During the second half of the sixteenth century, lapis lazuli vessels occur more and more frequently in the princely inventories: for example, in 1560 the French royal collections included three large tazze, two salts, seven vases and cups (none of which has survived in the collections in the Louvre). In 1589 Catherine de Medici had four bowls; in 1596 Archduke Ferdinand owned a goblet,[2] and the 1607–11 inventory of Emperor Rudolph II's collection in Prague includes, under 'Lapis-lazuli Geschirrlein', 'Ein stukh gleich einer muschel mit mascaron und wenig gold', which may well have looked like this piece.[3]

The Medici Grand Dukes had an especially large collection of lapis vessels, the earlier ones, dating from the 1560s onwards, commissioned by Cosimo de Medici from Milanese craftsmen, and Gasparo Miseroni in particular.[4] In 1572, however, the Regent, Francesco, founded the lapidary workshops in Florence by getting Gian Ambrogio and Gian Stefano Caroni to come over from Milan, and in 1576 the Venetian Ambassador, Gussoni, was sending back the report that Grand Duke Francesco, 'ora fa cavare alcuni pezzi di lapis lazuli'.[5] Vases did, however, continue to be imported from Milan.

The Florentine lapis vessels have a clear, rather massive outline, with precise almost architectural mouldings, reflecting the style of Bernardo Buontalenti, the architect who was put in charge of the lapidary workshops. The parallel between the ewer (fig 1) and this salt is close enough for one to be able to suggest that the salt was made in Florence. The ewer, which has a later gold handle and foot, first appears in the 1589 inventory of the Tribuna, when it had gold mounts enamelled white and black, with a handle in the shape of a brightly coloured serpent.[6] The salt would also almost certainly once have had a foot rim, perhaps of enamelled gold.

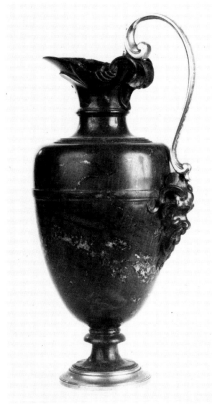

ILLUSTRATION
1 *Lapis lazuli ewer with later handle and foot rim, Florentine, circa 1580 (Museo degli Argenti, Florence)*

Notes
1 Fock (1976) p 119
2 Fock (1976) p 120
3 'A piece like a shell with a mask and a little gold'. No. 1475 in Bauer and Haupt
4 Fock (1976) pp 122–26
5 '. . . is now having vases carved out of pieces of lapis lazuli'. Fock (1976) p 127
6 Fock (1976) p 137, ill. 20

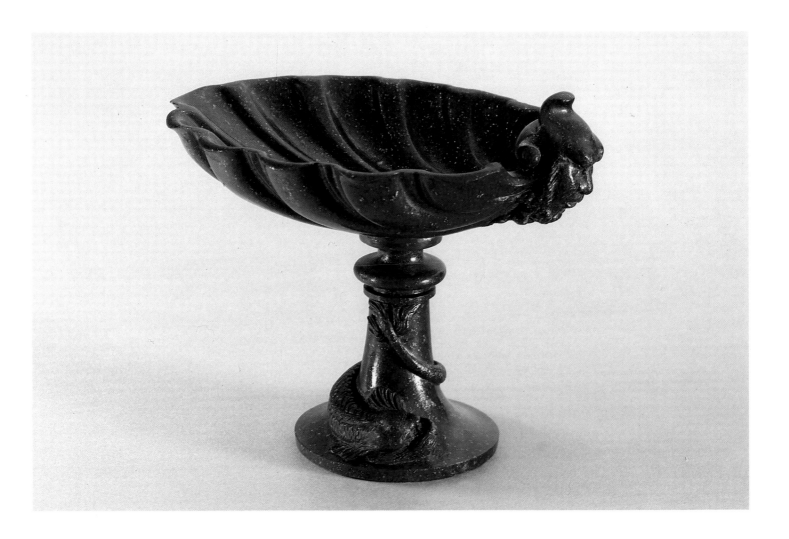

36 Covered cup in shape of ewer

Rock crystal with silver-gilt mounts, and one enamelled gold mount at the join of the
monster handle with the rim. The ewer takes apart at the shoulders leaving a perfectly
finished goblet with a polished lip beneath. A rock crystal plate at the level of the shoulder
mount cuts off the goblet part from the domed 'lid'. The handle carved as a monkey with a
dragon body. The foot mount concave with a heavy roll moulding attached to the edge. All
the engraving matt-cut apart from that on the handle.

Dimensions
Height: 30.3 cm; diameter of foot: 8.6 cm; diameter of lip of goblet: 12.2 cm

Gemstones or decorative scrolls have been removed from all the mounts except the
enamelled gold one. This, together with the handle, which is too small, is a modern repair.

Provenance
Duke of Saxe-Coburg-Gotha Collection
Jürg Stuker Gallery, Berne, catalogue 12 December 1969, no. 2028
K 149 A

Italian, Milan, *circa* 1600

Das herzogliche Museum zu Gotha (Gotha, 1937),[1] which illustrates this piece,
suggests that it was in the collection of Rudolph II, then passed into that of Duke
Maximilian of Bavaria, one of his heirs; was captured by the Swedes in 1632, and
thus arrived in the recently rebuilt Schloss Friedenstein in Saxe-Coburg-Gotha.
In the nineteenth century it was on show to the public in the newly opened ducal
museum in Gotha.

Unfortunately, the last statement is the only one to which credence can be given
at the moment as no evidence is cited for any of the others. Certainly, the fact that
the old mounts are only of silver-gilt does not preclude that the piece may have
been in Rudolph II's collection, as the 1607–11 inventory of his possessions
shows that he did indeed have a number of vessels mounted like this although
gold was more common.[2] The engraving of the crystal is, however, very standard-
ised and somewhat perfunctorily executed, although the engraver has skilfully
concealed a massive diagonal flaw in the crystal with his design. His style is that
current in Milan around 1600, the centre par excellence for hardstone carving,
and there is nothing to associate it with surviving pieces known to have been in
the imperial collections.

The division between the upper and lower part of the ewer may be because the
piece was intended for practical jokes, rather like the modern whiskey tumblers
with false bottoms, and that drinks of different colours were put in the two sections
to puzzle guests.

Notes
1 K. Burgold and E. Schenk zu
 Schweinsberg, p 144, ill.
2 eg, 'Das schone grosse orientalische
 jaspis ablange formirte geschir, grien,
 mit roten bluttropfen, welches der Oct.
 Miseron geschnitten A° 1608, mit silber
 vergultem fuss.' (The fine large oriental
 jasper oblong vessel, green with red
 drops of blood, which Ottavio Miseroni
 cut A° 1608, with a silver-gilt foot).
 Quoted in Bauer and Haupt, p 75

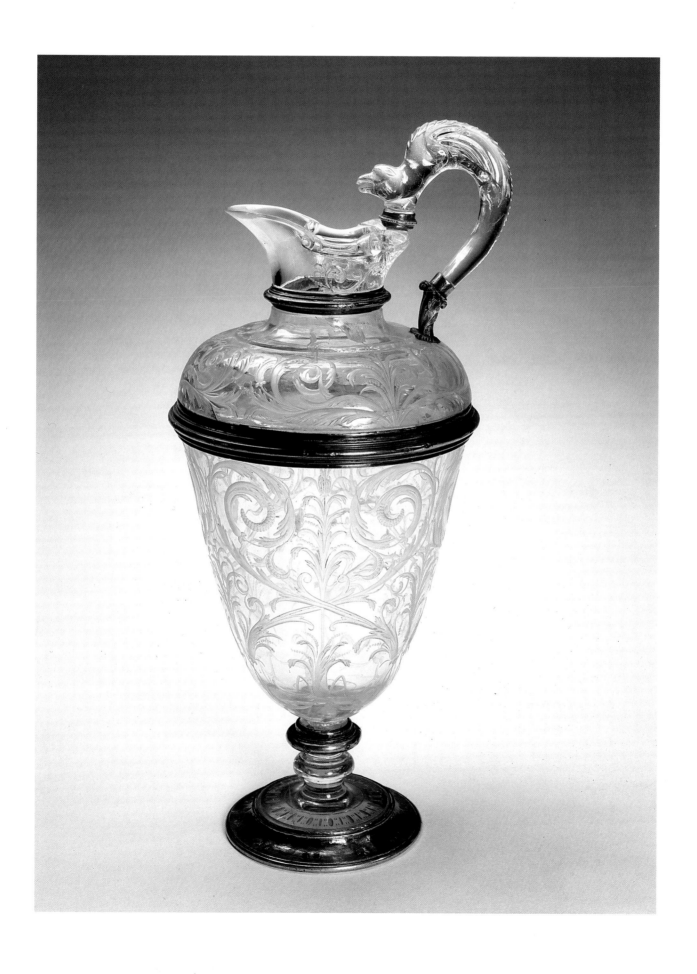

37 Fish ewer

Rock crystal mounted in enamelled gold. The head with its gaping mouth, and the wings, carved separately from the main body, as are the lid, the tail, the stem and the foot.

The mount around the wings and lid plain gold, *champlevé* enamelled white and mid-blue with an astragalled border. The other mounts have the same border, the area in between with detached cast scrolling foliage enamelled white and blue, translucent red and green. The tail and neck mounts match exactly, while the pattern of scrolling foliage on the foot mount differs slightly, although of the same type. Beneath the foot is a heavy gold roll moulding.

Dimensions
Height: 22.5 cm; length: 33 cm; width of neck and tail mounts: 0.7 cm

The tail, wings, stem and foot, and all the mounts nineteenth-century replacements.

Provenance
Arturo Lopez-Willshaw Collection, sold 10 October 1974, from the Sotheby's, London, sale
 10 June 1974, lot 24
K 140 Y

Italian, Milan, early seventeenth century

Fish and monster vessels like this one began to be made by the Milanese crystal cutters, and by the Sarachi workshop especially, in the 1580s; there is, for example, a vessel in the Kunsthistorisches Museum, Vienna (fig 1)[1] attributed to this workshop and dated around 1580. There are three more in the Museo degli Argenti, Florence,[2] also from the decade 1580–90, one of which has a stem consisting of closely intertwined dolphins, a feature which recurs on the piece under discussion. Two of them, like cat. no. 36 have delicate intaglio scrollwork, that is, to use the contemporary terms, 'lavoro di minuteria', as well as the 'lavoro di grosseria' which provided the basic form and the bolder incised lines and shapes.

It seems that these crystal fish and animals were probably made by craftsmen who specialised in opaque hardstone vessels which provided the 'intagliatori' with little to do, and that, therefore, the slightly later versions of these zoomorphic vessels ceased to have the additional fine intaglio carving. Thus, conjecturally, the crystal fish in the Rijksmuseum, Amsterdam (fig 2)[3] represents a later stage in the development of the form and dates from about 1600. The same museum also has a green jasper fishy monster (fig 3)[4] which must date from little later.

The fish monster most closely related to the piece under discussion is in the

Notes
1 Inv. no. 1495. I am most grateful to Dr Rudolph Distelberger of the Kunsthistorisches Museum for much helpful advice on this and the other hardstone pieces in the collection
2 1917 Bargello Inv. nos III, 11; III, 22; and III, 18
3 Inv. no. R.BK.17.193.
4 Inv. no. R.BK.17.076. This has the same mounts with applied cast details as the above, but I have not examined them, so I do not know whether they are contemporary

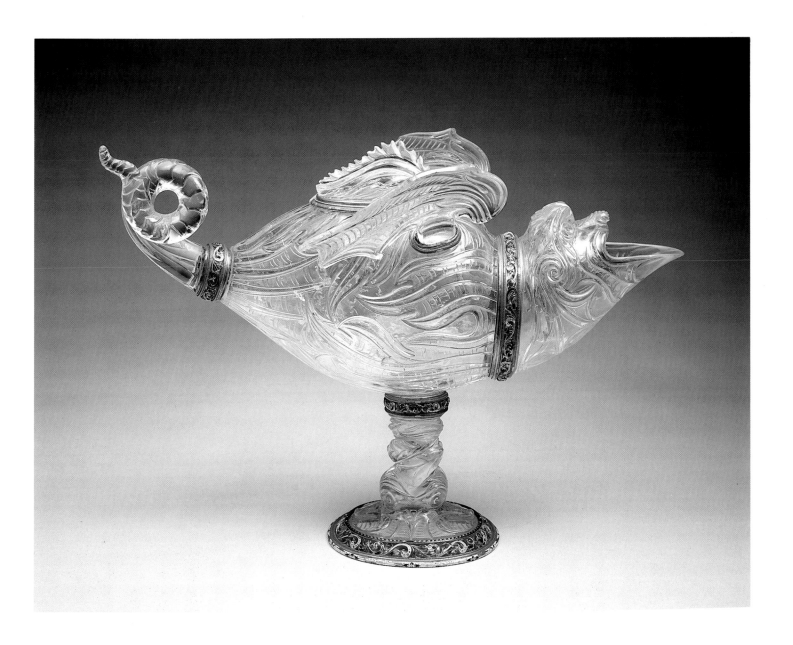

Metropolitan Museum in New York (fig 4).[5] This is so similar that it must be by the same workshop if not the same hand.

Cardinal Mazarin, who had a huge collection of hardstone vessels acquired from a variety of provenances which include Rudolph II, the Cardinal de Lorraine, the ducs de Guise, and possibly Henri IV, possessed three fish vessels at the time when his collection was inventoried in 1653. They were valued at 300 livres, 200 and 200 livres respectively, and one sounds very similar to ones which have been discussed: no. 581 'Un autre vase de cristal en forme de poisson gravé de relief porte sur son pied aussy de cristal aussy gravé de relief représentant deux figures de dauphin, ayant trois garnitures d'or esmaillés de noir'.[6]

OTHER EXAMPLES

Fish monster, green jasper, by the Miseroni workshop. *circa* 1600 (Musée du Louvre, Paris, Inv. no. O.A. 39)

Fish monster, rock crystal, Milanese, early seventeenth century (The Castle, Stockholm, Inv. no. HGK SS901)

Semi-realistic fish, crystal, Milanese, *circa* 1600, formerly Mazarin Collection (Musée du Louvre, Paris, Inv. no. MR 315)

Notes

5 Inv. no. 17.190.536, Pierpont Morgan Bequest. The tail and wings and the mounts modern; height: 19.6 cm; length: 30.4 cm

6 'Another crystal vase in the shape of a fish engraved in relief carried on a foot also of crystal, also engraved in relief representing two dolphins, and with three mounts of gold enamelled black.' Quoted in D. Alcouffe, 'The Collection of Cardinal Mazarin's Gems', *The Burlington Magazine* LXVI (September 1974) pp 514–26

Additional bibliography

E. Kris, *Steinschneidekunst in der Italienischen Renaissance* (Vienna, 1929)

R. Distelberger, 'Die Sarachi – Werkstatt und Annibale Fontana', *Jahrbuch der Kunsthistorischen Sammlungen* LXXI (1975) pp 95–164

R. Distelberger, 'Beobachtungen zur Steinschneidewerkstätten der Miseroni in Mailand und Prag', *Jahrbuch der Kunsthistorischen Sammlungen* LXXIV (1978) pp 78–152

Detail of nineteenth-century enamelled gold mount on the neck

Detail of nineteenth-century enamelled gold mount on the foot

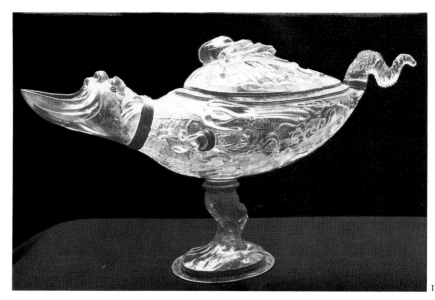

I

ILLUSTRATIONS

1 *Fish-dragon, rock crystal, mounted in enamelled gold, Sarachi workshop (?), circa 1580 (Kunsthistorisches Museum, Vienna)*

2 *Fish ewer, rock crystal, mounted in enamelled gold set with rubies, Milanese, circa 1600 (Rijksmuseum, Amsterdam)*

3 *Dragon, green jasper, mounted in enamelled gold set with rubies and diamonds, Milanese, early seventeenth century (Rijksmuseum, Amsterdam)*

4 *Fish ewer, rock crystal, mounted in enamelled gold set with stones, Milanese, early seventeenth century (Metropolitan Museum, New York)*

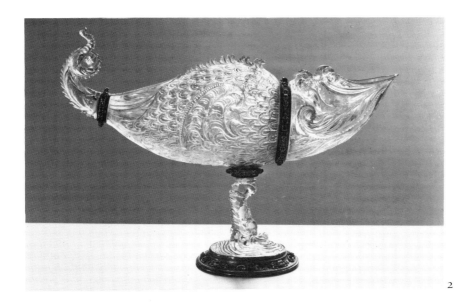

2

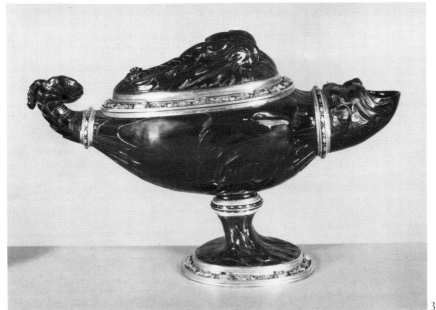

3

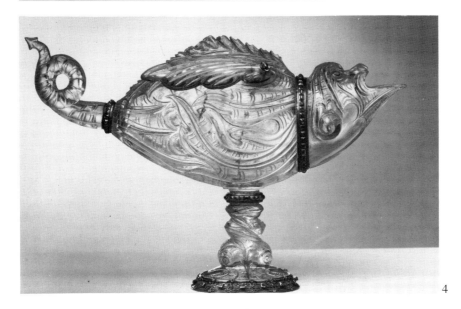

4

38 Chimera

Rock crystal mounted in enamelled gold. The neck collar with applied plaques of floral enamel set with table-cut garnets. Three of the other mounts with enamelled black ovals and spool-shapes on a striated ground; two on the tail with foliated scrolls on a dotted ground, and the wing mounts with foliated scrolls on a striated ground.

Dimensions
Height: 21.5 cm; length: 28 cm

The tail and rear feet modern replacements, as also the mounts with ovals and spools. The neck mount contemporary but the garnets added probably in the nineteenth century. The mounts with scrollwork sixteenth century and from another piece. Breaks in both wings, the tail and the rump.

Provenance
bought by Baron Heinrich Thyssen-Bornemisza (1875–1947) before 1938
K127

Italian, Milan, *circa* 1650

Detail of mid seventeenth-century enamelled gold mount with later stones on the neck

Detail of nineteenth-century enamelled gold mount on the tail

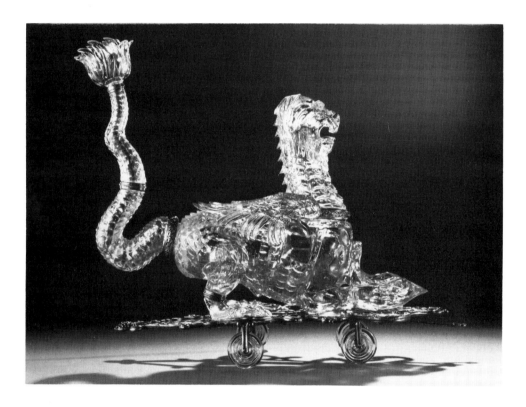

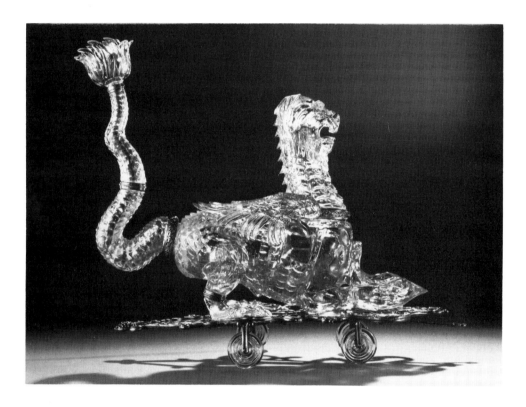

Detail of sixteenth-century enamelled gold mount on the tail

This chimera (a fire-breathing monster with a lion's head, a goat's body and a serpent's tail, or some similar combination) is very close to one in the Kunsthistorisches Museum, Vienna which is described as Milanese, *circa* 1650 (fig 1).[1] Not only is the general form very similar but the quality of execution and certain details such as the 'shoulder-straps' with alternating vertical and horizontal ovals cut into them are the same.

These animals belong to the last phase of the crystal cutting industry practised both in Milan and by Milanese craftsmen who had spread all over Italy, to Madrid, and to major centres north of the Alps. The execution is bold but rather routine and perfunctory when compared with even the run-of-the-mill works executed in the sixteenth and the earlier seventeenth century.[2]

It is very common for old hardstone vessels to have more recent mounts as the old ones were stripped off to be melted down.

ILLUSTRATION
1 *Chimera, rock crystal with enamelled gold mounts, Milanese, circa 1650 (Kunsthistorisches Museum, Vienna)*

Notes
1 Inv. no. 2331
2 I am most grateful to Dr Rudolph Distelberger of the Kunsthistorisches Museum, Vienna, for giving me his opinion of this piece

Additional bibliography
A. Feulner, *Stiftung Sammlung Schloss Rohoncz* III (Lugano – Castagnola, 1941) no. 127

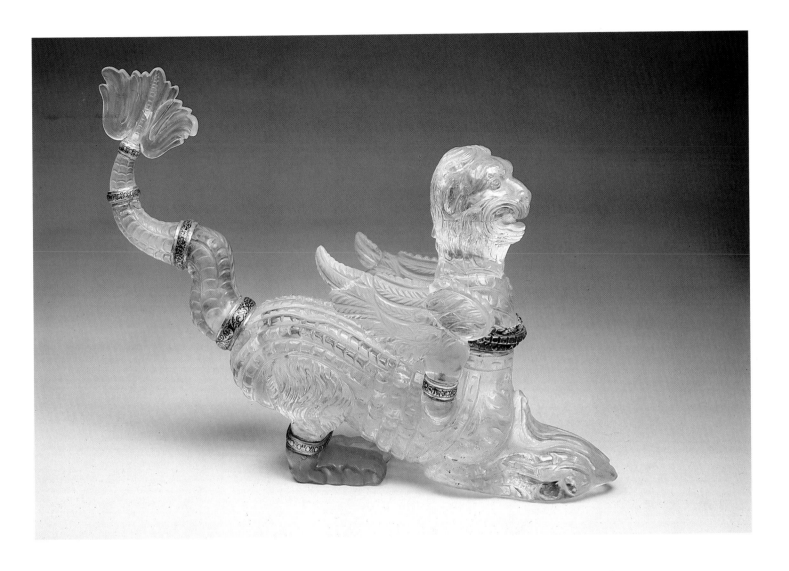

39 Pair of vases

Agate, mounted in enamelled gold. The necks removable. The lip-mounts enamelled pinkish-white with black painted enamel details, and *basse-taille* enamelled translucent green leaves in between. The stem-mounts enamelled white with a gold scrolling foliate pattern in reserve, the leaves *basse-taille* enamelled green. The foot rim with slightly raised white, pink, and pale blue enamel, the details painted in black and the leaves *basse-taille* enamelled green. The underside of the foot counterenamelled pale blue with a leaf-and-dart pattern painted in black.

Dimensions
Height: 18.5 cm; diameter of foot: 7.6 cm

Some restoration to the enamelling in resin and paint, especially on the lip-mounts.

Provenance
J. Kugel, Paris, 27 November 1970
K156A

Probably French, *circa* 1675

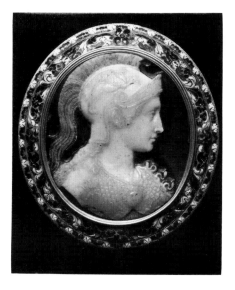

A large number of cameos in the Bibliothèque Nationale, Paris, have settings which, although not identical with the mounts on these vases, are close in their palette of colours, and their combination of built-up enamel (usually with painted details on a white ground) with translucent *basse-taille* enamelling.[1] Fig 1 shows one of these, and although the decoration is a much tighter acanthus leaf than the stylised scrolling acanthus on the vases, nonetheless they both use the same idiom. This cameo can be identified in the 1664 inventory of the engraved gems in the *Cabinet du Roi*, when it just had a plain gold mount; by the 1691 inventory it had been given an enamelled gold mount which must be this one.[2] It is on the basis of this that the approximate date of *circa* 1675 has been given to these vases, and one can suggest that such *objets de luxe* must have been made in a great centre such as Paris.

ILLUSTRATION
1 *Sardonyx cameo of Minerva, Hellenistic, in a French enamelled gold setting, circa 1675 (Bibliothèque Nationale, Paris)*

Notes
1 Babelon, nos 782, 17, 32 and 43, for example
2 Babelon, no. 17. Babelon wrongly calls all these mounts eighteenth century

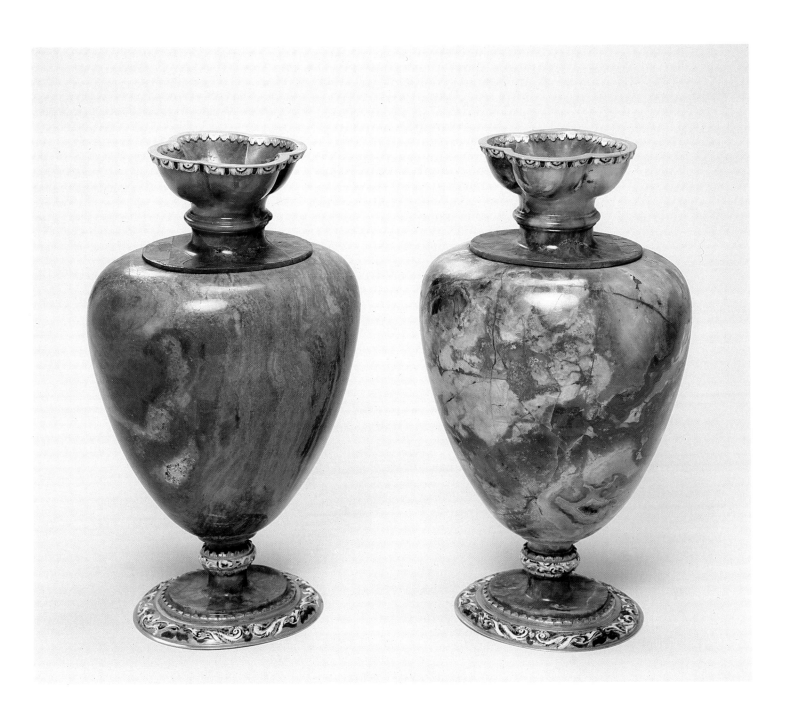

40 Pendant

Enamelled gold set with a lapis lazuli plaque on which is a stamped-out and chased plaque of
Emperor Charles V, the frame set with four table-cut rubies and diamonds. The inner border
champlevé enamelled black with orangey-red astragals. The c-scrolls *champlevé* enamelled
white and opaque mid-blue with translucent green and orangey-red outer edges to the
scrolls. The beading mid-blue. The reverse of the inner border alternately green and
orangey-red with a white rosette in the middle. The reverse of the scrolls white. The back of
the lapis plaque plain.

Dimensions
Height: 8.6 cm; height of gold relief: 4.5 cm

The relief slightly crushed.

Provenance
Max von Goldschmidt-Rothschild Collection
Andreina Torre, Zürich, November 1979
K135C

The relief Italian, mid sixteenth century; the mount probably Viennese, late nineteenth
century

3

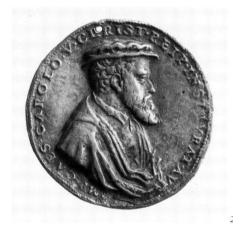

1 2

Apart from the portraits and full-scale sculptures, the means by which sixteenth-
century rulers' appearance were made known to their allies, to their noblemen
and loyal servants, were medals, cameos, miniature portraits and variants of
these in wax, and thin stamped-out gold reliefs on a contrasting ground. These last
were obviously sometimes made in series, such as the 'quattro medaglie, ció è il
Papa, Imperatore, Rè di Francia e il Turco d'oro sutile steso in campi di sardonio
negro', which belonged to Isabella d'Este in 1542.[1] The imperial collections in the
Kunsthistorische Museum, Vienna, own just such portraits, on obsidian back-
plates, of Charles V, François I and Pope Julius II.[2] These do not, however, all
belong to one series as the people represented are too diverse in date and style, but
they must be of the type listed in the 1607–11 inventory of the possessions of
Rudolph II. Here, under 'Beste Sachen no. 8', item 1502 is '9 medeyen von man-
cherley conterfett von dinnere gold uff schwartz schmeltzglas geleimbt, kommen
von Cantengray'; and further on, it lists another nine as being in the writing
table.[3] In 1560 the French royal jewels also included one of these reliefs: 'Une
pierre noire ou il y a dessus l'empereur Charles le Quint qui est dore seulement,
estime vi'.[4]

The relief under discussion and three in the Kunsthistorisches Museum, Vienna
(fig 1),[5] are all based on a medal by Leone Leoni of which there are examples in
silver and bronze in the Münzkabinett, Munich (fig 2).[6] The medal is undated, but
from the portrait type, which shows Charles in middle age, it must date from near

ILLUSTRATIONS
1 *Stamped and chased gold relief of Charles V
on an obsidian backplate and in a wooden
frame, Italian, circa 1550
(Kunsthistorisches Museum, Vienna)*
2 *Medal of Charles V by Leone Leoni,
circa 1550 (Staatliche Münzsammlung,
Munich)*
3 *Enamelled gold relief of Charles V, on a
heliotrope background and in a frame of
lapis lazuli set in enamelled gold, from the
same workshop as figs 1 and 2
(Metropolitan Museum, New York)*

Notes
1 'Four medals, that is, the Pope, the
Emperor, the King of France, and the
Turk, in thin gold on backgrounds of
black sardonyx'. From the inventory of
Isabella d'Este, edited by H.J. Herman in
*Jahrbuch der Kunsthistorischen
Sammlungen* XXVIII (1909–10) p215
2 E. Kris, *Goldschmiedearbeiten des
Mittelalters, der Renaissance und des
Barock* (Vienna, 1932) nos 38–42

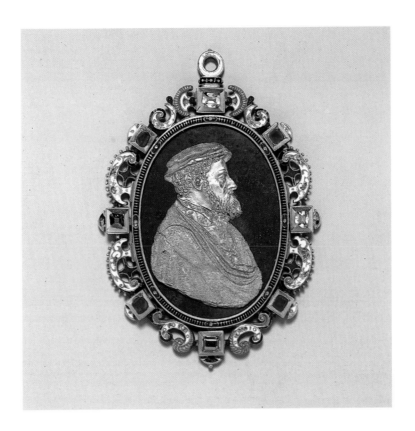

Notes

3 '9 medals of various portraits made of thin gold stuck on black glass, which come from Cantengray' (elsewhere also called the count of Cantegrai). From Bauer and Haupt, p 80

4 'A black stone on which there is the Emperor Charles v who is only gilded ... From the 1560 inventory of the jewels of the French crown, edited by Lacroix

5 Inv. nos 2136, 2221, 2211; Kris, *op. cit.*, no. 40 and ill. One of these will be the one listed in the 1619 inventory of Emperor Matthias's possessions: 'Caroli des Funften bildnus von gold auf ainem schwarzed anichell', i.e. 'Charles vs portrait of gold on a black onyx', from *Jahrbuch der Kunsthistorischen Sammlungen* XX (1899) no. 1306

6 M. Bernhart, *Die Bildnismedaillen Karls des Fünften* (Munich, 1919) nos 181 and 182 and ills.

7 Kris, *op. cit.*, nos 38 and 39

8 Inv. no. 17.190.863

the end of his reign, probably around 1550. The reliefs cannot be based technically on the medallic portrait as they are slightly larger in size (all *circa* 4.9 cm high as opposed to a diameter of 5.1 cm for the whole medal). They have all been chased up after stamping as there are slight differences of detail in their clothing.

Other works from the same, as yet unidentified, gemcutters' workshop, are the relief of Charles v as the victor of Tunis[7] and an enamelled version of the same on a heliotrope backplate and with a lapis lazuli and enamelled gold frame, in the Metropolitan Museum, New York (fig 3).[8]

No mention is made in any of the archival references to elaborate settings for these jewels, and all those surviving in Vienna are in wooden, or, in one case, ivory frames. This is not to exclude the possibility that such a relief could have been given a more lavish setting (eg fig 3), either at the time of making or later in the century. The setting of this piece, however, has a frame which is highly unconvincing, being very stiff and two dimensional. It looks as though it had been made by someone who had seen photographs of pieces produced in Prague at the end of the sixteenth century, but had not realised how much depth and movement the scrollwork should have. It is very likely, then, that the relief was removed from its original backplate, and given the lapis lazuli ground and setting some time in the late nineteenth century, possibly in Vienna. The damage to the lower left-hand corner of the relief may have occurred then.

41 Minerva pendant

Enamelled gold, cast in numerous sections and bolted together. Set with diamonds and rubies and hung with pearls.

Dimensions
Height without suspension ring: 14.1 cm; width: 6.6 cm

Provenance
possibly Count Elemér Batthyany Collection, Budapest, 1884
Eugen Gutman Collection
Countess Lathom Collection, sold Sotheby's, 16 July 1931, as a single lot after the Canning
 jewel, now in the Victoria and Albert Museum
A la Vieille Russie, New York, 21 December 1968
K I 38B

Marks
1 French import mark for gold imported from countries without customs conventions, since
 1 June 1893

Possibly German, second half of nineteenth century

Exhibitions
New York, A la Vieille Russie, *The Art of the Goldsmith and Jeweller*, 1968, no. 5

ILLUSTRATION
1 *Incomplete and made-up jewel exhibited by Count Elemér Batthyany at the 1884 Budapest Great Exhibition*

This is a fake, as revealed by its design and by various technical features.

It is very difficult when making a pastiche of a work of figurative art from a different age to emulate the physiognomical conventions and facial expressions of that age, and it is this failure which most quickly arouses suspicion. In the case of the Minerva pendant, the goddess has a Gaiety Girl cast to her features, and there is even a hint of the piled up curls and the fiercely corsetted waist fashionable at the end of the nineteenth century. The loose and unbalanced scrollwork on which she rests is also impossible for the sixteenth century, quite apart from the fact that this whole area of the jewel has obviously been assembled in a rather arbitrary manner as shown by the numerous bolts on the back. The ruby in the centre had faceted edges unlike any sixteenth-century stone, and its setting is a misunderstanding of the lobed cut-down setting used in the fifteenth and sixteenth century; the same applies to the settings of the table-cut diamonds at the ends of the scrolls and below the central ruby. The stones, with the exception of this ruby, and the pearls are of good quality, and it is unlikely that in the sixteenth century such an intrinsically expensive object would have been so crudely executed.

It is possible that this pendant is the same jewel which was shown in the Budapest Great Exhibition of 1884, and illustrated in the catalogue (fig 1) with the comment that although the figure was probably mid sixteenth century in date, 'elle est en tout cas d'une autre époque et d'un autre style que les rinceaux sur lesquels elle est fixeé'.[1] The palette of enamel colours is identical with this piece and there are striking similarities in the forms of the two figures and of the scrollwork. Obviously, for them to be the same one would have to suppose that the blue veil, the suspension chains, the bottom strapwork element, and the arrangement of some of the stones on the scrolls were later additions and alterations dating

Notes
1 Pulszky, Radisics and Molinier,
 pp 153–54 and ill.

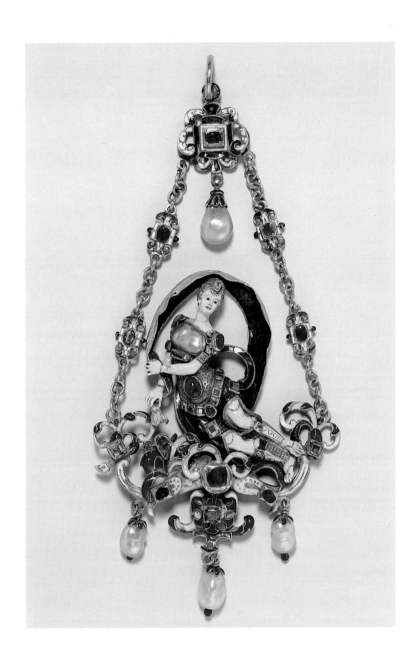

Additional bibliography
von Falke, p 23, no. 91

from before 1912 when von Falke describes the piece as it is now. There are, however, certain small differences in the unaltered parts which make one doubt whether they are the same after all: the Hungarian example has pointed diamonds on her head and skirt, while this has rectangular ones; nor, for example, has this one a diamond set in the middle of her chest. Thus, one is left with three possibilities: that they are one and the same; that they are separate and both entirely fake, from the same workshop; or that the Minerva on the Hungarian example is indeed old, and when it was embellished with its lower scrollwork sometime before 1884, the goldsmith made another version of it, this time complete with its chains.

42 Locket pendant

Enamelled gold set with nine small table-cut garnets and enclosing a sardonyx cameo of
Queen Elizabeth I. The enamel translucent blue, red, opaque pale blue, black and white.
The reverse hinged and set with a matching plain sardonyx, with a bevelled edge, engraved
with a rosette and $^{CR}_{SM}$. The triple suspension chain hung from a chased ring.

Dimensions
Height including suspension ring: 7.5 cm; width: 3.5 cm; height of visible surface of cameo:
2.1 cm; width: 1.8 cm

Provenance
Baron Max von Goldschmidt-Rothschild Collection, sold Parke-Bernet, 11 March 1950,
 lot 269
Melvin Gutman Collection, sold Sotheby's, New York, 24 April 1969, lot 76
K 134 C

Western European, the cameo *circa* 1580–1600; the setting probably nineteenth century

Exhibitions
Chicago, Art Institute, 1951–62
Baltimore, Museum of Art, 1962–68 (for catalogue reference, see Lesley below)

Cameo, and miniature portraits of Queen Elizabeth were much worn by her
courtiers as a gesture of loyalty; this can be seen, for example, in the painting at
Melbury House which shows the Queen's visit to Blackfriars in solemn procession,
surrounded by seven knights of the Garter, three of whom are wearing badges
around their necks with her portrait.[1]

A large number of cameos of Queen Elizabeth survive, none dating from before
about 1575 because of the costume she is wearing. The ones which this most
resembles are those in the Royal Collection, Windsor Castle and the Bibliothèque
Nationale, Paris.[2]

Cameo portraits of Queen Elizabeth probably formed part of the stock-in-trade
of the more prominent London goldsmiths – for example, there is a small unmounted
one among the early seventeenth-century goldsmith's stock discovered in Cheap-
side, London, in the early twentieth century.[3] The iconographic type represented
remains unchanged after the 1580s, so precise dating of these cameos is impossible
and one can only assume that production ceased with the Queen's death in 1603.

All the surviving examples are oval and this one has been cut down so that the
head is squashed against the top of the frame. The setting is a careful but ana-
chronistic forgery: the opaque blue dots of enamel are an early seventeenth-
century feature, but they are combined with gold scrollwork on the white enamel
which bears no resemblance to the sophisticated, asymmetrical attenuated scroll-
work in use in the early 1600s; the grouping of tiny garnets in the projecting
scrollwork is also untypical, and so is the rigorous symmetry of the piece, with its
scrolls at the four points of the compass, and the knobs at the bottom to balance
the knobs to which the chains are attached: this feature in particular reflects the
nineteenth-century aesthetic.

Notes
1 See The Earl of Ilchester, 'Cameos of
 Queen Elizabeth and their reproductions
 in contemporary portraits', *Connoisseur*
 LXIII (1922) pl III
2 Royal Collection, Windsor Castle,
 height: 6.4 cm; Bibliothèque Nationale,
 Paris, Inv. no. 967, height: 5.8 cm; both
 illustrated in R. Strong, *Portraits of Queen
 Elizabeth* (Oxford, 1963) ills.
 c.4 and c.12
3 Museum of London, Inv. no. A 14266,
 height: 3.8 cm

Additional bibliography
D'Otrange-Mastai, ill. p 70
Lesley, no. 44
Hackenbroch (1979) p 295, ill. 785

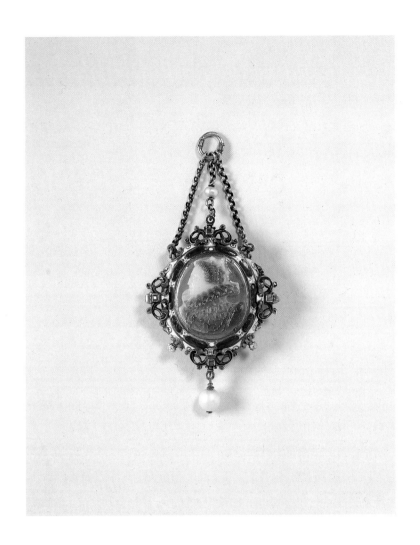

When describing the position of marks on pieces, the terms 'left' and 'right' have been used to designate the side on the cataloguer's left or right hand when facing the front of the piece, and the terms 'in' and 'on' indicate that the marks are on the inside or outside of the area specified. The clearest version of each mark is illustrated four times actual size.

When dating the Paris goldsmiths' work, a minor digression from normal practice has been considered advisable. It has hitherto been usual to date such pieces from the mark of the wardens of the guild of *marchands-orfèvres-joailliers* alone, thereby assuming completion of a piece within the year of commencement of production when this mark was struck. Evidence of completion is only supplied by the discharge mark of the office of the *fermier*, and in consequence, dates of pieces made in Paris in the catalogue have been given from the institution of the wardens' mark for a particular year, or the attainment of the *maîtrise* of the goldsmith responsible for the piece, whichever is the later, and the change of the discharge mark of the officer of the *ferme*, or the retirement or the death of the goldsmith, whichever is the earlier.

In all other cases, pieces have been dated in accordance with the authorities cited, or by stylistic analogy.

Gold boxes

French gold boxes

Gold boxes bearing marks imitating those used in France

Gold boxes from other European countries

43 Snuff-box

Rectangular snuff-box of six panels, each composed of mother-of-pearl plaques mounted in
gold scrollwork and encrusted with gold branches bearing flowers and foliage of shell and
carnelian berries, mounted *à cage* in gold chased with undulating mouldings (wavy bezel).

Dimensions
Height: 3.6 cm; length: 7.7 cm; depth: 5.7 cm

Provenance
Frederic R. Harris Collection, 1949
Sidney J. Lamon Collection, sold Christie's, 28 November 1973, lot 35
K 189 D

Marks

On the left-hand side of the bezel
1 Maker's mark of Pierre-Aymé Joubert, goldsmith registered in Paris, 26 September 1735
 until 23 December 1763[1]
2 Charge mark of the *sous-fermier* Antoine Leschaudel, 13 October 1744 until 9 October
 1750[2]
3 Wardens' mark for Paris, 6 July 1744 until 26 November 1745[3]
4 Restricted warranty mark for Paris for gold, since 10 May 1838[4]

In the lid and in the base 1, 2 and 3

On the left-hand rim of the lid 4 and
5 Discharge mark of the *sous-fermier* Antoine Leschaudel, 1744–50[5]

French, Paris, 13 October 1744 until 9 October 1750, by Pierre-Aymé Joubert

Pierre-Aymé Joubert was the son of the goldsmith Aymé (or Edmé) Joubert with
whom he was living at the cour Lamoignon, in the parish of St Barthélemy, when
he entered his mark, a crowned fleur de lis, two *grains de remède* with the letters
PAJ and a star, on 26 September 1735. By 1743, he had moved to the rue St Louis
at the sign of the Cordon Bleu, and subsequently moved to rue St Honoré by 1756
where he remained until he had ceased to practise by 23 December 1763. He
is recorded as having engaged Aimé-Joseph-Louis Couturier as an apprentice on
17 February 1736.[6]

Boxes of gold encrusted with mother-of-pearl were amongst the most popular
products of the *marchands-orfèvres-joailliers* from the early years of the eighteenth
century until the 1760s. An example dated about 1718 inscribed 'Gouers à Paris'
is in the Hermitage, Leningrad;[7] and a rather late example by Jean-Marie Tiron
dated 1765–66, is in the Rothschild Collection at Waddesdon Manor,[8] but the
greatest number date from the 1740s and '50s.

Lazare Duvaux records repairing a mother-of-pearl snuff-box for the dowager
Comtesse d'Egmont on 28 February 1753.[9]

Notes
1 Nocq II, pp 360–61
2 Nocq IV, p 234
3 Nocq IV, p 216
4 Carré, p 208
5 Nocq IV, p 234
6 Nocq II, pp 360–61
7 Snowman (1966) pl. 132–33
8 Waddesdon catalogue, no. 87
9 Courajod, no. 1361

Additional bibliography
Berry Hill, ill. 13 where the box is
attributed to P.-A. Grouvelle

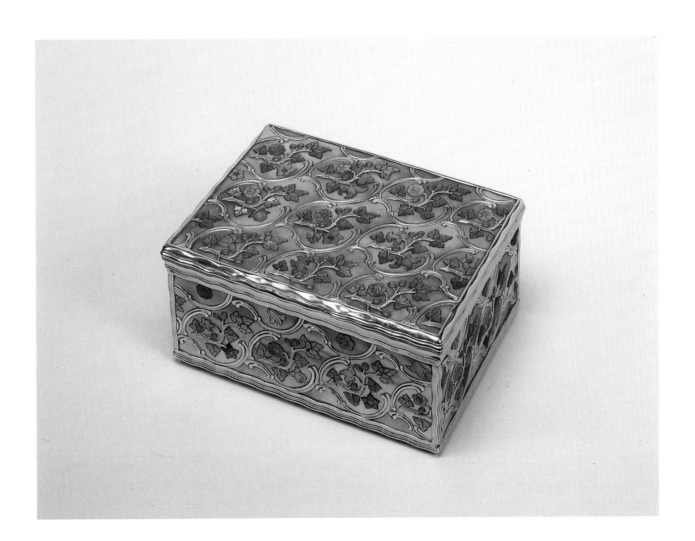

44 Snuff-box

Rectangular snuff-box comprised of six panels of gold engraved with swirling lines and encrusted with flowers and foliage in mother-of-pearl and shell, mounted *à cage* in gold chased with undulating parallel lines. The interior of the lid is set with a miniature in enamel under glass of a lady facing to the right, in the manner of C. F. Zincke (wavy bezel).

Dimensions
Height: 3.7 cm; length: 7.8 cm; depth: 6 cm

Provenance
Sotheby's, London, 29 April 1969, lot 132
K 132

Marks

On the right-hand bezel, in the lid and in the base
1 Partially erased maker's mark of a Paris goldsmith, probably that of Pierre-Aymé Joubert, goldsmith registered in Paris, 26 September 1735 until 23 December 1763[1]
2 Charge mark of the *sous-fermier* Antoine Leschaudel, 13 October 1744 until 9 October 1750[2]
3 Wardens' mark for Paris, 6 July 1744 until 26 November 1745[3]

On the left-hand rim of the lid
4 Discharge mark of the *sous-fermier* Antoine Leschaudel, 1744–50[4]

French, Paris, July 1744 until 9 October 1750, probably by Pierre-Aymé Joubert

For biographical details of Joubert, see cat. no. 43.

The existence of a very similar gold and mother-of-pearl box bearing the mark of Jean-François Breton and dated 1745,[5] suggests that the panels comprised in this box were the work of an independent craftsman from whom goldsmiths acquired pieces to mount in their own cagework. Furthermore, a box in the Metropolitan Museum, New York,[6] with engraved gold plaques encrusted with mother-of-pearl in a comparable style, and bearing the signature of Daniel Baudesson of Berlin raises the possibility that these plaques were made outside France, possibly in Germany, and imported for setting.

There are several designs in the Victoria and Albert Museum, London, for boxes decorated with flowers and foliage against an engraved scrolling ground,[7] but it is unclear from the drawings whether these are intended to be produced in coloured gold, enamels or mother-of-pearl (fig 1).

The similarity of the construction of this box and the chasing of the cagework to cat. no. 43 which clearly bears the mark of Pierre-Aymé Joubert should be noted since it may add weight to the attribution of the present box to this goldsmith.

The enamel portrait in the lid of a lady almost full face, with short curled hair wearing a white dress by Zincke is strikingly similar to that of a member of the Booth family,[8] and is probably contemporary with the box.

Christian Friedrich Zincke was born in Dresden in 1684 but moved to England in 1706 where he established a reputation as the leading enamel painter of the day.[9] André Rouquet said of him that 'never was there a man before him, that managed the enamel with such ease', and in discussing the difficulties of working in that medium stated 'But such an able artist as Mr Zincke, knows how to break those fetters by which genius is confined . . . [He] has likewise been master of particular materials, without which his portraits would never have had that freedom, that freshness, and that strength, which renders them so natural, and which constitutes the principal merits of his works'.[10] He died in 1767.

Notes
1 Nocq II, pp 360–61
2 Nocq IV, p 234
3 Nocq IV, p 216
4 Nocq IV, p 234
5 Berry Hill, p 36, ill. 14
6 Snowman (1966) figs 57 and 58
7 Inv. no. E 288–1938
8 Sotheby's, London, 24 February 1969, lot 116. I am grateful to Mr John Murdoch, of the Department of Prints and Drawings, Victoria and Albert Museum, for drawing this portrait to my attention
9 J. W. Bradby, *Dictionary of Miniaturists* II (London, 1898)
10 Rouquet, pp 54–56

ILLUSTRATION
1 *Design for the lid of a snuff-box, possibly of gold encrusted with mother-of-pearl, pen and ink with body colour, French, circa 1745 (Victoria and Albert Museum, London)*

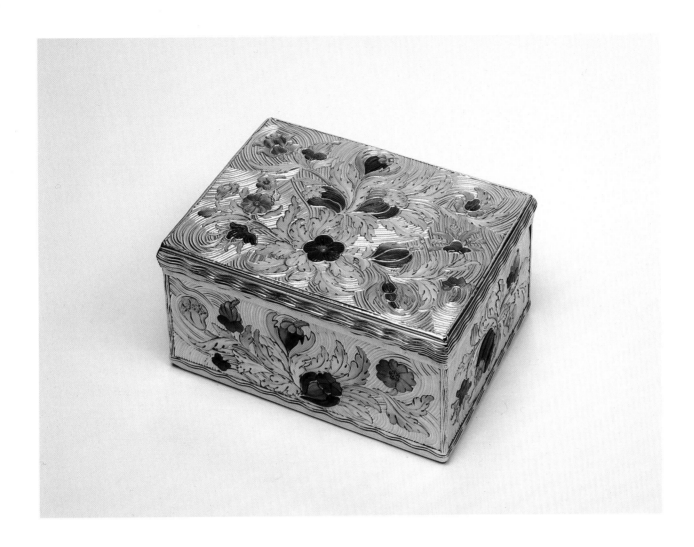

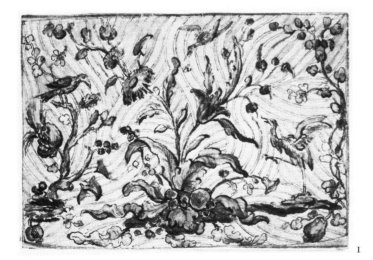

Interior of the lid

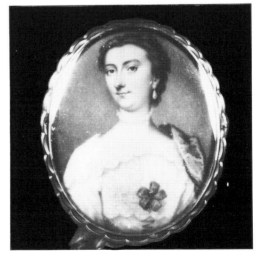

45 Snuff-box

Rectangular box of gold with six panels of engraved mother-of-pearl, shell and turquoise in gold settings, depicting fruit, flowers and foliage, and architectural caprices, bordered on all sides by a cagework of gold chased with undulating lines (wavy bezel).

Dimensions
Height: 3.4 cm; length: 8 cm; depth: 6.1 cm

Provenance
J. Kugel, Paris, 1968
K I 3 I B

Marks

In the lid and in the base
1 Partially erased mark of a Paris goldsmith, comprising a crowned fleur de lis and one *grain de remède* over an initial

On the right-hand side of the lid
2 Discharge mark of the *sous-fermier* Antoine Leschaudel, 13 October 1744 until 9 October 1750[1]

French, Paris, 13 October 1744 until 9 October 1750

1 2

The mounts used for the cagework of this box are of a pattern frequently used by a number of Parisian goldsmiths around the middle of the eighteenth century. A box by Noël Hardivilliers in the collection of Baron Elie de Rothschild dating from 1743–44,[2] another by Charles Le Bastier in the Metropolitan Museum, New York (Wrightsman Collection),[3] and a third by Pierre-Aymé Joubert (cat. no. 44) both dating from the following year and a box by Jean-Marie Tiron in the collection of Messrs Wartski, London, dated 1757,[4] bear almost identical mounts. Although the mounts are typically Parisian, the same cannot be said for the panels which make up the box. The rather chaotic ornament consisting of a marquetry of shells and stone suggests that the panels may have been imported into France possibly from Germany. A box set with similar panels bearing the Paris marks for 1744 to 1750 was in the collection of René Fribourg[5] and another belonged to Baron de Redé or Baron Guy de Rothschild.[6] The latter example was apparently unmarked which suggests that it was not of French origin.

Notes
1 Nocq IV, p 234
2 Snowman (1966) pls 171–73
3 Watson, p 117
4 Snowman (1974) p 67
5 Sotheby's, 14 October 1963, lot 321
6 Sotheby's, Monte Carlo, 25 May 1975, lot 44

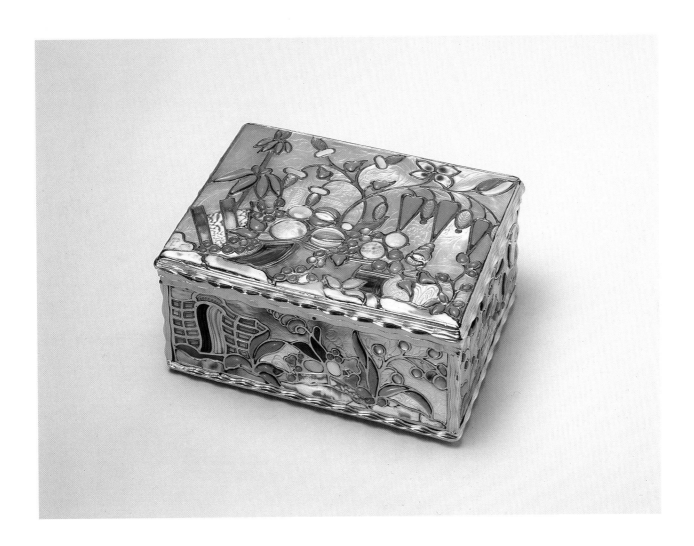

46 Snuff-box

Rectangular gold snuff-box with shaped sides, of bombé form, with chased and engraved borders to the lid, and an applied gold 'ribbon' around the lower part of the walls. The lid is engraved with a coat-of-arms as follows: in the first quarter, the chains of Navarre; in the second quarter, quarterly first and fourth azure three fleurs de lis or, second and third gules, for Albret (?); in the third quarter, ermine for Brittany (?); and in the fourth quarter, pallets gules for Aragon (?); overall on an escutcheon of pretence, a lion rampant.

Dimensions
Height: 2.9 cm; length: 6.4 cm; depth: 5.1 cm

Provenance
J. Ortiz-Patiño Collection, sold Christie's, 27 November 1973, lot 9
K 132 F

Marks

In the lid, in the base and in the front wall
1 Maker's mark of Philippe-Antoine Magimel, goldsmith registered in Paris, 8 March 1721 until 1772[1]
2 Charge mark of the *sous-fermier* Antoine Leschaudel, 13 October 1744 until 9 October 1750[2]
3 Wardens' mark for Paris, 27 November 1745 until 27 November 1746[3]

On the right-hand side of the bezel
4 Discharge mark of the *sous-fermier* Antoine Leschaudel, 1744–50[4]

French, Paris, 27 November 1745 until 9 October 1750, by Philippe-Antoine Magimel

This is the only gold box recorded by Philippe-Antoine Magimel, a distinguished goldsmith, who registered his mark on 8 March 1721, and was a *garde* in the *corporation* on three occasions (1736–37, 1737–38 and 1751–52). His address at his registration was the rue de Gèsvres, parish of St Jacques le Boucherie. By 1748, he had moved onto the pont Notre-Dame but had moved again to the quai Pelletier by 1756, where he remained until his death. He was elected Consul in 1759 and in 1760 was one of the officers of the guild entitled to melt down goods seized by the *gardes*.[5] He was said to have had some work of Daniel Gouers in his workshop when Gouers filed for bankruptcy in 1736.[6]

The arms have been identified as those of Jules Hercules, prince et duc de Rohan, duc de Montbazon et prince de Guemené, Pair de France,[7] but since they lack the *macles d'or* which appear on all Rohan arms in the eighteenth century, this is unlikely. Indeed, the pristine condition of the engraving of the arms is in marked contrast to the very rubbed borders of the box and it is therefore probable that they are a recent embellishment.

Notes
1 Nocq III, p 173
2 Nocq IV, pp 234–35
3 Nocq IV, p 216
4 Nocq IV, pp 234–35
5 Nocq III, p 173
6 Nocq II, p 273
7 Snowman (1974), no. 13

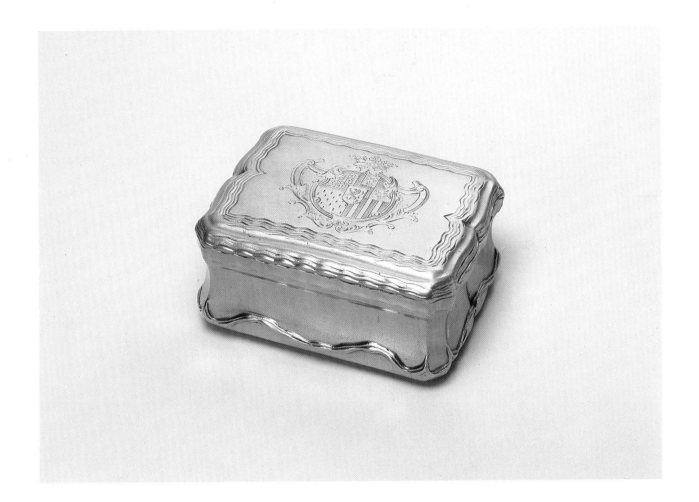

47 Snuff-box

Rectangular gold box, with slightly bombé sides, of gold chased with a diaper pattern of wavy lines, the reserves between which are enamelled with flowers in relief in opaque colours supported by engraved gold leaves and stems against translucent green enamel over a hatched ground, and the junctions of which are marked by an opaque pink and white enamelled quatrefoil. The rim of the lid is engraved with alternating flowers and leaves on a wavy ground (straight bezel).

Dimensions
Height: 3 cm; length: 7.2 cm; depth: 5.3 cm

Provenance
Sir Esmond Durlacher Collection
J. Ortiz-Patiño Collection, sold Christie's, 27 June 1973, lot 13
K160D

Marks

In the base
1 Almost wholly erased mark of a Paris goldsmith, comprising a crowned fleur de lis and two *grains de remède*
2 Charge mark of the *sous-fermier* Antoine Leschaudel, 13 October 1744 until 9 October 1780[1]
3 Wardens' mark for Paris, 14 October 1747 until 12 August 1748[2]

In the lid and inside the right-hand wall 2 *and* 3

On the right-hand side of the bezel
4 Discharge mark of the *sous-fermier* Antoine Leschaudel, 1744–50[3]
5 Restricted warranty mark for Paris for gold, since 10 May 1838[4]
6 Mark for Sweden, 1753–1912[5]
7 Standard mark for Sweden for 20-carat gold[6]
8 Mark of Frantz Bergs, goldsmith registered in Stockholm, 1725–*circa* 1777[7]

French, Paris, 14 October 1747 until 9 October 1750, possibly enamelled by Louis-François Aubert

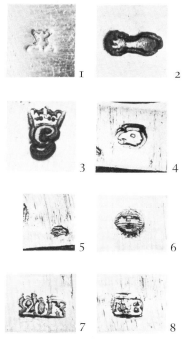

The style of enamelling on this box, and on the two following examples, may be tentatively attributed to the goldsmith and enameller Louis-François Aubert (see p31 above). Aubert's style was clearly recognised by his contemporaries, yet only one enamel which, it must be admitted, is quite unlike the present example, is known to bear his signature (Introduction, fig 16).[8] The accounts of the Menus Plaisirs mention at least two boxes by Aubert. One 'emaillée par Aubert, à fleurs de relief fond mat à mosaique et bordure d'or polie' was supplied by Jean Ducrolley in 1751, and another 'emaillée à fleurs peintes par Aubert' was delivered by La Hoguette two years later.[9] Lazare Duvaux sold Mme de Pompadour a *piqué* box with gold mounts 'emaillé de rose par Aubert' in April 1754[10] and the Marquise possessed two further examples of his work at her death in 1764. One box is described as simply enamelled by Aubert, but the other is 'emaillée à fleur en relief par Aubert'.[11] So far as the author is aware, no other enameller is credited with painting flowers in relief in the mid eighteenth century. Therefore, it is not unreasonable to assume that boxes decorated in this manner and dating from 9 January 1748 when Aubert attained the *maîtrise* until 20 October 1755, when he died, may be from Louis-François Aubert's workshop.[12]

There is, however, a box by Jean Frémin, dated 1756–57, in the Metropolitan

Notes
1 Nocq IV, p234
2 Nocq IV, p216
3 Nocq IV, p234
4 Carré, p208
5 Andrén, p27
6 Andrén, p28
7 Andrén, p104
8 Christie's, London, 23 June 1981, lot 130
9 Maze-Sencier, pp153–54
10 Courajod II, p197
11 Cordey, pp197–98
12 Nocq I, p23

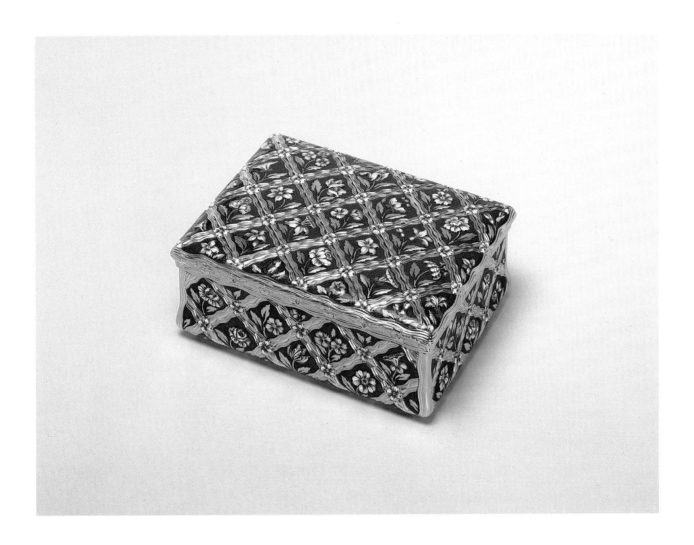

Notes

13 Watson, p 152
14 Emile Molinier, *Dictionnaire des Emailleurs* (Paris, 1885) p 10
15 Nocq I, p 24
16 Maze-Sencier, p 157
17 J. Guiffrey, 'Liste de Scellés d'Artistes et d'Artisans', *Nouvelles Archives de l'Arte Français* 2ᵉ serie, v (Paris, 1884); see also Introduction, p 32
18 Nocq I, p 23

Additional bibliography
Nortons, pl. 3B
Snowman (1974) no. 15

Museum, New York (Wrightsman Collection), which appears to have been enamelled by the same hand. Sir Francis Watson consequently dismissed the attribution of this group to L.-F. Aubert, but suggests that it might be the work of another of the same surname.[13] He sites Molinier who mentions an Aubert working in 1754 (not 1756 as stated by Watson) and 1771.[14] This appears to be a confusion between Louis-François Aubert who was working at the earlier date and Ange-Joseph Aubert, *joaillier du Roi* who worked from 1762 until 1775[15] and who supplied the *corbeille de marriage* of the comtesse d'Artois in 1774.[16] However, L.-F. Aubert's widow, Marie-Antoinette Rapillard du Clos, retrieved several pieces of gold and enamel, all unfinished work, from the apartment of her late husband which was sealed at his death, thus providing evidence that she or her workshop was prepared to continue working.[17] Even the sale of L.-F. Aubert's enamels and mixtures for making enamels on 24 November 1755 does not necessarily mean that the workshop, or Veuve Aubert, ceased production at that date.[18] However, the author is unaware of any box with enamel in this style which dates after 1758, when Veuve Aubert herself died.

It is clear from the marks on this box that it was imported into Sweden by Frantz Bergs, the famous Stockholm goldsmith, between 1753 and about 1777.

48 Snuff-box

Rectangular snuff-box of gold each surface of which is chased with a cartouche, containing sprays of flowers in relief, enamelled in opaque pink, blue and yellow with stems and leaves of translucent green *basse-taille* enamel and a diaper engraved ground, bordered by further sprays, similarly enamelled, with engraved gold stems and leaves, all on a ground of translucent green enamel over a hatched ground. The rim of the lid is chased with alternate upward and downward gadroons on a wavy ground. The rim of the base is chased as slightly undulating rods bound with ribbons (straight bezel).

Dimensions
Height: 3.5 cm; length: 7.1 cm; depth: 5.4 cm

Provenance
Sotheby's, London, 12 December 1966, lot 111
K139A

Marks

In the base
1 Maker's mark of Jean Moynat, goldsmith registered in Paris, 5 October 1745 until 12 December 1761[1]
2 Charge mark of the *sous-fermier* Antoine Leschaudel, 13 October 1744 until 9 October 1750[2]
3 Wardens' mark for Paris, 13 August 1748 until 17 July 1749[3]

In the right-hand wall and in the lid 2 and 3

On the right-hand side of the bezel
4 Discharge mark of the *sous-fermier* Antoine Leschaudel, 1744–50[4]
5 Paris mark for gold and silver imported from countries without customs conventions, 1864–93, with anvil marks beneath[5]

On the front of the bezel
6 Prussian tax-exemption mark for 1809[6]

French, Paris, 13 August 1748 until 9 October 1750, by Jean Moynat, possibly enamelled by Louis-François Aubert

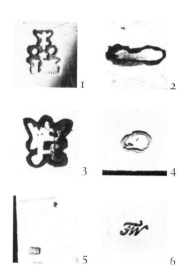

Jean Moynat became master on 5 October 1745 when he struck the mark, a fleur de lis crowned, two *grains de remède*, JM and a star. His address was given as rue de Harley, in the parish of St Barthélemy. In 1747, he was found to be in possession of two substandard bases for the linings of snuff-boxes, which were confiscated by the guild. He moved to the place Dauphine the following year, where he remained until 1752 or '53. In 1754, when he provided the *caution* for the famous gold box maker Charles le Bastier, his address was in the rue St Louis but by December 1759, he had moved to the pont St Michel. He died in 1761.[7]

It is clear from the boxes bearing the mark of Jean Moynat that he favoured the enameller of the present example. A box of 1747–49 is in the Metropolitan Museum, New York,[8] and another of 1749–50 was in the collection of René Fribourg.[9]

The style of enamelling of this box is tentatively attributed to Louis-François Aubert (see pp 31 and 32 and cat. nos 47 and 49). A.K. Snowman mentions a connection between Jean Moynat and an enameller 'Auber' and says that they have come to be linked with beautifully enamelled flower motifs.[10] A box which appears to be of a similar description 'une boîte d'or emaillée par Aubert, à fleurs de relief, fond mat à mosaique et bordure d'or polie' was supplied to the Menus Plaisirs by Jean Ducrolley in 1751.[11]

Notes
1 Nocq III, p 270
2 Nocq IV, p 234
3 Nocq IV, p 216
4 Nocq IV, p 234
5 Carré, p 213
6 Rosenberg III, no. 4422
7 Nocq III, p 270
8 Snowman (1966) fig 219
9 Sotheby's, 14 October 1963, lot 332
10 Snowman (1966) p 74
11 Maze-Sencier, p 153

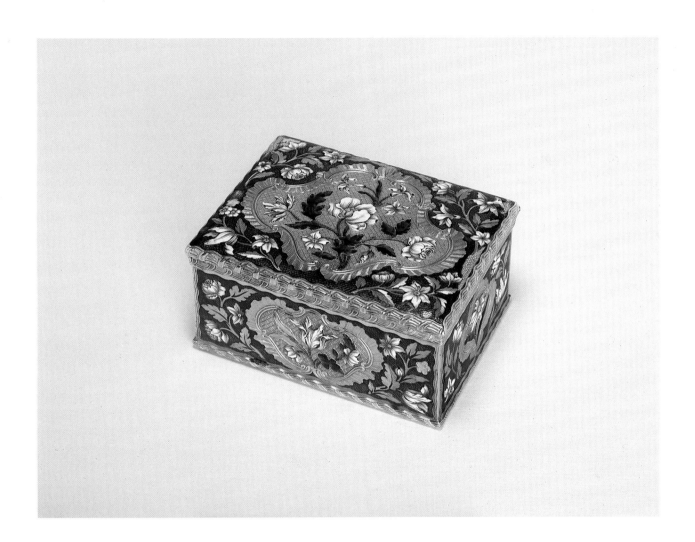

49 Snuff-box

Rectangular gold box, with six cartouches bordered by flowers in relief enamelled in opaque colours with leaves of translucent green over an engraved ground, containing on the lid and base peasants smoking and drinking probably after David Teniers the Younger, on the front and back, a hurdy-gurdy player and his companion, and two travellers resting, and on the sides, a dog and a goat, all chased in relief against a striated background (wavy bezel).

Dimensions
Height: 3.4 cm; length: 8.1 cm; depth: 6.2 cm

Provenance
Seligmann Collection, sold Georges Petit, Paris, 10 March 1914, lot 198
Sotheby's, London, 12 December 1966, lot 111
K160A

Marks

In the lid and in the front wall
1 Partially erased mark of a Paris goldsmith, comprising a crowned fleur de lis, two *grains de remède*, and two initials, presumably with a device between
2 Charge mark of the *sous-fermier* Antoine Leschaudel, 13 October 1744 until 9 October 1750[1]
3 Wardens' mark for Paris, 13 August 1748 until 17 July 1749[2]

In the base 2 and 3

On the right-hand side of the bezel
4 Discharge mark of the *sous-fermier* Antoine Leschaudel, 1744–50[3]
5 Unidentified mark, probably a countermark
6 Restricted warranty mark for Paris for gold, since 10 May 1838, struck twice[4]

French, Paris, 13 August 1748 until 9 October 1750, possibly enamelled by Louis-François Aubert

The mark of the goldsmith on this box has been attributed to Pierre-François Delafons, registered in Paris, 6 December 1732 until 1787. He struck the mark, a crowned fleur de lis, two *grains de remède*, PD and a helmet in profile.[5] However, the mark is too indistinct for a precise attribution to be made.

The vogue for Flemish paintings gradually increased during the eighteenth century,[6] and, indeed, continued into the following century, although it was more or less eclipsed by the taste for Neo-Classicism. Jean-Baptiste Descamps suggested that the War of the Austrian Succession, during which French troops had been stationed in the low countries, was the cause of the fashion. Be that as it may, in 1727 Dezallier d'Argenville recommended collectors to acquire Flemish or French paintings, with some Italian work, which was in marked contrast to the collecting habits of the French *amateur* in the reign of Louis XIV. In his introduction to the catalogue of the Quentin de L'Orangère Collection in 1744, the dealer Gersaint announced that 'l'école flamande . . . est ici fort à la mode'. So popular were the Flemish masters that a great collector such as the duc de Choiseul possessed in 1770 no less than ten Wouwermans, eight Rembrandts, seven Teniers, six Berghems, five Terborchs, five Metsus and many others.

The exact source for the reliefs on the present box have not been traced, but are presumably taken from engravings after David Teniers the Younger. The figures to the left of centre of the scene on the lid, for example, appear in a painting attributed to Teniers formerly in the collection of Professor Pozzi of London (1928).[7]

The style of the enamelling, with flowers in relief, may be attributed to Louis-François Aubert (see cat. nos 47, 48 and pp 31–32).

Notes
1 Nocq IV, p 234
2 Nocq IV, p 216
3 Nocq IV, p 234
4 Carré, p 208
5 Nocq II, p 35
6 F. J. B. Watson, *The Choiseul Box* (Oxford, 1963) discusses both this fashion and the paintings in the duc de Choiseul's collection at length
7 Photograph in the Department of Prints and Drawings, British Museum

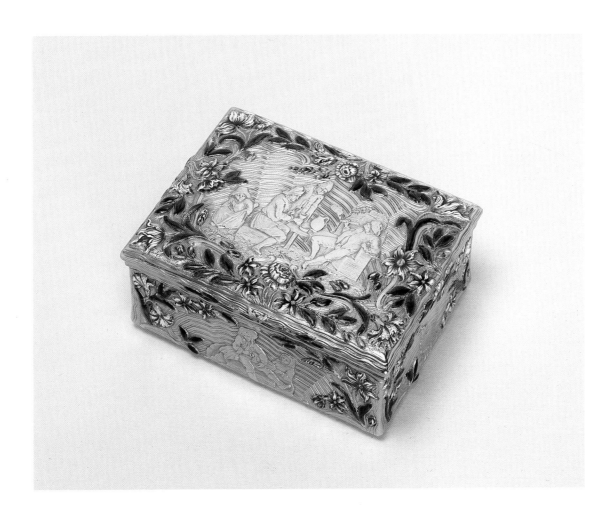

50 Snuff-box

Rectangular gold box chased and engraved with sprays of flowers on a matted ground in reserves formed between undulating lines (straight bezel).

Dimensions
Height: 3.5 cm; length: 8 cm; depth: 5.9 cm

Provenance
J. Ortiz-Patiño Collection, sold Christie's, 27 June 1973, lot 7
K 160B

Marks

In the lid, in the base and in the left-hand wall
1 Maker's mark of Georges-Joseph Jacquelart, goldsmith registered in Paris, 28 January 1747 until 8 March 1763[1]
2 Charge mark of the *sous-fermier* Antoine Leschaudel, 13 October 1744 until 9 October 1750[2]
3 Wardens' mark for Paris, 18 July 1749 until 15 July 1750[3]

On the left-hand side of the bezel
4 Discharge of the *sous-fermier* Antoine Leschaudel, 1744–50[4]
5 Dutch mark for old work, 1814–1953[5]

On the right-hand side of the bezel
6 French mark for gold imported from countries without customs conventions, since 1864[6]

French, Paris, 18 July 1749 until 5 October 1750, by Georges-Joseph Jacquelart

1 2

3 4

5 6

Georges-Joseph Jacquelart became one of the few *orfèvres privilegiés*, that is to say, a member of the small group of goldsmiths appointed master by the court in excess of the limit of 300 masters maintained by the guild. He struck his mark, a crowned fleur de lis, GJ, a club and the two *grains de remède*, on 28 January 1747. In the same year, an enamelled gold snuff-box which had been seized by the *gardes* of the guild was returned to him, presumably because it was of the correct standard and properly marked. In 1753, when he lived on the pont Notre-Dame, he advertised for the return of a lady's gold box. It is clear from the *Avant-Coureur* of 14 April 1760, that his stock in trade was the manufacture of silver plates, embellished in gold which sold for 1200 livres each. He died in the faubourg St Martin on 8 March 1763.[7]

According to the *Encyclopédie*, boxes wholly of gold were known as *tabatières pleines*.[8]

Notes
1 Nocq II, p348
2 Nocq IV, p234
3 Nocq IV, p216
4 Nocq IV, p234
5 Voet, p45
6 Carré, p213
7 Nocq II, p348
8 *Encyclopédie* XV (Paris, 1765) p792

Additional bibliography
Snowman (1974), p47

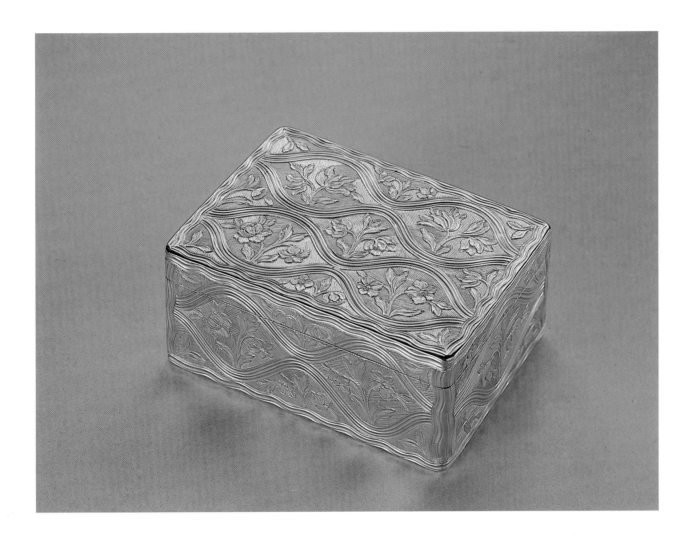

51 Snuff-box

Rectangular snuff-box of bloodstone panels inset with roundels of apricot-coloured agate in gold *cloisons* mounted *à cage* in gold chased with flowers on a matted gold ground. A small gold stud, possibly a later addition, serves as a thumbpiece.

Dimensions
Height: 4.1 cm; length: 8.1 cm; depth: 6 cm

Provenance
A la Vieille Russie, Geneva, 13 May 1966
K135

Marks

In the left-hand side of the bezel
1 Charge mark for the *sous-fermier* Antoine Leschaudel, 13 October 1744 until 9 October 1750[1]
2 Wardens' mark for Paris, 18 July 1749 until 15 July 1750[2]
On the right-hand side of the bezel
3 Discharge mark of the *sous-fermier* Antoine Leschaudel, 1744–50[3]
4 Countermark of the *fermier* Eloy Brichard, 14 October 1756 until 21 November 1762[4]
5 Unidentified mark, probably a countermark

French, Paris, 18 July 1749 until 9 October 1750

The panels of stone which make up this unusual box bear a close affinity to the *zellenmosaik* technique used in Dresden in the latter part of the eighteenth century. However, a fashion for stone boxes existed in France much earlier. The goldsmith Jean-François Ravechet apparently had a reputation for mosaic work in about 1740, and in 1736 Joaguet sold snuff-boxes of hardstone mounted in gold.[5] Madame de Pompadour bought six stone boxes from the dealer Lazare Duvaux between 14 November 1752 and 18 August 1753,[6] and she possessed at least eighteen at her death,[7] while the Dauphine Marie-Josèphe owned fourteen stone and gold boxes when she died in 1767.[8]

Notes
1 Nocq IV, p 234
2 Nocq IV, p 216
3 Nocq IV, p 234
4 Nocq IV, p 236
5 Maze-Sencier, p 149
6 Courajod, nos 1255, 1270, 1304, 1373, 1489
7 Cordey, nos 2385–2401
8 Bapst (1883) pp 137–38

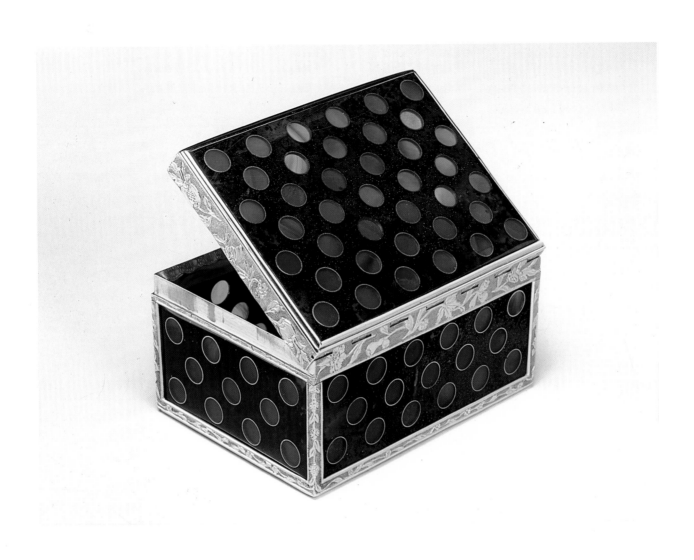

52 Snuff-box

Rectangular snuff-box comprising six panels of late seventeenth-century Japanese *hiramaki-e* lacquer, with, on the lid, plum blossom and pines and, on the remaining surfaces *doha* (literally 'waves of land'), mounted *à cage* in ribbed gold mounts, with a scrolled projecting thumbpiece. The unlined interior is lacquer red (straight bezel).

Dimensions
Height: 4 cm; length: 8.1 cm; depth: 7.4 cm

Provenance
Christie's, Geneva, 19 November 1970, lot 72
Zervudachi, Vevey, 1976
K203C

Marks

On the right-hand side of the bezel
1 Part of the maker's mark of an unidentified goldsmith
2 Partially erased charge mark of the *sous-fermier* Julien Berthe, 10 October 1750 until 13 October 1756[1]
3 Almost wholly erased mark, presumably the Paris wardens' mark

On the right-hand rim of the lid
4 Discharge mark of the *sous-fermier* Julien Berthe, 1750–56[2]
5 Countermark of the *fermier* Eloy Brichard, 14 October 1756 until 21 November 1762[3]
6 Restricted warranty mark for Paris for gold, since 10 May 1838, struck twice[4]

French, Paris, 10 October 1750 until 13 October 1756

Sir Francis Watson has demonstrated the increased popularity of lacquer from the middle of the eighteenth century,[5] and boxes in the Thyssen-Bornemisza Collection appear to confirm this. The *marchand-mercier* Gersaint, who prepared the introduction to the sale of the great collection of the chevalier Antoine de la Rocque in 1745, was the leading dealer in lacquer at this time. However, Lazare Duvaux sold panels of lacquer to goldsmiths for mounting (see cat. no. 53) as well as selling lacquer snuff-boxes, fifteen of which are mentioned in his day book between December 1750 and June 1758. Mme de Pompadour possessed seventeen lacquer boxes at her death in 1764,[6] and the Dauphine Marie-Josèphe owned four in 1767.[7] So popular was the taste for oriental lacquer during the second half of the eighteenth century that, as Watson has noted, there was a marked increase in the prices paid in 1745 and those raised at the auction of the collection of the duchesse de Mazarin in 1781.

Notes
1 Nocq IV, p235
2 Nocq IV, p235
3 Nocq IV, pp235–36
4 Carré, p208
5 F.J.B. Watson, 'Beckford, Mme de Pompadour, the duc de Bouillon and the taste for Japanese lacquer in Eighteenth century France', *Gazette des Beaux Arts* LXI (February 1963)
6 Cordey, p198ff
7 Bapst (1883) p138

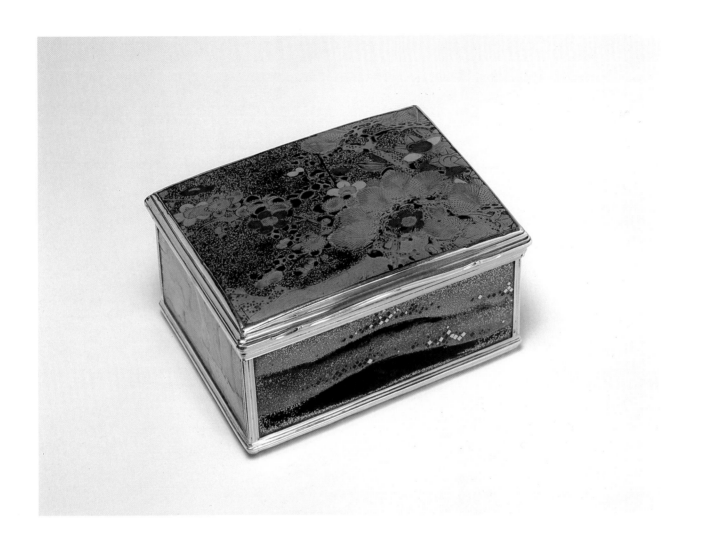

53 Snuff-box

Rectangular snuff-box of six panels of late seventeeth- or early eighteenth-century Japanese lacquer depicting, on the larger panels, Paulownia (*Kiri*) branches and at either end, stylised ginger (*myōga*) mounted *à cage* in gold chased with flowers and leaves on a matted ground and lined with gold (wavy bezel).

Dimensions
Height: 4.8 cm; length: 7.8 cm; depth: 3.8 cm

Provenance
Mrs C. K. Prestige Collection, sold Sotheby's, London, 27 May 1968, lot 49
J. Ortiz-Patiño Collection, sold Christie's, 27 November 1973, lot 15
K 171 B

Marks

In the lid, in the base and in the right-hand wall and on the left-hand side of the bezel
1 Maker's mark of Jean Ducrollay, goldsmith registered in Paris, 26 July 1734 until after 14 April 1760[1]
2 Charge mark of the *sous-fermier* Julien Berthe, 10 October 1750 until 13 October 1756[2]
3 Wardens' mark for Paris, 15 July 1750 until 14 July 1751[3]

On the right-hand side of the lid
4 Discharge mark of the *sous-fermier* Julien Berthe, 1750–56[4]

French, Paris, 10 October 1750 until 13 October 1756, by Jean Ducrollay

Jean Ducrollay is amongst the most esteemed of Paris gold box makers. Born in 1709, Ducrollay was apprenticed to Jean Drais at the age of thirteen. On 26 July 1734 he struck the mark, a crowned fleur de lis, two *grains de remède*, JD and a heart. His address was given as rue Lamoignon where he remained until before 14 August 1748 by which time he had moved to the place Dauphine. He stayed at this address until at least 14 April 1760.[5] The name Ducrollay appears as the supplier of a snuff-box 'emaillée par Aubert, à fleurs de relief, fond à mosaique et bordure d'or polie, 2,184 livres' and another 'à fleurs emaillées de relief' at the same price to the Menus Plaisirs in 1751,[6] and the Registres des Presents du Roi record 'une tabatière d'or, de chez Ducrollay, emaillée, gravée à fleurs, garnie de diamants, du rubis, d'emeraudes, et du portrait du Roi, peint én email par Rouquet', which was given to Count Stahremberg on 16 April 1757. A similar piece was given to the Polish commander-in-chief and Prince Lobkovitz received a *boite à portrait* by Ducrollay on the same occasion.[7] These documents do not specify whether they refer to Jean Ducrollay, or Jean-Charles Ducrollay, also of the place Dauphine. However, the number of boxes bearing the mark JD and a heart which date from the 1750s suggests that the goldsmith in question was indeed Jean Ducrollay, the maker of the mounts on this box.

It is clear from the number of boxes which survive and from the entries in the *Livre Journal* of Lazare Duvaux that providing mounts for lacquer panels was Jean Ducrollay's speciality. Between 22 and 24 December 1751, he bought from Duvaux 'Deux boetes de lacq fond noir et or, à feuillage, de 96 livres'[8] and on 4 October 1752, he purchased another box similarly described for 144 livres.[9] It is tempting to suggest that it was one of these boxes which was cut up to form the panels used in the present box.

Notes
1 Nocq II, p 110
2 Nocq IV, p 235
3 Nocq IV, p 216
4 Nocq IV, p 235
5 Nocq II, p 110
6 Maze-Sencier, p 153
7 Maze-Sencier, pp 174–75
8 Courajod, no. 986
9 Courajod, no. 1225

Additional bibliography
Snowman (1974)

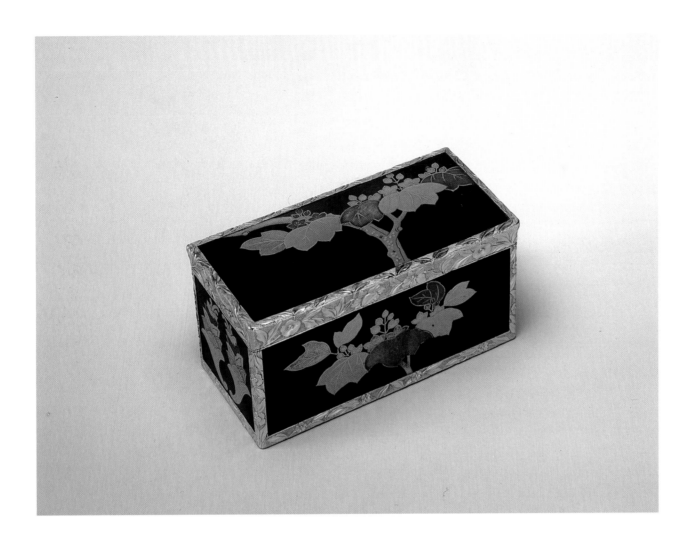

54 Nécessaire

Square Japanese lacquer box, lined with red silk braided in gold and containing four bottles and two flasks of rock crystal mounted in gold enamelled with opaque pink flowers with translucent green leaves, with stoppers of copper-gilt surmounted by a shallow gold dome wreathed with opaque pink flowers and translucent green leaves supporting handles formed of double cartouches of gold enamelled with opaque pink and white roses, with green leaves, at the centre. A rock crystal funnel and cup, both mounted in gold, and a gold spoon enamelled over a diaper ground en suite with the bottles, complete the *nécessaire*.

Dimensions
CASE height: 18 cm; length: 23.5 cm; depth: 21.4 cm
BOTTLES height: 13.5 cm; width: 4.8 cm; depth: 4.8 cm
FLASKS height: 13.5 cm; width: 5 cm; depth: 2.8 cm
FUNNEL height: 7.2 cm; diameter: 4.4 cm
SPOON length: 14.5 cm; width: 3.1 cm

Provenance
Russian Imperial Collections (Leningrader Museen und Schlosses Eremitage, Palais Michaeloff, Gatschina u.a.), sold Rudolph Lepke, Berlin, 6–7 November 1928, lot 265
David David-Weill Collection, sold Ms Ader et Picard, Palais Galliera, Paris, 4 June 1971, lot 69
A la Vieille Russie, New York, 22 November 1976
K 2001

Marks

On the spoon
1 Charge mark of the *sous-fermier* Julien Berthe, 10 October 1750 until 13 October 1756[1]
2 Discharge of the *sous-fermier* Julien Berthe, 1750–56 (except on no. D.W. 33/9–3)[2]
3 Tax mark for the town of Lemberg (Lwow, Poland), 1806–07[3]

On the bottles 2, 3 and
4 French mark for gold and silver imported from countries without customs conventions[4]
5 Paris mark for gold imported from countries without customs conventions, 1864–93[5]

French, Paris, 10 October 1750 until 13 October 1756

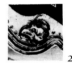

1
2
3
4
5

When this *nécessaire* was catalogued for sale in Paris in 1971, it was described as being by Jean Ducrollay. However, an exhaustive search has failed to reveal his mark and it can only be suggested that the Lemberg tax mark, containing the letter D was misread for that of the Paris goldsmith. The attribution was perpetuated when the *nécessaire* was exhibited in New York in 1974–75.[6]

A rock crystal scent bottle, dated 1750–51 with gold mounts enamelled by the same hand as the spoon and mounts on the bottles in the *nécessaire*, was exhibited by M. Hakim at the Burlington House Fair, London, 1982, and a box likewise enamelled and bearing the mark of Noël Hardivilliers is in the collection of S. J. Phillips, London.

Nécessaires such as this have a long history in France. One bought by Charles VI of France on 3 May 1387, from Henry de Grès appears in the *comtes de l'Argenterie*. The entry describes 'un estuy de cuir bouilli . . . pendant à un gros las de soie, garny de trois pignes, une broche et un mirroir, pour pigner le chief du dit Seigneur [the King], et baillé à Salomon, son barbier'. In the sixteenth century, the *comtes de depense* of François I show that he owned another of astonishing richness. This was supplied by the goldsmith Jehan Cousin l'aîné and comprised an ebony box containing a mirror, three combs, a brush to clean them and a pair of scissors of gold engraved with arabesques and set with rubies and turquoises. On the lid was a clock whose cover was a large sapphire. The *nécessaire* also contained another small mirror of ebony, and three writing cases with quills mounted in silver-gilt, two of which were set with precious stones.

However, it was not until the early eighteenth century that these collections of

Notes
1 Nocq IV, p 235
2 Nocq IV, p 235. Each item is identified in paint with David-Weill catalogue numbers
3 Tardy, p. 329; Rosenberg IV, no. 7986
4 Carré, p 212
5 Carré, p 213
6 New York, Metropolitan Museum of Art, *The Grand Gallery*, 19 October 1974 – 5 January 1975

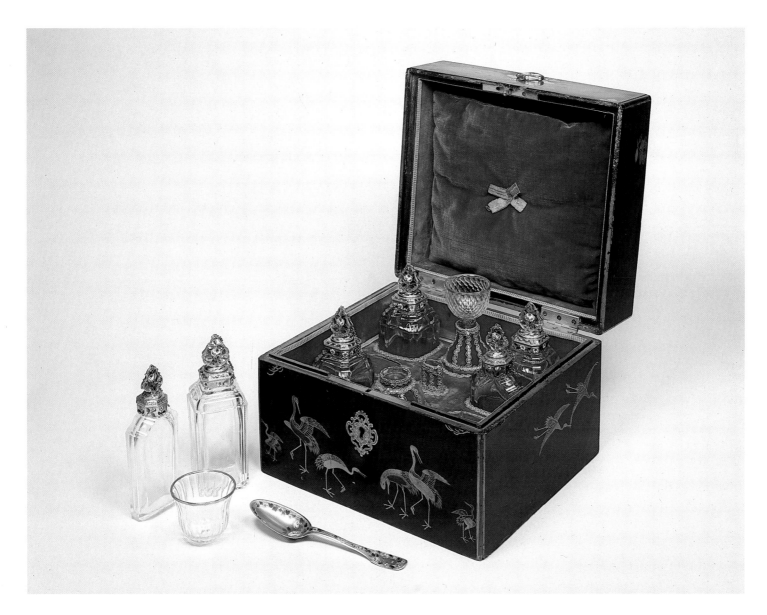

Notes

7 'My son [the Regent of France] has given his sister a *nécessaire*; that is a small square chest where all that is essential for taking tea, coffee and chocolate is found. The cups are white, the rest in enamelled gold'. Quoted in Havard III, col. 964–70

8 Courajod, no. 538

9 Courajod, no. 3097

10 Havard III, col. 964–70

necessities were referred to as '*nécessaires*'. In a letter dated 24 March 1718, the duchesse d'Orleans wrote, 'Mons fils a donné a sa soeur un nécessaire; c'est une petite caisse carré, où se trouve tout ce qu'il faut pour prendre le thé, le café, le chocolat, les tasses sont blanches, et tout ce qui ressort est or et émail'.[7] Such rich *nécessaires* enjoyed popularity throughout the eighteenth century. The *marchand-mercier* Lazare Duvaux furnished several to his distinguished clientele. On 18 June 1750, for example, he supplied M. Duflot with one which contained four rock crystal and gold flasks, a gold-mounted beaker, a funnel to fill the flasks, a box for soap and another for a sponge, a small gold brazier, a mirror, a tortoise-shell and gold comb, two razors with handles of mother-of-pearl *piqué* with gold, earpick and toothpick, tongue-scraper and tweezers, all in gold, and two eggs of rock crystal in gold mounts.[8] Not all the *nécessaires* which are mentioned in Duvaux's day book are as grand as this. One which was ordered by Louis XV as a gift to the duc d'Aumont on 7 April 1758, was in a walnut case lined with blue and silver cloth containing four cut-glass bottles with silver stoppers, a glass beaker, a *pot à pâte* and another pot for sponges, a tortoise-shell tongue-scraper and some sponges for the teeth. It cost 135 livres, with an additional three livres for the transport to Versailles.[9] Lazare Duvaux was also frequently required to remodel the interiors of *nécessaires* to take new fittings. In July 1774, the *Mercure de France* mentioned a *nécessaire* at Monsieur Granchez's shop au Petit Dunkerque and noted that it contained all that was necessary for eating at table as well as being especially useful for catering to the sick in bed.[10]

55 Snuff-box

Cylindrical gold snuff-box engraved all over in a diaper pattern and enamelled with
translucent maroon, green, yellow and blue flowers and leaves over engraved grounds; the
lid and the base with single sprays with wreaths, the walls divided into four reserves each
containing a single stem. Some enamel, particularly at the front of the box, has been
replaced with resin.

Dimensions
Height: 3.5 cm; diameter: 7.1 cm

Provenance
HRH the Duke of Cambridge Collection, sold Christie's, 18 June 1904, lot 343, bought
 A. Goldschmidt
Sidney J. Lamon Collection, sold Christie's, 28 November 1973, lot 32
K189C

Marks

In the lid and in the base
1 Maker's mark of Barnabé Sageret, goldsmith registered in Paris, 28 February 1731 until
 5 December 1758[1]
2 Charge mark of the *sous-fermier* Julien Berthe, 10 October 1750 until 13 October 1756[2]
3 Wardens' mark for Paris, 15 July 1750 until 14 July 1751 or 22 January 1752[3]

Inside the wall 3

On the left-hand side of the bezel
4 Discharge mark of the *sous-fermier* Julien Berthe, 1750–56[4]

French, Paris, 10 October 1750 until 13 October 1756, by Barnabé Sageret

1 2

3 4

Barnabé Sageret became a master goldsmith following Louis XV's permission for
the duc d'Orleans to have two goldsmiths in his household. He registered his mark,
a crowned fleur di lis, BS and as a device a knight's cross, with two *grains de remède*,
on 28 February 1731. In 1743, he incurred the displeasure of the *fourbisseurs*,
makers of sword mounts, who seized a sword guard which Sageret had sent to
Duplessis, and by him to Scot, for engraving and polishing, but the Court overruled
them and the piece was returned to Sageret. He died at the age of seventy on
5 December 1758.[5] It was probably his son, Charles Barnabé, who attained the
maîtrise in 1742, who supplied the Menus Plaisirs with a variety of boxes from
1756 until 1778, including those for the *corbeille de marriage* of the comtesse de
Provence in 1771.[6]

 The enamel on this box is clearly by the same hand as that on the *carnet* by
Jean Ducrollay of the same date, and on the box by Jean Frémin of 1752–53
(cat. nos 56 and 58) and the enamelled gold spy glass by Hubert Cheval also of
1750–51, at Waddesdon Manor (fig 1, cat. no. 56).[7] It is tempting to suggest that
this enamel is the work of Hubert Cheval's son, Hubert-Louis, who was also known
as Hubert Cheval de St Hubert, and was described as *orfèvre-emailleur* when he
made an inventory of the stock of Louis-François Aubert, following the latter's
death in 1755. Hubert-Louis Cheval became master in 1751 and continued work-
ing until the Revolution.[8] However, no description of his work survives and so any
attribution would be hypothetical to say the least.

Notes
1 Nocq IV, p 2
2 Nocq IV, p 235
3 Nocq IV, p 216
4 Nocq IV, p 235
5 Nocq IV, p 2
6 Maze-Sencier, pp 154–58
7 Waddesdon catalogue, no. 73
8 Nocq I, p 263

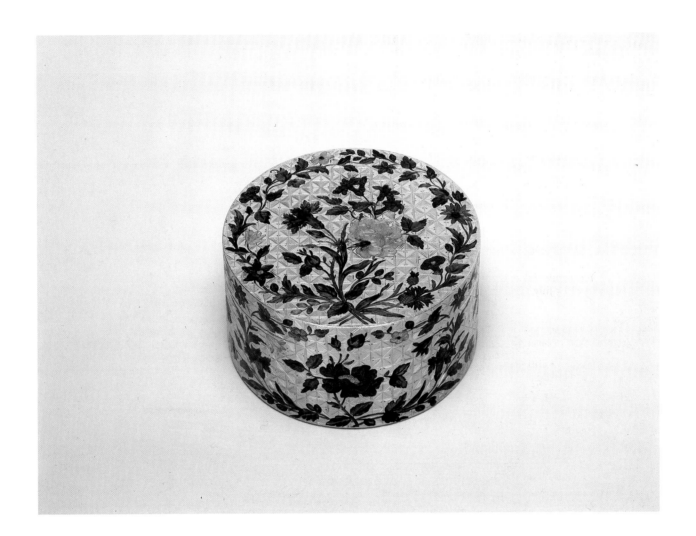

56 Carnet

Book cover (*carnet*) of gold enamelled *en basse-taille* with blue, green and yellow flowers and foliage against a ground engraved with a pattern of continuous chevrons. The reverse is decorated with the same design but in the opposite sense. The book cover is lined in salmon pink silk and contains a gilt-edged volume, bound in the same cloth, held in place by two split pins through the spine. A page of the volume bears a watermark dated 1746.

Dimensions
Length: 9.6 cm; width: 6.3 cm; depth: 1 cm

Provenance
Sidney J. Lamon Collection, sold Christie's, 28 November 1973, lot 15
K189B

Marks

Inside the spine
1 Maker's mark of Jean Ducrollay, goldsmith registered in Paris, 26 July 1734 until after 14 April 1760[1]
2 Charge mark of the *sous-fermier* Julien Berthe, 10 October 1750 until 13 October 1756[2]
3 Wardens' mark for Paris, 15 July 1750 until 14 July 1751 or 22 January 1752[3]

On the top of the spine
4 Discharge mark of the *sous-fermier* Julien Berthe, 1750–56[4]

French, Paris, 15 July 1750 until 13 October 1756, by Jean Ducrollay

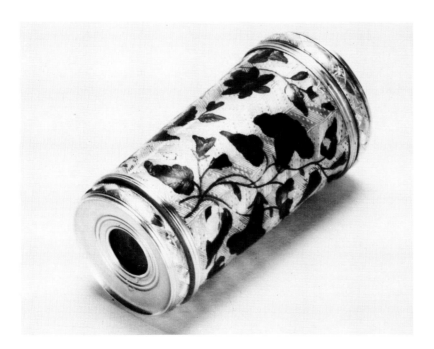

For biographical details of Ducrollay, see cat. no. 53.

The *basse-taille* enamel on this book cover uses the same pallette as that on the circular box by Barnabé Sageret, also with the wardens' mark for 1750–51 (cat. no. 55), and to the box by Jean Frémin, 1752–53 (cat. no. 58). The same enamel, combined with similar engraving of chevrons is found on a spy glass (*lorgnette*) at Waddesdon Manor by Hubert Cheval, made between 1750 and the goldsmith's death in 1751 (fig 1).[5] Indeed so close are the *carnet* and the *lorgnette* in decoration that it is tempting to suggest that they were intended to be used en suite. That two important goldsmiths could produce matching pieces such as these suggests the intervention of a *marchand-mercier*. An attribution of the enamelling to Hubert-Louis Cheval de St Hubert has been tentatively suggested above (p 190).

ILLUSTRATION
1 *Spy glass (lorgnette), engraved and enamelled gold, by Hubert Cheval, Paris, 1750–51 (National Trust, Waddesdon Manor)*

Notes
1 Nocq II, p 110
2 Nocq IV, p 235
3 Nocq IV, p 216
4 Nocq IV, p 235
5 Waddesdon catalogue, no. 73

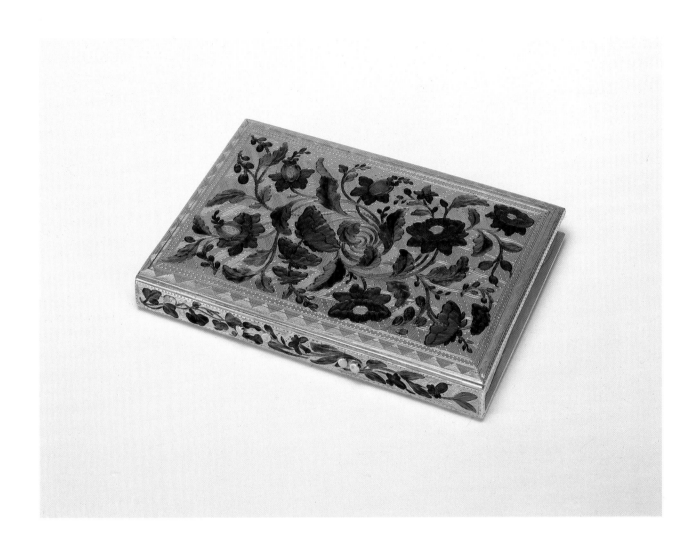

57 Snuff-box

Rectangular snuff-box of gold engraved with fans and Tao-ist symbols against a ground of translucent blue enamel over gold engraved with a continuous 'carpet' of feathers; the borders engraved as rods loosely bound with ribbon. Much of the enamel has been replaced by resin.

Dimensions
Height: 3.5 cm; length 7 cm; depth 5.3 cm

Provenance
M. Hakim, London 1971
J. Kugel, Paris, 7 October 1975
K 148 c

Marks

In the lid, in the base and in the front wall
1 Maker's mark of Nicholas Prévost, goldsmith registered in Paris, 10 March 1742 until 1790[1]
2 Charge mark of the *sous-fermier* Julien Berthe, 10 October 1750 until 13 October 1756[2]
3 Wardens' mark for Paris, 15 July 1751 or 22 January 1752 until 27 September 1752[3]

On the left-hand side of the bezel
4 Discharge mark of the *sous-fermier* Julien Berthe, 1750–56[4]

French, Paris, 15 July 1751 until 13 October 1756, by Nicholas Prévost

Nicholas Prévost was living on the pont au Change, in the parish of St Barthélemy when he struck his mark, a crowned fleur de lis, two *grains de remède*, N P and a pomegranite, on 10 March 1742. He remained at the same address until at least late 1759 but is then unrecorded until 6 July 1776 when his new address is given in rue de la Calandre, where he remained until 1782. From 1783 to 1785 published directories list Prévost in rue de la Pelleterie, in rue de Haut Moulin in 1786, rue du Monceau St Gervais in 1787, rue des Orfèvres in 1788 and rue de Sève in 1789 and 1790.[5]

This particularly striking box, the only box by Nicholas Prévost known to the author, bears unusually accurate imitations of Chinese lacquer. The symbols around the walls, which are repeated on their opposite sides, represent the fans carried by Zhongli Quan (ends) and the castanets of Cao Guoqiu (front and back).[6] Similar images appear around the borders of Chinese lacquer screens of the early eighteenth century, and the representations on this box are so close to the originals as to suggest that the engraver or perhaps even Prévost himself had seen a Chinese example probably in the shops of one of the *marchands-merciers* where such things were sold.

Notes
1 Nocq III, p 363
2 Nocq IV, p 235
3 Nocq IV, p 216
4 Nocq IV, p 235
5 Nocq III, p 363
6 I am grateful to Miss Rose Kerr and Miss Verity Wilson of the Far Eastern Department, Victoria and Albert Museum, for identifying these symbols

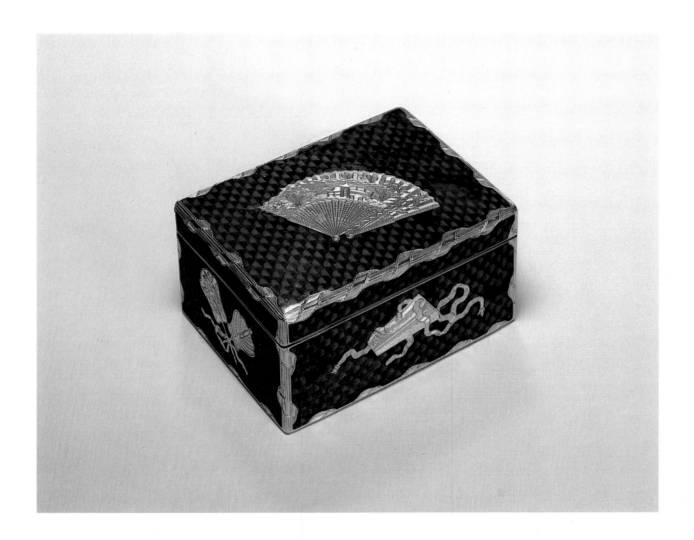

58 Snuff-box

Rectangular snuff-box of gold engraved over all with a diaper pattern, and enamelled with borders of flowers and leaves in green and blue translucent *basse-taille* enamel enclosed by undulating engraved lines surrounding sprays of flowers and leaves similarly enamelled.

Dimensions
Height: 3.7 cm; length: 8.2 cm; depth 6 cm

Provenance
Sotheby's, London, 17 December 1966, lot 188
K 140

Marks

 In the base
1 Partially struck maker's mark, probably that of Jean Frémin, goldsmith registered in Paris, 24 September 1738 until 24 January 1786[1]
2 Charge mark of the *sous-fermier* Julian Berthe, 10 October 1750 until 13 October 1756[2]
3 Wardens' mark for Paris, 27 September 1752 to 13 July 1753[3]

 In the lid and in the right-hand wall Part of 2 and 3

 On the left-hand bezel
4 Discharge mark of the *sous-fermier* Julian Berthe, 1750–56[4]
5 Restricted warranty mark for Paris for gold, since 10 May 1838, struck twice[5]

French, Paris, 27 September 1752 until 13 October 1756, probably by Jean Frémin

Jean Frémin, the son of a goldsmith, struck his mark, a crowned fleur de lis, two *grains de remède*, J F and an eagle's head, on 24 September 1743. He was sponsored by François-Nicolas Ilharart de Lachambre who was himself a maker of gold boxes. In 1743, his address was given as rue St Louis but five years later he had moved to the rue de l'Arbre Sec, and had moved once more by 1756 to the quai de l'Horloge. Further addresses are given as pont St Michel (1762), pont au Change (1766) where his shop was at the sign of la Reine de France, rue Hautefeuille (1781) and rue Censier from 1785. It is probable that he gave up as a practising goldsmith in 1783 when he is described as 'ancien orfèvre'. To judge from the inventory made when his property was sealed at his death, he made a comfortable living as a goldsmith. His apartment appears to have been well furnished, there was some silver flatware and cups in the silver chest, but the candlesticks in his bedroom were only plated.[6] Gold boxes by Jean Frémin are found in many public

ILLUSTRATION
1 *Snuff-box of gold, enamelled en basse-taille with flowers and leaves, unmarked, possibly made in Berlin circa 1760, formerly in the collection of Queen Charlotte (1744–1818), wife of George II (British Museum, London)*

Notes
1 Nocq II, pp 194–95
2 Nocq IV, p 235
3 Nocq IV, p 217
4 Nocq IV, p 235
5 Carré, p 208
6 Nocq II, pp 194–95

Notes

7 Waddesdon catalogue, no. 73

8 Christie's, 28 June 1972, lot 32

9 Nocq I, pp 263–64

10 Inv. no. 1873, 3–22, 3

and private collections in Europe and America, including the Metropolitan Museum, New York (Wrightsman Collection), the Louvre, Paris, and the Wallace Collection, London.

The enamelling on this box bears a striking similarity to that on the box by Barnabé Sageret (cat. no. 55), on the *carnet* by Jean Ducrollay (cat. no. 56) and on a spy glass at Waddesdon Manor by Hubert Cheval (fig 1, cat. no. 56)[7] all dated 1750–51. A box from the collection of Sir Charles Engelhard by Charles-Simon Bocher of 1753–54[8] also appears to have been enamelled by the same hand. It is possible that the artist was Hubert-Louis Cheval de St Hubert an *orfèvre-emailleur* who worked from at least 1751 until 1762.[9] The style of decoration should be compared to another box, apparently unmarked, and therefore probably not French, which is in the British Museum, London (fig 1).[10]

59 Snuff-box

Rectangular snuff-box of 'vernis' mounted with a gold hinge, bezel and thumbpiece, painted with six scenes of birds and dogs bordered by green trefoils over a ground of stamped foil under a yellow varnish. On the cover, a swan is surprised in her nest by a dog, on the front another dog points at ducks while the sides, back and base show pheasant and partridge in landscapes. The interior is painted black (straight bezel).

Dimensions
Height: 4.1 cm; length: 9.1 cm; depth: 7.1 cm

Provenance
Baron Max von Goldschmidt-Rothschild Collection (no. 383)
Baron Maximilien de Goldschmidt-Rothschild and Baronne de Becker Collection, sold
 Sotheby's, Monte Carlo, 29 November 1975, lot 130
K125L

Marks

On the right-hand side of the bezel
1 Partially struck mark of an unidentified Paris goldsmith, comprising a crowned fleur de lis, two *grains de remède* and part of the *différent*
2 Charge mark of the *sous-fermier* Julien Berthe, 10 October 1750 until 13 October 1756[1]
3 Wardens' mark for Paris, 14 July 1753 until 12 July 1754[2]

On the left-hand side of the bezel
4 Discharge mark of the *sous-fermier* Julien Berthe, 1750–56[3]

French, Paris, 14 July 1753 until 13 October 1756

Whilst frequently referred to as Vernis Martin, the decoration of this box does not appear to be that developed by the Martin brothers. Although they clearly made snuff-boxes, for example that supplied by Lazare Duvaux to M. Coucicault on 8 January 1749,[4] it would appear that their speciality was either imitating aventurine lacquer, a cabaret of which was sold to Mme de Pompadour by Duvaux on 26 September 1751[5] or lacquer in relief, such as the toilet-set noted in Mme de Pompadour's posthumous inventory: 'Une toillette de Martin, dans le goût de Japon, en relief de Martin'.[6] Indeed the *arrêt de Conseil* of 18 February 1744 gave the Martin brothers the exclusive right to produce 'toutes sortes d'ouvrage en relief et dans le goût de Japon et de la Chine'.[7] Watin adds that the lacquer which they produced was encrusted with mother-of-pearl.[8] By 1748, under the title of Manufacture Royale de MM. Martin they had three branches in the faubourg St Martin, faubourg St Denis and in the rue St Magloire.

The unusually large thumbpiece appears to be a feature of these 'vernis' boxes; see, for example, that on the box of 1750–57 signed 'Tiron Frerres a Paris' sold by Sotheby's, Zurich, 23 November 1978, lot 30.

The painting on the lid is after Jean-Baptiste Oudry's *Le Cygne et Barbet* which was exhibited in the *Salon* of 1740 and which subsequently is said to have formed part of the decoration of the dining-room of Jacques Samuel Bernard, comte de Combert.[9] There are, however, two versions of the painting known, one in the Swedish Embassy in Paris, where it has been since at least the mid nineteenth century and another version in a private collection in England. A drawing of the same subject and signed by Oudry formerly in the collection of Edmond de Goncourt, is now in the Art Institute, Chicago.[10] The subject was clearly very popular at the time. It was modelled at Vincennes by Blondeau in 1752[11] and appears on a drawing for a *cuvette à fleurs* by Jean-Claude Duplessis at Sèvres.[12] It also appears in hardstone on the base of a Berlin box in the Robert Lehman Collection[13] and on the lid of a japanned box from the Felix Doisteau Collection.[14]

Notes
1 Nocq IV, p235
2 Nocq IV, p217
3 Nocq IV, p235
4 Courajod, p11
5 Courajod, p97
6 Cordey, p63
7 H. Vial, A. Marcel and A. Girodie, *Les Artistes Decorateurs du Bois* II (Paris, 1922) pp15–16
8 Watin, *L'Art de peintre, doreur, vernisseur* (Paris, 1785) p308
9 References to Jean Locquin, 'Catalogue raisonné de l'Oeuvre de Jean-Baptiste Oudry', *Nouvelles Archives de l'Art Français* 4e serie, VI (1912) p46, no. 235; to Pierre Gaxotte, et al, *Le Faubourg St Germain* (Paris, 1966) pp170–71 and to the Royal Academy, London, *European Masters of the Eighteenth Century* (London, 1954) no. 169, are given in a model entry in the sale catalogue of Sotheby's, Monte Carlo, 29 November 1975
10 Paris, Musée du Louvre (Cabinet de Dessins), *Dessins Français de l'Art Institute de Chicago de Watteau à Picasso* (Paris, 1976) no. 4
11 Paris, Grand Palais, *Porcelaines de Vincennes* (Paris, 1977) p158, no. 466
12 Philippe Chapu in *Les Porcelainiers du XVIIIe siècle Français* (Paris, 1964) p157
13 Snowman (1966) fig 547
14 Paris, 16–17 June 1928, lot 153

60 Snuff-box

Rectangular gold snuff-box comprising six panels of translucent red *cloisonné* enamel over gold foil stamped with radiating lines, mounted in gold engraved with lozenges containing radiating lines (wavy bezel).

Dimensions
Height: 3.7 cm; length: 7 cm; diameter: 5.1 cm

Provenance
Neville Hamwee Collection
J. Ortiz-Patiño Collection, sold Christie's, 26 June 1974, lot 14
K160H

Marks

In the lid, in the base and on the right-hand bezel
1 Maker's mark of Claude Lisonnet, goldsmith registered in Paris, 15 October 1736 until 3 January 1761[1]
2 Charge mark of the *sous-fermier* Julien Berthe, 10 October 1750 until 13 October 1756[2]
3 Wardens' mark for Paris, 14 July 1753 until 12 July 1754[3]

On the left-hand side of the bezel
4 Discharge mark of the *sous-fermier* Julien Berthe, 1750–56[4]

French, Paris, 14 July 1753 until 13 October 1756, by Claude Lisonnet

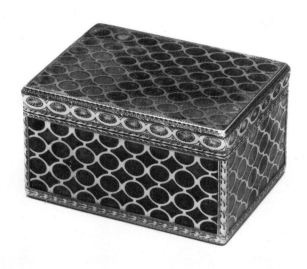

This box, with its curious enamelled decoration, is paralleled by another of the same date and by the same maker, and decorated in the same technique, in the Victoria and Albert Museum (fig 1).[5] Both boxes have shown the inability of the foil beneath the enamel to survive atmospheric change, possibly caused by the humidity of the snuff which the box contained, and many of the panels on the London box have become semi-opaque. It may be noted here that humidity was a problem not only to this form of decoration, but also to miniatures. In 1774, Louis-Nicholas van Blarenberghe wrote to his friend, Charles Lenglart, in Lille, 'Vous me mande que votre miniatur et gate cé ce qu'il arrive à tous celle que l'on mé dans les Boite. Si les bors du velins ne (sont) poins pouris par humidite du tabac je peux le racomede; vous pouve me l'envoier dans une lettre entre deux cartons et recommandé la lettre à la poste sans aucuns risque'.[6]

ILLUSTRATION
1 *Snuff-box of gold set à cage with panels of cloisonné enamel over stamped foil, by Claude Lisonnet, Paris, 1753–56 (Victoria and Albert Museum, London)*

Notes
1 Nocq III, p 144
2 Nocq IV, p 235
3 Nocq IV, p 217
4 Nocq IV, p 235
5 Inv. no. 265–1878
6 'You tell me that your miniature is damaged – it is something that happens to those that are set on boxes. If the edges of the vellum are not damaged by the damp of the snuff I can put it right; you could send it to me in a letter between two pieces of cardboard and entrust the letter to the post without any risk.' Waddesdon catalogue, p 249

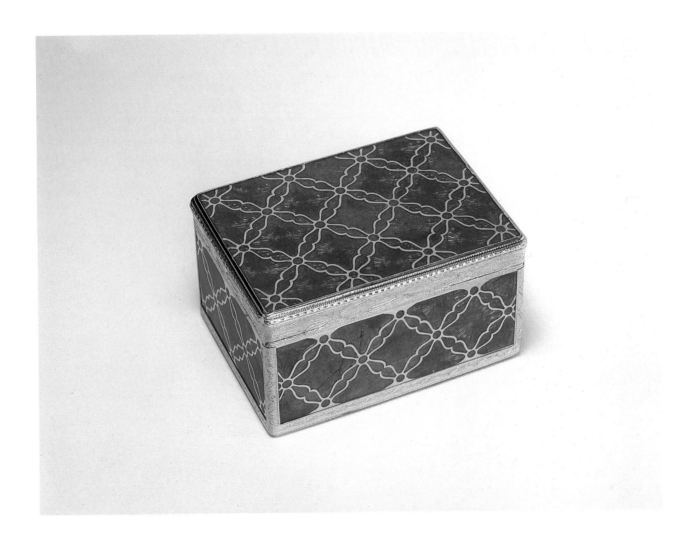

Notes
7 Nocq III, p 144
8 Watson pp 130–31

Additional bibliography
Snowman (1974) no. 24

Claude Lisonnet was the son of the goldsmith, Jean-Etienne Lisonnet, who sponsored him when he became master in 1736, and struck his mark, a crowned fleur de lis, two *grains de remède* and a 'lisse' (a lily?). His address at that time was given as cour neuve du Palais, but by 1748 he had moved to the rue St Louis au Palais in the parish of St Barthélemy, where he was living at the time that the present box was made. By 30 October 1756, he had returned to cour neuve du Palais.

He took on two apprentices during his career, François Ducamp from 1736 until 1751, and Pierre Chobert in 1756, but the latter had to move to Vincent Chobert when Lisonnet died in Spain in 1761.[7] Further gold boxes by Claude Lisonnet are to be found in the Metropolitan Museum, New York (Wrightsman Collection) and in the Musée d'Art et d'Histoire, Geneva.[8]

61 Snuff-box

Rectangular gold snuff-box with six reserves decorated with birds enamelled in opaque colours among branches of leaves and fruit enamelled in translucent green and yellow, over a ground engraved with a basketwork pattern, bordered by vine leaves and branches in translucent green.

Dimensions
Height: 3.5 cm; length: 7 cm; depth: 5.3 cm

Provenance
Sotheby's, London, 10 June 1974, lot 49
Sotheby's, Monte Carlo, 29 November 1975, lot 33
K125D

Marks

In the base
1 Maker's mark, possibly that of Pierre-François Delafons, goldsmith registered in Paris, 6 December 1732 until 15 July 1787[1]
2 Charge mark of the *sous-fermier* Julien Berthe, 10 October 1750 until 13 October 1756[2]
3 Wardens' mark for Paris, 12 July 1755 until 19 July 1756[3]

In the lid and in the front wall 2 and 3 partially erased

On the right-hand bezel
4 Discharge mark of the *sous-fermier* Julien Berthe, 1750–56[4]

On the left-hand bezel
5 Countermark of the *fermier* Eloy Brichard, 13 October 1756 until 21 November 1762[5]
6 Mark for gold and silver imported from countries without customs conventions with France, Paris, since 24 October 1864, struck twice[6]

French, Paris, 12 July 1955 until 13 October 1756, possibly by Pierre-François Delafons

Notes
1 Nocq II, p 36
2 Nocq IV, p 235
3 Nocq IV, p 217
4 Nocq IV, p 235
5 Nocq IV, p 235
6 Carré, p 213
7 Sotheby's, London, 10 June 1974, lot 49
8 Nocq II, p 36
9 Snowman (1974) no. 23
10 Snowman (1966) figs 229–33
11 Snowman (1966) fig 294
12 Snowman (1966) figs 334–35
13 Snowman (1966) fig 361

Although at one time the maker's mark on this box was attributed to Jean Ducrollay,[7] the *différent* is clearly not a heart and therefore the mark cannot be his. Despite being almost totally defaced, the *différent* could be read as a helmet in profile facing right, and the mark consequently attributed to Pierre-François Delafons. This distinguished goldsmith struck the mark, a crowned fleur de lis, two *grains de remède*, PD and a helmet in profile, on 6 December 1732 at which date he was living at rue neuve Notre-Dame. His father, the goldsmith David Delafons, supplied the *caution*. Six years later, Delafons was reprimanded by an officer of the guild for working on the second floor, at the back of the Hotel de Mony in contravention of the regulations concerning the position of workshops (see p 28). He held several offices in the guild, being *Garde* in 1746 and 1747, *Commissaire au bureau des Pauvres* in 1753 and *Grande-Garde* in 1759. Later that year his stock comprising a number of gold snuff-boxes partly enamelled in all shapes and sizes was sold. Delafons is listed in the directory of goldsmiths in 1783 but not in the following year. His death was reported on 15 July 1787.[8]

Exotic birds in decorative schemes enjoyed particular popularity in the 1750s and early 1760s. At the royal French porcelain factory at Sèvres at least two artists, Ledoux and Evans, specialised in painting these fanciful creatures. Several gold boxes with this type of decoration are known, for example, a small oval box from the Ortiz-Patiño Collection by Henri Delobel dated 1752–53,[9] another of the same date by J.-C.-S. Dubos in the collection of Lord Bearsted[10] and a third of that year by Jean George in the Rijksmuseum,[11] and a box by Charles Piat of 1765 in the same collection.[12] The treatment of the vine leaf border is very close to that on a barrel-shaped box by Jean-Joseph Barrière dated 1768–69, also in the Rijksmuseum.[13]

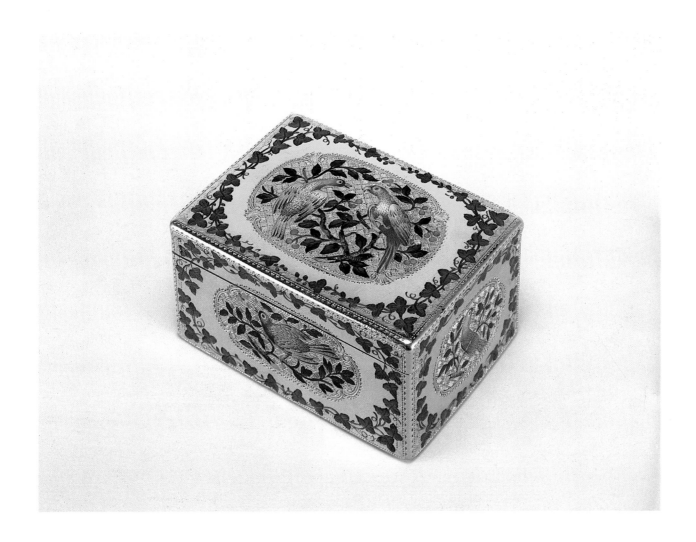

62 Sewing case

Sewing case of gold and mother-of-pearl, of slightly swollen rectangular form with concave corners, each panel paned in gold, with, on the lid, a chased gold scene of a Chinese musician sitting beneath a palm tree, a girl dancing before him, and a pavilion in the background, and, on the sides, front and back, gold anthemions springing from asymmetrical scrolls. The front panel bears in addition a scrolling thumbpiece above and below the rim. The corners contain gold panels encrusted with mother-of-pearl branches and flowers. The whole is supported by four gold bun feet. The case contains two facet-cut glass bottles with gold stoppers, a needlecase, a penknife, scissors, tweezers, a bodkin, a combined earpick and toothpick, a thimble, a spike, tablets of ivory, two pearl cotton winders and a mirror-lined compartment, presumably intended to contain patches.

Dimensions
Height: 9.5 cm; length: 12.2 cm; depth: 9.3 cm

Provenance
K 167 B

Marks

Inside the patch compartment
1 Charge mark of the *fermier* Eloy Brichard, 14 October 1756 until 21 November 1762[1]

Inside the patch compartment, on the left-hand side of the bezel and on the needlecase
2 Discharge mark of the *fermier* Eloy Brichard, 1756–62[2]

French, Paris, 14 October 1756 until 21 November 1762

Mother-of-pearl needlecases dating from the middle of the eighteenth century are not uncommon. However, most of those known are in the more extravagantly bombé forms, decorated with an abundance of scrollwork, which are usually associated with Germany.[3]

Kirsten Aschengreen Piacenti has pointed out that sewing cases of this kind were used by the grandest ladies. She cites one belonging to Anna Maria Luisa de'Medici, the Electress Palatine who died in 1743, which was of gold and contained 'two balls of silk, a needle for making socks, a pen, a knife, scissors, thimble and a needlecase – all ornamented with diamonds'.[4]

Notes
1 Nocq IV, pp 235–36
2 Nocq IV, pp 235–36
3 eg, Those in the Waddesdon catalogue, nos 45–47
4 Waddesdon catalogue, p 102 (Inventory of 1742 in the Florentine State Archives, Miscellanea 991)

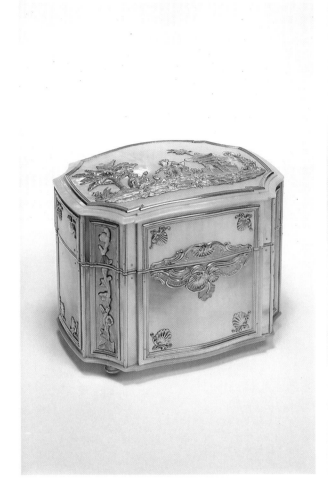

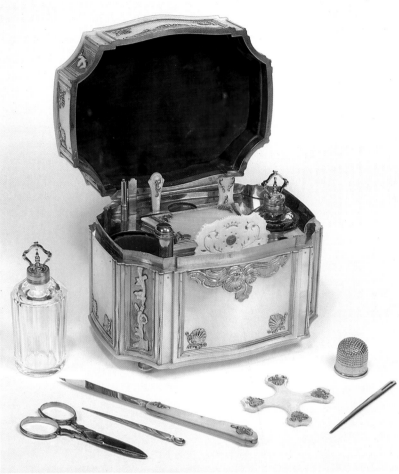

63 Snuff-box

Oval snuff-box of steel, cast, carved and encrusted with gold foil of two colours, with reserves enclosing four trophies emblematic of horticulture and agriculture, and with sprays of roses at either end. The box is lined with gold, and has a gold hinge and straight gold bezel.

Dimensions
Height: 3.9 cm; length: 8.3 cm; depth: 3.9 cm

Provenance
Christie's, Geneva, 25–26 April 1978, lot 345
K148D

Marks

In the lid, in the base and inside the right-hand front of the bezel
1 Almost wholly erased maker's mark of Jean George, goldsmith registered in Paris, 24 January 1752 until 1765[1]
2 Charge mark of the *fermier* Eloy Brichard, 14 October 1756 until 21 November 1762[2]
3 Wardens' mark for Paris, 10 July 1757 until 20 July 1758[3]

On left-hand side of bezel
4 Discharge mark of the *fermier* Eloy Brichard, 1756–62[4]

On the right-hand side of the bezel
5 Restricted warranty mark for Paris for gold, since 10 May 1838[5]

French, Paris, 10 July 1757 until 21 November 1762, mounted by Jean George

Inscribed on the bezel

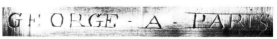

Jean George, one of the most distinguished and prolific of the Parisian *marchands-orfèvres-joailliers*, struck his mark, a crowned fleur de lis, two *grains de remède*, JG and a star, on 24 January 1752. His shop in the place Dauphine was at l'Observatoire, which may explain his choice of a star for a device. Amongst items at the sale on 7 November 1765, following his death the previous June, was a 'quantité de bijoux nouveaux et du dernier goût, de la fabrique du dit Sr. Georges, comme tabatières, étuis, flacons, boetes à mouches, bonbonnières, navettes, étuis de pièces, montres d'homme et de femme, chaines, cachets, tant en or que garnis d'or et émaux'.

His widow continued his business, and subsequently married Pierre-François-Mathis de Beaulieu who had been apprenticed to her late husband. The firm continued under the name of Veuve George Beaulieu and subsequently Veuve George Beaulieu & Guenet, until 1778.[6]

Jean George was the author of a type of box referred to as a 'Georgette' the exact form of which is not known. Nocq and Dreyfus have highlighted the confusion of this term in eighteenth-century usage. In 1758, Commissaire Leclerc noted the theft of a 'tabatière, lequelle est de figure en boisseau connue sous la denomination de tabatière Georgette ou galonnée', and the *Petits Affiches* in 1778 announced the loss of a 'boîte d'or quarrée, dite Georgette, avec charnière', while in December 1762, George himself advertised for the return of a 'Georgette montée en or' which suggests that like the present example, the box was not entirely of gold.[7]

The decoration of this box is unusual for a snuff-box, although it is quite common on swords of the mid eighteenth century (fig 1). Indeed, it is quite likely the box was made en suite with a sword-hilt by a *fourbisseur* before being mounted in gold by George. The steel was probably cast and carved with the trophies and scrolls, and the surfaces to be gilt roughened before thin gold foil was rubbed on. The technique is similar to that known as false damascening, and quite unlike the method used for gilding brass and bronze.[8]

An enamelled gold box of similar shape, and with a similar decorative scheme, substituting dogs for the horticultural trophies, also by Jean George but dated 1755–56 is in the collection of Baron Elie de Rothschild.[9]

Notes
1 Nocq II, pp 234–35
2 Nocq IV, pp 235–36
3 Nocq IV, p 217
4 Nocq IV, pp 235–36
5 Carré, p 208
6 Nocq II, pp 234–35
7 Nocq and Dreyfus, p X and Nocq II, p 234
8 I am grateful to Mr A. V. B. Norman, the Master of the Armouries, HM Tower of London for this technical information
9 Snowman (1966) fig 278

ILLUSTRATION
1 *Small sword-hilt of steel, carved and encrusted with gold foil, French, mid eighteenth century (Victoria and Albert Museum, London, Inv. no. M2731–1931)*

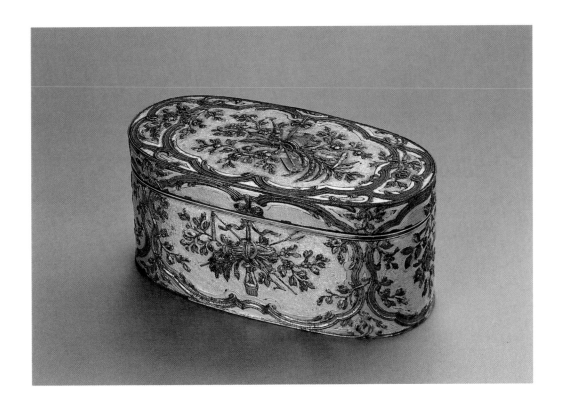

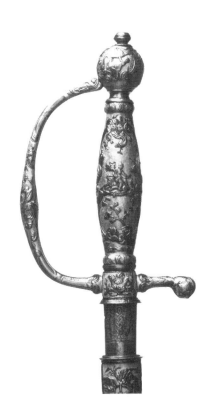

64 Snuff-box

Oval gold snuff-box with six reserves bordered by scrolls and flowers engraved with radiating lines and encrusted with sprays of flowers *en quatre couleur* (green, white and yellow).

Dimensions
Height: 3.1 cm; length: 7.8 cm; depth: 3.7 cm

Provenance
J. Kugel, Paris, 1964
K133A

Marks

In the lid, in the base and in the front wall
1 Maker's mark of Jean Frémin, goldsmith registered in Paris, 24 September 1738 until 24 January 1786[1]
2 Charge mark of the *fermier* Eloy Brichard, 14 October 1756 until 21 November 1762[2]
3 Wardens' mark for Paris, 15 July 1761 until 20 July 1762[3]

On the right-hand side of the bezel
4 Discharge mark of the *fermier* Eloy Brichard, 1756–62[4]
5 Restricted warranty mark for Paris for gold, since 10 May 1838, struck twice[5]

French, Paris, 15 July 1761 until 21 November 1762, by Jean Frémin

For biographical details of Frémin, see cat. no. 58.

Mrs Le Corbeiller has pointed out that boxes engraved with a sunburst beneath a bouquet of flowers were popular from 1750 to 1757, although since this box dates from 1761–62, it may be wiser to extend the terminal date, and that Jean Frémin was among the leading exponents of this technique.[6] Gold boxes decorated with coloured gold do not survive from before the mid 1750s, although the records of earlier examples exist. Lazare Duvaux first mentions the technique on 1 July 1755, when he sold Mme de Pompadour 'un cadre de miniature en or, à contours, les fonds unis à moulures, coins et milieux ciselé d'or de couleurs'.[7]

According to the *Encyclopédie*, boxes wholly of gold were referred to as *tabatière pleine*.[8]

Notes
1 Nocq II, pp 194–95
2 Nocq IV, pp 235–36
3 Nocq IV, p 217
4 Nocq IV, pp 235–36
5 Carré, p 208
6 Le Corbeiller, p 24
7 Courajod II, p 247
8 *Encyclopédie* XV (Paris, 1765) p 792

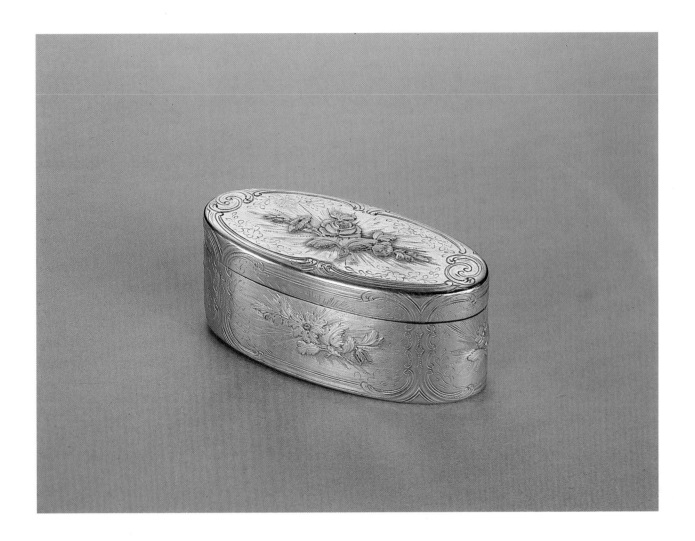

65 Snuff-box

Oval box of ten panels of cinnabar-red lacquer mounted in a cagework of gold pierced and engraved with leaves, and set with six reserves of black shell in gold frames, those on the cover and base being flanked by foliage and paterae. The reserve on the lid is *piqué* with red, green and yellow gold wire, and those around the walls encrusted with trophies representing music and gardening, whilst that on the base represents hunting. The interior is lined with tortoise-shell (straight bezel).

Dimensions
Height: 3.4 cm; length: 8.8 cm; depth: 4.5 cm

Provenance
R. W. M. Walker Collection, sold Christie's, 17 July 1945, lot 51, bought S. J. Phillips
Sir A. Chester Beatty Collection, sold Sotheby's, 3 December 1962, lot 162
J. Ortiz-Patiño Collection, sold Christie's, 27 June 1973, lot 8
K 160 C

Marks

On the left-hand side of the bezel
1 Maker's mark of Nicolas-Antoine Vallière, goldsmith registered in Paris, 23 July 1766 until 1792[1]
2 Charge mark of *adjudicataire des fermes générales unies* Jean-Jacques Prévost, 22 November 1762 until 22 December 1768[2]
3 Discharge mark of the *adjudicataire des fermes générales unies* Jean-Jacques Prévost, 1762–68[3]

On the right-hand side of the bezel
4 Restricted warranty mark for Paris for gold, since 10 May 1838, struck twice[4]

French, Paris, 23 July 1766 until 22 December 1768, by Nicolas-Antoine Vallière

Nicolas-Antoine Vallière was sponsored for the *maîtrise* by his father, Nicolas-Clement, also a goldsmith, but a large worker rather than a maker of gold boxes. Vallière fils struck his mark, a crowned fleur de lis, two *grains de remède*, NAV and a mitre, on 23 July 1766, when his address was given as place Dauphine. On 26 June 1774, he advertised the loss of a gold mounted tortoise-shell box in the *Affiches de Paris*, which showed that he had moved to the rue St Anne, where he was to remain until 1790. He is recorded on pont St Michel in 1791 and 1792. In the records of taxation for 1774 he is listed as the 267th of the guild in the amount that he paid. Given that there were only 300 master goldsmiths in Paris, his output that year must have been quite small.[5]

The technique of *piqué* in imitation of lacquer was brought to perfection in Paris in the eighteenth century. Three types of *piqué* are identified in the *Encyclopédie*: *piqué point*, the use of gold wires pierced through the ground as on the present example; *coulé*, where the gold wire is laid in grooves across the ground; and *incrusté*, where plaques of metal are applied to the surface. A combination of any of these techniques was known as *le brodé*.[6]

Many boxes decorated in this technique are known. In the inventory of the jewels belonging to the late Dauphine Marie-Josèphe de Saxe in 1767, a box 'de lacq rouge de forme quarrée montée et doublée en or cartouche d'écaille piquée' is

Notes
1 Nocq IV, p 82
2 Nocq IV, p 237
3 Nocq IV, p 237
4 Carré, p 208
5 Nocq IV, p 82
6 *Encyclopédie* planches, IX (1771)

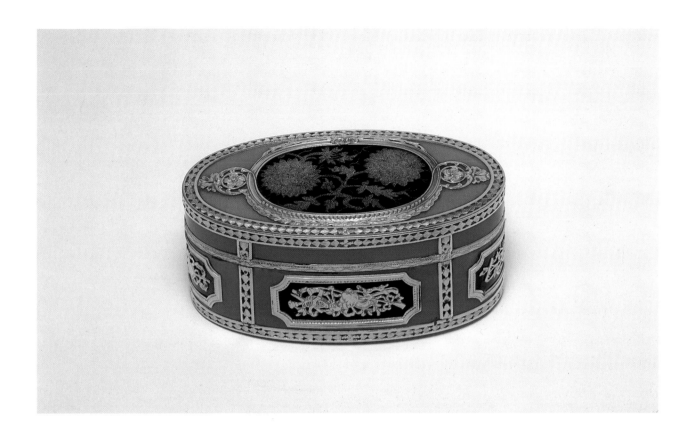

Notes
7 Bapst (1883) p 139
8 Watson, no. 19, pp 170–73
9 Paris, 8 April 1777, lot 1866
10 Maze-Sencier, p 148
11 Maze-Sencier, p 153
12 Grandjean, p 160
13 Watson, nos 11 and 19
14 Waddesdon catalogue, no. 83
15 Grandjean, no. 193
16 Inv. no. G.41

Additional bibliography
Snowman (1966) fig 366
Snowman (1974) no. 40
Bramsen, fig 207
London, Victoria and Albert Museum,
 *British Antique Dealers Association Golden
 Jubilee Exhibition* (London, 1968) no. 16

listed.[7] The sale of Louis-Jean Gaignat in 1769 contained 'une boëte presque quarrée, d'écaille coulé à charnière, le dessus représente un rhinoceros sur terrasse et arbres à côté,' which is now in the Metropolitan Museum, New York (Wrightsman Collection) in a different mount,[8] and the Prince de Conti, whose collection was sold in 1777, owned a 'boîte d'or forme quarré-long, ornée de belle piqure en or sur écaille dans sa boîte de chagrin'.[9]

However, we have very little information about the craftsmen who practised the art of *piqué*. Maze-Sencier mentions the name of Devair who apparently worked at the end of the Régence.[10] Perhaps he may be the same artist who decorated 'une tabatière d'écaille piquée de Devert, pour femme, à cage, doublée d'or, émaillée de vert, 1,200 livres' supplied by Hebert to the Menus Plaisirs in 1749.[11] Serge Grandjean sites references to *L'Avant Coureur* of 1761 and 1765 which mentions 'Compigné, tabletier privelegié du roi', as another artist in this field.[12]

Apart from the box by Pierre-François Drais, of 1767–68 (cat. no. 69), boxes with panels *piqué* in gold in imitation of Japanese lacquer are to be found in the Metropolitan Museum, New York (Wrightsman Collection), by Jean Ducrollay, 1754–55 and Louis Roucel, 1768–69;[13] at Waddesdon Manor by Jean Ducrollay, 1758–60;[14] in the Louvre by Jean-Marie Tiron, 1761–63;[15] and in the Wallace Collection, London by Louis Roucel, 1786–1866.[16]

66 Snuff-box

Oval box of vermilion composition lined with gold and mounted in gold borders pierced and chased with a guilloche, the lid set with an enamel plaque depicting Europa and the Bull, in a red and white gold frame, the base set with another enamel plaque of a still life with a vase of flowers, a recorder and music; the thumbpiece chased with flowers *en quatre couleur* (red, white and yellow) (straight bezel).

Dimensions
Height: 4.7 cm; length: 9.1 cm; depth: 6.8 cm

Provenance
Francis, Earl of Hertford Collection
Horace Walpole Collection, sold *Thirteenth Day's Sale of the Valuable Contents of Strawberry Hill, on Monday, the 9th Day of May, 1842*, lot 106, bought Russell (or Raphael)
H. N. Walford Esq Collection, sold Christie's, 24 June 1946, lot 167
Sotheby's, Monte Carlo, 29 November 1975, lot 129
K125K

Marks

In the rim of the lid, in the base and inside the front wall
1 Maker's mark of Antoine-Alexis Fontaine, goldsmith registered in Paris, 25 January 1763 until 1793[1]
2 Charge mark of the *adjudicataire des fermes générales unies* Jean-Jacques Prévost, 22 November 1762 until 22 December 1768[2]
3 Wardens' mark for Paris, 13 July 1763 to 17 July 1764[3]

In the rim of the lid
4 Discharge mark of the *adjudicataire des fermes générales unies* Jean-Jacques Prévost, 1762–68[4]

French, Paris, 13 July 1763 until 22 December 1768, by Antoine-Alexis Fontaine

Antoine-Alexis Fontaine, began his career apprenticed to François-Simeon Charbonné on 1 August 1748, but in 1760 moved to the workshop of François-Nicolas Bouillerot, himself a maker of gold boxes who had voluntarily submitted to prison in the Conciergerie following the sale of substandard snuff-boxes made in his workshop in 1749.[5]

Fontaine struck his mark, a crowned fleur de lis, two *grains de remède*, A A F and a heart, on 25 January 1763. At that time, he was living in the rue de Harlay, where he remained until 1772. By 1774, he had moved to pont au Change, and moved again in 1786 to the rue des Arcis where he stayed until at least 1793. In the records of taxation for 1774, he is listed as thirty-fifth in the guild.[6]

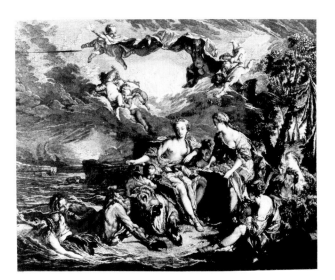

ILLUSTRATION
1 *Claude Duflos le jeune. Engraving of L'enlèvement d'Europe after François Boucher, 1752 (Musée du Louvre, Legs Rothschild)*

Notes
1 Nocq II, p 181
2 Nocq IV, pp 236–37
3 Nocq IV, p 217
4 Nocq IV, pp 236–37
5 Nocq I, p 163
6 Nocq II, p 181

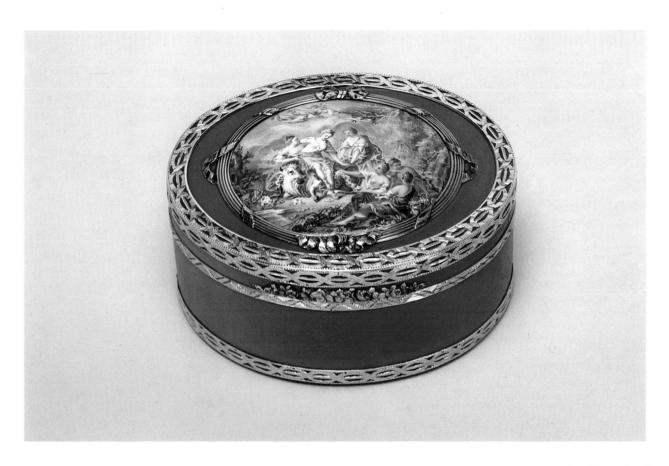

Notes
7 Jean-Richard, p 239, no. 923

The enamel mounted in the lid is after an engraving by Claude Duflos le jeune (1700–86) of François Boucher's *L'enlèvement d'Europe* published in 1752 (fig 1).[7]

In the *Description of the Villa of Horace Walpole . . . at Strawberry Hill*, 1774, it is stated that 'a red snuff-box with enamelled top and bottom, given to Mr W by Francis, Earl of Hertford', was in the Tribune, that small gothic closet where Walpole displayed some of the finest pieces in his collection. Francis Conway, Earl of Hertford, a relative of Walpole's, paid several visits to France as Ambassador extraordinary, and presumably it was on one of these visits that this box was acquired. His letters to Walpole are both friendly and solicitous but none of those which are known make any mention of this gift. It is intriguing to speculate as to how the inveterate Goth, Walpole, would have received such a box which combines both Rococo and Neo-Classical themes. However, it is clear that Walpole appreciated French works of art, particularly Sèvres porcelain, several pieces of which he bought on his visits to Paris.

When the box was catalogued for the sale of the contents of Strawberry Hill on 9 May 1842 (lot 106), it was described as follows: 'An oval red Japan snuff-box, mounted and lined with fine gold; on the top a splendid enamel representing the rape of Europa and the reverse one of flowers in a vase, it was *presented to Horace Walpole by Francis, Earl of Hertford*' and was bought by Russell or Raphael for £36–15s–0d.

In the 1975 sale the box was erroneously stated to have been offered for sale in 1946 by Lady Raphael of Wood End, Hythe, when in fact, it had been sent for auction by Mr H. N. Walford whose grandfather was said to have bought it at the Strawberry sale.

67 Snuff-box

Oval gold snuff-box enamelled *en plein* in opaque apple green with sprays of chrysanthemum in opaque pink and white in gold *paillons*. The rim of the lid and base, and the divisions between the four reserves around the walls are of engraved gold.

Dimensions
Height: 3 cm; length: 6.3 cm; depth: 3.8 cm

Provenance
Solomon Phillipe Collection
Sir Esmond Durlacher Collection
Mr Charles Engelhard Collection, sold Christie's, 28 June 1972, lot 29
K 185 A

Marks

In the lid and in the base
1 Almost wholly erased mark of a Paris goldsmith
2 Charge mark of the *adjudicataire des fermes générales unies* Jean-Jacques Prévost, 22 November 1762 until 22 December 1768[1]
3 Wardens' mark for Paris, 18 July 1764 until 21 July 1765[2]

In the front wall Part of 3

On the right-hand side of the bezel
4 Discharge mark of the *adjudicataire des fermes générales unies* Jean-Jacques Prévost, 1762–68[3]

French, Paris, 18 July until 22 December 1768

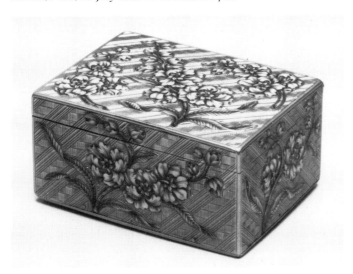

The curious enamelling technique on this box deserves special mention. Rather than paint the flowers over the apple green ground the enameller has used gold foil *paillons* to retain the pink and white enamel. Such a technique is often associated with Joseph Coteau,[4] who is thought to have developed the 'jewelled' decoration of Sèvres porcelain. Although not employed at Sèvres, Coteau worked there on his own account between 1780 and 1782. The jewelling involved the use of *paillons* of gold containing translucent coloured enamel which was applied to the ground colour, itself an enamel on the porcelain.[5]

So far as is known only one gold box has survived bearing Coteau's signature, and this bears the poinçon of Michel-René Bocher, and is dated 1774–80.[6] It is possible that the combination of colours used on the present box may have been influenced by their success at Sèvres where green was first used in 1756 and pink the following year.[7] A gold box dated 1747–50 by Paul Robert in the Victoria and Albert Museum (fig 1) was clearly enamelled by the same hand.

ILLUSTRATION
1 *Rectangular gold box by Paul Robert, Paris, 1747–50, with enamelled decoration by the same hand as cat. no. 68 (Victoria and Albert Museum, London, Inv. no. M.166–1941)*

Notes
1 Nocq IV, pp 236–37
2 Nocq IV, p 217
3 Nocq IV, pp 236–37
4 Snowman (1966) p 57
5 London, The Queen's Gallery, Buckingham Palace, *Sèvres from the Royal Collection* (London, 1979) nos 126–27
6 Snowman (1966), fig 422
7 Svend Eriksen, *The James A. de Rothschild Collection at Waddesdon Manor, Sèvres Porcelain* (Fribourg, 1968) p 31

Additional bibliography
Snowman (1966) fig 347
Nortons, pl 18A

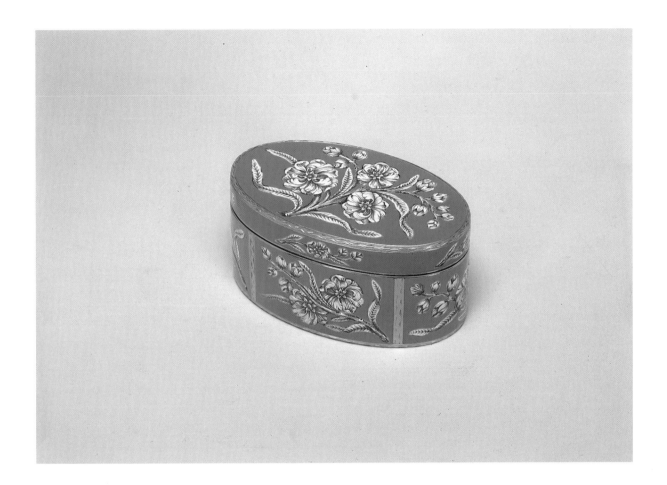

68　Snuff-box

Octagonal snuff-box *à pans carré* of ten panels of *hiramaki-e* lacquer, of Japanese origin, or possibly Chinese work imitating Japanese[1] dating from the first half of the eighteenth century, mounted *à cage* in gold chased with pilasters, swags, guilloche and leaves, with a bow and quiver at the centre of the hinge and a trophy of musical instruments at the front, all in red, green and white gold, and lined with tortoise-shell (wavy inner rim, straight bezel).

Dimensions
Height: 4.2 cm; length: 8.6 cm; depth: 4.3 cm

Provenance
Max von Goldschmidt-Rothschild Collection (no. 385)
Sotheby's, Monte Carlo, 29 November 1975, lot 115
K 125 J

Marks

On the right-hand side of the bezel
1　Maker's mark of François-Guillaume Tiron, goldsmith registered in Paris, 4 August 1747 until before 1782[2]
2　Charge mark of *adjudicataire des fermes générales unies* Jean-Jacques Prévost, 22 November 1762 until 22 December 1768[3]
3　Wardens' mark for Paris, 22 July 1765 until 11 July 1766[4]

On the left-hand rim of the lid
4　Discharge mark of the *adjudicataire des fermes générales unies* Jean-Jacques Prévost, 1762–68[5]

French, Paris, 22 July 1765 until 22 December 1768, by François-Guillaume Tiron

Inscribed on the rim

François Tiron a Paris

François-Guillaume Tiron was the son of Pierre Tiron, also a maker of gold boxes. From 27 November 1749, when his brother, Jean-Marie, called Tiron de Nanteuil, became master, the goldsmith was a partner in the firm MM. Tiron frères, *marchands-orfèvres-joailliers*, in rue St Louis, parish of St Barthélemy, Paris.

The partnership ceased between June 1754 and January 1756, but F.-G. Tiron appears to have remained on the premises *à la Pomme d'or* (fig 1). By 1776 he had moved to rue Thibautodé, which may indicate that he had retired from practice. Furthermore, on 11 December 1775 an advertisement for the sale of stock of Sr. Tiron appeared which listed amongst other things, 'boîtes émaillées, ciselées, gravées et guillochées; étuis, porte-crayons, flacons . . . boites à mouches et à rouge, boîtes d'écaille et de vernis . . . et bonbonnières', to be sold on December 15 and the following days.[6]

It is clear that the mounting of lacquer in gold was a practice of both Tiron brothers. A *carnet* of Japanese lacquer in gold dating from 1761–62 by Jean-Marie Tiron is in the Victoria and Albert Museum (fig 2).[7]

The engraver of the signature on the bezel of this box was also employed by Pierre-François Drais (see cat. nos 69 and 72) and by Barnabé Sageret.[8]

Notes
1　I am grateful to Mr J. Earle, Keeper of the Far Eastern Department of the Victoria and Albert Museum for his opinion on the lacquer
2　Nocq IV, p 55
3　Nocq IV, pp 236–37
4　Nocq IV, p 217
5　Nocq IV, pp 236–37
6　Nocq IV, p 55
7　Inv. no. 954 and a–1882
8　Grandjean, p 406, no. 25

ILLUSTRATIONS
1　*Trade card of François Tiron (National Trust, Waddesdon Manor)*
2　*Carnet of Japanese lacquer mounted in three coloured gold, by Jean-Marie Tiron, Paris, 1761–62 (Victoria and Albert Museum, London)*

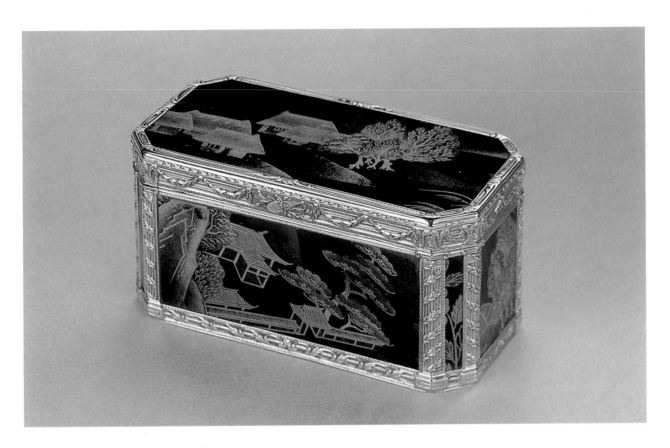

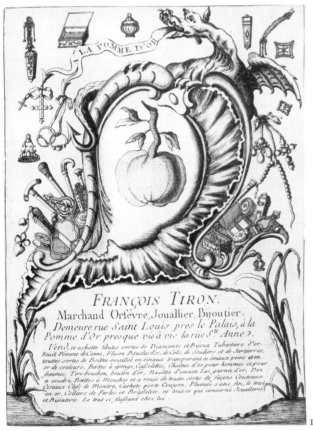

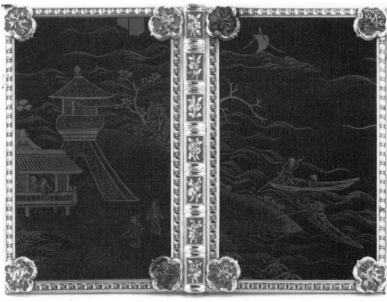

2

69 Snuff-box

Octagonal snuff-box, *à pans carré*, with ten panels of black shell *piqué* with two-colour gold and silver wire in imitation of lacquer set *à cage* in gold rolled with an acanthus design and chased with an ovolo motif around the rim of the lid.

Dimensions
Height: 3 cm; length: 5.7 cm; depth: 4.2 cm

Provenance
René Fribourg Collection, sold Sotheby's, 14 October 1963, lot 317
K133H

Marks

In the lid, in the base and in the front wall
1 Maker's mark of Pierre-François Drais, goldsmith registered in Paris, 29 December 1763 until 1788[1]
2 Charge mark of the *adjudicataire des fermes générales unies* Jean-Jacques Prévost, 22 November 1762 until 22 December 1768[2]
3 Wardens' mark for Paris, 14 July 1767 until 12 July 1768[3]

On the left-hand side of the bezel
4 Discharge mark of the *adjudicataire des fermes générales unies* Jean-Jacques Prévost, 1762–68[4]
5 Countermark of the *régisseur général des droits de Marque* Jean-François Kalendrin, 23 February 1789 probably until 1792[5]

On the right-hand side of the bezel
6 Countermark of the *régisseur général des droits de Marque* Henry Clavel, 4 June 1783 until 22 February 1789[6]

French, Paris, 14 July 1767 until 22 December 1768, by Pierre-François Drais

Signed on the front of the bezel

Pierre-François Drais is one of the most celebrated of Paris goldsmiths. Probably the son of Pierre Drais, also a goldsmith, he was baptised on 30 May 1726. When he attained the *maîtrise* in 1763 his *caution* was supplied by Jean Frémin (see cat. nos 58 and 64). On 29 December of that year he struck a mark which was recorded as a crowned fleur de lis, two *grains de remède*, PFD and a heart. However, the mark which is found in conjunction with the engraved signature 'Drais à Paris' appears to lack the initial F. One can only assume that an error was made in the records at the time of striking the mark. In the following year Drais had a trade card engraved giving his address as 'à l'entrée de la Place Dauphine à gauche par le Pont neuf' (fig 1) and acknowledging his dept to the goldsmith Ducrollay. It is not known whether this was Jean Ducrollay or Jean-Charles Ducrollay, but the former is most likely for if J.-C. Ducrollay had been his master, it is probable that he would have offered the *caution* in 1763. However, Jean Ducrollay had either died or retired at this date and the *caution* was supplied by Frémin. Drais seems to

ILLUSTRATION
1 *Trade card of Pierre-François Drais*

Notes
1 Nocq II, pp 97–98
2 Nocq IV, pp 236–37
3 Nocq IV, p 217
4 Nocq IV, pp 236–37
5 Nocq IV, pp 241–42
6 Nocq IV, pp 240–41

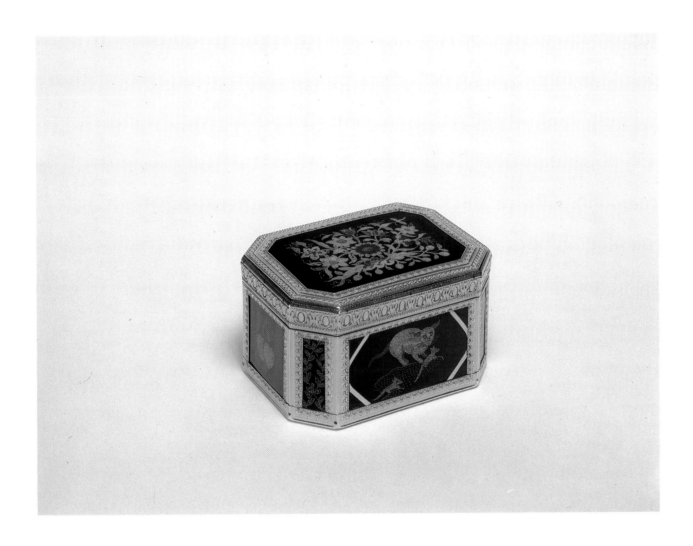

Notes
7 Nocq II, pp 97–98
8 Maze-Sencier, p 109
9 Maze-Sencier, pp 157–58
10 Grandjean, p 82
11 Watson, pp 146–48, no. 11
12 Grandjean, no. 193
13 Christie's, 18 December 1973, lot 152
14 Grandjean, no. 196

Additional bibliography
Le Corbeiller, fig 638

have remained in the place Dauphine until 1781 when he had moved to the quai des Orfèvres where he is recorded until 1788.[7]

In 1770, Drais supplied gifts worth 4800 livres for the King to dispose of at the marriage of the Dauphin to Marie-Antoinette.[8] In the same year he supplied two boxes for the Dauphine's *corbeille de marriage* for which he was paid 2400 livres each, despite having asked 6000 livres for the two. From 1774 until 1776, in 1778 and in 1782, Drais supplied the Menus Plaisirs with further boxes.[9] In 1786 he entered into a partnership with Charles Ouizille.[10]

The *piqué* on this little box would seem to be by the same artist as that on a box in the Metropolitan Museum, New York (Wrightsman Collection) by Jean Ducrollay dated 1754–55,[11] on a box by Jean-Marie Tiron, dated 1761–62, in the Louvre,[12] and on a box by Louis Roucel dated 1775.[13] The connection between Tiron and Drais may be further noted from a box in Louvre which bears both their marks but struck eight years apart.[14]

70 Snuff-box

Oval gold snuff-box, engine-turned and enamelled in translucent blue set with gold wire *cloisons* enclosing reserves containing leaf-shaped *paillons* holding translucent green enamel, with white gold points at the wire's intersections, bordered around the lid and the base by a guilloche of chased gold, and with engraved gold bands around the body (straight bezel).

Dimensions
Height: 4 cm; length: 8.7 cm; depth: 6.9 cm

Provenance
Christie's, Geneva, 20 November 1974, lot 246
K 149 B

Marks

On the left-hand side of the bezel
1 Maker's mark of an unidentified goldsmith, possibly from Paris, comprising a crowned fleur de lis, two *grains de remède*, the *différent*, a flower and three initials the third of which is the letter A
2 Partially struck mark, possibly a charge mark
3 Probably the wardens' mark for Paris, 13 July 1768 until 12 July 1769[1]
4 Probably the discharge mark of the *adjudicataire des fermes générales unies* Jean-Jacques Prévost, 22 November 1762 until 22 December 1768[2]

Probably French, Paris, 13 July until 22 December 1768

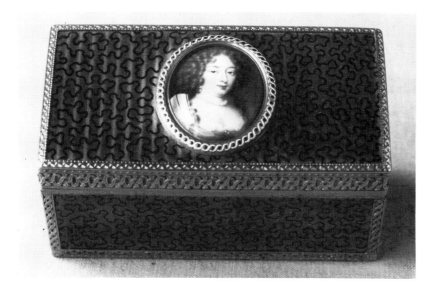

Despite the marks on this box it presents some problems of attribution. Nocq does not appear to list a maker's mark for a Paris goldsmith which used a comparable combination of letters and device. The mark which should be the charge mark, even in its almost totally erased state, does not appear to resemble the two interlaced laurel branches used by the *adjudicataire des fermes*, Jean-Jacques Prévost during his *régie* from 1762 to 1768. Furthermore, the highly skilled use of translucent enamel over engine-turning, combined with gold *cloisons* and *paillons* with further translucent enamel suggests a date between 1775 and 1785 rather than one of 1768–69. Be that as it may, reference should be made to a box by P. J. Bellanger in the Louvre, dated 1762–63 (fig 1),[3] which has very sophisticated translucent enamel and gold mounts comparable to those on the present box. However, the author is unable to exclude with certainty the possibility that the marks may be the so-called 'prestige marks' frequently found on boxes made in Switzerland and elsewhere in the last quarter of the eighteenth century.

ILLUSTRATION
1 *Snuff-box of enamelled gold set with a miniature, by P. J. Bellanger, Paris, 1762–63 (Musée du Louvre, Paris)*

Notes
1 Nocq IV, p 218
2 Nocq IV, pp 236–37
3 Grandjean, no. 24

71 Snuff-box

Oval snuff-box of tortoise-shell striped with red gold and mounted in yellow gold, chased and engraved with a guilloche.

Dimensions
Height: 3.8 cm; length: 7.1 cm; depth: 5.6 cm

Provenance
Zervudachi, Vevey, 1976
K 200 F

Marks

On the right-hand side of the bezel
1 Partially struck maker's mark of a Paris goldsmith, comprising a crowned fleur de lis, two *grains de remède*, the initials I or L, G and possibly another, with an indistinct device
2 Charge mark of the *adjudicataire général des fermes générales unies* Julien Alaterre, 23 December 1768 until 31 August 1775[1]
3 Wardens' mark for Paris, 16 July 1770 until 9 July 1771[2]
4 Discharge mark of the *adjudicataire général des fermes générales unies* Julien Alaterre, 1768–75[3]

French, Paris, 16 July 1770 until 31 August 1775

The crisp decoration of this box represents a Neo-Classical manifestation of the technique of *écaille coulé d'or*, that form of *piqué* where gold is laid across the surface of the tortoise-shell rather than pierced through it. As with *piqué*, the decoration would be carried out when the shell had been warmed, so that on cooling, the contracted shell would grip the gold firmly. A disadvantage of this technique is that these boxes are adversely affected by atmospheric change, and, as on the present example, the gold stripes are prone to lift from the shell.

A box in the Louvre, dated 1773–74,[4] decorated in the same technique appears to have an identical mount, and may be from the same workshop.

Notes
1 Nocq IV, pp 237–38
2 Nocq IV, p 218
3 Nocq IV, pp 237–38
4 Grandjean, no. 245

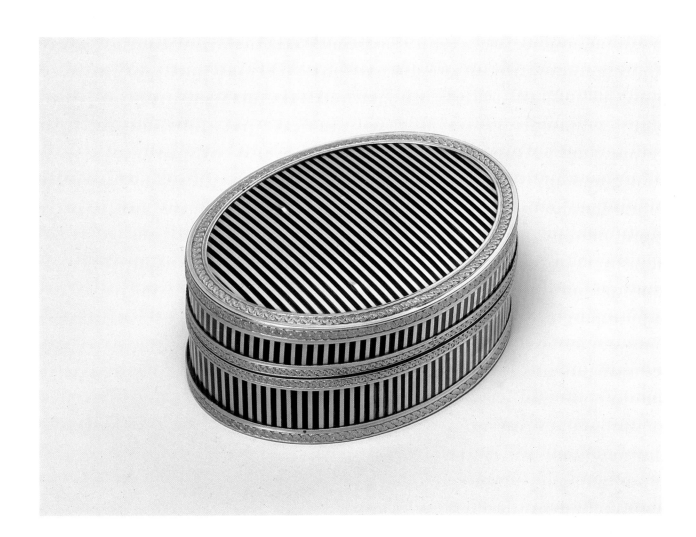

72 Snuff-box

Octagonal gold box, *à pans carré*, set with panels of dark blue translucent enamel over an engine-turned ground and mounted with ten grisaille miniatures of bacchanalian figures and caryatids under glass, in a cagework of gold chased with acanthus and guilloches, the corners with pilasters hung with green gold swags and supporting a frieze embellished with green gold wreaths and foliage tied with ribbons (straight bezel).

Dimensions
Height: 3.5 cm; length: 8.1 cm; depth: 6 cm

Provenance
René Fribourg Collection, sold Sotheby's, 14 October 1963, lot 320
A La Vieille Russie, New York, 1968
K I 3 3 E

Marks

In the lid, in the base and in the left-hand wall
1 Maker's mark of Pierre-François Drais, goldsmith registered in Paris, 23 December 1763 until 1788[1]
2 Charge mark of *adjudicataire général des fermes générales unies* Julien Alaterre, 23 December 1768 until 31 August 1775[2]
3 Wardens' mark for Paris, 16 July 1770 until 9 July 1771[3]

On the right-hand side of the bezel
4 Discharge mark of the *adjudicataire général des fermes générales unies* Julien Alaterre, 1768–75[4]

French, Paris, 16 July 1770 until 31 August 1775, by Pierre-François Drais

1 2

3 4

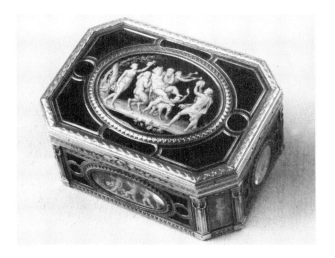

Signed on the front of the bezel

For biographical details of Drais, see cat. no. 69.

The grisaille miniatures 'peints à bas relief' are probably by Jacques-Joseph de Gault, a prolific painter who specialised in painting in imitation of cameos. Several paintings in this style bear his signature, including those on six boxes in the Louvre,[5] and on the jewel cabinet made for Marie Antoinette at Versailles. Many bear dates ranging from 1771 until 1785. It seems that J.-J. de Gault was born in 1738 and worked as a painter in the porcelain factory at Sèvres from 1758 until 1760. In 1777, he exhibited four paintings in imitation of cameos at the Academie de St Luc, and subsequently exhibited similar work at the Salon de la Correspondance. It is clear that he was still alive in 1812, for his wife wrote to Alexandre Brongniart, then director of the Sèvres factory, asking him to persuade her son, who worked at Sèvres from 1808 to 1817, to allow her 500 livres a year for the

ILLUSTRATION
1 *Snuff-box of gold, enamelled and set with miniatures by J.-J. de Gault, by P.-F. Drais, Paris, 1772–73 (Musée du Louvre, Paris)*

Notes
1 Nocq II, pp 97–98
2 Nocq IV, pp 237–38
3 Nocq IV, p 218
4 Nocq IV, pp 237–38
5 Grandjean, nos 55, 103, 172, 264, 284 and 394

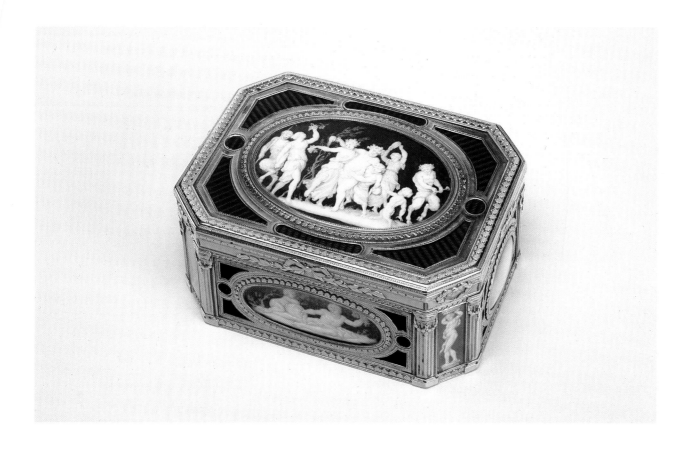

Notes

6 Carlo Jeannerat, 'De Gault et Gault de Saint Germain', *Bulletin de la Société de l'Histoire de l'Art Français* (Paris, 1935) pp 221–35

7 Grandjean, nos 82, 83, 85–88 and 89; Wallace Collection, London, no. 53; formerly in the Sir Bernard Eckstein Collection, Sotheby's, 30 November 1948, lot 86; formerly in the Chester Beatty Collection, Sotheby's, 3 December 1962, lot 167; etc.

8 Sotheby's, Zurich, 7 November 1975, lot 101

9 Maze-Sencier, pp 157–58

10 Grandjean, no. 82

11 Inv. no. G53

12 Nocq and Dreyfus, no. 97

13 Inv. no. G45

14 Waddesdon catalogue, no. 89

15 Nocq and Dreyfus, nos 99 and 101

Additional bibliography
Le Corbeiller, fig 157
Bramsen, fig 130

next four years.[6] Several boxes by P.-F. Drais with miniatures by J.-J. de Gault are known.[7]

This form of box seems to have been a favourite of Pierre-François Drais. A very similar box of 1772–73 is in the Louvre (fig 1) and another with chased plaques by Gérard Debèche was sold by Sotheby's, Zurich, in 1975 (Introduction, fig 12).[8] Others were supplied to the Menus Plaisirs. For example, amongst the boxes supplied by Drais for the *corbeille de marriage* of the Dauphine Marie Antoinette in 1770 were a box 'à huit pans, les cartels du milieu en bas relief à figures, d'après Boucher, la bordure à feuilles d'acanthe, avec rosettes et guirlandes détachées sur un fond d'émail bleu', and another also *à huit pans* with panels of shell (*magellan*) and a central medallion chased by Debèche after the antique. In 1775, Drais supplied 'une boîte emaillée en vert, à cartels peinte à bas-relief',[9] which must have resembled the box in the Louvre of 1768–69[10] or that of 1774–75 in the Wallace Collection.[11]

The signature on the bezel is also worthy of comment. It seems clear that several goldsmiths used the same engravers even for such apparently simple work as that shown above, and that the same goldsmiths also used several engravers.

A box by Drais in the Louvre also with miniatures by de Gault and dating from 1769–70 is signed in the same hand,[12] as is cat. no. 68 by François Tiron and dating from 1765–66 and a box in the Wallace Collection by J.-M. Tiron, dated 1767–69, is inscribed 'Garnie' in the same distinctive script.[13] However, a box at Waddesdon Manor, dated 1768–1775,[14] and two boxes in the Louvre, dated 1770–72 and 1771–2[15] all by Drais, are signed in another hand.

73 Snuff-box

Oval snuff-box of gold with six reserves of green and red squares of gold soldered in a chequer-board pattern and engine-turned, the lid and the base bordered with a continuous frieze of interlaced flowers and ribbons *en quatre couleur* (green, red and white) and the walls hung with trophies in the same colours (straight bezel).

Dimensions
Height: 3.7 cm; length: 9.2 cm; depth: 4.5 cm

Provenance
A La Vieille Russie, New York, 21 December 1968
K 138 E

Marks

In the lid, in the base and in the front wall
1 Maker's mark of Matthieu Philippe, goldsmith registered in Paris, 30 June 1756 until after 10 December 1781[1]
2 Charge mark of the *adjudicataire général des fermes générales unies* Julien Alaterre, 23 December 1768 until 31 August 1775[2]
3 Wardens' mark for Paris, 10 July 1771 until 14 July 1772[3]

On the extreme right-hand side of the bezel
4 Discharge mark of the *adjudicataire général des fermes générales unies* Julien Alaterre, 1768–75[4]

French, Paris, 10 July 1771 to 31 August 1775, by Matthieu Philippe

1

2

3

4

The engine-turning of the squares of coloured gold on the reserves of the box reflects the light in an almost dazzling manner when this box is moved in the hand.

Matthieu Philippe made as his masterpiece the bezel of a snuff-box under the scrutiny of Louis Morel and Pierre-Remy Mary in Mary's shop on the quai de Morfondus on 30 June 1756. In 1761, he offered a reward for the return of some spoons, a jug and an écuelle, and gave his address as 'quai des Orfèvres, à la Garde royale'. He later moved to rue Quincampoix where he is recorded on 10 December 1781. Not a prolific goldsmith, Philippe was listed 222nd in the amount of tax paid in 1774.[5]

Notes
1 Nocq III, pp 322–23
2 Nocq IV, pp 237–38
3 Nocq IV, p 218
4 Nocq IV, pp 237–38
5 Nocq III, pp 322–23

Additional bibliography
New York, A la Vieille Russie, *The Art of the Goldsmith and Jeweler* (New York, 1968) no. 92, p 46

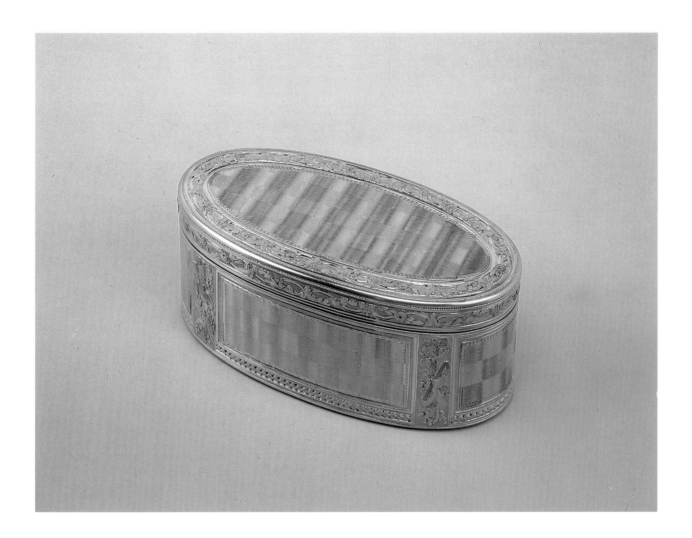

74 Snuff-box

Octagonal gold snuff-box, *à pans carré*, with ten miniatures of rural scenes under glass mounted *à cage* in gold chased with pilasters at the corners, with borders of green gold acanthus on a red gold ground, and with green gold laurel branches at the centre of the front and sides of the rim of the lid. On the lid, a bird seller arrives on a horse at a cottage; on the base two girls, a man and a donkey are greeted by haymakers, cowherds and woodsmen; on the front, a boy and a girl fish while a gardener wheels a barrow of flowers; the back shows a washerwoman and a shepherd with a boy riding a horse by a river. The sides show boys and girls at a well and picking fruit.

Dimensions
Height: 2.7 cm; length: 6.8 cm; depth: 3.3 cm

Provenance
Demmers, Amsterdam, 22 June 1970
K 153 A

Marks

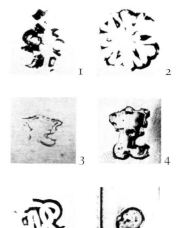

In the front wall
1 Maker's mark of Pierre-François Drais, goldsmith registered in Paris, 29 December 1763 until 1788[1]
2 Charge mark of the *adjudicataire général des fermes générales unies* Julien Alaterre, 23 December 1768 until 31 August 1775[2]
3 Wardens' mark for Paris, 14 July 1773 until 15 July 1774[3]

Inside the front bezel 1 and 2 only

Inside the lid 1, 2 and
4 Wardens' mark for Paris, 16 July 1774 until 14 July 1775[4]

In the base 1, 4 and
5 Charge mark of the *régisseur des droits de marque* Jean-Baptiste Fouache, 1 September 1775 until 6 April 1781[5]

On the left-hand side of the bezel
6 The discharge mark of the *régisseur des droits de marque* Jean-Baptiste Fouache, 1775–81[6]

French, Paris, 14 July 1773 until 6 April 1781, by Pierre-François Drais

For biographical details of Drais, see cat. no. 69

The large number of marks on this box are hard to comprehend. It is clear that Drais used for the front wall a piece of gold assayed between 14 July 1773 and 15 July 1774 (3). The lid must have been marked the following year before 14 July 1775 (4). However, the gold used in the base of the box cannot have been marked until 1 September 1775 (5) and consequently the use on this piece of mark 4, which should have been replaced six weeks earlier, must have been a mistake on the part of the wardens.

The miniatures on this box, although unsigned, may be attributed to the van Blarenberghes. At least five members of the van Blarenberghe family appear to have painted in miniature and since they hardly ever signed with initials there has been considerable confusion over attributions to individual artists. Professor Anthony Blunt has published a thorough review of the family's output, based on the collection at Waddesdon Manor and on that formerly at Mentmore Towers, but now largely dispersed.[7] The reputation of these *petits maîtres* is upheld by the

Notes
1 Nocq II, pp 97–98
2 Nocq IV, pp 237–38
3 Nocq IV, p 218
4 Nocq IV, p 218
5 Nocq IV, pp 238–39
6 Nocq IV, pp 238–39
7 Waddesdon catalogue, pp 232–49 and Sotheby's, Mentmore Towers, 25 May 1977

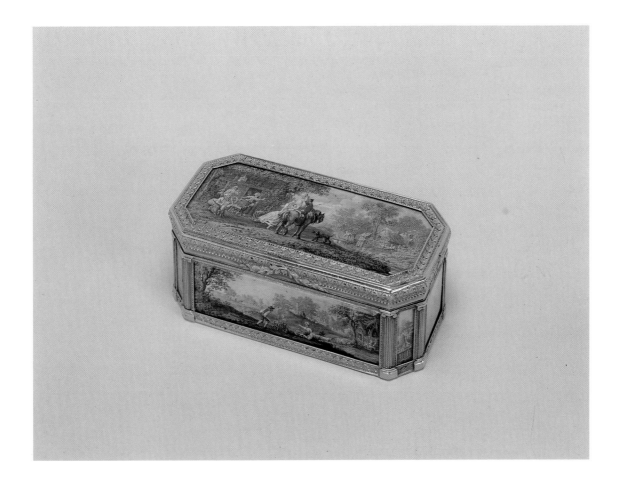

Notes
8 London, Victoria and Albert Museum,
 *Catalogue of the Jones Collection. Part III
 Paintings and Miniatures* (London, 1923)
 nos 592–94

work of Louis-Nicolas van Blarenberghe and his son Henri-Joseph. Louis-Nicolas was born in Lille in 1716, but moved to Paris in 1751 following the death of his wife. In the capital, he gained favour with the duc de Choiseul and worked first at Versailles, and later received appointments at the department de la Guerre, and subsequently at the Ministère de la Marine. He died in 1794. His son, Henri-Joseph (1741–1826) worked with him in a style which is indistinguishable from that of his father. In 1774, the younger van Blarenberghe was made drawing master to the children of Louis XVI but with the advent of the Revolution, no doubt demand for his work declined and he retired to Lille where he opened a drawing school and in 1803 became director of the local museum.

Of the extant miniatures by the van Blarenberghes, the closest to those on the present box are a set of ten paintings on a box dated 1764–65 and 1786–87 in the Jones Collection at the Victoria and Albert Museum, one of which is signed and dated 1764, and two large circular miniatures in the same collection dated 1775.[8]

75 Sealing-wax case

Cylindrical gold sealing-wax case decorated *en quatre couleur* (red, white, green and yellow) with four reserves containing allegories of music and love which are divided at the top by *atheniennes*, in the centre by flaming vases, and at the base by rabbits in landscapes.

Dimensions
Height: 12.5 cm; diameter: 2 cm

Provenance
Ader, Picard et Tajan, Paris, 11 March 1975, lot 121
K 153 D

Marks

In the cover
1 Maker's mark of Pierre Boucret, goldsmith registered in Paris, 12 December 1750 until 20 December 1777[1]
2 Charge mark of the *adjudicataire général des fermes générales unies* Julien Alaterre, 23 December 1768 until 31 August 1775[2]
3 Wardens' mark for Paris, 14 July 1773 until 15 July 1774[3]

On the body of the case
4 Discharge mark of the *adjudicataire général des fermes générales unies* Julien Alaterre, 1768–1775[4]
5 Unidentified mark
6 Restricted warranty mark for Paris for gold, since 10 May 1838, struck twice[5]

French, Paris, 14 July 1773 until 31 August 1775, by Pierre Boucret

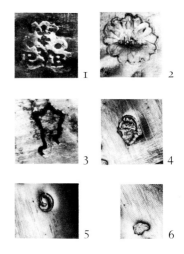

Pierre Boucret is a goldsmith with little reputation, and although it is clear that Nocq had seen an example of his work, no other piece by him is known to the author. His mark, a crowned fleur de lis, PB, and a cockerell with two *grains de remède*, was struck on 12 December 1750. His address was given as rue du Grand Hurleur, where he remained until 1766. His death was recorded on 20 December 1777.[6]

 Although nowadays referred to as *étui à cire à cacheter*, the term is not found in eighteenth-century documents. However, Diderot and d'Alembert describe the making of sealing wax, demonstrating that it was rolled into *bâtons*[7] and it is not unreasonable to assume that these cylindrical *étuis*, several of which have bases engraved with initials or coats-of-arms, were designed to hold sticks of wax.

 Pen and wash drawings by P. Moreau for four *étuis à cire* are in the Musée des Arts Decoratifs, Paris,[8] and engraved designs for them were published by Richard Lalonde.[9]

Notes
1 Nocq I, p 161
2 Nocq IV, pp 237–38
3 Nocq IV, p 218
4 Nocq IV, pp 237–38
5 Carré, p 208
6 Nocq I, p 161, and V, p 161 where his mark is reproduced
7 *Encyclopédie* III (Paris, 1753) p 473
8 A. de Champeaux, *Portefeuille des Arts Decoratifs* I (Paris, 1888–89) pl. 35
9 *Oeuvres diverses de Lalonde, decorateur et dessinateur, contenant un grand nombre de dessins pour la decoration interieure des appartements* (Paris, Chez Chéreau, n.d.)

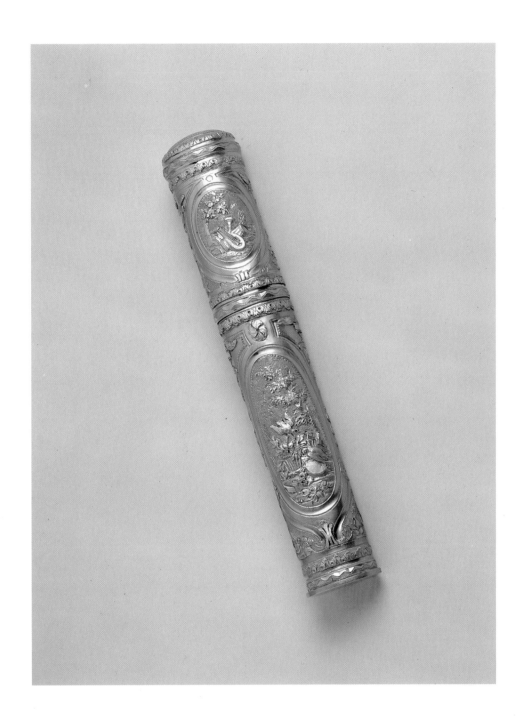

76 Snuff-box

Circular snuff-box of rock crystal mounted in gold *en quatre couleur* (yellow and red) chased on the lid and base with a border of acanthus and around the rim with a continuous scroll of leaves and flowers (straight bezel).

Dimensions
Height: 2.7 cm; diameter: 5.2 cm

Provenance
Comtesse d'Aubigny Collection, Monte Carlo
Sotheby's, Monte Carlo, 29 November 1975, lot 43
K 125 E

Marks

In the right-hand side of the bezel
1 Maker's mark of Barthélemy Pillieux, goldsmith registered in Paris, 23 July 1774 until 1790[1]
2 Charge mark of the *régisseur des droits de marque* Jean-Baptiste Fouache, 1 September 1775 until 6 April 1781[2]
3 Wardens' mark for Paris, 13 July 1776 until 12 August 1777[3]

On the left-hand side of the bezel
4 Discharge mark for imported objects of the *régisseur des droits de marque* Jean-Baptiste Fouache, 1775–81[4]
5 French mark for gold and silver imported from countries with customs conventions, June 1864 until June 1893[5]

French, Paris, 13 July 1776 until 6 April 1781, by Barthélemy Pillieux

Barthélemy Pillieux was apparently apprenticed to Jean-Baptiste Mercier in 1764 although, as Sir Francis Watson has suggested, it is more likely that he learnt his craft under Louis Mercier, the son of Jean-Baptiste, since Mercier pére is said to have retired in 1748, and Mercier fils supplied the *caution* when Pillieux attained the *maîtrise* in 1774.[6] He struck his mark, a crowned fleur de lis, two *grains de remède*, BP and a magpie, on 23 July 1774 and at the time was living on the pont au Change, where he remained until 1786. The following year saw him move to the rue St Honoré, and from 1789 until 1790 he lived in the passage du Grand Cerf. He was a creditor at the bankruptcy of the *marchand-mercier* Grancher, au Petit Dunkerque, in 1776.[7] In 1786 he provided the *caution* for a relative Toussaint-François Pillieux.[8] The discharge mark on this box is that normally reserved for foreign goldsmith's work. Since the box is clearly struck with Paris marks, it must be assumed that the official of the *fermier* selected the wrong punch to strike the discharge mark.

Notes
1 Nocq III, p 336
2 Nocq IV, pp 238–39
3 Nocq IV, p 218
4 Nocq IV, pp 238–39
5 Carré, p 213
6 Watson, p 304
7 Watson, p 304
8 Nocq III, p 336

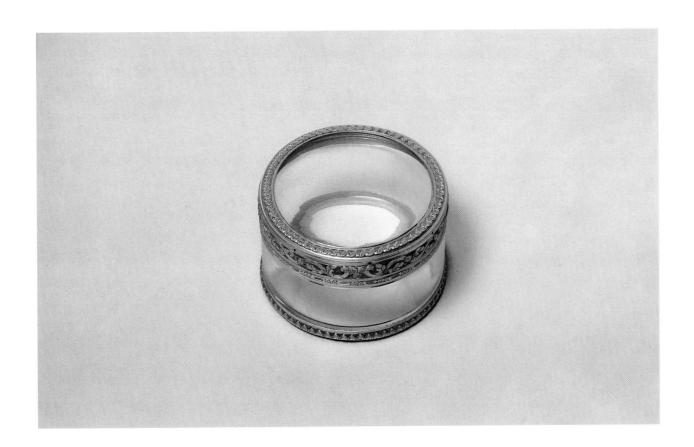

77 Snuff-box

Oval gold box with six reserves enamelled in imitation of lapis lazuli and set with plaques of red and green gold, that on the lid depicting a basket, a hat, fruit and flowers with two doves, that on the front a trophy of a quiver and a torch, that on the back billing doves, and those on the sides and base chased as paterae. The lid and the base are bordered by acanthus leaves and a guilloche in gold with a band of opaque white enamel between. Around the walls are four pilasters beneath a frieze of flowers and leaves and an oval thumbpiece chased with billing doves. The interior of the box has been fitted with a silver-gilt liner, the lid of which is engraved with two coats-of-arms beneath a crest, and which contains a mirror. The straight bezel of the box has been cut to allow for the thumbpiece of the inner lid.

Dimensions
Height: 2.5 cm; length: 6.7 cm; depth: 5.4 cm

Provenance
K I 3 2 G

Marks

In the lid, in the base and in the right-hand side of the wall
1 Charge mark of the *régisseur des droits de marque* Jean-Baptiste Fouache, 1 September 1775 until 6 April 1781[1]
2 Wardens' mark for Paris, 13 July 1776 until 12 August 1777[2]

In the right-hand side of the bezel 2 and
3 Discharge mark of the *régisseur des droits de marque* Jean-Baptiste Fouache, 1775–81[3]
4 Countermark of the *régisseur général des droits de marque* Henry Clavel, 7 April 1781 until 3 June 1783[4]
5 Countermark of the *régisseur général des droits de marque* Henry Clavel, 4 June 1783 until 22 February 1787[5]
6 Restricted warranty mark for Paris for gold, since 10 May 1838[6]

French, Paris, 13 July 1776 until 6 April 1781

The use of enamel in imitation of lapis lazuli here executed so successfully was practised at about the same time at the Sèvres porcelain factory. A pair of vases (*vase cygne à roseau en buire*) dated 1781 in the Royal Collection, London, were painted in this way by the gilder and decorator Nicolas Schrade.[7] At an earlier date Mme de Pompadour possessed a snuff-box described as 'fond de lapis, emaillée'.[8]

The coats-of-arms on the inner lid are, on the left, or, an eagle displayed sable, and on the right, azure, a bend between in chief a demi fleur de lis parted per pale or, florencée and in the base three roses in demi orle argent for Riquetti, Marquis de Mirabeau.[9]

Notes
1 Nocq IV, pp 238–39
2 Nocq IV, p 218
3 Nocq IV, pp 238–39
4 Nocq IV, pp 239–40
5 Nocq IV, p 240–41
6 Carré, p 208
7 London, The Queen's Gallery, Buckingham Palace, *Sèvres from the Royal Collection* (London, 1979) pp 36–37, no. 21
8 Cordey, no. 2359
9 I am indebted to Mr Michael Holmes of the National Art Library, Victoria and Albert Museum, for this blazoning and identification

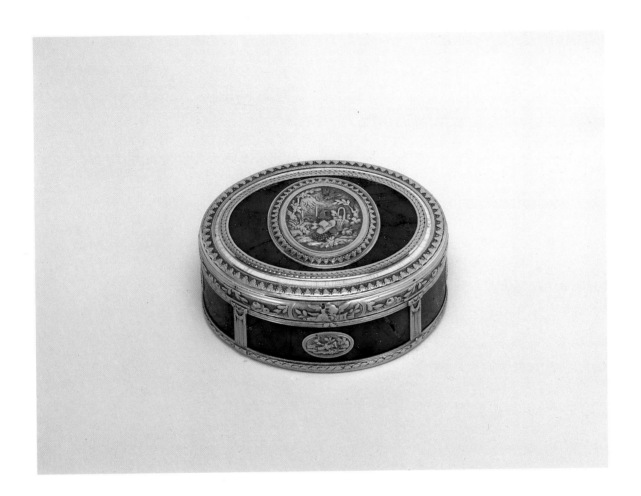

78 Folding knife

Folding knife, the handle of which is formed of two sections enamelled in translucent blue over an engine-turned ground bordered by white enamel 'pearls', with engraved rosettes at either end, and which contains a gold blade and a steel blade with a gold top edge.

Dimensions
Handle length: 10.3 cm; width: 1.3 cm; total length: 19.5 cm

Provenance
Vicomtesse de Courval Collection (1816–1901)
Sotheby's, Monte Carlo, 29 November 1975, lot 3
K125C

Marks

On the gold blade
1 Makers' mark of an unidentified Paris cutler, comprising an ermine in cameo in a rectangle
2 Charge mark of the *régisseur général des droits de marque* Henry Clavel, 7 April 1781 until 3 June 1783[1]
3 Wardens' mark for Paris, 1 August 1781 until 12 July 1782[2]
4 Discharge mark for the *régisseur général des droits de marque* Henry Clavel, 1781–83[3]
5 Restricted warranty mark for Paris for gold, since 10 May 1838[4]

Inside both sections of the knife handle 1, 2 and 3

On the steel blade
6 An ermine incuse, an unidentified Paris cutler's mark

French, Paris, 1 August 1781 until 3 June 1783, for Delaunay

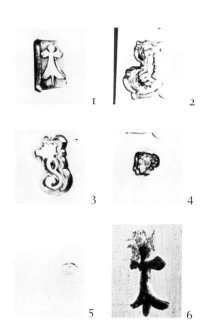

1 2

3 4

5 6

Stamped on the steel blade

For the first half of the eighteenth century, a cutler's right to work in gold or silver was severely limited. An *arrêt* of 30 March 1740 forbade the cutlers of Paris to make 'aucuns ouvrages d'or & d'argent pleins & massifs' allowing only the simple embellishments on cutlery to be made in precious metal. A further *arrêt* dated 4 May 1748 upheld this and added that any such decoration should be carried out in metal of the prescribed standard, bought from members of the goldsmiths' guild.[5] However, such restrictions were lifted on 7 May 1756 following an *arrêt* which the cutlers had obtained, apparently by surprise, and which authorised them to make all their wares of gold and silver. The goldsmiths, it seems, reluctantly acknowledged defeat.[6] The marks on this knife illustrate how cutlers used their new found freedom. Since the cutler was not a goldsmith he had no mark registered at the *maison commune*, and as a result used his cutler's mark, an ermine, as his maker's mark on the goldwork. As with the goldsmiths he would have contracted the enamelling, chasing and engraving to specialist workshops.

The ermine mark occurs on several knives dating from the late 1760s until about 1790 in conjunction with a number of different names. The steel blade to a knife contained in a *nécessaire* by Pierre-Nicholas Pleyard dated 1768–69 is one of the earlier recorded pieces to bear the mark.[7] It is also found on the blade of a knife marked 'Grangeret Cout^er du Roi' dated 1781–82, together with the crowned H mark used by Pierre Grangeret, and on another dated 1789–90 marked 'L? Comte' both in the Louvre.[8] A knife in coloured gold, with blades of gold and steel marked with an ermine and stamped Delaunay dated 1771–72 was in the collection of D.S.Lavender, London in 1982, and an enamelled example of 1781–82 is in the Louvre.[9]

Notes
1 Nocq IV, pp 239–40
2 Nocq IV, p 218
3 Nocq IV, pp 239–40
4 Carré, p 208
5 Poullin de Vieville, pp 203 and 226
6 Nocq IV, p 174
7 Sotheby's, Monte Carlo, 29 November 1975, lot 109
8 Y. Bottineau, *Catalogue de l'Orfèvrerie* (Paris, 1958) nos 107 and 213
9 Y. Bottineau, *op. cit.*, no. 204

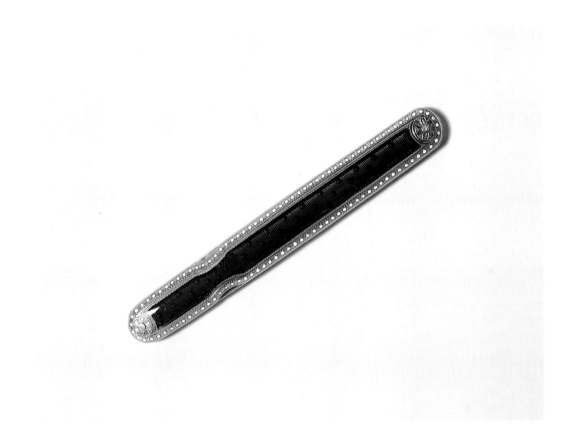

79 Snuff-box

Oval gold box with six reserves of translucent blue and opaque white enamel over an engine-turned ground bordered by opaque white bands, opaline 'pearls' and translucent green enamels on a matted gold ground (straight bezel).

Dimensions
Height: 2.2 cm; length: 9.1 cm; depth: 5.3 cm

Provenance
Jean Jahnsson Collection, sold Lempertz, Cologne, 6 May 1960, lot 560
K132C

Marks

In the base and in the front wall
1 Maker's mark of Joseph-Etienne Blerzy, goldsmith registered in Paris, 12 March 1768 until between 1806 and 6 April 1808[1]
2 Charge mark of the *régisseur général des droits de Marque* Henry Clavel, 7 April 1781 until 3 June 1783[2]
3 Wardens' mark for Paris, 1 August 1781 until 12 July 1782[3]

In the lid 1, 2 and
4 Wardens' mark for Paris, 13 July 1782 until 22 August 1783[4]

On the right-hand side of the bezel
5 Discharge mark of the *régisseur général des droits de Marque* Henry Clavel, 1781–83[5]
6 Restricted warranty mark for Paris for gold, since 10 May 1838, struck twice[6]

On the left-hand side of the bezel
The number 255

French, Paris, 1 August 1781 until June 1783, by Joseph-Etienne Blerzy

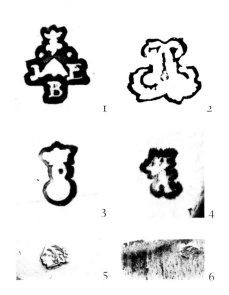

Joseph-Etienne Blerzy was apprenticed on 27 February 1750 to François-Joachim Aubert, the goldsmith who also sponsored him when he became master on 12 March 1768. Blerzy's address was given on that occasion as rue du Grand Hurleur in the parish of St Laurent. The following year a gold box of his making was seized by the *fermier*, but being found in order was returned. By 1774 he had moved to the pont au Change where he stayed until 1786 when the buildings on the pont au Change were demolished. His new address was given as rue de la Monnaie, no. 41. In 1774 he is listed 112th in the order of goldsmiths' businesses. After the Revolution he had moved to rue du Coq St Honoré, no. 3 where he is listed in the 1806 edition of S. P. Douet's *Tableau des Symboles de l'Orfèvrerie de Paris*.[7] However it is clear that he died shortly afterwards, since the 1809 edition lists, '1161 Boisot (la dame), v[e] BLERZY, Victoire, bij . . .' who used a pansy with a bird above as *différent*. Douet states that this mark was struck on 6 April 1808. The address is the same as that of her late husband.[8]

Boxes by J.-E. Blerzy frequently bear numbers struck on the bezel, but the precise significance of them is hard to understand. It is, however, evident that the numbers and the dates of the boxes are unrelated. Of the thirteen boxes by Blerzy in the Louvre,[9] the earliest, dated 1772–73, bears the number 6 or 9, and the latest of 1784–85, the number 505. A box of 1787–88 in the Victoria and Albert Museum bears the number 843.[10] Between these dates one finds 865 on a box of 1779–80, 84 on a box made the following year and 98 on one dated 1780–82. One example in the Louvre made in 1781–82 is numbered 235, but another of the same date is numbered 162, and that of 1782–83, bears the number 264. This box is enamelled in the same distinctive pattern as the present example.

Mrs Le Corbeiller has noted that the shape of the box was popular between the years 1770 and 1775,[11] but it clearly continued to be fashionable until the 1780s.

Notes
1 Nocq I, pp 137–38; Douet, p 23
2 Nocq IV, pp 239–40
3 Nocq IV, p 218
4 Nocq IV, p 219
5 Nocq IV, pp 239–40
6 Carré, p 208
7 Nocq I, pp 137–38
8 Douet, p 23
9 Grandjean, nos 27–41
10 Inv. no. 267–1878
11 Le Corbeiller, pl. IIIG

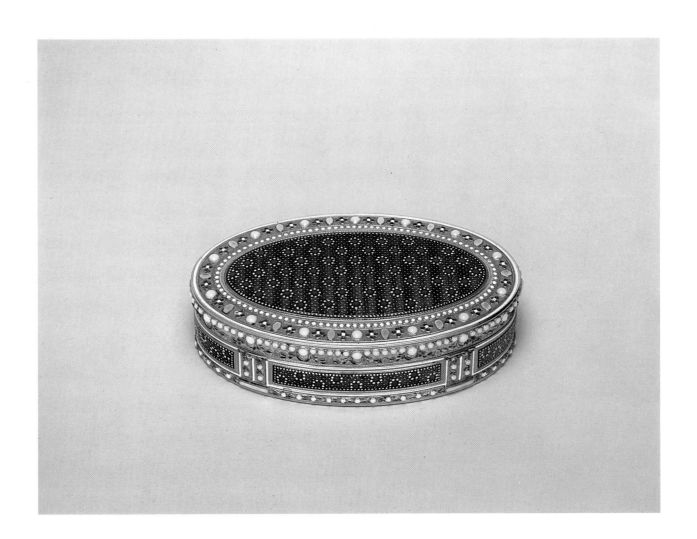

80 Bonbonnière

Circular box of tortoise-shell mounted in borders of stamped gold.

Dimensions
Height: 2.5 cm; diameter: 7.5 cm

Provenance
K 731

Marks

On the rim of the base
1 Discharge mark of the *régisseur général des droits de Marque* Henry Clavel, used for very
 small work in gold, 4 June 1783 until 22 February 1789[1]

French, Paris, 4 June 1783 until 22 February 1789

1

Boxes of tortoise-shell or *carton* with minimal gold decoration became popular
towards the end of the eighteenth century and their common existence in many
collections bears witness to their widespread use.

The term *bonbonnière* is normally used today to describe boxes without hinges.
However the term does not appear to have been used until about 1770. Up to
about that date the term *boîte à bonbons* was used to describe boxes for comfits or
dragées for sweetening the breath. Mme de Pompadour possessed 'Une boeste à
bonbons de topaze de Bohème, garni d'or' in 1764[2] but by 1772 the *Mercure de
France* refers to 'bonbonnières en écaille garnies ou non garnies'.[3] Those of which
were 'garnie' probably resembled the present example. However, the absence of a
hinge cannot have been the sole criterion by which to term a box a *bonbonnière*, for
'Deux bonbonnières rondes guillochées de crystal de roche garnies de gorge bec &
Charnière d'or' appeared in the duc d'Aumont's sale in 1782.[4]

Notes
1 Nocq IV, pp 240–41. Repeated attempts
 by the photographers failed to locate this
 mark and it is here reproduced from
 Nocq
2 Cordey, p 200, no. 2411
3 Havard I, col. 351
4 Paris, 12 December 1782, lot 426

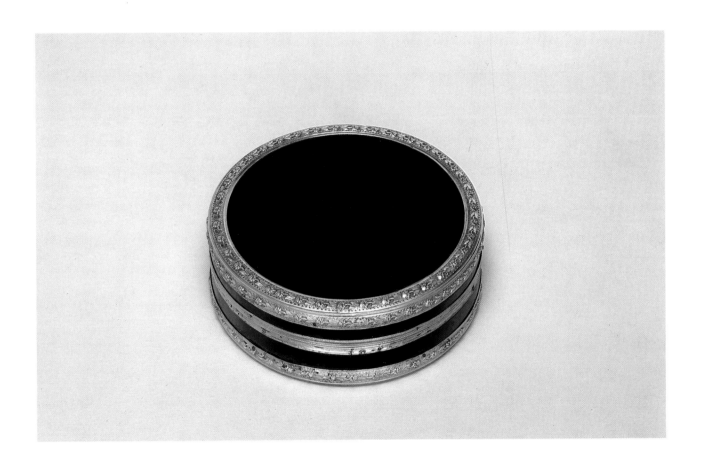

81 Snuff-box

Rectangular tortoise-shell snuff-box mounted and lined with gold and set above the hinge with a gold lozenge, bordered in translucent blue enamel and chased with an anthemion, and set on the lid with an enamel miniature of Madame Deshoulières by Jean Petitot framed in gold and beneath glass secured by a border enamelled in translucent blue over a ground engraved with wrigglework (straight bezel).

Dimensions
Height: 2.1 cm; length: 7.3 cm; width: 5.2 cm

Provenance
Sotheby's, Monte Carlo, 29 November 1975, lot 60
K 1250

Marks

In the lid, in the base and in the left-hand wall
1 Maker's mark of Adrien-Jean-Maximilien Vachette, goldsmith registered in Paris, 21 July 1779 until 23 September 1839, this mark being used after 1798[1]
2 Mark, possibly a standard mark for 20-carat gold in France between 1793 and 1797 or later

On the right-hand bezel 1, 2 and
3 Second standard mark for gold, Paris, 1809–19[2]

On the left-hand bezel
4 Excise mark for large goldwork, Paris, 1809–19[3]

French, Paris, late eighteenth or early nineteenth century, by Adrien-Jean-Maximilien Vachette

Inscribed on the front rim

It is possible that the version of the maker's mark on the right-hand side of the bezel is that used by Vachette before the Revolution, but since he used the same *différent* and the *grains de remède* in his post-Revolutionary work, it is difficult to be certain with the mark in such a rubbed condition. However, it is not uncommon to find both pre- and post-Revolutionary marks on a single piece.[4]

Adrien-Jean-Maximilien Vachette is one of the best known of the Parisian goldsmiths working at the turn of the eighteenth century. Born at Couffroy (Oise) in 1753, Vachette moved to Paris for his apprenticeship possibly under Pierre-François Drais, who supplied the *caution* when he struck his mark of a fleur de lis crowned, two *grains de remède*, A V and a cockerell, on 21 July 1779. Following the Revolution, Vachette resumed his profession, first at 3 quai de l'Hologe du Palais, and later at 45 quai du Nord where he is listed in 1806. Under the Empire he seems to have worked with Marie-Etienne Nitot and, following the restoration of the monarchy, with Charles Ouizille. Vachette died on 23 September 1839 aged eighty-six.[5]

The mark of a boy's head and the numeral 2, and its companion mark a bear's head with the number 3 (see cat. no. 82) are frequently found on goldsmith's work apparently dating from soon after the Revolution. It has been suggested that these are standard marks for 20- and 18-carat gold and that they were used during the period 1793 to 1797.[6] However, the presence of the child's head mark on a gold eagle in the Wallace Collection by Biennais,[7] which is unlikely to date from before 1804, and on the top chape of a scabbard to a sword mounted by Biennais for Napoleon in the Wellington Museum, London,[8] suggests that the

Notes
1 Douet, p 102
2 Carré, p 202
3 Carré, p 202
4 Waddesdon catalogue, no. 127
5 Nocq IV, p 76
6 Nocq and Dreyfus, p xv; Dennis, p 21
7 Inv. no. XII A66
8 Inv. no. WM 1230c–1948

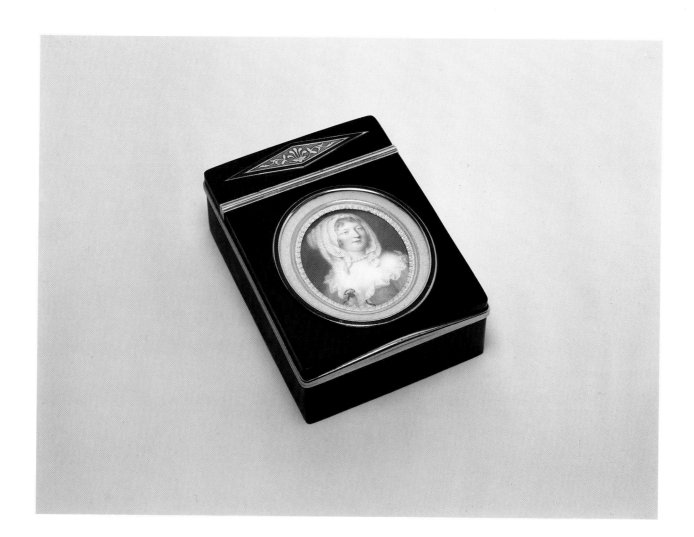

mark was used later. Furthermore, a box in the collection of Messrs Garrards, London, bears the boy's head mark in conjunction with that of Veuve Blerzy whose mark was not registered until 1808 (see cat. no. 79). Gold bearing these marks had to be re-marked before sale and so the present box bears the additional marks used in Paris between 1809 and 1819.

The miniature set in the lid may be attributed Jean Petitot. This prolific enameller was born in Geneva on 12 July 1607, and was later apprenticed to the goldsmith Jean Royaume, his uncle, until 1626. Leaving Geneva after 1632, Petitot worked in England for the court of Charles 1 between about 1636 and 1643, having arrived by way of Paris, where he probably learned the art of painting portraits in enamel. It seems that he returned to Paris because of the dangers of the Civil War in England, and worked in that city until 1686. It was presumably during this period that the present portrait was executed. So much in demand was the work of Jean Petitot that he only had time to paint the faces of his sitters while his life long friend Pierre Bordier filled in such details as clothes and jewellery. A staunch protestant, Petitot was not welcome in France following the Revocation of the Edict of Nantes and he returned to his native Geneva and then to Vevey for the remainder of his life. He died in 1691 at the age of eighty-four.[9]

Madame Antoinette du Ligier de la Garde Deshoulières was born in Paris on 1 January 1638. Her father was maître d'hotel of Anne of Austria. She married Guillaume de la Fon de Boisguérin, sieur Deshoulières, a gentleman ordinary of the Prince de Condé in 1651. She and her husband accompanied Condé to Brussels where, it has been suggested, that she had an affair with the Prince. Returning to France in 1660, she devoted herself to letters, and published her first volume of poems in 1672 under the pseudonym of Amarylis. Her salon in the rue de l'Hommes armé was famed as a centre for literati and she herself earned the title of tenth Muse, Calliope français. She died in 1694.

Although boxes with portraits are frequently referred to as *boîtes à portrait*, it seems likely that Nocq and Dreyfus were correct in emphasising that by the eighteenth century a *boîte à portrait* was a pendant containing a miniature rather than a box.[10] There is clearly a distinction in the *Registres des Presents du Roi* between a *boîte à portrait* and a *tabatière*, as for example with the gift to the Venetian ambassador M. Moncenigo, on 30 July 1735, 'une boîte à portrait, de chez Gouers, garnie de diamants roses et brilliants' which was surely different in type from the 'tabatière d'or de chez Rondé, renferment les portraits du Roi et de la Reine' given to the Abbé Lascaris two years later.[11] For a fuller discussion of the term *boîte à portrait*, see pp 19 and 20 above.

A similar box by Vachette, but with marks for 1798–1809, bearing a portrait of Colbert by Petitot is in the Louvre (fig 1)[12] and another which had the same distinctive hinge was in the Chester Beatty Collection.[13]

Notes

9 Clouzot, p 202, no. xxxv
10 Nocq and Dreyfus, p vi
11 Maze-Sencier, p 170
12 Grandjean, no. 355
13 Sotheby's, 3 December 1962, lot 123

ILLUSTRATION

1 *Box of gold and tortoise-shell, set with a miniature of Colbert by Petitot, by A.-J.-M. Vachette, Paris, 1798–1809 (Musée du Louvre, Paris)*

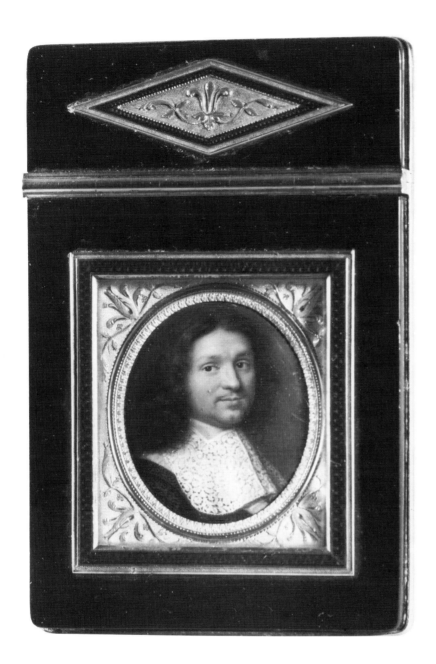

82 Snuff-box

Octagonal gold box, *carré à pans*, of six panels engine-turned with circles and quatrefoils edged by translucent blue *champlevé* enamel, the gold ground forming Neo-Classical borders.

Dimensions
Height: 2 cm; length: 8.9 cm; depth: 5.6 cm

Provenance
K 1 3 2 B

Marks

In the lid, in the base, in the right-hand wall and in the right-hand side of the bezel
1 Maker's mark of Jacques-Ambroise Oliveras, goldsmith recorded in Paris in 1810[1]
2 Mark, possibly a standard mark for 18-carat gold in France between 1793 and 1797 or later[2]

On the left-hand side of the bezel
3 Restricted warranty mark for Paris for gold, 1798–1809[3]

French, Paris, late eighteenth or early nineteenth century, by Jacques-Ambroise Oliveras

The form and decoration are typical of boxes produced in the period following the French Revolution. Several makers such as Charles Ouizille, Etienne Nitot and Pierre-André Montauban seem to have favoured the shape and boxes by them in this style may be seen in many public collections in Europe and America.

The marks on this box are of a type frequently found on goldsmiths' work but, as yet, not satisfactorily explained. Nocq and Dreyfus affirm that the bear's head with a number 3, and its companion mark presumably for a higher standard, a boy's head and a 2 (see cat. no. 81), were marks used from the fall of the monarchy in 1793 until the official re-establishment of hall-marking in France following the law of 19 Brumaire VI (9 November 1797). Dennis confirms this and notes that silver and gold had to be re-marked under the new law before it could be sold, which would explain the presence of later marks on boxes which are stamped with the bear's or the boy's head. Hence, therefore, the restricted warranty mark on the present example. However, the picture is confused by the presence of the child's head mark on a small gold eagle in the Wallace Collection, London, by Martin-Guillaume Biennais, which is unlikely to have been made before Napoleon's ascension to the purple in 1804,[4] and on the scabbard of a sword in the Wellington Museum, London, signed Biennais, formerly the property of the Emperor.[5] Furthermore, a box in the collection of Messrs Garrards, London, bears the boy's head mark in conjunction with that of Veuve Blerzy whose mark was not registered until 1808 (see cat. no. 79).

Mrs Le Corbeiller has kindly supplied the following information about Jacques-Ambroise Oliveras. J. A. Azur[6] lists Oliveras under the heading 'Bijoutiers (fabricans en or). Et genre principal de la fabrique', a category which specifically excludes those goldsmiths who had a shop. His address is given as quai de la Mégisserie, no. 48, and he is described as specialising in 'La bijouterie dans Toutes ses parties et la joaillerie'. This is the only box known to the author to bear his mark, but a silver-gilt and tortoise-shell comb set with Roman mosaics bearing post-Revolutionary marks and those for Paris, 1798–1809, is also by him.[7]

Notes
1 J. A. Azur, *Almanach des fabricans* (Paris, 1810) p 31
2 Nocq and Dreyfus, p XV
3 Carré, p 200
4 Inv. no. XII A 66
5 Inv. no. W.M. 1230C–1948
6 J. A. Azur, *loc. cit.*
7 Christie's, London, 12 July 1983

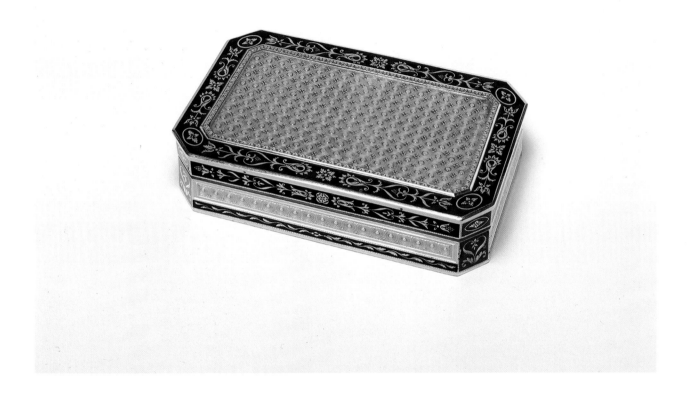

83 Snuff-box

Rectangular gold snuff-box with six panels of mother-of-pearl engraved with leaves and inlaid with a diaper pattern of gold engraved with ribbons and leaves enclosing gold flowers and leaves, mounted *à cage* in gold engraved with scrolls and set with an asymmetrical scrolling thumbpiece. Inside the lid is a portrait in gouache of a lady wearing an open robe with a stomacher and matching petticoat over a white chemise, and a white cap beneath a black lace shawl which hangs around the shoulders. In her left hand she holds a book, and to her right is a small table on which are a bag and a gold box.

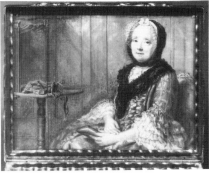

Interior of the lid

Dimensions
Height: 3.9 cm; length: 7.9 cm; depth: 6.2 cm

Provenance
Mary A. Boyle Collection, sold Sotheby's, New York, 20 November 1970, lot 74
J. Ortiz-Patiño Collection, sold Christie's, 27 June 1973, lot 16
K160F

Marks

In the base and in the front wall
1 Unidentified maker's mark in the style of a Paris goldsmith's, comprising the initials DF(?)P and a *différent* beneath what is intended as a crowned fleur de lis and two *grains de remède*
2 Mark imitating the charge mark of the *sous-fermier* Antoine Leschaudel, 1744–50
3 Mark imitating the wardens' mark used in Paris, 14 October 1747 until 12 August 1748

On the left-hand side of the bezel
4 Mark imitating the discharge mark of the *sous-fermier* Antoine Leschaudel, 1744–50

Probably French, nineteenth century or later

It has been supposed hitherto that the marks on this box are those used by the Paris guild between 14 October 1747 and 12 August 1748, and that the maker's mark is that of a Paris goldsmith. Until recently the mark was identified as that of Dominique François Poitreau, whose mark, DFP and a crown beneath a crowned fleur de lis and two *grains de remède*, was registered on 16 July 1757.[1] Since this was ten years after the use in Paris of the date letter 'G' (1747–48), it is clear that Poitreau cannot have been the author of the present box. The goldsmith Denis Desportes has been suggested as an alternative maker.[2] However Desportes' mark, struck on 18 January 1715, comprised the initial DDP and the device of a doorway (*porte*).[3] It has also been pointed out that Desportes was dead by 26 November 1748, when his widow assumed control of the workshop at pont au Change. It is not possible to read the device in the maker's mark on the present box as a doorway, and indeed the initials do not appear to be DDP but rather DFP as is shown by examining the same mark clearly struck on cat. no. 84. Comparison of the marks purporting to be those of the *sous-fermier* Antoine Leschaudel with those on Paris boxes of the period 1744–50 reveals a difference in the drawing of the arm (charge) and of the salmon's head (discharge). Similarly the crown and script of the 'date letter' digress from the wardens' mark in Paris for 1747–48 in slight details.

Notes
1 Nocq III, p 347
2 Christie's, 27 June 1973, lot 16; Snowman (1974) p43
3 Nocq II, p 78 and Addenda p 16
4 Norton, pl. 3A, p 35
5 Sotheby's, New York, 20 November 1970, lot 74
6 Christie's, *loc. cit.* I am most grateful to Miss Barbara Scott for her opinion on the identity of the sitter
7 Snowman (1966) fig 263
8 I am indebted to Dr Carl Hernmark and to Dr Gunnar Lundberg for their assistance over the question of the identity of the sitter
9 My thanks are due to Mrs Madeleine Ginsburg of the Textiles Department of the Victoria and Albert Museum, London, for her opinion as to the date of the costume

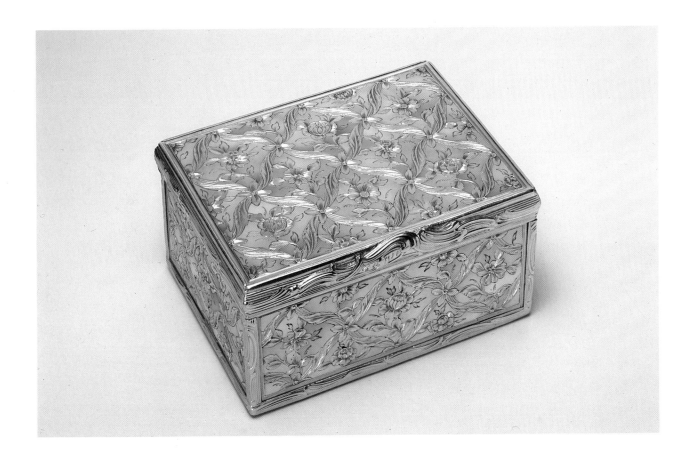

ILLUSTRATION
1 *Snuff-box of gold and diamonds by Louis Pin, Paris, 1747–48 (S. J. Phillips, London)*

It has long been accepted that goldsmiths outside France struck their wares with marks imitating those used in Paris. However, so close are the marks on the present box to those used by the Paris guild that it is tempting to suggest that they are not of the type used in Switzerland and elsewhere in the eighteenth century but were struck by a maker acquainted with French eighteenth-century practice sometime in the nineteenth century, or later, probably in France. The decorative scheme for the box would appear to be adapted from a Paris box dating from 1747 where very similar ornament is used but in diamonds rather than gold and mother-of-pearl (fig 1).[4]

The identity of the sitter in the portrait has also raised problems. At one time the portrait was thought to have been of Marie Leczinska, wife of Louis XV, after a portrait by Nattier.[5] More recently Miss Barbara Scott has suggested that the subject is in fact Countess Tessin, wife of the Swedish ambassador to the Court of France, and a close friend of the queen.[6] She attributes the miniature to Nicholas Lafrensen the Elder and notes that the sitter wore the same dress in a portrait by Lundberg in a private collection. This identification is not universally accepted and it has been drawn to the author's attention that the dress in the miniature is similar to that worn by Marie Leczinska in a portrait in a box in the Wrightsman Collection at the Metropolitan Museum, New York,[7] and that if these two great ladies wore such similar dresses there is no reason to suppose that others of their circle did not wear the same.[8] Both the miniatures appear to date from the late 1750s, and it is therefore probable that the present box was made as a vehicle for this charming portrait.[9] That such things were not uncommon is witnessed by a box in the Wallace Collection, London (see fig 2, cat. no. 87) which also contains an eighteenth-century miniature.

Additional bibliography
Snowman (1974) no. 16

84 Snuff-box

Rectangular gold snuff-box with six panels of mother-of-pearl marquetry encrusted with gold depicting the arts of architecture and sculpture, mounted in a cagework of gold engraved with flowers and scrolls.

Dimensions
Height: 4.4 cm; length: 7.5 cm; depth: 5.6 cm

Provenance
S. J. Phillips, London, 1970
K 154 A

Marks

In the lid, in the base and in the front wall
1 Unidentified maker's mark in the style of a Paris goldsmith's, comprising the initials DFP and a *différent* beneath what is intended as a crowned fleur de lis and two *grains de remède*
2 Mark imitating the charge mark of the *adjudicataire des fermes générales unies* Jean-Jacques Prévost, 1762–68
3 Mark imitating the wardens' mark used in Paris, 18 July 1764 until 22 July 1765

On the right-hand side of the bezel
4 Mark imitating the discharge mark of the *adjudicataire des fermes générales unies* Jean-Jacques Prévost, 1762–68
5 Restricted warranty mark for Paris for gold, since 10 May 1838[1]

Probably French, nineteenth century or later

The maker's mark on this box has been attributed to Dominique-François Poitreau who was received as master on 16 July 1757 and continued working until his retirement in 1781.[2] However Poitreau used a crown as his device and this is not evident in the mark on the present box. Furthermore, the mark on this piece is the same as that used to strike cat. no. 83 in conjunction with marks purporting to be those used in Paris in the years 1747–48 but considered by the author to be of later date. Since Poitreau had not registered his mark at this early date neither maker's marks can be his. As with the other marks on cat. no. 83 those on the present box, with the exception of 5, differ from those used in Paris in the eighteenth century. Whilst it is not impossible that the marks are those used outside France in imitation of those used by the Paris guild by craftsmen in Switzerland and elsewhere at more or less the same time as those used in Paris, it seems more probable that they were struck by a maker acquainted with French eighteenth-century practice sometime in the nineteenth century, or later, probably in France.

Boxes with mother-of-pearl decoration enjoyed considerable popularity in the mid-eighteenth century, not just in Paris but in other fashionable centres such as Berlin and Dresden. However, while it is not impossible that parts of this box are of eighteenth-century origin, the slightly stiff attitude of the figures and the flat engraving of the gold suggest a date of manufacture in the nineteenth century at the earliest. A box in the Rijksmuseum, Amsterdam, also bearing simulated Paris marks but attributed to Berlin may be cited in comparison with the present example.[3]

Notes
1 Carré, p 208
2 Nocq III, p 347
3 Snowman (1966) figs 552–54

Additional bibliography
London, Victoria and Albert Museum, *Third International Art Treasures Exhibition* (London, 1962) no. 346, pl 203, where the box is erroneously stated to date from 1784

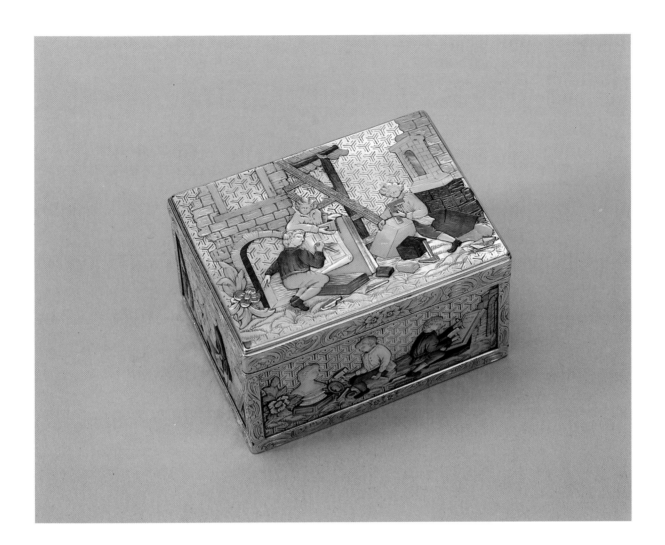

85 Snuff-box

Rectangular snuff-box of gold decorated on all sides with red and black japanning *piqué* with gold and silver wire and encrusted with mother-of-pearl depicting chinoiserie scenes on the lid and sides, and a cartouche on the base. The front of the lid is embellished with an unusually large thumbpiece of scrolls and a mask.

Dimensions
Height: 3.6 cm; length: 8.2 cm; depth: 6.5 cm

Provenance
Wartski, London, 1966
J. Ortiz-Patiño Collection, sold Christie's, 27 June 1973, lot 15
K 160 E

Marks

In the lid and in the right-hand wall
1 Unidentified maker's mark in the style of a Paris goldsmith's, comprising the initials CP and a star beneath a crowned fleur de lis and two *grains de remède*
2 Mark imitating the charge mark of the *adjudicataire générale des fermes générales unies* Julien Alaterre, 1768–72
3 Mark imitating the wardens' mark, Paris, 12 July 1769 until 15 July 1770

On the right-hand side of the bezel
4 Mark imitating the discharge mark of the *adjudicataire générale des fermes générales unies* Julien Alaterre, 1768–72

Possibly German, probably mid eighteenth century; the marks added later

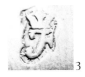

The marks on this box have hitherto been accepted as that of Claude Perron, who struck his mark, CP and a star beneath a crowned fleur de lis and two *grains de remède*, on 17 July 1758 and continued working until his death on 20 December 1777,[1] and the Paris marks for 1769–70. However, examination of the 'charge', 'discharge' and 'wardens' marks reveal that these differ from those used in Paris for gold at that date, and are not dissimilar to those used in Switzerland and elsewhere in imitation of those of the Paris guild at the same time. However, the possibility that the marks have been added at a later date cannot be excluded. Furthermore, the style of the box is rather too early for the date which the marks purport to give it. Although the red substance covering the surfaces of the box has

ILLUSTRATION
1 *Plaque, painted and encrusted with gold, silver and shell, signed 'Counrad fecit 1756', possibly Dresden, dated 1756 (S. J. Phillips, London)*

Notes
1 Nocq III, p 315

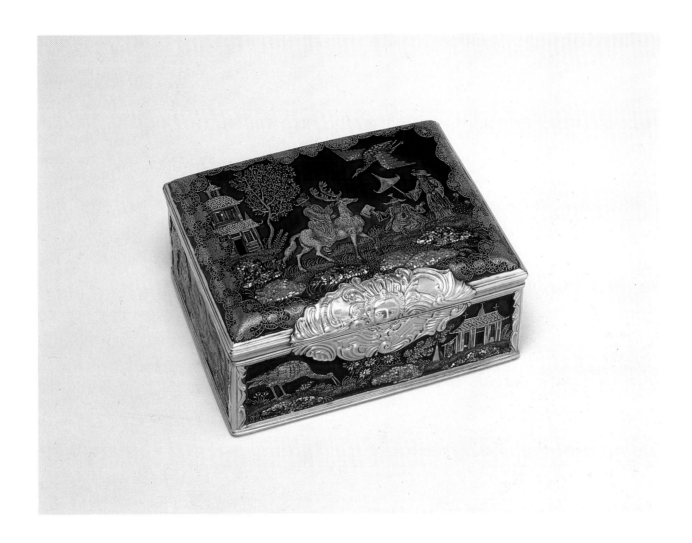

Notes
2 Pazaurek, T., pp 161–64
3 Collection of Arturo Lopez-Willshaw, Sotheby's, Monte Carlo, 23–24 June 1976, lot 322

Additional bibliography
Snowman (1966) fig 375
Snowman (1977) no. 43

been described as leather, occasional splashes of colour on the gold borders of the box indicate that the colour was painted on, that is to say, what in England would be referred to as 'japanned'. The large baroque thumbpiece is quite untypical of French boxes although it would not seem out of place on one produced in Germany. The use of mother-of-pearl, so called *lac burgauté*, and the gold wire in the decoration recall the style of work usually attributed to Johann Martin Heinrici, the decorator of Meissen and other porcelain.[2] Further reference should be made to a plaque decorated with gold and silver wire, mother-of-pearl and paint which is signed 'Counrad fecit 1756' and which has been attributed to Dresden (fig 1).[3]

86 Snuff-box

Oval gold box engraved all over with a diaper pattern bordered by scrolls enclosing six chinoiserie scenes after François Boucher and sprays of flowers enamelled *en basse-taille* in translucent blue. On the lid, three musicians play on a dais in a garden; on the base two fishermen and a girl are shown on a wooden pier; on the front a flautist and a child play in a garden; on the back a lady and child take tea; on the left a man sits beneath a lean-to shed, a girl with a net standing beside him; and on the right a cymbal player entertains a girl with a parrot.

Dimensions
Height: 3.8 cm; length: 8.5 cm; depth: 6.2 cm

Provenance
Mme Dhainaut Collection, Paris, sold Sotheby's, 10 December 1936, lot 43
Henry Nyberg, London
Villiers David Collection
J. Ortiz-Patiño Collection, sold Christie's, 17 June 1973, lot 19
K160G

Marks

On the lid, in the base and inside the front wall
1 Maker's mark imitating that of the Paris goldsmith Noël Hardivilliers
2 Mark imitating the charge mark of the *sous-fermier* Julien Berthe, 1750–56
3 Mark imitating the wardens' mark for Paris, 14 July 1753 until 12 July 1754

On the right-hand side of the bezel
4 Mark imitating the discharge mark of the *fermier* Eloy Brichard, 1756–62

Western European, possibly French or Russian, nineteenth century

Although this group of marks has passed unquestioned hitherto, there are several inconsistencies which it is impossible to explain.

The maker's mark, although similar to that of Noël Hardivilliers differs in certain respects from that usually ascribed to the famous Paris goldsmith. The mark registered by Hardivilliers in 1729 was a crowned fleur de lis, two *grains de remède*, NH and a cockerel (fig 1).[1] The same combination of letters and symbols is used for the mark struck on cat. no. 86, but the shape of the mark is quite different from that found on boxes by Hardivilliers dated 1752–53 in the Louvre[2] and of 1729–30, 1753–54 and 1754–55 in the Metropolitan Museum, New York (Wrightsman

ILLUSTRATIONS
1 *Maker's mark of Noël Hardivilliers from a gold box dated 1752–53 (Musée du Louvre, Paris, Inv. no. OA7679)*
2 *Etui, enamelled gold, bearing the same maker's mark as cat. no. 86 (National Trust, Waddesdon Manor)*
3 *Box of gold and enamel by Hubert Cheval, Paris, 1749–50 (Wallace Collection, London, Inv. no. G8)*

Notes
1 Nocq II, pp 311–12
2 Grandjean, no. 124, p414
3 Watson, no. 67, p251; no. 9, p140;
 no. 12, p149
4 Inv. no. M.169–1941
5 Grandjean, nos 125 and 127
6 Snowman (1966), figs 252–53
7 Snowman (1966), fig 181
8 Waddesdon catalogue, no. 63, p139
9 Nocq IV, p235 and nos 53–62

Additional bibliography
Snowman (1966), fig 295
London, Wartski, *A Thousand Years of
 Enamel* (London, 1971) pl. 100
Snowman (1974), no. 25

Collection)[3] and on a box of 1753–54 in the Victoria and Albert Museum, London,[4] and in any case the cockerel contained in the mark on cat. no. 86 faces the opposite direction. The mark struck on the present example is found on two boxes attributed to Hardivilliers in the Louvre.[5] One bears the same group of marks as cat. no. 86, but the other, about which M. Grandjean clearly has reservations, is said to date from 1778–79, when the goldsmith is thought to have retired in 1771. A further box bearing the same marks as the Thyssen box is in the Museum of Fine Arts, Boston[6] which is unusual in that it is encrusted with silver-gilt and which the author considers is a pastiche of the box Thévenot, dated 1745–46 in the Hermitage at Leningrad.[7] It seems unlikely that Hardivilliers, at the peak of his career would copy an earlier box in a cheaper medium. The maker's mark also appears in an *étui* at Waddesdon Manor which was ascribed by the author to Paris and dated 1767–68, but which he now feels may be nineteenth century (fig 2).[8] The shaped base appears in the drawing in Nocq.

The charge mark on cat. no. 86 again differs from that normally accepted to be the mark used by Julien Berthe between 19 October 1750 and 12 October 1756.[9] Although it may be argued that the difference in shape may be accounted for by stretching the metal during the work following marking, this cannot be the case in this instance, for the mark would have had to be stretched in exactly the same

4 *Detail of fig 3*

5 *Jean Pierre Louis Laurent Hoüel. Engraving from Suite de Figures Chinois after François Boucher (Musée du Louvre, Paris, Inv. no. 18624LR)*

6 *Gabriel Huquier. Engraving of 'Chinois et Chinoise pêchant au bord d'un vivier' from Scènes de la Vie Chinoise after François Boucher, circa 1742 (Musée du Louvre, Paris, Inv. no. 18658LR)*

way on the lid, in the walls and in the base, which would be unlikely, and in exactly the same way as on the box in Boston and as on the Louvre's no. 125.

The date letter used by the wardens of the Paris guild when marking gold from 14 July 1753 until 12 July 1754 was a cursive capital 'N' beneath a crown.[10] Such a mark is clearly illustrated by Grandjean[11] and by Watson.[12] Neither has the scrolled end to the base of the left-hand upright as on the mark on cat. no. 86 or on the Louvre box (no. 125) and the Boston box.

The mark of a scallop shell used on the Thyssen-Bornemisza box also differs from that found on boxes completed between 1756 and 1762. The mark of the scallop which is accepted as that used in Paris in the eighteenth century has a concave depression at the 'hinge' above the straight edge of the mark.[13] The mark on the present example has a shaped base above a convex protrusion from the shell and, therefore, cannot have been the mark struck by the office of the *ferme* in Paris between 1756 and 1762.

If the marks on this box are not accepted as those used in Paris in the eighteenth century, several attributions are possible. It could be that the box is of eighteenth-century Parisian origin having rubbed marks and that spurious marks have been added, much as a genuine picture might be given the signature of an important artist in order to increase its value. However, the absence of a Paris discharge mark, combined with the absence of any damage to the enamel makes this unlikely. It is possible that the box originated in Switzerland or Sweden[14] where the use of translucent enamel *en basse-taille* is well documented. However, the marks are quite unlike those often found on eighteenth-century boxes attributed to Switzerland and termed by A.K. Snowman 'prestige marks'. It therefore seems probable that this box is the product of a highly skilled goldsmith working before 1914, the year in which the Louvre acquired their box which is said to date from 1778-79

Detail of engraving and enamel

7 *Gabriel Huquier. Engraving of 'Flutiste et enfant timbalier' from Scènes de la Vie Chinoise after François Boucher, circa 1742 (Musée du Louvre, Paris, Inv. no. 18654LR)*

8 *Gabriel Huquier. Engraving of 'Chinois et Chinoise portant un poisson' from Scènes de la Vie Chinoise after François Boucher, circa 1742 (Musée du Louvre, Paris, Inv. no. 18655LR)*

9 *François-Antoine Aveline. Engraving of 'L'Oiseau à bonnes fortunes' after François Boucher, circa 1748 (Musée du Louvre, Paris, Inv. no. 18256LR)*

Notes

10 Nocq IV, p 217
11 no. 163, p 417
12 no. 9, p 140
13 Watson, nos 12, p 150; no. 14, p 154; no. 15, p 156 and Waddesdon catalogue, no. 66, p 144; no. 83, p 164; no. 112, p 257; no. 138, p 312. Grandjean does not, unfortunately, illustrate the discharge on no. 125 in his catalogue
14 Bramsen, pp 282 and 284. See also Snowman (1966) figs 226–28 for an unmarked box with translucent enamel in the Rijksmuseum, Amsterdam
15 Rosalind Savill, 'Six Enamelled Snuff-Boxes in the Wallace Collection', *Apollo* CXI (1981) p 305, figs 3 and 4. I am also grateful to Miss Savill for the reference to the Dhainaut sale
16 Jean-Richard, no. 1088
17 Jean-Richard, no. 1133
18 Jean-Richard, nos 1126 and 1132
19 Jean-Richard, no. 202
20 Snowman (1966) pp 127–28 'Some remarks upon a number of the gold boxes illustrated in colour' by Sacheverall Sitwell

and which bears the same maker's mark.

The Louvre box (no. 125) said to date from 1753–54 may be a pastiche of another box in the same collection by François-Nicolas Génard, dated 1763–64. If it is accepted that the box in Boston is derived from that by Thévenot in Leningrad, it suggests that the goldsmith who used a spurious Hardivilliers mark was a clever copyist. The present box may well have been copied from one in the Wallace Collection, London which is similarly enamelled in translucent blue by the Paris goldsmith Hubert Cheval,[15] dated 1749–50 (fig 3), but it is clear that the maker of the Thyssen box had access to additional Boucher engravings.

The chinoiserie scenes appear to be taken from various engravings after François Boucher. The girl playing the flute on the right-hand side of the lid (fig 4) is after plate 6 in *Suite de Figures Chinois* engraved by Jean Pierre Louis Laurent Hoüel (fig 5)[16] and the two right-hand figures on the base are after 'Chinois et Chinoise pêchant au bord d'un vivier' from Gabriel Huquier's *Scènes de la Vie Chinoise* engraved after drawings by Boucher (fig 6).[17] The group on the front and that on the left-hand side are from two further engravings from the same series (figs 7 and 8).[18] The girl with the parrot shown on the right-hand side is taken from an engraving by François-Antoine Aveline after Boucher's 'L'Oiseau à bonnes fortunes' (fig 9).[19]

Denys Sutton, in an article entitled 'The Rich and the Rare' in *Apollo*, November 1980, on the taste of Sir Sacheverall Sitwell refers to this box. 'One perceptive comment' he writes, 'is on a yellow gold snuff-box made by Noël Hardivilliers once in the collection of Villiers David (Plate XV), which, Sachie says, is a little masterpiece of fantasie in its own right'. In his assessment of the box, Sir Sacheverall goes on to say that 'This little oval golden and blue object emerges as an entity more complete in itself than any creation'.[20]

87 Snuff-box

Rectangular gold snuff-box with six panels of chased gold, translucent blue enamel *en basse-taille*, shell and mother-of-pearl composed to form architectural caprices mounted *à cage* in gold chased with foliate scrolls. The base has an additional foot rim (wavy bezel).

Dimensions
Height: 4 cm; length: 8.5 cm; depth:6.5 cm

Provenance
J. Kugel, Paris, 1967
K142A

Marks

On the left-hand bezel
1 Maker's mark of an unidentified goldsmith, comprising the initials PT and a mitre beneath a crowned fleur de lis and two *grains de remède*
2 Mark imitating the charge mark of the *sous-fermier* Antoine Leschaudel, 13 October 1744 until 9 October 1750
3 Mark imitating the wardens' mark for Paris, 27 November 1745 until 27 November 1746

Partially repeated in the base 1

On the left-hand rim of the lid
4 Mark imitating the discharge mark of the *sous-fermier* Antoine Leschaudel, 1744–50

Probably French, nineteenth century

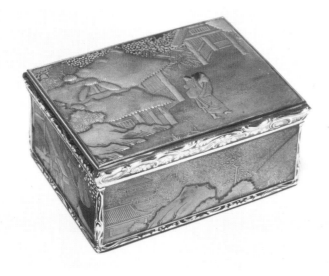
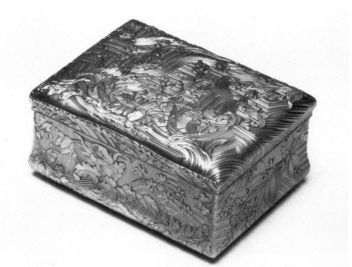

1

2

Nocq does not list a goldsmith with the initials PT using the device of mitre. Two goldsmiths with the initials PT are listed as working in the mid eighteenth century. Paul Thiboust (also called Pierre Thibout) registered a mark containing a crown on 30 September 1739 and worked until about 1766.[1] However, no gold box bearing his mark is recorded. Pierre Tiron attained the *maîtrise* on 2 December 1740 and struck the mark PT, a crowned fleur de lis, two *grains de remède* and an orb. This goldsmith filed for bankruptcy on 10 June 1754, and amongst his stock was listed boxes of gold, some enamelled, boxes of tortoise-shell, and of 'carton' mounted in gold. Two further boxes were said to have been at Jean George's.[2]

ILLUSTRATIONS
1 *Box of enamelled gold and lacquer with maker's mark P.T. with a mitre between (Wallace Collection, London)*
2 *Gold snuff-box with the maker's mark P.T. with a mitre between (Victoria and Albert Museum, London)*

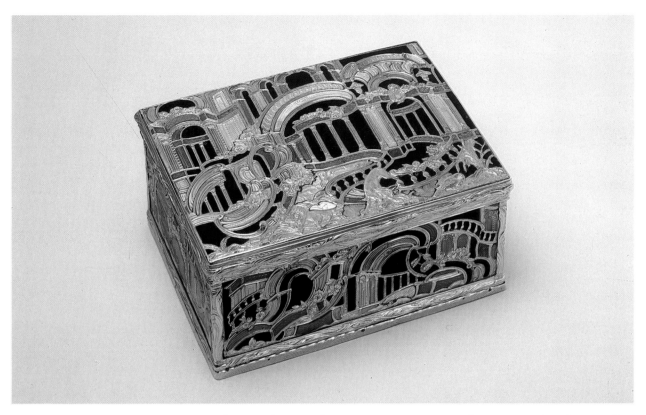

Notes
1 Nocq IV, p 41
2 Nocq IV, p 55
3 Inv. no. G.7
4 Inv. no. M.131–1917
5 I am grateful to Dr Graham Martin of
 the Victoria and Albert Museum,
 London for performing this assay

The mark PT and a mitre appears on at least two other boxes. One, in the Wallace Collection,[3] purporting to date from 1745–47, comprises Japanese lacquer panels which date from no earlier that the late eighteenth century, mounted *à cage* in rather coarsely enamelled gold (fig 1). The other, in the Victoria and Albert Museum,[4] which bears marks imitating those used in Paris in 1746–47 is of chased gold (fig 2). On all three boxes the maker's mark is struck more clearly than those purporting to be of the *sous-fermier* and of the wardens, which is a feature uncharacteristic of the eighteenth century.

However, further doubts have been raised as to the authenticity of the box in the Wallace Collection and the unusually coarse treatment of the decoration of the present box has given cause for believing it not to be of the period suggested by the marks. In consequence of these misgivings the author had the box in the Victoria and Albert Museum assayed. This test, carried out by x-ray fluorescence, and by atomic absorbtion spectrometry, demonstrated that the box was of 18-carat gold,[5] rather than of 20.25 carats the standard permissible in 1745–46. Since the marks are so close to those used in the eighteenth century rather than the looser interpretation of Paris marks favoured by the Swiss and known now as 'prestige marks', it is likely that they were deliberately intended to deceive. Of the three boxes examined by the author, that in the Wallace Collection can be shown to have existed possibly by 1872 when the collection was exhibited at Bethnel Green Museum, and certainly by 1897 when the collection was bequeathed to the nation by Lady Wallace. The Victoria and Albert's box was bequeathed to the museum by W. W. Aston in 1917. No earlier provenance is indicated in the museum's records. Thus it is reasonable to suppose that all three boxes were made at some time during the last century. The identical nature of the marks on all three boxes leaves no doubt that they are from the same workshop.

88 Snuff-box

Rectangular box of gold *en quatre couleur* (red, green, white and yellow) chased and engraved with harbour scenes with classical ruins in reserves bordered by scrolls. Some of the scenes depict the loading and unloading of various packages several of which bear numbers and initials. The container being manhandled on the front wall of the box is inscribed '1758 XI HL', which presumably refers to the date of manufacture. The rim of the lid is engraved with a diaper pattern with a raised thumbpiece at the front (straight bezel).

Dimensions
Height: 3.6 cm; length: 8.1 cm; diameter: 6.2 cm

Provenance
A la Vieille Russie, New York, 1968
K 1 3 3 D

Marks

Behind the lining of the lid
1 Mark probably imitating a Paris goldsmith's mark
2 Mark imitating the charge mark of the *fermier* Eloy Brichard, Paris, 1756–62
3 Mark imitating a Paris date letter

On the front of the bezel
4 Austro-Hungarian tax mark for 1806–1807[1]
5 Mark for objects imported into Paris from countries without customs conventions with France, since 24 October 1864[2]

Probably Swiss, dated 1758

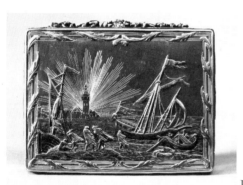

1 *Inscribed on the front wall*

During the examination of this box, the lining of the lid was removed and this revealed the marks illustrated above which are in the style similar to those usually ascribed to Swiss goldsmiths, and referred to as 'prestige marks'. It is interesting to note that the mark used in imitation of the Paris charge mark relates exactly in date to the inscription on the front of the box, and suggests that the goldsmith was aware of the changes in the Parisian tax marks. It is therefore not unreasonable to assume that when marks imitating those used in Paris are found, the pieces which bear them probably date from a period approximating that when they were legitimately used in France. Comparison between the present box and a similar piece in the Walters Art Gallery, Baltimore by Jean George, Paris, 1758–59 (fig 1), confirms that goldsmiths outside France were up to date with Paris fashions and not trailing several years behind as is normally believed.

 The harbour scenes would appear to be adapted, probably from an engraving, from a painting of a sea port by David Teniers the Younger in the Hermitage, Leningrad (fig 2).[3] The painting was in the collection of Count Bruhl, the director of the Meissen factory in Dresden when this box was made. The goldsmith has dated his work in the same place that Teniers had signed his painting, on the package being handled by three labourers.

ILLUSTRATIONS
1 *Gold snuff-box chased with harbour scenes by Jean George, Paris, 1758–59 (Walters Art Gallery, Baltimore)*
2 *David Teniers the Younger, Harbour Scene (State Hermitage Museum, Leningrad)*

Notes
1 Rosenberg IV, no. 7875
2 Carré, p 213
3 Inv. no. 565. N. Smols' Kaya, *Teniers* (Leningrad, 1962) no. 55, ill.

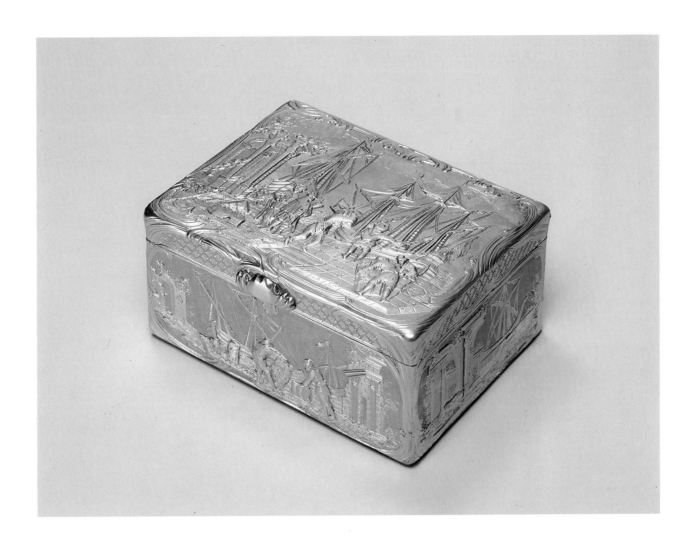

89 Snuff-box

Rectangular gold snuff-box of unusually small size with six enamelled miniatures mounted *à cage* in gold with bright-cut borders and engraved pilasters at the corners. The scenes, which appear to be after David Teniers the Younger, depict, on the lid, two peasants smoking and a peasant girl preparing onions, and on the base, three peasants at a table smoking, and, around the walls, children in rustic interiors.

Dimensions
Height: 2.5 cm; length: 4.4 cm; depth: 3 cm

Provenance
Baron Max von Goldschmidt-Rothschild Collection
Mr Charles E. Dunlap Collection, sold Sotheby's, Monte Carlo, 29 November 1975, lot 146
K I 25 N

Marks

In the lid
1 Initials G G, probably those of a master goldsmith
2 Mark probably imitating the charge mark of the *adjudicataire général* Julien Alaterre, Paris, 1768–75

On the bezel
3 Mark for Sweden, 1753–1912[1]
4 Standard mark for Sweden for 18-carat gold[2]

Probably Swiss, late eighteenth century

The marks 1 and 2 on this box, although not identified, are of a type normally ascribed to Switzerland. It has been demonstrated that marks of this sort appear to have been used at approximately the same date as those struck in Paris, which they imitate (see cat. no. 88). However, the taste for boxes with Flemish scenes continued into the nineteenth century as is demonstrated by a box by Gabriel Raoul Morel who is recorded in Paris from 1798 until 1832. This is similarly set *à cage* with plaques enamelled after paintings by Teniers.[3] The interior with three peasants smoking on the base of the present box is taken from an anonymous engraving after David Teniers the Younger (fig 1).

ILLUSTRATION
1 *Anonymous engraving (cut) of peasants after David Teniers the Younger*

Notes
1 Andrén, p 27
2 Andrén, p 28
3 Sotheby's, London, 10 December 1973, lot 85

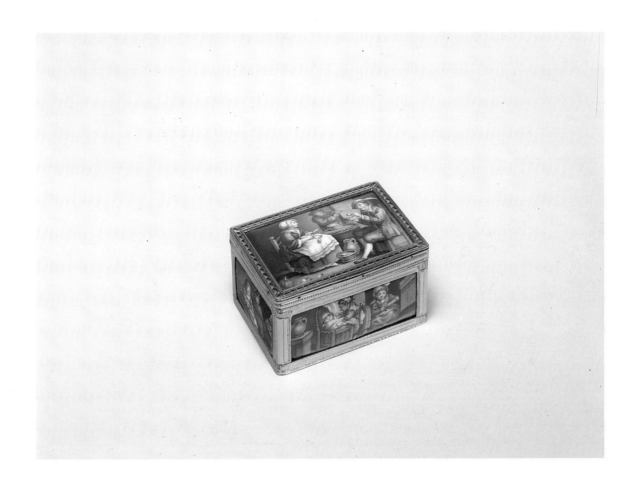

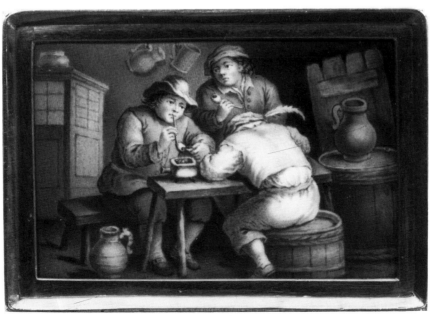

Detail of the base

90 Cane handle

Cane handle of brass set with five panels of mother-of-pearl encrusted with gold. Each panel around the sides has strapwork and foliage above, on two panels, a figure dressed in the costume of a Roman soldier, with a dog, and Diana carrying a hawk, and on the other two, a pair of putti holding spears and with a dog. The panel on the top shows a goat and goatherd.

Dimensions
Height: 5.4 cm; diameter: 3 cm

Provenance
bought by Baron Heinrich Thyssen-Bornemisza (1875–1947) before 1938
K 131

Apparently unmarked

Probably German, *circa* 1730

Although there is a certain similarity in the treatment of the figures on the cane handle to the treatment of figures in gold-encrusted enamels made by Guillaume Bouvier[1] and others in France in the mid eighteenth century, the style of the ornament suggests a German origin. Indeed, the strapwork appears closest to those accompanying grotesque designs by the architect Paul Decker (1677–1713). The absence of any mark may indicate that the piece is not of French origin.

Notes
[1] See cat. no. 91

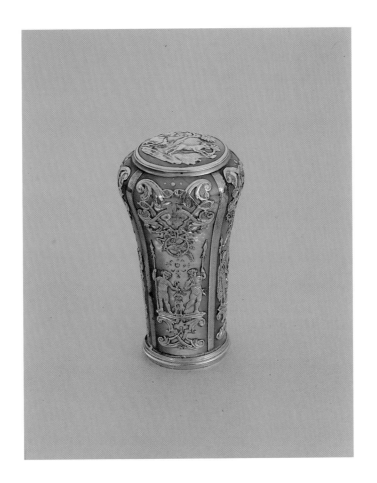

91 Snuff-box

Cartouche-shaped box with tapering base, the lid and body of which are of painted enamel on copper encrusted with gold foil joined with a plain gold mount. On the lid masks, birds and cartouches surround a central reserve of blue enamel encrusted with gold; on the body, which is painted en suite with the lid, are a gold mask and smaller gold encrustations. The inside of the lid is painted with a cartouche of flowers, leaves and diapered reserves.

Dimensions
Height: 3.2 cm; length: 6.3 cm; depth: 4.7 cm

Provenance
René Fribourg Collection, New York, sold Sotheby's, 14 October 1963, lot 275
A la Vieille Russie, New York, 1968
K133C

Marks

On the left-hand side of the bezel and on the left-hand side of the lid
1 Dutch tax mark for old work, 1859–93[1]
2 French mark for gold imported from countries with customs conventions with France, since 1 June 1864[2]

German, probably Berlin, *circa* 1730, workshop of Pierre Fromery

Several workshops in Europe specialised in encrusting enamel with gold foil, rather than simply gilding the enamel. Those establishments in Russia or that of the mysterious C.F.Laurentz,[3] which used silver encrustation rather than gold need not concern us here.

It is evident that the practice was common in France. For example, several enamels usually in the form of watchcases, with raised goldwork bear the signature of Guillaume Bouvier, who is recorded in Paris around 1740 (fig 1).[4] Another group may be associated with France since the gold *paillons* used in their decoration match those used on St Cloud porcelain. The enamels of this group are usually white, or stippled blue or grey (fig 2). It seems likely that they were made in or near Paris, and that the enamellers purchased *paillons* from one of the *Communauté des Paillonneurs* who were amalgamated into the goldsmiths' guild in 1777.[5]

At least two craftsmen are associated with gold encrustations on enamels or porcelain in Germany; Christian Friedrich Heröld and Conrad Hunger. Heröld worked as an enameller at the Meissen factory from 1726 until his death in 1779, and was one of the leading painters in the factory.[6] However, before taking up his employment at Meissen, he is said to have worked in the Berlin enamel workshop of Pierre Fromery, a Huguenot who left France for Prussia in 1668. This workshop is well known from a variety of enamelled copper pieces which bear the signatures: 'Fromery à Berlin', 'fromery à berlin kupfer' and 'Pierre Fromery' amongst others. Pierre Fromery died in 1738 and his son Alexander continued the business.[7] It is clear that C.F.Heröld was in the unusual position of working on his own account outside the Meissen factory, for a plaque, now in the Victoria and Albert Museum,[8] which is signed 'Herold fecit' and 'Alex. Fromery à Berlin', depicts the flight of Stanislas Leczinski from Danzig to Bar in 1734 (fig 3). Five years later, Heröld exhibited 'a sample of gold relief on porcelain' at the Meissen factory. This form of decoration is documented by a cup and saucer in the British Museum (fig 4) inscribed 'C.F.Herold invt. et fecit à Meisse 1750 d. 12 Septr', and other signed

Notes
1 Voet, p47
2 Carré, p212
3 London, South Kensington Museum, *Special Exhibition of Works of Art* (1862) no. 4829, a beaker of turquoise, pink and green enamel with silver figures in relief signed 'C.F.Laurentz fecit' which was in the collection of A.J.B.Beresford-Hope
4 Walters Art Gallery, Baltimore, Inv. no. 58.211
5 Poullin de Vieville, p429
6 Hugh Tait, 'Herold and Hunger', *British Museum Quarterly* XXV (1962) nos 1–2, pp39–41
7 Walter Holzhausen, 'Email mit Goldauflage in Berlin und Meissen nach 1700', *Der Kunstwanderer* (September 1930) pp4–12 and 73
8 Formerly in the Lady Charlotte Schreiber, Lady Bessborough and Lord Oranmore and Browne Collections; Sotheby's, 11 July 1960, lot 104; Christie's, 24 November 1981, lot 134; Victoria and Albert Museum, Inv. no. c.52–1982
9 British Museum, Inv. no. 1958.5–2.1; Sotheby's, London, 24 February 1981, lot 19
10 Holzhausen, *loc. cit.*
11 Uto Auktion, Ag Zurich, 3–5 November 1981, lot 11

Additional bibliography
Le Corbeiller, fig 569
Bramsen, p129, no. 281

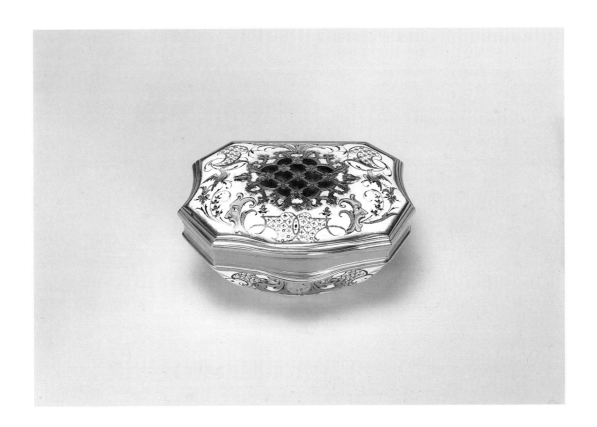

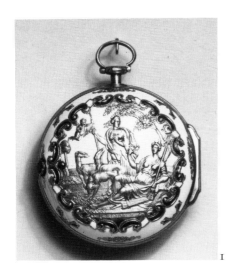

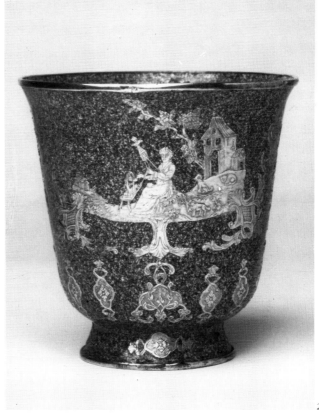

ILLUSTRATIONS
1 *Watchcase of copper, enamelled, and decorated with raised gold foil, signed G. Bouvier, French, Paris, second quarter eighteenth century (Walters Art Gallery, Baltimore)*
2 *Beaker of copper, enamelled grey-blue with raised gold paillons, French, mid eighteenth century (Victoria and Albert Museum, London)*

examples indicate that he practised the same technique on enamels (figs 5 and 6).[9] It has been demonstrated that many of the gold *paillons* were rubbed from medals by Raymund Falz and J. Boksam, as well as from those of Martin Brunner, P. H. Muller, G. F. Numberger and others.[10] It is likely that these *paillons* were supplied by specialists as in France, although, since Heröld's signature frequently appears on boxes with raised gold taken from medals it is possible that he rubbed the gold himself.

Apart from those pieces signed by Heröld, the Fromery workshop produced enamels, with and without raised gilding, which are documented by the signatures mentioned above. The style of painting is quite different from that found on the Heröld/Fromery plaque, and when depicting landscapes, at least one artist in Heröld's employ used a distinctive style. A small box in a private Swiss collection[11] (fig 7) shows, despite its condition, that this painter highlighted trees in black or dark green and portrayed grass with tufts of black comprising three near vertical strokes rising from a horizontal bar. An unsigned box in the Victoria and Albert Museum displays this style in a more refined form (fig 8). A very similar technique is used on the grand toilet services in the Munich Schatzkammer, in the Kunstsammlung, Hamburg, in the Kunst und Industrie Museum, Vienna and at Rosenborg Castle, Copenhagen,[12] as well as on a number of caskets and beakers, including one in the Thyssen-Bornemisza Collection (fig 9). Despite the temptation to attribute the whole group to Fromery, the presence of an enamel plaque signed 'JGV fec' (fig 10),[13] which is almost certainly by the same hand as the toilet services, adds confusion. The sole difference between them is one of technique. Where the gold has worn from enamels signed by Fromery, or in the style of Heröld, a coarse yellow background enamel is frequently found. On those associated with the plaque signed 'JGV' a fine white enamel is the base.

It could, of course, be argued that the unidentified enameller JGV was working for Fromery, as was Heröld, but the existence of another workshop cannot be excluded. It has recently become fashionable to attribute this style of work to an Augsburg workshop,[14] largely because so many of the enamels are mounted in silver by goldsmiths of that city. However, a great deal of Meissen porcelain was mounted in Augsburg, which indicates that there was a trade in mounting pieces from other cities. It does not suggest that Augsburg was necessarily the centre of production, and indeed the enamels commonly attributed to Augsburg are of quite a different nature. Furthermore, a snuff-box in the Corning Museum, New York, the body of which is of enamel decorated in a style similar to that of the toilet services, has a lid of glass cut on the wheel with the monogram FR, presumably for Frederick II, the Great, and therefore probably made in Berlin (fig 11).

The work of Conrad Hunger is altogether different. A cup and saucer signed 'Hunger F' in the Museum für Angewandte Kunst, Vienna,[15] shows his work to be lighter, closer in spirit to the French work, and apparently not depending on rubbings from medals for his *paillons*. In addition, like many unsigned enamels found in association with Paris goldsmiths' work, and in consequence likely to be French rather than German, as they are frequently described, Hunger's gold reliefs were decorated with translucent enamels.

The style of the present box is closest to the products of the Fromery workshop. The masks can be paralleled by gold-encrusted masks on the box in the Victoria and Albert Museum referred to above and the diaperwork is not unlike that on the Hamburg toilet service or the three boxes formerly in the Salomon Collection, Dresden.[16] An *étui* from the Goldschmidt-Rothschild Collection[17] is decorated in a very similar way. Indeed it is so close to the present example that it may well have been made en suite (fig 12).

ILLUSTRATIONS

3 Plaque of copper, enamelled and gilt, depicting the flight of Stanislas Leczinski from Danzig to Bar in 1734, signed 'Alex. Fromery à Berlin' 'Herold fecit', Berlin, workshop of Alexander Fromery, painted by C. F. Heröld, circa 1734 (Victoria and Albert Museum, London)

4 Saucer, hard-paste porcelain painted in enamel with raised gold foil decoration, signed 'C. F. Herold invt. et fecit à Meisse 1750 d. 12 Septr', Meissen, 1750 (British Museum, London)

5 Snuff-box top of enamelled copper with raised gold foil decoration, signed 'Herold fecit', Berlin, workshop of Alexander Fromery, decorated by C. F. Heröld (British Museum, London)

6 Snuff-box of copper, enamelled and decorated with raised gold foil, signed 'Herold fuit Meissen'. The box makes use of the same paillons as those on the cup and saucer in the British Museum (Sotheby's, London)

7 Box of enamelled copper with raised gold foil, now almost all retouched in paint, and mounted in silver-gilt, signed 'fromery Berlin' (private collection, Switzerland)

8 Snuff-box of copper, enamelled and decorated with raised gold foil, possibly from the workshop of Pierre or Alexander Fromery, Berlin, or by the enameller JGV, second quarter of the eighteenth century (Victoria and Albert Museum, London)

9 Detail of a beaker of enamelled copper with gold foil decoration, mounted in silver-gilt, Berlin, Fromery's workshop, or by the enameller JGV, second quarter of the eighteenth century (Thyssen-Bornemisza Collection, Lugano)

10 Plaque from a toilet box, of enamelled copper with gold foil decoration. The figure of Hercules is taken from a medal by Raymond Faltz; the plaque is signed 'JGV fec', circa 1730 (Christie's, London)

11 Snuff-box, the body of which is of copper, enamelled and decorated with raised foil, and the lid of glass cut on the wheel with the monogram FR, probably Berlin, Fromery's workshop, circa 1730 (Corning Museum of Glass, New York)

12 Etui, possibly intended to be en suite with the snuff-box (no. 91) from the Goldschmidt-Rothschild Collection (present whereabouts unknown)

Notes

12 Holzhausen, loc. cit.
13 Christie's, London, 8 December 1982, lot 15
14 Jahrbuch der Hamburger Kunstsammlungen II (1952) p 105 ff
15 Pazaurek, pl. facing p 146
16 Holzhausen, op. cit., Abb. 19
17 Ball and Graupe, Berlin, 24 March 1931, lot 324

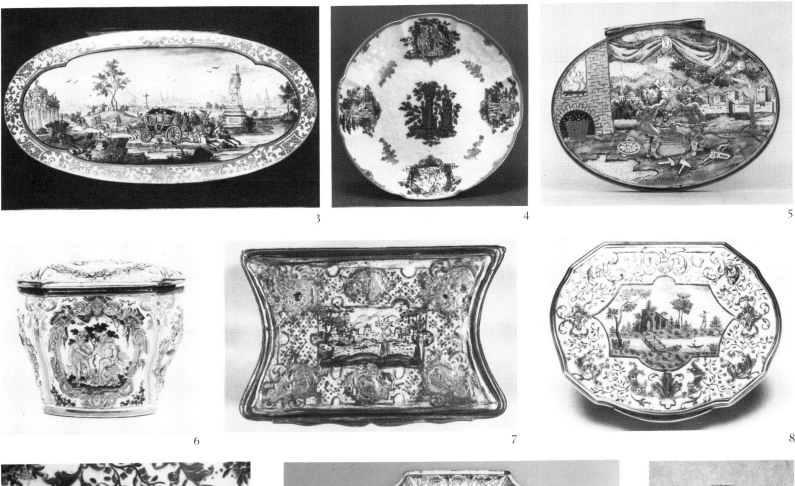

3

4

5

6

7

8

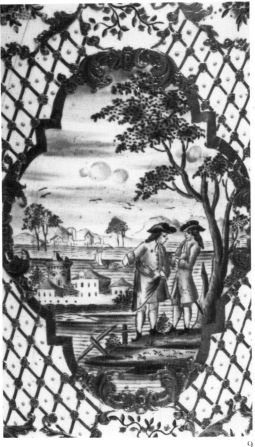

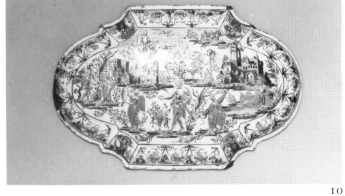

10

9

11

12

92 Snuff-box

Snuff-box in the form of a recumbent pug of Meissen hard-paste porcelain painted in enamels and gilt. The dog's coat and features are naturalistically treated. He wears a collar of blue decorated with purple scrolling and bordered in gold, with a gold buckle, and sits on a mauve cushion painted and gilded with flowers. The base, which opens to form the lid of the box, is painted inside and out with views of a castle and classical ruins. The gold mount is chased with scrolls and flowers, and has a slightly raised gold thumbpiece (straight bezel).

Dimensions
Height: 4.8 cm; length: 8.2 cm; depth: 4.6 cm

Provenance
Ader, Picard et Tajan, Paris, 21 February 1978, lot 30
K 190E

Apparently unmarked

German, Meissen, *circa* 1755

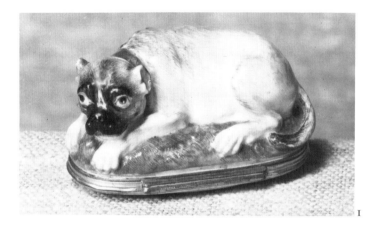

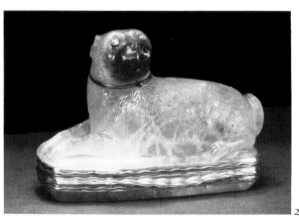

A pair of Meissen boxes of identical form, but with a child, and a putto, both with pugs painted on the bases is at Waddesdon Manor (fig 1). Several other Meissen boxes modelled as pugs but in different poses are known[1] and a particularly fine example is one in amethystine quartz, also at Waddesdon (fig 2).[2] The pug gained particular significance in Europe following the bull issued by Clement XII in 1738 forbidding Roman Catholics from belonging to Masonic orders. Many high born Catholics formed themselves into quasi-masonic lodges and took as their symbol the pug-dog. These orders of Mopses (after the German for 'pug') were pledged to secrecy, though not by an oath which would have conflicted with papal wishes, and unlike Freemasons, admitted women to their lodges. The author of *L'Ordre des Francs-Maçons trahi, et le secret des Mopses révelé* (Amsterdam, 1763), gives an amusing account of the order together with a description of the ceremony of initiation into it. Having been thoroughly frightened by rattling swords and chains and the threat of branding, and having had his or her tongue examined by the Grand Mopse, the novice was asked to kiss the tail of a model Mopse. The aims of the order were Love and Friendship and *Sociabilité*, and the meetings were usually accompanied by an excellent dinner with fine wines. Decency, we are told, was preserved at these occasions; 'They make love there, but it is usually only with the eyes: a more express declaration . . . would pass for indiscretion and for rudeness'.[3]

The carrying of a box such as the present example might have sufficed for the model pug which all initiates carried during lodge meetings, and it would certainly have identified the owner to others of the Order of Mopses.

ILLUSTRATIONS
1 *One of a pair of snuff-boxes in the form of pug-dogs, Meissen porcelain mounted in gold, circa 1755 (National Trust, Waddesdon Manor)*
2 *Snuff-box of amethystine quartz mounted in gold, Dresden, circa 1760 (National Trust, Waddesdon Manor)*

Notes
1 Collection of E. von Goldschmidt-Rothschild, Berlin, Ball and Graupe, 1931, lot 510, and in the Kunstindustrimuseum, Copenhagen, and Sotheby's, 6 December 1960, lot 37
2 Inv. no. WI/22/13
3 I am very grateful to the librarian at Freemasons' Hall, London for his generous assistance

Additional bibliography
Darmstadt, Schlossmuseum, *Mopsiade* (Darmstadt, 1973)

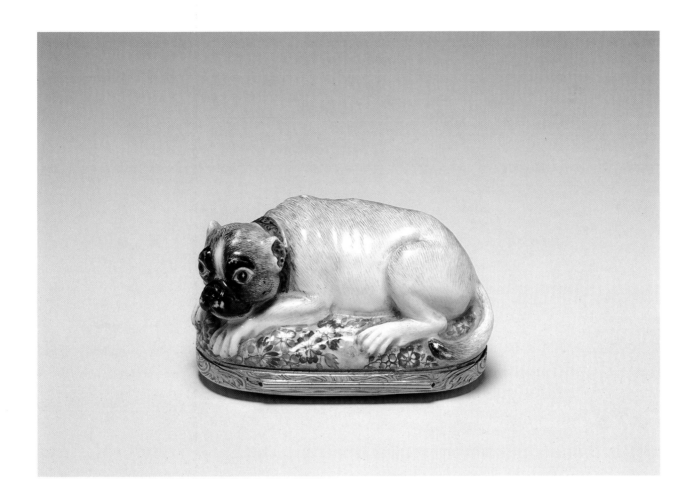

93 Double box

Double box of rock crystal in the form of a barrel, divided in the centre, and facet-cut in imitation of wooden panels. Each end of the barrel has a rock crystal lid, set in rouletted gold mounts, with gold reliefs depicting saints, painted in black, and decorated with gold wire. The body of the box is ribbed and hooped with short strips of gold wire set on paint, with similarly prepared scrollwork between. The interior division is decorated with the Sacred Monogram on one side and M beneath a crown on the other, both in gold.

Dimensions
Length: 5.5 cm; height: 4.2 cm; depth 3.5 cm

Provenance
Lord Rothschild Collection, sold Christie's, London, 30 June 1982, lot 52
K 154 B

Apparently unmarked

Probably German, mid eighteenth century

The purpose of this box is unclear. The saint depicted on one end, lying beneath a shelter whilst in the background a ship founders in a thunderstorm, may be identified as St James the Greater. That on the other end is shown with a pastoral staff and a putto at his feet. The source for this figure is clearly Pierre Puget's figure of Alessandro Sauli (1534–92) in the church of Sta Maria in Carignano, Genoa.[1] Puget worked on the figure from 1663 until 1668 and it was drawn by Bouchardon in 1732,[2] and may subsequently have been engraved. The Sacred Monogram IHS and the crowned M (or possibly MV in monogram) on the interior of the box both suggest that it was intended for religious use, rather than as a container for snuff. The size and shape make it unsuitable as a pyx, and it may therefore have been intended as a small portable reliquary.

It has been suggested that this box is Spanish, but no Spanish parallels are known to the author. A rock crystal and gold box in the form of a barrel by Jean François Ravechet, dated 1743–44, was in the collection of Mrs Elizabeth Parke Firestone.[3] However the absence of marks on cat. no. 93 preclude an attribution to Paris. A chalcedony and gold barrel-shaped box is in the Louvre and is probably English or German.[4] The decoration of the present example is similar in technique to the chinoiseries on cat. no. 85, and to the plaque signed 'Counrad' and dated 1756 in the collection of Messrs S. J. Phillips, London.[5] It also has affinities with the style of decoration attributed to Johann Martin Heinrici. The style of decoration, the absence of hall-marks and use of cut-stone, so popular with the goldsmiths of Germany suggest that this box may be of German origin, dating from about 1750–60. However, the representation of such an obscure saint may indicate that either the original owner, or maker, had connections with Genoa.

Notes
1 I am indebted to my colleague, Mr Malcolm Baker, for identifying the source. Klaus Herding, *Pierre Puget* (Berlin, 1970) pp 155–57 and pls 107–23
2 Herding, *op. cit.*, pl. 312
3 Christie's, New York, 19 November 1982, lot 35, and New York, A la Vieille Russie, *The Art of the Goldsmith and Jeweler* (New York, 1968) no. 54
4 Grandjean, no. 440
5 Illustrated with cat. no. 85, fig 1

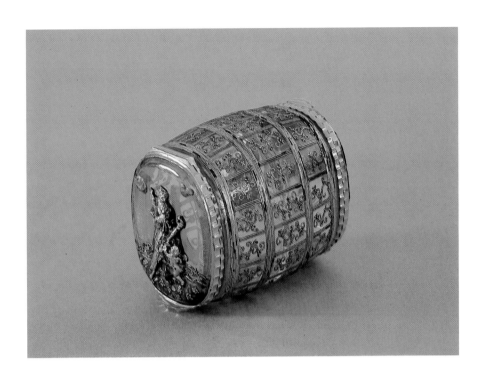

94　Snuff-box

Cartouche-shaped snuff-box of bloodstone, the vertical sides of which are composed of eight panels of stone mounted *à cage* in gold chased with undulating lines. The front panel is encrusted with an asymmetrical cartouche of scrolls. The lid is set with a further cartouche of scrolls upon which sit two putti holding a floral swag, and which is bordered by a broad rim of gold chased in scrolls. The thumbpiece is formed as a dog with a diamond collar recumbent upon a chequered cushion. The base is carved with a patera.

Dimensions
Height: 3.1 cm; length: 8.4 cm; depth: 6.6 cm

Marks

On the right-hand side of the bezel
1 French mark for gold imported from countries without customs conventions, since 1 June 1893[1]

 1

South German (Augsburg?), *circa* 1750

The crisply chased Rococo ornament, particularly in the cartouche on the lid, suggests a German origin. Although the precise source for the design of the lid has not been traced it is strongly reminiscent of the work of several Bavarian artists such as François Cuvilliés (fig 1), Franz Xavier Habermann and J. S. Klauber.[2]

　The breed of the dog which forms the thumbpiece is difficult to determine, but it is probable that the goldsmith intended to portray a pug, a dog which had considerable significance in eighteenth-century Germany.[3]

ILLUSTRATION
1 *François Cuvilliés. Design for a fountain*

Notes
1 Carré, p 213
2 See, for example, R. Berliner, *Ornamentale Vorlageblätter* (Leipzig, 1925) pp 385–406
3 See cat. no. 92

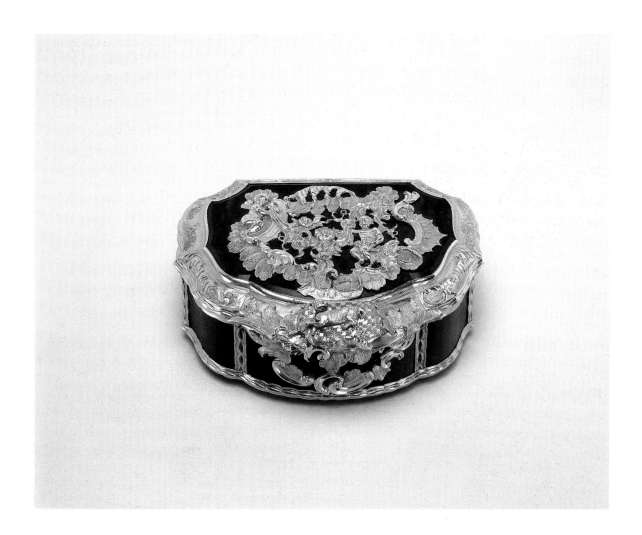

95 Snuff-box

Rectangular snuff-box covered with plaques of mother-of-pearl engraved and stained red, brown and blue and encrusted with gold, mounted *à cage* in gold chased with foliage. On the lid a lady and gentleman shoot pheasant accompanied by a dog-handler, on the base a gallant is shown beside a vase on a plinth, and around the walls, a hunter with his dogs, a deer, a rabbit and the spoils of the chase.

Dimensions
Height: 4 cm; length: 7.8 cm; depth: 6 cm

Provenance
Christie's, Geneva, 30 March–1 April 1975, lot 272
K I 30B

Marks

In the lid, in the base, in the left-hand rim of the lid and on the left-hand side of the bezel
1 Maker's mark of Alexandre Leferre, goldsmith working in Paris during the first half of the nineteenth century, when working with plated metal[1]
2 Mark denoting the quantity of gold used in the plated metal

On the left-hand rim of the lid and on the left-hand side of the bezel
3 Restricted warranty mark for Paris for silver, since 10 May 1838[2]

The box probably South German, *circa* 1760; the lining French, first half of the nineteenth century, by Alexandre Leferre

It is clear from the many boxes which bear his mark that Alexandre Leferre was a prolific and skilled goldsmith who worked in the style of the second half of the eighteenth century. Many of these boxes are vehicles for earlier miniatures, or plaques of mother-of-pearl. However, in this case Leferre has apparently only replaced the lining with what is now referred to as 'rolled gold'.

Mother-of-pearl encrusted with gold was popular with South German goldsmiths in the third quarter of the eighteenth century. Several sewing cases, for example, having figures in gold set against a pearl ground, but usually within a border of scrolls in gold rather than against an engraved ground as here, are known in various public and private collections.[3] These are usually ascribed to Augsburg, but so far as is known none bears the mark of that city. A gold box, with mother-of-pearl encrusted in gold in the Reiss-Museum, Mannheim, was made about 1745–50 by Jacob Breton, a Frenchman who became court goldsmith in that city in 1749.[4] This, however, has a particularly French flavour to the Rococo ornament rather than the crispness of that on the present box and on the sewing cases mentioned above.

The use of the restricted warranty mark for silver is remarkable but not, it seems, uncommon on plated metal.[5]

Notes
1 Grandjean, no. 302
2 Carré, p 209
3 eg, Waddesdon catalogue, nos 45–47
4 Reiss-Museum, Mannheim, *Kunst und Kunsthandwerk, Neuerwerbungen*
5 See, for example, Grandjean, nos 302 (where it is incorrectly identified), 305, 306 and 315

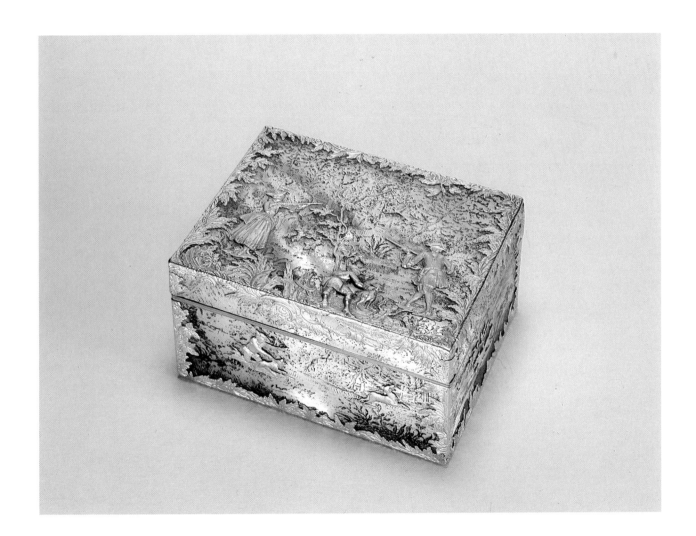

96 Snuff-box

Large cartouche-shaped box of slightly bombé form, comprising panels of chrysoprase mounted *à cage* in gold set with diamonds, some backed by pink foil, and encrusted with panels of gold *en quatre couleur* (red, green, white and yellow) depicting shepherds and shepherdesses in classical ruins likewise set with diamonds. Several of the architectural elements are inscribed with what appear to be a random selection of letters in imitation of classical inscriptions. On the base a plinth so inscribed also bears the numbers 176– probably intended to indicate the year of manufacture. The box is lined with gold (wavy bezel).

Dimensions
Height: 5 cm; length: 9.5 cm; depth 5 cm

Provenance
Frederick II, the Great, King of Prussia
Frederick William II, King of Prussia
Friedrich Alexander, Graf zu Dohna, and thence by descent through the Dohna-Schlobitten
 family
A la Vieille Russie, New York, 1968
K137

Apparently unmarked

German, Berlin, *circa* 1765

This box forms part of the group which were commissioned by Frederick II, the Great, King of Prussia, from 1740 until his death in 1786. Paul Seidel, who published the accounts relating to these boxes,[1] estimated that the King had purchased 125 boxes between 1742 and 1775, and that when he died there were 120 boxes at Sans Souci, all but one of which was set with diamonds. By 1939, fourteen boxes survived in the Hohenzollern Collection displayed in the museum at Monbijou. Eleven of these exist today, of which eight are displayed at Schloss Charlottenburg, Berlin, and three, lacking their diamonds following a theft in 1953, are at Burg Hohenzollern.[2] Two further examples are in the Hermitage, Leningrad,[3] and two more were in the collection of King Farouk of Egypt,[4] one of which is now in the Robert Lehman Collection at the Metropolitan Museum, New York. The Louvre possesses an example,[5] and another is in the collection of the Hessen-Darmstadt family.[6] Two additional boxes were offered for sale through Christie's in 1927, one from a foreign royal house (7 December, lot 68) and the other from the Russian royal collection (16 March, lot 91). Three other boxes from this group were offered for sale between 1972 and 1974,[7] and another from the collection of the Dukes of Anhalt-Dessau appeared at auction in 1982.[8] A further example is in a private collection in England.

The designs for these boxes seem to have been supplied by Jean Guillaume George Kruger,[9] an artist born in London in 1728 but who moved to Berlin in 1753. It is evident that Kruger went to Paris for he is recorded at the Academie de St Luc in 1774, but he returned to Berlin, where he died in 1791. Fourteen designs for boxes by Kruger survive, thirteen of which are in the Kupferstich Kabinett, Berlin, and one was offered for sale by Christie's on 30 June 1971 (lot 25). However, none relates directly to the present box.

Several goldsmiths supplied boxes to Frederick II and these firms, together with brief descriptions of the pieces supplied, and their prices are recorded in the *Schatullen-Rechnungen* (accounts of the privy purse). From 19 January 1742 until 2 January 1753, Christian Ludwig Gotzkowsky supplied watches, rings, a sword and snuff-boxes in gold, hardstones, Vernis Martin, mother-of-pearl and papier maché. From 1743 until 1765, the firm of Veitel Ephraim and Son delivered a variety of jewellery but only one snuff-box, which was of gold set with diamonds

Notes
1 Paul Seidel, 'Die Prunkdosen Friedricks des Grossen', *Das Hohenzollern Jahrbuch* V (1901) pp 74–86
2 Winfried Baer, 'Ors et Pierres des boîtes de Frédéric-le-grand', *Connaissance des Arts* CCCXLVI (December 1980) pp 100–105
3 Snowman (1966) figs 536–37
4 Sotheby's, Koubbeh Palace, Cairo, 11 March 1954, lot 355 and 13 March 1954, lot 726; Snowman (1966) pp 546–49
5 Grandjean, no. 420
6 Martin Klar, 'Die Tabatieren Friedricks des Grossen', *Der Cicerone* XXI (1929) pt I, pp 7–18; Snowman (1966) figs 523–34
7 Christie's, 28 June 1972, lot 41; Sotheby's, New York, 12 December 1973, lot 593; Sotheby's, London, 10 June 1974, lot 26
8 Christie's, Geneva, 11 May 1982, lot 176
9 Klar, *loc. cit.*
10 C. Grommelt and C. von Mertens, *Das Dohnasche Schloss Schlobitten in Ostpreussen* (Stuttgart, 2nd edn 1962) p 287. I am most grateful to Alexander von Solodkoff for this extremely useful reference

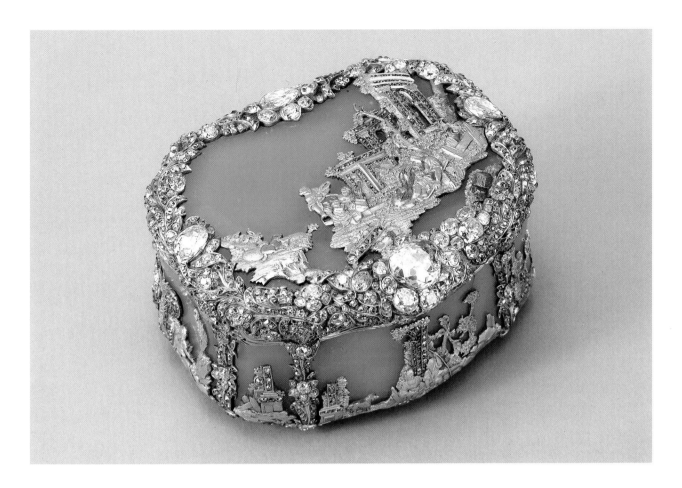

Additional bibliography
Snowman (1966) fig 545
Le Corbeiller, figs 466–70
Alexander von Solodkoff and Géza von
 Habsburg-Lothringen, 'Tabatièren
 Friedrichs des Grossen', *Kunst und
 Antiquitäten* III/83 (Munich, 1983)
 p40, fig 7
New York, A la Vieille Russie, *The Art of the
 Goldsmith and Jeweler* (New York, 1968)
 cover and fig 129, pp 58–59
John Winter and others, *Smalti, Gioielli,
 Tabachiere* (Milan, 1981) p 68, ill.

and a portrait of the King. André and Jean-Louis Jordan supplied thirty-two snuff-boxes between 1743 and 1765 and these ranged in price from 125 thalers for an enamel box lined with gold to 8500 thalers for a 'Tabatierre d'or à pierres d'Email taillé et très riche en Brillants'. Eighteen boxes were bought from Daniel Baudesson, probably the most famous of the Berlin box makers, between 1747 and 1765. Only three chrysoprase boxes appear in the accounts, although eight were recorded in 1901. One supplied by Gotzkowsky on 20 January 1752 described simply as 'Tabatiere von Chrysopras und Gold' would seem to be too cheap at 380 thalers to be the present box. However, Daniel Baudesson's account of 27 October 1763 mentions '1 Tabatière de Chrisoprase enrichie de Brillants et ornée d'or de couleurs' at 6500 thalers and in a supplement to the accounts an order from the Jordan brothers is recorded on 11 December 1775 for a 'Tabatière de Crisoprase, riche en brilliants' at 12,000 thalers. Given that the description of the Baudesson box mentions coloured gold, so evident on the Thyssen-Bornemisza box, and since it is the only chrysoprase box which could correspond in date with the inscription on the base of that box, it seems tempting to attribute the present example to Daniel Baudesson, but other chrysoprase boxes in the Hohenzollern Collection, which are not mentioned in the accounts, make a firm attribution impossible.

The Thyssen-Bornemisza box is mentioned in an inventory of Schloss Schlobitten of 1810: 'Eine goldene mit grunen Chrysopras und Brillanten bedecke Dose, deren sich Se. Majestat der Konig Friedrich II gewohnlich bedient hat und welche Se. Majestat, des Konig Friedrich Wilhelm II, im Jahre 1789 Sr. Exellence dem Obermarschall Grafen zu Dohna zum Geschenk machten. Diese Dose soll dem hochseligen Konige, Friedrich II 10,000 Tl. gekostet haben'. The Graf Dohna in question would have been Friedrich Alexander (1741–1810).[10]

97 Snuff-box

Oval gold box set with hardstones, the rim and the border of the lid decorated with flowers and leaves alternating with oval reserves of carnelian surrounding a panel made up with agate triangles, the striations of each being at right angles to the next, containing a wreath of bloodstone laurel tied with a white porcelain ribbon around a diamond-set miniature of a lady facing three-quarters to the right, under glass. The wall of the box is divided into four reserves of agate triangles separated by branches of laurel and berries in stone tied with a porcelain ribbon, and the base is decorated with a cartouche of laurel and berries enclosing a bow, quiver of arrows and a flaming torch with a wreath of flowers and leaves, all set against a ground of striated agate triangles. Inside the lid is another miniature of a man, surrounded by the inscription in Cyrillic 'Moskovskoe Dvoryanstvo + Radostnomu ryestniku + 8yn Sentyabrya 1843 goda'.[1]

Dimensions
Height: 4.1 cm; length: 9.3 cm; depth: 6.8 cm

Provenance
A la Vieille Russie, New York, 1968
K138C

Apparently unmarked

German, Dresden, *circa* 1770–80, by Johann Christian Neuber

Inscribed on the bezel

The technique of decorating gold boxes with a *zellenmosaik* of hardstones from Saxony appears to have been developed by Heinrich Taddel, a goldsmith and director of the Saxon princely treasury, the Green Vaults in Dresden.[2] Working in Dresden from 1739 until his death in 1769, Taddel's boxes are usually distinguished by use of stone set to gain an effect not dissimilar to that of *champlevé* enamel, that is to say that there are often relatively large areas of gold around the stones. A box signed and dated the year of his death was formerly in the collection of Messrs S. J. Phillips, London.[3]

Johann Christian Neuber's technique reduced the visible gold to little more than collets securing the stones to the body of a box although larger areas of gold, such as those dividing the oval reserves on the wall of the present box are found. Such boxes were known as *Stein Cabinetts-Tabatieren* and the stones were frequently identified by little handwritten booklets contained within the boxes (see cat. no. 98).

Born in Neuwunsdorf on 7 April 1736, J. C. Neuber was apprenticed at the age of seventeen to Johann Friedrich Trechaon. On 13 July 1762, he became a master of the goldsmiths' guild in Dresden and by 1775 he had been appointed *hofjeuwelier* to the court of Frederick Augustus III, the Just, to whom he had supplied a side table, a gift of the city of Freiberg in 1769. However, the earliest dated piece by Neuber was a box formerly in the Green Vaults which bore the date 1770. Apart from such ambitious projects as table decorations for Frederick Augustus in 1775, and for Prince Repnin in 1780 and a mantelpiece of stone and Meissen porcelain, all of which were made in cooperation with the sculptor Acier, Neuber's workshops produced boxes, watchcases, chatelaines, *carnets* and chains. He appears to have been prosperous enough to rent several quarries and between 1786 and 1798 he had seven apprentices. However, he was not a successful businessman and in 1788 held a lottery to alleviate his financial position. Neuber died a poor man at his son's house in Eibenstock on 1 January 1808.[4]

Notes
1 'The Citizens of Moscow + Welcome to the herald + 8 September 1843'
2 Snowman (1966) p100
3 Snowman (1966) fig 550
4 Walter Holzhausen, 'Johann Christian Neuber', *Apollo* LII (October 1950) pp104–106
5 Maze-Sencier, p522

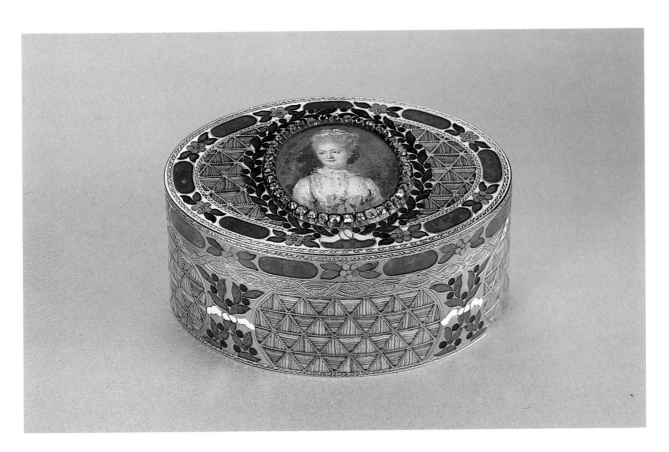

Detail of the interior of the lid

Additional bibliography
Walter Holzhausen, *Johann Christian Neuber* (Dresden, 1935)
New York, National Antique and Art Dealers Association of America, *Art Treasures Exhibition* (Parke-Bernet Galleries, New York, 1967) no. 143

The miniatures on the lid and set inside the box appear to be contemporary with the box, rather than with the Russian inscription, and are in a style attributed to Pierre Adolf Hall. Hall was a Swede by birth who, in 1766, moved to Paris where he frequently exhibited in the *Salon*. In 1774 he was appointed *peintre du cabinet du Roi*. Following the Revolution, Hall left France and died in Liège on 15 May 1793. Whilst in France he is reputed to have painted between sixty and eighty portraits a year.[5]

98 Snuff-box

Oval gold box set with 164 different hardstones in gold collets, each numbered, with five military trophies in gold, silver and hardstone on the lid and around the sides, and a hexafoil on the base. The top and the rim of the lid are bordered by scrolls, flowers and leaves in stones. A stone at the base of the trophy on the right-hand side of the box is sprung to release the base revealing three compartments, that on the right containing a miniature of a lady full face, on the left a bar of platinum set with sixteen precious stones and the central reserve contains two manuscript catalogues of the stones, one in French and one in German entitled 'Catalogue of all sorts of stones found in Saxony, and principally of the 180 named stones which are among the 800 used in this snuff-box'.

Dimensions
Height: 3.7 cm; length: 8.8 cm; depth: 6.6 cm

Provenance
A la Vieille Russie, Paris, 1972
K168A

Apparently unmarked

German, Dresden, *circa* 1770–80, probably by Christian Gottlieb Stiehl

Several of these *Stein Cabinetts-Tabatieren* produced in Dresden during the last quarter of the eighteenth century have ingeniously hidden compartments containing miniatures or catalogues of the stones used in their decoration. However, this is amongst the most impressive of the extant examples, having two catalogues, a miniature and additional stones mounted on a bar of platinum. A comparable example by Johann Christian Neuber is in a private collection.[1] Neither of the catalogues bears the name of the manufacturer, as is sometimes the case, but the style of the setting of the stones in fluid curves, rather than in geometric patterns (cf. cat. no. 97) suggest that this box is the work of Christian Gottlieb Stiehl (1708–92), a contemporary of Neuber's. Stiehl was appointed *Hofsteinschneider* to Augustus II and subsequently elevated in 1775 to *Hof- und Cabinetts-Steinschneider* under Augustus III, from whom he received a pension after 1780.[2]

Writing in 1782, J. A. Lehninger described 'La Fabrique de Tabatières, composées de pierres precieuses, representant toute sorte de figures en bas-relief trés artistement travaillées chez Biehl (*sic*) . . . Ce celebre lapidaire qui est unique dans son art, envoie quantité de ses ouvrages en France et d'autres pays étrangers'.[3] His business was continued by Joseph Gottfried Carl Rodermund.

The earliest datable example of a box by Stiehl is a circular box in the Palazzo Pitti, Florence, which was presented to General Pasquale de Paoli by Augustus III in 1774.[4] A box in the Louvre[5] contains a catalogue of stones printed in Copenhagen and dated 1775, and a box formerly in the Egyptian Royal Collection was dated 1718, probably for 1778.[6] The catalogues in the present example note that the stones were mined at Rochlitz, Cunnersdorf, Freiberg and Waldheim.

Notes
1 Sotheby's, Monte Carlo, 4 May 1977, lot 155
2 Thieme-Becker, XXXII, p40
3 'The manufactury of snuff-boxes composed of precious stones, representing all sorts of figures in bas relief very artistically done by Biehl . . . This lapidary who is alone in his art, sends quantities of his work to France and other foreign countries.' Quoted by Le Corbeiller, p66
4 Inv. no. Gemme 1921, no. 890
5 Grandjean, no. 434
6 Sotheby's, Koubbeh Palace, Cairo, 13 March 1954, lot 705

Additional bibliography
Snowman (1966) figs 585–86

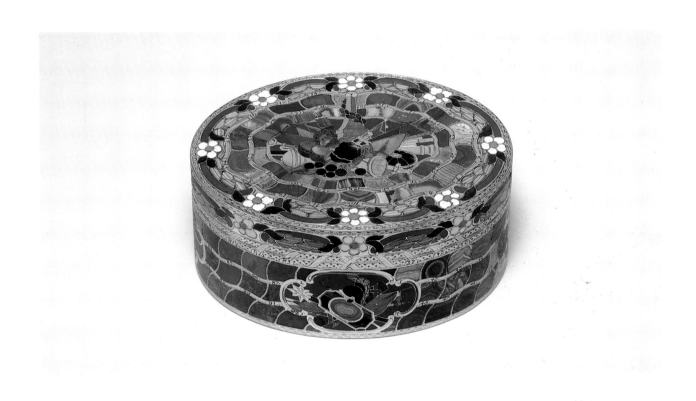

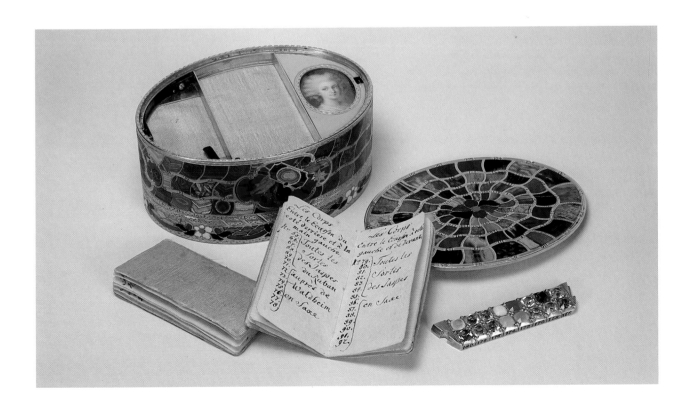

99 Box

Circular tortoise-shell box with a waisted profile, mounted in gold and set with a miniature under glass by Peter Mayr which depicts Maximilian Joseph I, King of Bavaria, his Queen Frederike, his son Ludwig and his wife Therese. Each portrait is surrounded by an inscription identifying the sitter as follows: (*at the top*) 'MAXIMILIAN JOSEPH KÖNIG VON BAYERN. GEBORH: D: 27 MAY 1756. PROCLAM: ANNO 1806'; (*at the bottom*) 'FREDERIK WILHELM: CAROLINE.KÖNIGEN V. BAYERN. GEB: PRINZ: V. BAADEN GEBOHREN DEN 13.JUNI. ANNO.1776'; (*to the left*) 'LUDWIG.KARL.AUGUST.KRONPRI VON BAYERN. GEB. D.25.AUGUST.1786. VERMAEHLT D.12.OCTOB: 1810'; (*to the right*) 'THERESE CHARLOTTE LOUISE KRONPRINZESS VON BAYERN. GEB. P.V.SACHS.HILDB:G:8:JULI.1792.'

Dimensions
Height: 2.3 cm; diameter 9.2 cm

Provenance
acquired *circa* 1960
K 137 B

Apparently unmarked

Miniature signed: P.Mayr v. Augsburg

German, Augsburg, *circa* 1810

Maximilian Joseph (27 May 1756–13 October 1825) was the son of Count Palatine Frederick of Zwiebrucken-Birkenfeld, to which title he himself succeeded on the death of his brother in 1795. He became Elector of Bavaria four years later. Having been in the army of France under the *ancien régime*, Maximilian introduced into Bavaria an enlightened, and post-Revolutionary French style of government, and remained one of the staunchest of Napoleon's allies until 1813. Indeed a daughter of his married Eugène Beauharnais. His reward was to be declared King of Bavaria on 1 January 1806. Throughout his reign he resisted any move towards the unification of Germany and strongly maintained the independence of Bavaria. His son Ludwig was born to his first wife, Wilhemine Auguste of Hessen Darmstadt, on 25 August 1786. His second wife, Frederike Wilhelmine Caroline of Baden is depicted here.[1]

Ludwig (1786–1868) succeeded to the title of King on his father's death in 1825. On 12 October 1810, he married Therese Charlotte Louise von Sachsen Hildburghausen (1792–1854) and it is this event that this box would seem to commemorate. Always a romantic, Ludwig became captivated by the Spanish dancer Lola Montez who visited Munich in 1846. His attempt to have her elevated to the Bavarian nobility as Countess Landsberg, although successful, eventually led to his abdication in 1848 in favour of his son, Maximilian II.

Peter Mayr, the painter of the miniature, was born in Freiburg in 1758 and having worked in Bavaria, died in Munich in 1836.[2]

Notes
1 J.M.Soltl, *Max Joseph, König von Bayern* (Stuttgart, 1837)
2 J.J.Foster, *Dictionary of Painters of Miniatures* (London, 1926) p202

Additional bibliography
Munich, Völkerkundemuseum, *Wittelsbach und Bayern, Krone und Verfassung* (Munich, 1980)

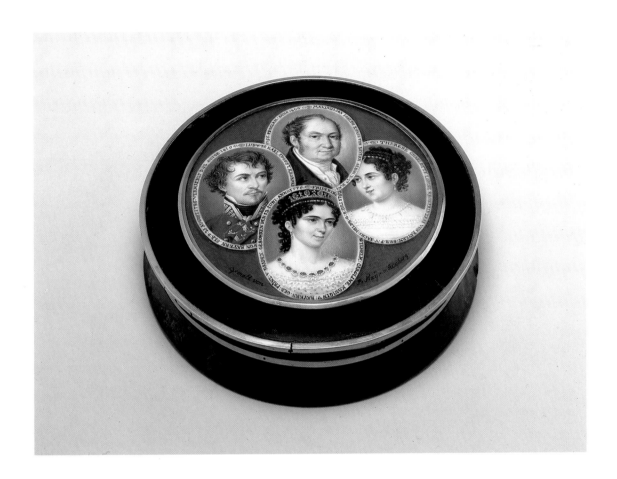

100 Snuff-box

Oval gold snuff-box enamelled in colours *en plein* with six scenes of peasants in rustic interiors, after David Teniers the Younger, with sixteen small cartouches containing landscapes in grey and yellow, and scrollwork of engraved gold and translucent blue *basse-taille* enamel.

Dimensions
Height: 3.4 cm; length: 7.4 cm; depth: 5.3 cm

Provenance
Maria-Theresa, Empress of Austria
Maximilian Joseph of Bavaria
Maximilianmuseum, Augsburg, 1777–1925
S.J. Phillips, London, 1938
A la Vieille Russie, New York, 1968
K133G

Apparently unmarked

Miniature on the right-hand wall signed: s

Austrian, Vienna, *circa* 1760, painted by Philipp Ernst Schindler II

Miniature signed on the lid

I

ILLUSTRATION
1 *Pierre Chance. Engraving of Les Amusements des Matelots after David Teniers the Younger (Victoria and Albert Museum, London)*

Philipp Ernst Schindler II (1723–93) was the son of a porcelain painter of the same name at the Meissen factory.[1] Indeed P.E. Schindler II also worked at the factory between about 1740 and 1750 during which time the formidable J.G. Heröld, director of painting at Meissen, complained about the young man's activities as a *hausmaler*, that is to say working on his own account as a painter.[2] In 1750, he moved to Vienna, where, in 1777, he was appointed director of painting in the imperial porcelain factory, and 'arcanist', one privy to the secrets of porcelain making.

Schindler appears to have enamelled boxes by several different goldsmiths, possibly not all Austrian. Two unidentified Viennese box makers, one with the initials IS or SI, and the other with the initials ISP, supplied boxes to Schindler and to the chaser Johann-Paul Kolbe.[3]

The enamels on the present box are adapted from prints after paintings by David Teniers the Younger. Those on the lid and rear of the box are both from an engraving by Pierre Chance, *Les Amusements des Matelots*, after the painting in the collection of the comte de Vence (fig 1) and on the base from an engraving by

Notes
1 Pazaurek, pp 287–88. This box is illustrated on Tafel 23
2 W.B. Honey, *Dresden China* (London, 1946) p 157
3 Waddesdon catalogue, no. 55, and Victoria and Albert Museum, Inv. no. 920–1882

Additional bibliography
Nortons, p 106, pl. 39B
Bramsen, p 149, no. 332
Le Corbeiller, no. 235
New York, A la Vieille Russie, *The Art of the Goldsmith and Jeweler* (New York, 1968) p 64, no. 140

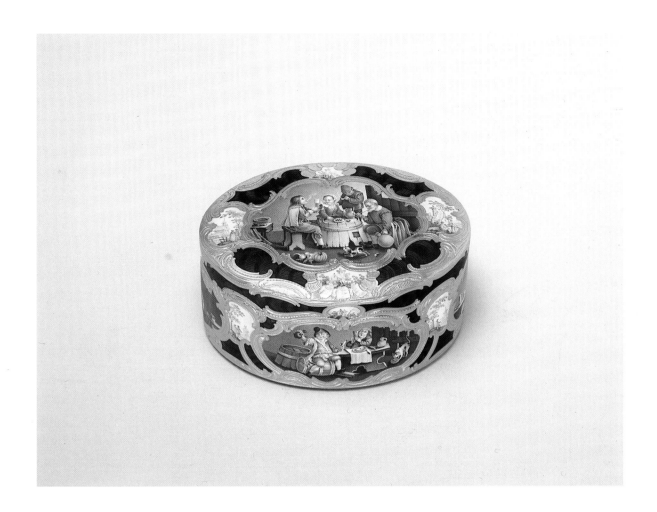

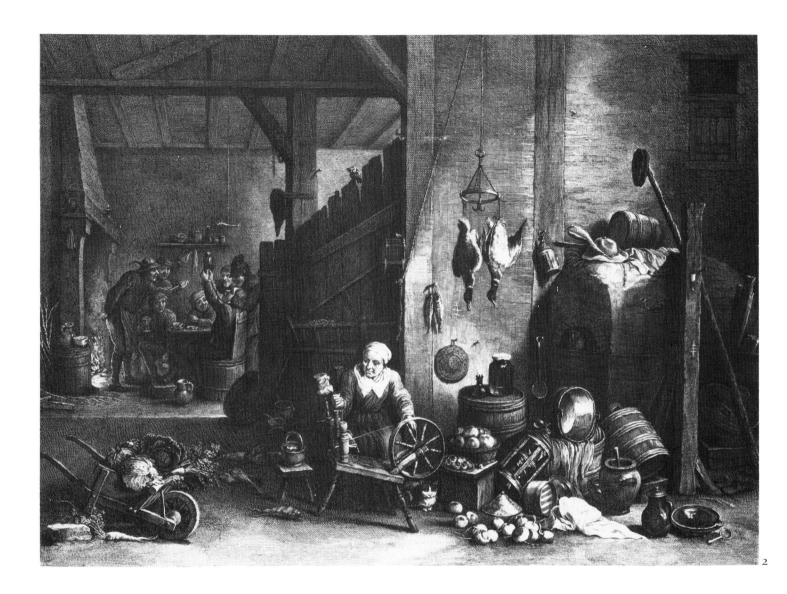

2

Louis Surugue, *La Fileuse Flamande*, after the painting which was then in the collection of the Abbé de Majinville (fig 2).

Several boxes with Teniers scenes enamelled by Schindler are known. Two are in the Wallace Collection, London (fig 3)[4] one is in the Louvre (fig 4)[5] and another in the Victoria and Albert Museum (fig 5).[6] An *étui* in the Metropolitan Museum, New York, is similarly decorated (fig 6).[7]

This box is said to have been presented by Maria-Theresa, the Empress of Austria, to Maximilian Joseph of Bavaria as a token of gratitude for his support in the election of her husband, Francis, duke of Lorraine, to the purple in 1745. In 1777 the box passed into the collections of the Maximilianmuseum, Augsburg, where it remained until at least 1925. It left the Museum through a policy of disposing of items not of Augsburg origin and was in private hands by 1932.[8]

Notes
4 Inv. nos G.68 and G.69
5 Grandjean, no. 516
6 Inv. no. 920–1882
7 Inv. no. 1974.356.625, Bequest of Emma A. Schaefer. This *étui* was kindly drawn to my attention by Mrs Le Corbeiller
8 I am grateful to Dr Hannalore Müller for this information

3

4

6

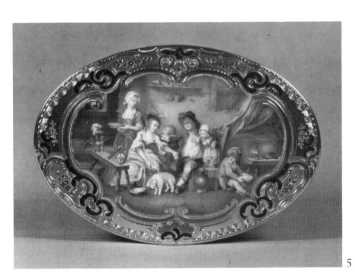

5

ILLUSTRATIONS

2 *Louis Surugue. Engraving of La Fileuse
 Flamande after David Teniers the Younger
 (Victoria and Albert Museum, London)*

3 *Gold and enamel box by P. E. Schindler II,
 Vienna, circa 1760 (Wallace Collection,
 London, Inv. no. G69)*

4 *Gold and enamel box by P. E. Schindler II,
 Vienna, circa 1760 (Musée du Louvre,
 Paris)*

5 *Gold and enamel box by P. E. Schindler II,
 Vienna, circa 1760 (Victoria and Albert
 Museum, London)*

6 *Etui of gold and enamel by
 P. E. Schindler II, Vienna, circa 1770
 (Metropolitan Museum of Art, New York,
 Bequest of Emma A. Shaefer, 1974. The
 Lesley and Emma Shaefer Collection)*

101 Etui

Etui of gold, engraved and enamelled with five reserves of pink camaieu depicting, on the front of the lid, a seated girl; on the back of the lid, a boy with a bird and a basket, and on the top of the lid, a sleeping dog; on the front of the body of the *étui*, a girl with a tame bird and a boy, after Boucher, and on the back, a girl with fruit and a boy with ice cream (?). Each reserve is bordered by translucent green *basse-taille* enamel. The *étui* contains a folding knife, a pencil and pen-knib holder, a toothpick and earpick combined, all in gold, a pair of ivory tablets with a gold rivet, and a pair of steel scissors with gold handles.

Dimensions
Height: 8.8 cm; length: 4.8 cm; depth: 1.7 cm

Provenance
A la Vieille Russie, New York, 1968
K 133B

Marks

On the bezel of the étui and on each item except the tablets
1 Duty mark for gold, Vienna, 1806–1807[1]

Austrian, Vienna, *circa* 1775, enamelled by Philipp Ernst Schindler II

1

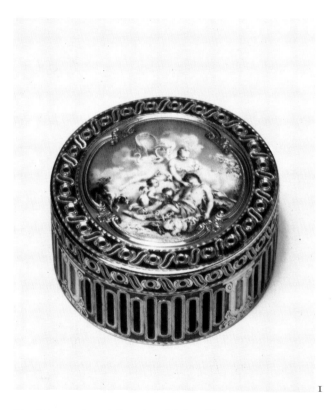

1

2

For biographical details of Schindler, see cat. no. 100.

The painting of this *étui* is clearly by the same hand as that on a circular gold box enamelled in pink camaieu in the Victoria and Albert Museum, which is signed 'Schindler Wien' (fig 1)[2] and on a box signed 'Schindler' illustrated by A. K. Snowman,[3] formerly in the collection of Messrs S. J. Phillips, London. The similarity in painting between these pieces and a sealing-wax case at Waddesdon Manor which is painted in grisaille on a blue ground, and which may bear Viennese marks, suggests that this too may be by Schindler.

The subject on the front of the body of the *étui* is probably taken from an engraving by Huquier fils, *La fille à l'oyseau*, after Louis Martin Bonnet's engraving in the opposite sense of François Boucher's *Pastorale* (fig 2).[4]

ILLUSTRATIONS
1 *Cylindrical snuff-box of gold and enamel, signed 'Schindler Wien' and bearing the maker's mark IS or SI, Vienna, circa 1775 (Victoria and Albert Museum, London)*
2 *Louis Martin Bonnet. Engraving of La fille à l'oyseau after François Boucher's Pastorale (Musée du Louvre, Paris)*

Notes
1 Rosenberg IV, no. 7877
2 Inv. no. 912–1882
3 Snowman (1966) fig 329
4 Jean-Richard, p 109, no. 329

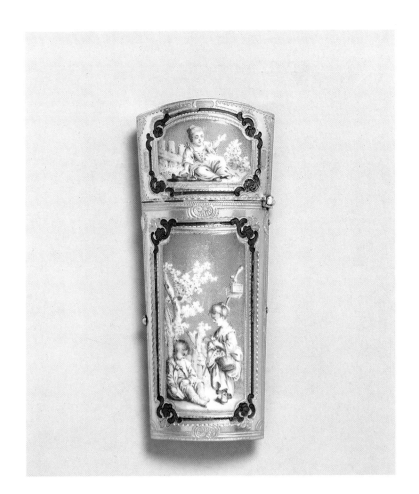

102 Snuff-box

Cartouche-shaped snuff-box of extravagantly bombé form, chased all over with a pattern of basketwork and enamelled *en plein* with six sprays of flowers in naturalistic colours. The rim of the lid, the thumbpiece and the rim of the foot are chased as rope.

Dimensions
Height: 4.6 cm; length: 8.1 cm; depth: 6.2 cm

Provenance
Baron Elie de Rothschild Collection
J. Kugel, Paris
K134U

Marks

In the base
1 Maker's mark possibly of Jacques Stoundre, goldsmith registered in Copenhagen, 10 September 1759 until 1773[1]
2 Town mark of Copenhagen, used in 1758 or 1759[2]
3 Mark of the *møntguardein* Christopher Fabritius, 1749–87[3]
4 Danish standard mark for 21-carat gold[4]

On the right-hand side of the bezel and on the right-hand rim of the lid
5 Restricted warranty mark for Paris for gold, since 10 May 1838[5]

Danish, Copenhagen, 1758 or 1759, possibly by Jacques Stoundre

The maker's mark on this box does not appear to be recorded, but it may be that of Jacques Stoundre who obtained his trade licence as jeweller on 10 September 1753. A snuff-box said to bear Stoundre's mark was at Rosenborg Castle, but is now lost.[6]

Boxes in the form of baskets are found from several areas in the eighteenth century. The duc de Villeroy's porcelain factory at Mennecy, for example, specialised in basketwork decoration combined with painted flowers on boxes. Two hardstone boxes from Dresden or Berlin in the shape of baskets are illustrated by Snowman,[7] and the Louvre possesses a fine example enamelled by de Mailly whilst he was in Russia.[8] The present example is the only one of this shape known to the author to have been made in Copenhagen. However, a rectangular gold box chased with basketwork and enamelled with flowers by the Danish master Jocob Henrichsen Moinichen, dated 1758, is in the Kunstindustrimuseum, Copenhagen.[9]

Notes
1 Chr. A. Bøje, *Danske Guld-og Sølvsmedemaerker før 1870* revised by Bo Bramsen, vol. 1 (Copenhagen, 1979) p154
2 BØJE, p27
3 BØJE, p29
4 BØJE, p24
5 Carré, p208
6 I am most grateful to Vibeke Woldbye of the Kunstindustrimuseum, Copenhagen, for this information
7 Snowman (1966) figs 511 and 521–22
8 Grandjean, no. 530
9 Bramsen, fig 661

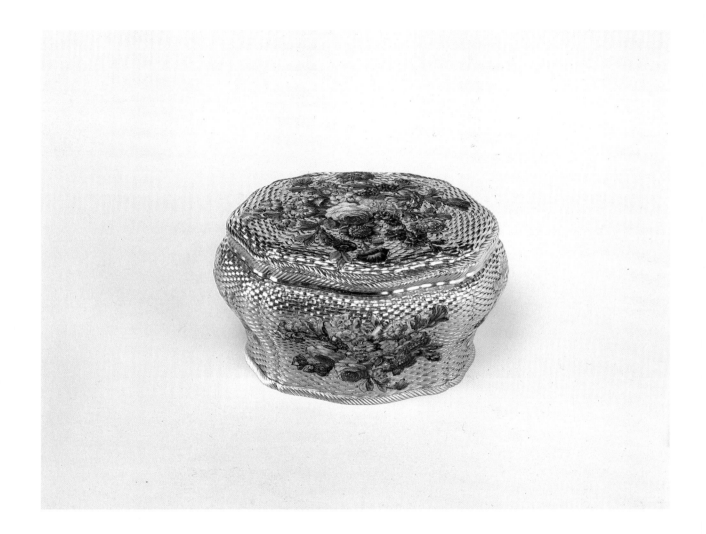

103 Etui

Etui of slightly tapering cylindrical agate mounted in a network of gold scrolls, trees and swags, and fastened with a steel catch.

Dimensions
Height: 10.5 cm; diameter: 2.4 cm

Provenance
K 131C

Apparently unmarked

English, *circa* 1760

As with cat. no. 104 the loose scrollwork on this *étui* is typically English and may be compared with the rather less sophisticated *nécessaires* which bear watches with English movements, or that are signed by English goldsmiths.[1] That the form existed in England is demonstrated by an example in the Victoria and Albert Museum (Inv. no. 950–1882) which is inscribed 'Masham from her Lovin Dux', and was a present from Queen Anne to Mrs Masham, when the latter supplanted the first Duchess of Marlborough in the Queen's affection and confidence.

Although this form of *étui* is frequently referred to as a 'bodkin-case', the term is not found in the eighteenth century. However, it is very probable that it is either a toothpick case or a tweezer case, both found frequently in contemporary documents. In the first published Birmingham directory, dated 1767,[2] the manufactures of the toymen are listed as 'trinkets, seals, twesser and toothpick cases, smelling bottles, snuff-boxes and filigree work'. In London, the goldsmith John Stamper advertised 'Etweezer Cases' and 'Toothpick cases' between 1762 and 1766,[3] and one Morris in St James's, Haymarket, sold 'All sorts of Enamelled Work in Snuff Boxes, Watches & Chains, Toothpick cases, Trinkets Etc.', at about the same time.[4]

Indeed, the production of such pieces was not confined to goldsmiths. The records of the Chelsea porcelain factory in 1770, at that time owned by William Duesbury of Derby, contain a reference to '12 Tooth Picks with Head of Turk and Companions, painted with emblematic Mottoes, ditto, at 1.s. 6.d.',[5] which could not refer to the instrument and therefore must allude to the container. The terms toothpick and tweezer case may have been synonymous in the mid eighteenth century. A trade card of Marie Anne Viet and Thos. Mitchell, on Cornhill, London, dated 1742, listed 'Snuff Boxes, Tweezer Cases, Equipages after the Newest Fashion, Ready Chased & c' and translated this into French as 'Tabatieres, Estuits a Curedents & Garniture Cizelé a la Nouvelle Mode'.[6] However, other references suggest that the 'tweezer case' denoted an instrument case or *nécessaire*. *The Tatler* of 1709–10 notes 'Tweezer-Cases . . . not much bigger than your Finger, with 17 instruments in them'[7] and Mrs Delaney, in 1742, wrote 'They much admired my tweezers and the trinkets that were in them'.[8]

Notes
1 eg, that at Waddesdon Manor, with a watch signed by James Cox (no. 21) or a *nécessaire* signed by John Barbot (Christie's, New York, 28 March 1979, lot 236)
2 Bernard Watney, 'Petitions for Patents' part 1A, *Transactions of the English Ceramic Circle* VI (1966) pt II, p 63
3 Heal, pl. LXVII
4 Heal, pl. XLIX
5 Llewellyn Jewitt, *Ceramic Art of Great Britain* II (London, 1878) p 72
6 Heal, pl. LXXIV
7 *The Tatler*, no. 142, p 5 quoted in the *Oxford English Dictionary*, 'Tweezer-Case' (Oxford, 1916)
8 Mrs Delaney, *Life and Correspondence* II (1861) p 173

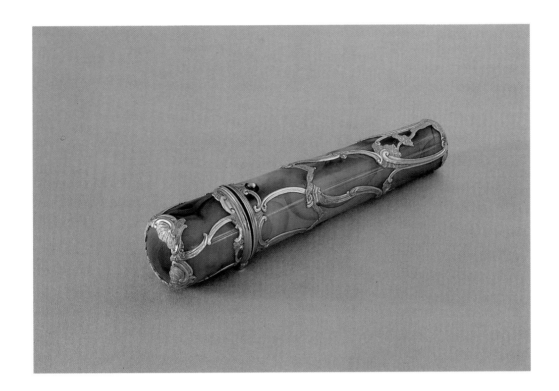

104 Etui

Etui of ribbed panels of agate mounted in gold chased with scrolls, flowers and masks, around a copper-gilt core. The case contains a pair of steel scissors with gold handles, two ivory tablets joined by a gold-headed rivet, a gold pencil holder, a gold folding knife with silver blade, a pair of steel tweezers and nail-file combined, and a gold bodkin, held in wooden compartments surmounted by pierced copper-gilt. A loop on the lid of the case indicates that the case was intended to be hung from a chateleine.

Dimensions
Height: 10.3 cm; width: 4.5 cm; depth: 2 cm

Provenance
K 134 V

Marks

On the bodkin
1 Discharge mark of *adjudicataire des fermes générales unies* Jean-Jacques Prévost, Paris, 22 November 1762 until 22 December 1768[1]
2 Unidentified mark, probably a countermark, possibly provincial French

English, *circa* 1760, except the bodkin, which is apparently a replacement

Cases in hardstone mounted in gold containing instruments such as this, dating from the middle of the eighteenth century, are relatively common. The Victoria and Albert Museum possesses four, one of which is very similar to the present example,[2] and they are found frequently in public collections in Britain, as well as regularly appearing in the major salerooms. These cases are generally ascribed to England from the style of the chased gold mounts, although, since their construction and the small quantity of gold in them, made them exempt from hall-marking, no documentary English examples are known to the author.

Usually referred to as *étuis* or *nécessaires*, these handy little instrument cases were probably known as 'Etweezers' or 'Tweezer-cases' in the eighteenth century (see cat. no. 103 for a fuller discussion of these terms). Several trade cards of eighteenth-century goldsmiths mention these cases, and some such as that of H. Pugh of Racquet Court, Fleet Street dating from about 1740 illustrate the type.[3]

Notes
1 Nocq IV, p 237
2 Inv. no. 940–1882
3 Heal, pl. LX

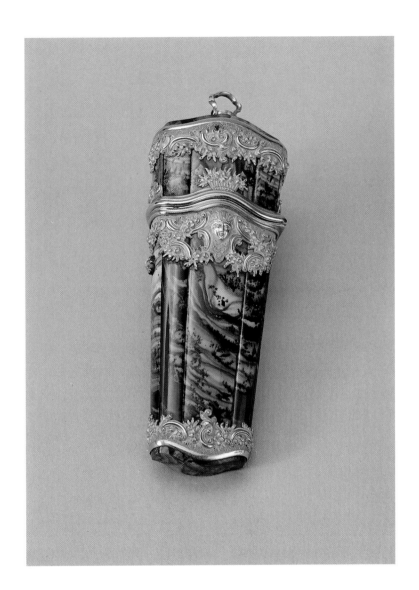

105 Nécessaire

Rectangular *nécessaire* of striated agate mounted in a cagework of gold chased with scrolls, flowers, shells and exotic birds, with a band of opaque white enamel around the rim of the lid bearing the inscription in gold: 'L'ESPOIR DE TA FIDELITE' FAIT MA SEULE FELICITE'.' A diamond thumbpiece serves to open the steel sprung catch. The interior of the *nécessaire* is lined with copper, with a wooden core, the top of which is set with copper-gilt pierced to contain ivory tablets held by a gold rivet, two glass scent bottles with gold covers, a combined nail-file and tweezers, a gold handle with detachable steel corkscrew and spike, a pencil, a spoon, a combined ear- and toothpick, and a gold mounted blue glass mirror case which is gilt in the manner of the London workshop of James Giles. A space remains for a penknife which is now missing. The interior of the lid is set with a mirror.

Dimensions
Height: 5.9 cm; width: 5.1 cm; depth: 4.6 cm

Provenance
Maud Feller Collection
K 167 D

Apparently unmarked

English, *circa* 1765

Several *nécessaires* of this form, which have characteristics close enough to allow them to be considered the products of a single workshop, are known. The Louvre possesses three,[1] one of which is attributed to the workshop of James Cox, and another is at Waddesdon Manor.[2] Other examples have recently passed through the salerooms of Sotheby's and Christie's.[3] However, the characteristics of these pieces differ from those pieces which contain watches signed by James Cox, neither do they match the work of John Barbot, a contemporary of Cox's, whose work in this genre is documented by a *nécessaire* dated 1765.[4] Indeed, the white enamelled band with an inscription often in very poor French, which is such an amusing part of this group of *nécessaires*, is not found on work signed by Cox or Barbot.

James Giles, who may be responsible for the gilding of the glass of the mirror case, was a decorator of porcelain and glass in Berwick Street and Cockspur Street, London, working from 1749 until 1774. His style of painting flowers is in many ways similar to that on the blue glass mirror case, but the small amount of decoration makes a firm attribution to his workshop impossible.[5]

Notes
1 Grandjean, nos 493–95
2 Waddesdon catalogue, no. 23
3 See, for example, Christie's, Geneva, 19 November 1970, lot 74 and Sotheby's, Zurich, 23 November 1978, lots 27, 32 and 33
4 Christie's, New York, 28 March 1979, lot 236. A *nécessaire* with a watch signed by Barbot is in the Metropolitan Museum, New York
5 London, Delomosne and Son Ltd, *Gilding the Lily* (London, 1978)

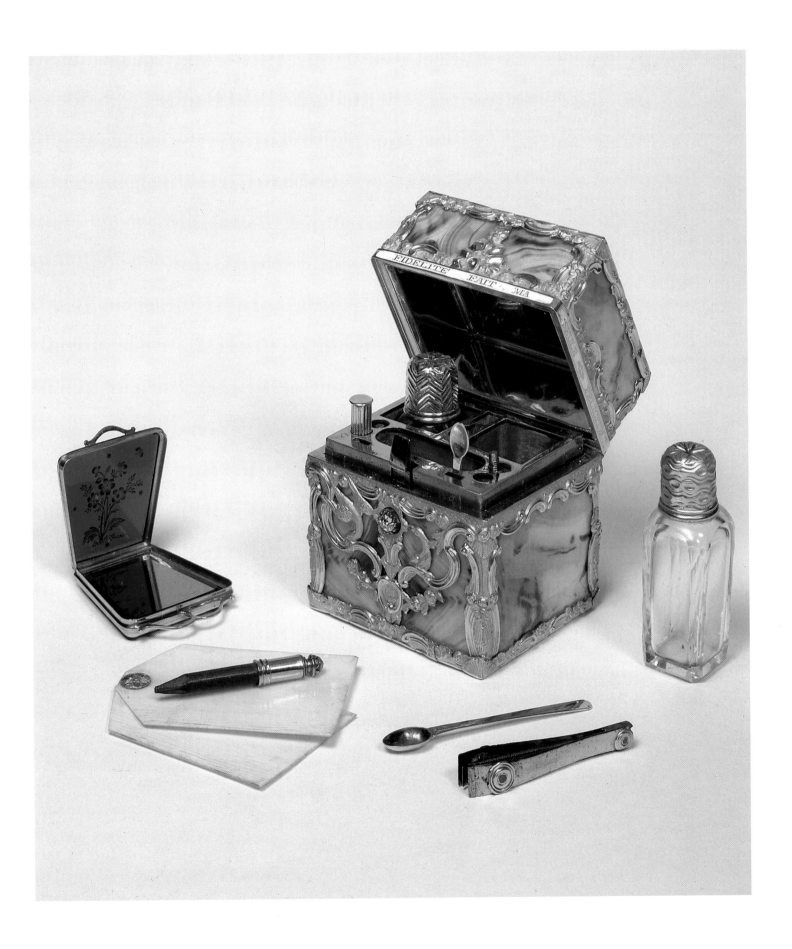

106 Double snuff-box

Double snuff-box of amethystine quartz of oblong form with ogee shaped ends, and divided across the centre. Both lids are mounted with gold pierced and chased with scrolls and flowers, and the walls hung with floral swags in chased gold.

Dimensions
Height: 3 cm; length: 9.1 cm; depth: 5.2 cm

Provenance
K 1 3 2 H

Apparently unmarked

English, *circa* 1765–70

The rather loose treatment of the scrolls and swags of flowers find parallels with several stone and gold pieces which are either signed by English craftsmen or attributed to England, and made in the third quarter of the eighteenth century. Particular reference should be made to a *nécessaire* and a needle or toothpick case both of agate and gold at Waddesdon Manor,[1] and to a similar needle or toothpick case in the Louvre.[2] A *carnet* formerly in the Goldschmidt-Rothschild Collection[3] is so similar as to suggest that it was made in the same workshop. However, the quality of the goldsmith's work on the present box appears to be superior to that found on pieces emanating from the workshops of James Cox[4] or John Barbot.[5]

Amethystine quartz boxes are traditionally ascribed to Dresden, and while the gold decoration on this box is unlike that found on German boxes, the shape is not dissimilar to that of a double box attributed to Dresden in the collection of A. K. Snowman.[6]

It is clear that this box, or its double, was in Russia around the early years of this century. A double box in porcelain mounted in gold by Carl Fabergé which appears to have been modelled on this piece was made for Tsar Nicholas II in 1911.[7]

Notes
1 Waddesdon catalogue, nos 25 and 18 respectively
2 Grandjean, no. 485
3 Ball and Graupe, Berlin, 24 March 1931, lot 291
4 Clare Le Corbeiller, 'James Cox, a biographical review', *The Burlington Magazine* CXII (June 1970) pp 351–58
5 Christie's, New York, 28 March 1979, lot 236
6 Snowman (1962) fig 543
7 Snowman (1962) fig 95

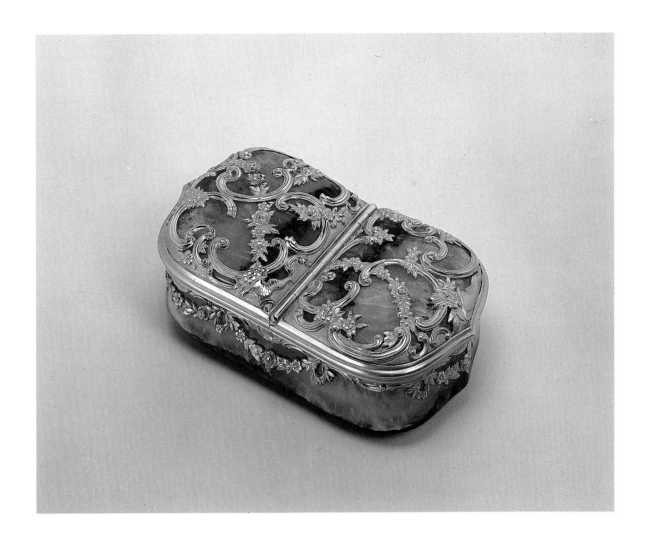

107 Freedom-box

Oval silver freedom-box the lid of which is bright-cut with a border of rosettes and scrolls of flowers against a striated ground, with, in the centre, a double circle containing the inscription 'CORK ARMS' and the motto, 'STATIO BENE FIDA CARINIS' around the arms of the city of Cork, Ireland. The base is inscribed

For the Right Hon^ble Lord Viscount Royston,
with the Complimentary Freedom of the City of Cork. Sept^r 1802
Mich^l Rob^t Westrop, Mayor
In^o Nich^s Wrixon }
In^o Geo^e Newsom } Sherrifs
W^m Jones, Town.Clerk

Dimensions
Height: 2.6 cm; width: 9.2 cm; depth: 6.8 cm

Provenance
Philip, Viscount Royston
Mr H. B. McCance Collection, sold Sotheby's, London, 25 October 1973, lot 138
K179C

Marks

In the lid
1 Maker's mark of Carden Terry and John Williams, goldsmiths of Cork registered 1797–1806[1]
2 Standard mark for Cork for sterling silver[2]

Irish, Cork, *circa* 1802, by Carden Terry and John Williams

Carden Terry (1742–1821) entered into partnership with John Williams in 1795 when they jointly registered the mark T&W at the Cork assay office. Williams was a former apprentice of Terry, who had married Jane Terry, his master's daughter. In 1797, the mark struck on this box was registered and continued to be used after John Williams's death in 1806, when Jane continued the partnership with her father.

The recipient of this box was Philip Yorke, Viscount Royston, son of the third Earl of Hardwicke. Born in 1784, Philip Yorke was educated at Harrow School, and St John's College, Cambridge, where he was when he was given the freedom of the city of Cork. In 1806 he became Tory member of Parliament for Reigate, but two years later he lost his life when the ship *Agathe* in which he was sailing, foundered off Lübeck. The fact that he received the freedom of the city at so young an age must be explained by the fact that his father was Viceroy of Ireland from 1801 until 1806.

This box has several parallels. Similar examples, by the same makers, were given to the first Baron Redesdale in 1803,[3] to Lord John Beresford, bishop of Cork in 1805[4] and to Sir Arthur Wellesley, later the first Duke of Wellington, in 1807.[5] On each the goldsmiths have used the ingenious overlapping hinge on the lid to overcome the problem presented by a straight hinge being required despite the oval shape of the box.

Notes
1 Douglas Bennet, *Irish Georgian Silver* (London, 1972) pp 186–87
2 Bennet, *op. cit.*, p 168
3 Christie's, 24 June 1975, lot 122
4 Sotheby's, London, 24 April 1975, lot 61
5 Wellington Museum, London, Inv. no. WM 1293–1948

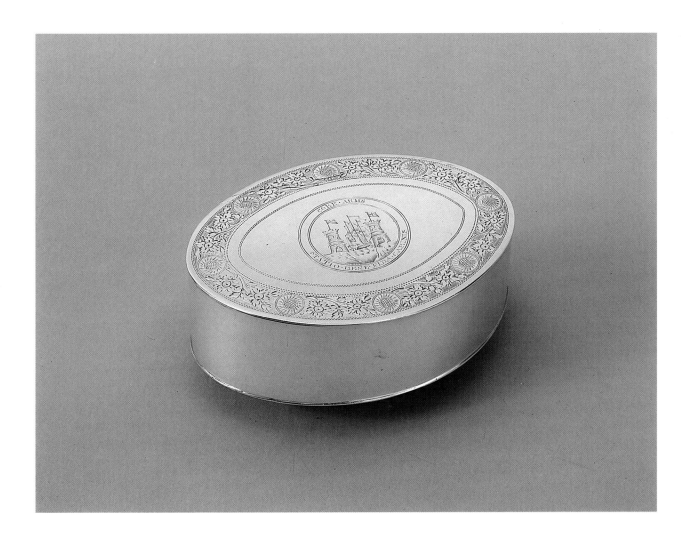

108 Snuff-box

Oval box of steel engraved all over with a pattern of peacock's feathers and encrusted with
gold *en quatre couleur* (red, white and green) forming cartouches of leaves and ribbons
enclosing, on the lid, two putti with a goat, on the base, a putto with a dog, both among
classical ruins, on the front and back, goats and sheep in landscapes and on the sides,
classical ruins with trees. The interior is lined with red gold, but the lining of the lid, which is
in yellow gold, has probably been replaced (wavy bezel).

Dimensions
Height: 4.5 cm; length: 8.6 cm; depth: 6.6 cm

Provenance
C.H.T. Hawkins Collection, sold Christie's, 6 June 1905, lot 145
Sotheby's, Zurich, 17 November 1976, lot 225
K 200 L

Marks

On the top of the hinge and on the left-hand side of the bezel
1 Dutch mark for old work, since 1814[1]

Russian, St Petersburg, *circa* 1770, by a member of the Kolbe family

 1

Signed on the bezel

The identity of the author of this box has not yet been established. At least three
goldsmiths or metal chasers with the name Kolb or Kolbe are known. Johann
Gottfried Kolbe, an iron chaser from Suhl in Thuringia, worked in London between
1730 and 1737. During this period he made the airgun (fig 1), which was once in
the collection of George II, and is now in the Victoria and Albert Museum. Al-
though he was responsible for the mechanics of the gun, and the chasing of the
lock, he is thought to have been unlikely to have made the silver mounts which

Notes
1 Voet, p45

Additional bibliography
Solodkoff, fig 189

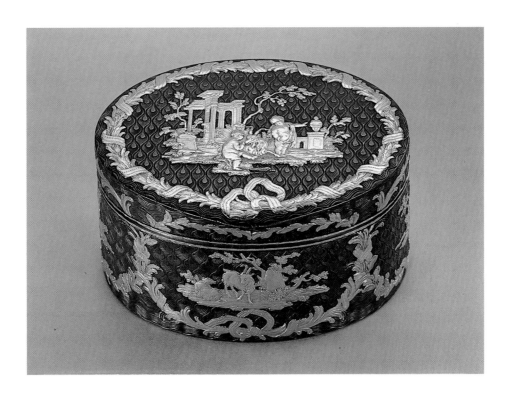

decorate the stock and barrel. A pair of five barrelled pistols at Windsor Castle also by J. G. Kolbe was made at this time.

A magnificent suite of six fire-arms signed 'Kolb a Sul' in the Capodimonte Museum, Naples, demonstrates his work after his return to Thuringia about 1740 and before 1753.[2]

Another member of the family, Johann Paul Kolbe, was working in Vienna during the second half of the eighteenth century. A *quatre couleur* box chased with a view of Schonbrunn inscribed 'Wienne Kolbe' was in the collection of Lord Rothschild,[3] and a chased gold and enamel box signed 'Kolbe W:' is at Waddesdon Manor (fig 3).[4] Three volumes of designs for boxes dated between 1776 and 1790 are preserved in the Kunstbibliothek, Berlin, and two further sheets, dated 20 April and 22 July 1776 are in the collection of Messrs S. J. Phillips, London (fig 2).

A third Kolb, Friedrich Joseph moved from Wurzburg to St Petersburg in 1793, and worked there as a master goldsmith between 1806 and 1826.[5] However, this would seem to be too late a date to make him author of the present box. It would also appear to be too late to make him responsible for a chased gold box in the Walters Art Gallery, Baltimore, which is signed 'Kolb a St. Petersbourg' (fig 4) and which bears certain affinities in the treatment of the ground chased with 'fans' and in the chasing of the trees to the box discussed here. It is, therefore, suggested that an unrecorded Kolb, or Kolbe, was working in St Petersburg about 1770, and that he was the author of the two boxes which bear his signature. Alternatively, the F. J. Kolb recorded in the nineteenth century may have simply sold the Walters and Thyssen-Bornemisza boxes, which had been made some years earlier, and on which he put his name.

Notes

2 J. F. Hayward, *The Art of the Gunmaker* II (London, 1963) pp 81–83
3 Christie's, London, 30 June 1982, lot 43
4 Waddesdon catalogue, no. 55
5 Solodkoff, p 219

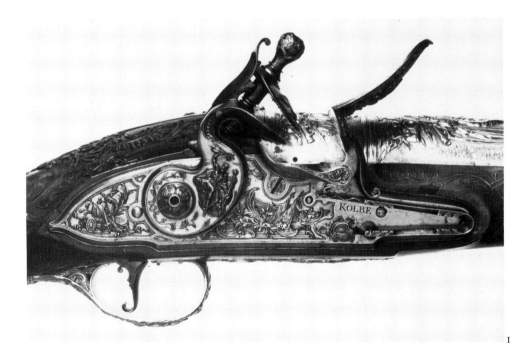

1

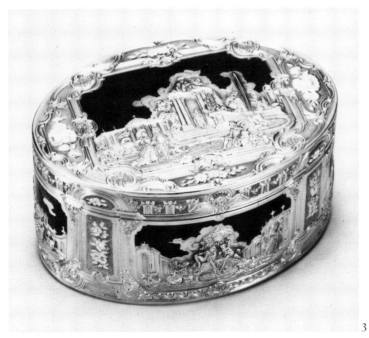

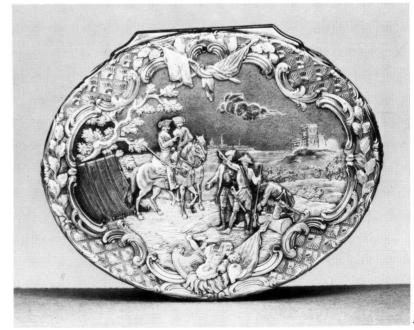

109 Carnet

Carnet comprising five panels of bloodstone encrusted with a profusion of scrolls, flowers and foliage chased in red and yellow gold, and set on the larger panels, on the overlapping catch and on the hasp with 156 diamonds in silver collets. The book cover contains two pockets of green silk, four ivory tablets, a gold pencil and a volume entitled *Entrennes mignones, curieuses et utiles, augmentées pour l'année 1749. A Paris, Chez Durand, Libraire, rue St Jacques, au Griffon. MDCCXLIX.*

Dimensions
Length: 11.7 cm; depth: 7.2 cm; height: 2.2 cm

Provenance
Princess Xenia Alexandrovna of Russia Collection
Prince Rostizlov Mikhailovitch Collection
Demmers, Amsterdam, 1967
K136B

Apparently unmarked

Probably Russian, late nineteenth century

Despite the presence of the almanac for 1749 which is set into the book cover, the flamboyant style of the Rococo ornament and the setting of the stones suggest that the piece dates from the end of the nineteenth century. Furthermore, the gold which is used in the *carnet* varies in standard. That which is bright and of reddish colour is 18 carat whereas the dull gold is 22 carat.[1] Such a disparity is in itself unusual but is unlikely to be found in eighteenth-century goldsmiths' work, especially that from Paris.

This *carnet* is paralleled by one in the Wernher Collection at Luton Hoo made by Michael Perchin for Fabergé between 1886 and 1899 (fig 1). The Grand Duchess Xenia, former owner of the Thyssen example was the aunt of Lady Zia Wernher and it may be that one of the *carnets* was made in imitation of the other. A third example in the Rijksmuseum, Amsterdam, was formerly in the Hermitage, Leningrad,[2] and a fourth was in the collection of Henrico Caruso.[3] This last example was apparently inscribed MD and 72 which may be a reference to a Russian maker and the Russian 18-carat gold standard. Another similar *carnet* rumoured to have had Paris marks of the *ancien régime* is said to have passed through the London art market.

Considering that so many of these *carnets* appear to have a Russian connection, it seems resonable to suppose that they are all of Russian origin.

ILLUSTRATION
1 *Carnet of green jasper mounted in gold and set with diamonds, by Michael Perchin for the firm of Fabergé, St Petersburg, before 1899 (Wernher Collection, Luton Hoo)*

Notes
1 Assay performed by Messrs Gübelin, Zurich
2 I am most grateful to Dr A. den Blaauwen for his assistance in sorting out this group. *Les Trésors d'Art en Russie* II (St Petersburg, 1902) p338 and Baron Foelkersam, 'La Calcédoine et son application aux arts', *Starye Gody* (St Petersburg, March 1916) ill. opp. p7
3 New York, American Art Association, 5–8 March 1923, lot 1129

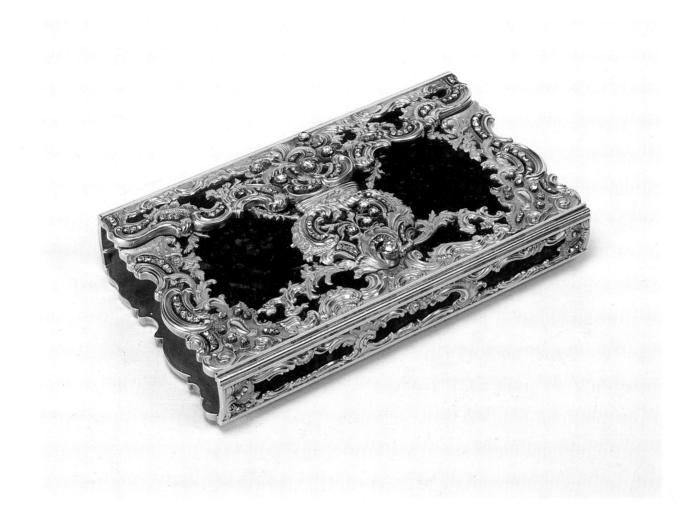

Objets de vertu from the workshops of Carl Fabergé
and other Russian goldsmiths

110 Paper knife

Nephrite paper knife mounted in red, yellow and green gold cast and chased with various classical motifs.

Dimensions
Length: 24 cm; width: 3.5 cm

Provenance
Christie's, Geneva, 19 November 1974, lot 269
K 221 B

Marks

On the pommel and on the ovolo band
1 Maker's mark of Michael Evlampievitch Perchin, goldsmith working for the firm of Fabergé in St Petersburg from (?) 1886 until 1903[1]
2 Standard mark of St Petersburg for gold of 56 zolotniks (14 carat) used before 1899[2]

Russian, St Petersburg, 1886–99, by Michael Evlampievitch Perchin for the firm of Fabergé

2 1

Michael Evlampievitch Perchin was born of peasant stock at Petrozavodsk in 1860. At the age of twenty-six, he assumed control of the chief workshop in the Fabergé premises in Bolshaya Morskaya Street, St Petersburg. The output of the workshop appears to have been enormous and included the Imperial Easter Eggs between 1886 and 1902 or 1903, the year in which Perchin died.[3]

A comparable knife was sold by Sotheby's, Zurich, 17 May 1979, lot 184.

Notes
1 Habsburg, no. 29
2 Habsburg, no. 2
3 Bainbridge, p 125; Snowman (1962) p 122

111 Frame

Small rectangular frame of translucent pale green enamel over an engine-turned ground around an oval silver-gilt border enclosing bevelled glass, the whole being surrounded by a border of red gold beneath green gold laurel leaves tied at the corners and at the centre of each side by red gold ribbons. The back of the frame is of ivory with a scrolling strut and a suspension loop.

Dimensions
Height: 7.9 cm; width: 6.3 cm

Provenance
Zervudachi, Vevey, 1976
K 200 E

Marks

On the right-hand side of the frame and on the strut
1 Maker's mark of Michael Evlampievitch Perchin, goldsmith working for the firm of Fabergé in St Petersburg from (?) 1886 until 1903[1]
2 Mark of the firm of Fabergé used in St Petersburg[2]
3 Standard mark of St Petersburg for gold of 56 zolotniks (14 carat) used before 1899[3]

Russian, St Petersburg, 1886–99, by Michael Evlampievitch Perchin for the firm of Fabergé

For biographical details of Perchin, see cat. no. 110.

Small frames such as this provided an excellent vehicle to display the skill of Fabergé's enamellers. Several of the workmasters produced them, usually in the revived Neo-Classical taste derived from French late eighteenth-century goldsmiths' work.

Notes
1 Habsburg, no. 29
2 Habsburg, no. 10
3 Habsburg, no. 2

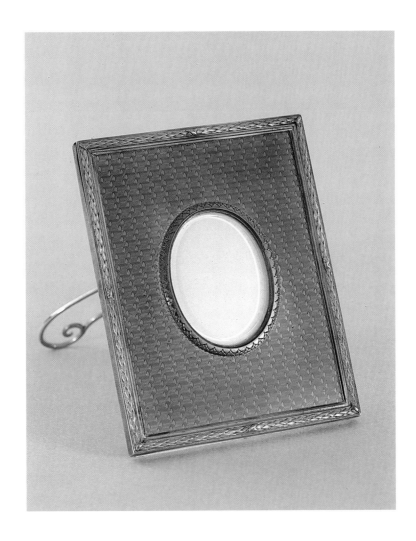

112 Vase

Small vase of pale rose aventurine quartz supported on a domed foot of two coloured gold cast with an ovolo motif from which rises a calyx of leaves interspersed with trefoils. The rim of the vase has a border of two coloured gold from which hang green gold swags tied with red gold ribbons.

Dimensions
Height: 6.8 cm; diameter: 5 cm

Provenance
Sotheby's, Monte Carlo, 29 November 1975, lot 86
K I 2 5 F

Marks

Beneath the rim of the base
1 Maker's mark of Michael Evlampievitch Perchin, goldsmith working for the firm of Fabergé in St Petersburg from (?) 1886 until 1903[1]
2 Mark of the firm of Fabergé used in St Petersburg[2]
3 Standard mark of St Petersburg for gold of 56 zolotniks (14 carat) used before 1899[3]

Russian, St Petersburg, 1886–99, by Michael Evlampievitch Perchin for the firm of Fabergé

For biographical details of Perchin, see cat. no. 110.

The choice of the pale aventurine quartz is untypical of Fabergé, who seems to have preferred stones with a greater visual impact, such as nephrite, or which have a pleasant translucency such as agate, but it is by no means unique. Any but the most chaste Neo-Classical mount would have overpowered the subtle colouring of the stone.

Notes
1 Habsburg, no. 29
2 Habsburg, no. 10
3 Habsburg, no. 2

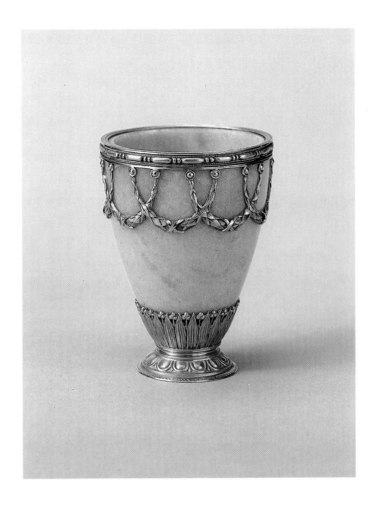

113 Frame

Photograph frame of gold set with diamonds in silver settings surrounded by rock crystal wheel-engraved with swags, ribbons and a wreath bordered in red gold beneath yellow gold chased with laurel leaves and set with eight rubies. The inner frame is backed with ivory and supported on a gold strut in the form of a lyre above scroll feet.

Dimensions
Diameter: 8.9 cm

Provenance
Christie's, Geneva, 26 April 1978, lot 378
K 148 F

Marks

On the outer rim
1 Maker's mark of Michael Evlampievitch Perchin, goldsmith working for the firm of Fabergé in St Petersburg from (?) 1886 until 1903[1]
2 Mark of the firm of Fabergé used in St Petersburg[2]
3 Standard mark of the St Petersburg assay-master Jakov Ljapunov for gold of 56 zolotniks (14 carat) used between 1899 and 1908[3]

On the strut 1, 3 and
4 French mark for gold and silver imported from countries without customs conventions, 1864–93[4]

Russian, St Petersburg, 1899–1903, by Michael Evlampievitch Perchin for the firm of Fabergé

1 2

3 4

For biographical details of Perchin, see cat. no. 110.

The photograph contained in the frame is of Grand Duke Boris Vladimirovitch, nephew of Tsar Alexander III, in the uniform of a Hussar.

Notes
1 Habsburg, no. 29
2 Habsburg, no. 10
3 Habsburg, no. 4
4 Carré, p 213

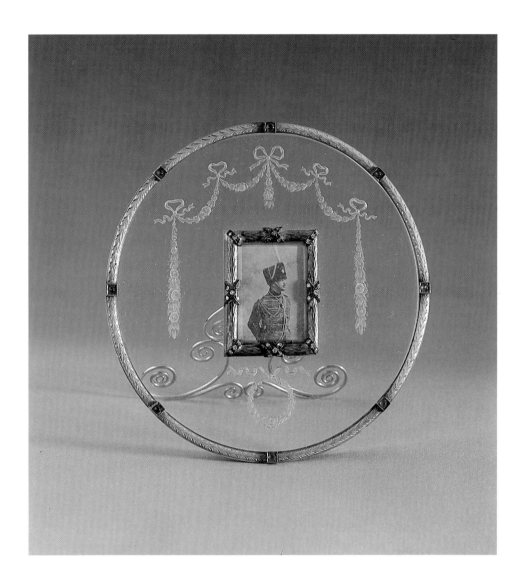

114 Cigarette and match case

Cigarette and match case in silver cast with ribs radiating from the top right-hand corner and gilt, and encrusted with a variety of devices, signatures, monograms, badges, helmets, some music, a violin, a bottle in gold and enamel and a turquoise. The top of the case opens to reveal a container for matches and right-hand side of the case holds a tinder cord surmounted by a helmet of the Imperial Horse Guard. The lid has a cabochon sapphire thumbpiece.

Dimensions
Height: 13 cm; width: 8.5 cm

Provenance
Sotheby's, Zurich, 23 November 1978, lot 154
K125S

Marks

In the lid and in the base
1 Maker's mark of August Wilhelm Holmström, goldsmith working for the firm of Fabergé in St Petersburg from 1857 until 1903[1]
2 Mark of the firm of Fabergé used in St Petersburg[2]
3 Standard mark of St Petersburg for silver of 88 zolotniks (91.6%) used before 1899[3]

Russian, St Petersburg, *circa* 1896, by August Wilhelm Holmström for the firm of Fabergé

Cigarette cases of this type may be considered the Russian male equivalent of the charm bracelet, and as with the bracelet the significance of the charms may only be known to the owner, or donor. Amongst those on the present example which are identifiable are, on the base, the name P. Kostlivzeff, the coat-of-arms of Count von Nowosittzoff,[4] the helmet of a mounted grenadier, the jetton of the Imperial Guard Hussar regiment of his Majesty with the monogram of Tsar Nicholas II,[5] and the date '26 iv 1896', and on the lid the sabre-tache of the Imperial Guard Hussar regiment, the helmet of the Imperial Horse Guard, the Order of St George, a Christmas tree, and a violin and music.[6]

August Wilhelm Holmström was a Finn, born in Helsinki on 2 October 1829, who served his apprenticeship to the German jeweller Herold in Malaya Sadovaya Street, St Petersburg. In 1850 he became a journeyman and seven years later, on becoming master, was appointed principal jeweller to the firm of Gustave Fabergé. On his death in 1903, his workshop was taken over by his son Albert who used the same maker's mark.[7]

Notes
1 Habsburg, no. 22
2 Habsburg, no. 10
3 Habsburg, no. 2 illustrates the comparable mark for 56 zolotniks
4 Siebmacher, Band III, 11, Taf. 142, p 378
5 Serge Andolenko, *Badges of Imperial Russia* (Washington DC, 1972) no. 29
6 I am most grateful to Mr Alexander von Solodkoff for his advice on this piece
7 Bainbridge, p 130; Snowman (1962) p 122; Helsinki, pp 33–34

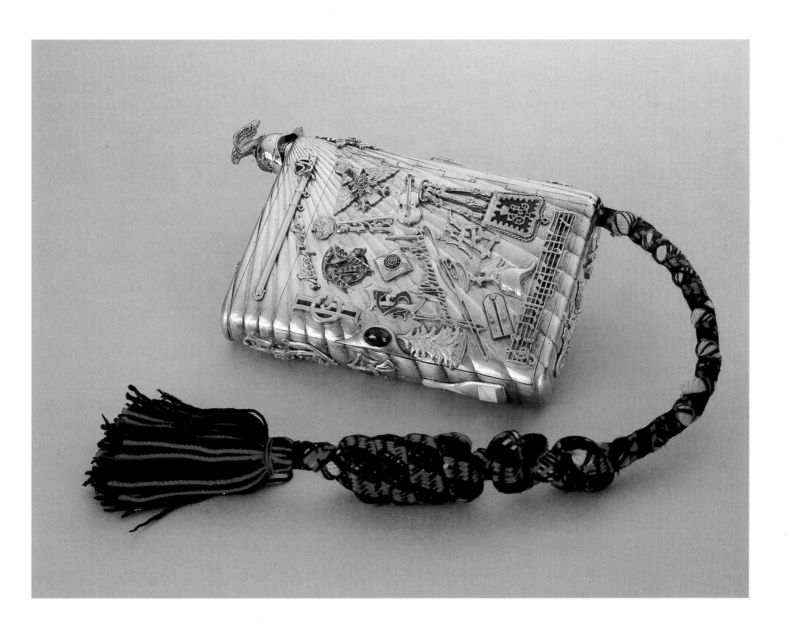

115 Kovsh

Kovsh of silver-gilt, the outside of the bowl of which is decorated with *cloisonné* enamel feathers in alternating bands of red and white over naturalistically engraved grounds, and bordered by a rope of silver-gilt and a plain rim set with four emeralds. The handle is enamelled in translucent red and set with stylised leaves beneath a further emerald in a collet enamelled with opaque white vertical stripes.

Dimensions
Height: 5.5 cm; length: 11.5 cm; width: 7 cm

Provenance
Christie's, Geneva, 1 April 1974, lot 181
K237C

Marks

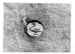

Under the base
1 Maker's mark of Anders Juhaninpoika Navalainen, goldsmith working for the firm of Fabergé in St Petersburg from 1885 until 1918[1]
2 Standard mark of St Petersburg for silver of 88 zolotniks (91.6%) used before 1899[2]
3 French mark for silver imported from countries without customs conventions, since 1 June 1893[3]

Russian, St Petersburg, 1885–99, by Anders Juhaninpoika Navalainen for the firm of Fabergé

Anders Juhaninpoika Navalainen was a Finn born at Pielisjärvi on 1 January 1858. He moved to St Petersburg in 1874, and having become master in 1885 joined the firm of Fabergé, at first in the workshop of August Holmström, and later on his own. Occasionally his mark is found on pieces which bear Fabergé's Moscow mark.[4]

Notes
1 Habsburg, no. 26
2 Habsburg, no. 2 illustrates the comparable mark for 56 zolotniks
3 Carré, p 213
4 Bainbridge, p 127; Snowman (1962) pp 123–24; Helsinki, p 42

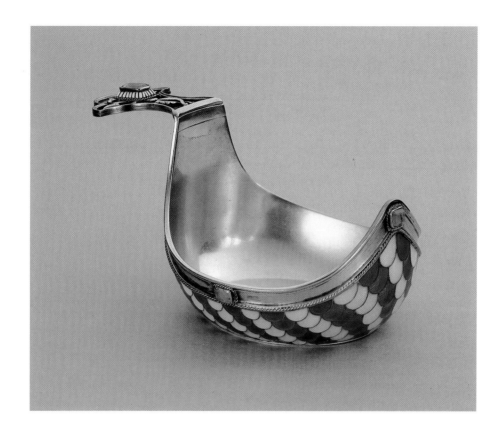

116 Frame

Frame of silver cast as rods bound at intervals with crossed ribbons and gilt, bordered by Karelian birchwood, and supported at the back by a strut of the same wood.

Dimensions
Height: 18.2 cm; width: 14.5 cm

Provenance
Christie's, Geneva, 19 November 1979, lot 325

Marks

On the lower left-hand corner of the silver-gilt border
1 Maker's mark of Anders Juhaninpoika Navalainen, goldsmith working for the firm of Fabergé in St Petersburg from 1885 until 1918[1]
2 Mark of the firm of Fabergé used in St Petersburg[2]
3 Standard mark of the St Petersburg assay-master Jakov Ljapunov, for silver of 88 zolotniks (91.6%) used between 1899 and 1908[3]

Russian, St Petersburg, 1899–1908, by Anders Juhaninpoika Navalainen for the firm of Fabergé

For biographical details of Navalainen, see cat. no. 115.

According to the surviving ledgers of the London branch of Fabergé, these wooden mounted frames cost between four and seven pounds in 1912–13. In comparison, Alexander von Solodkoff has pointed out that in 1911 a room at Claridges Hotel and dinner at the Ritz could be had for 10/6d (52½p).[4]

Notes
1 Habsburg, no. 26
2 Habsburg, no. 10
3 Habsburg, no. 4 illustrates the comparable mark for 56 zolotniks
4 Alexander von Solodkoff, 'Fabergé's London Branch', *Connoisseur* CCIX (February 1982) p 108

117 Pair of vases

Pair of vases turned from grey-green Kalgon jasper hung with oxidised silver swags looped between rosettes and mounted on a base cast with a border of leaves, and set on three ball feet.

Dimensions
Height: 11.8 cm; diameter: 9 cm

Provenance
Sotheby's, Zurich, 13–14 November 1979, lot 487
K190G

Marks

Under the base of each
1 Maker's mark of Julius Alexandrovitch Rappoport, goldsmith registered in St Petersburg from 1883 until 1916[1]
2 Mark of the firm of Fabergé used in special circumstances from 1884 until 1918[2]
3 Standard mark of St Petersburg for silver of 88 zolotniks (91.6%) used between 1908 and 1917[3]
4 Russian standard mark for silver of 88 zolotniks[4]

Russian, St Petersburg, 1908–17, by Julius Alexandrovitch Rappoport for the firm of Fabergé

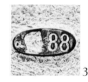

Julius Alexandrovitch Rappoport, a German, was born in 1864 and trained in Berlin. In 1883, he set up his workshop at Ekaterininski Canal, no. 65. Unlike the other workmasters Rappoport did not move into the firm's branch in Bolshaya Morskaya Street, but continued working for Fabergé from his own premises. He died in 1916. As on the two vases, Rappoport's mark is sometimes accompanied by that of the house of Fabergé beneath the imperial warrant mark.[5]

Notes
1 Habsburg, no. 31
2 Habsburg, nos 12 and 14
3 Habsburg, no. 7A
4 Goldberg, nos 18–24 show comparable marks for different standards
5 Bainbridge, p 126; Snowman (1962) p 122

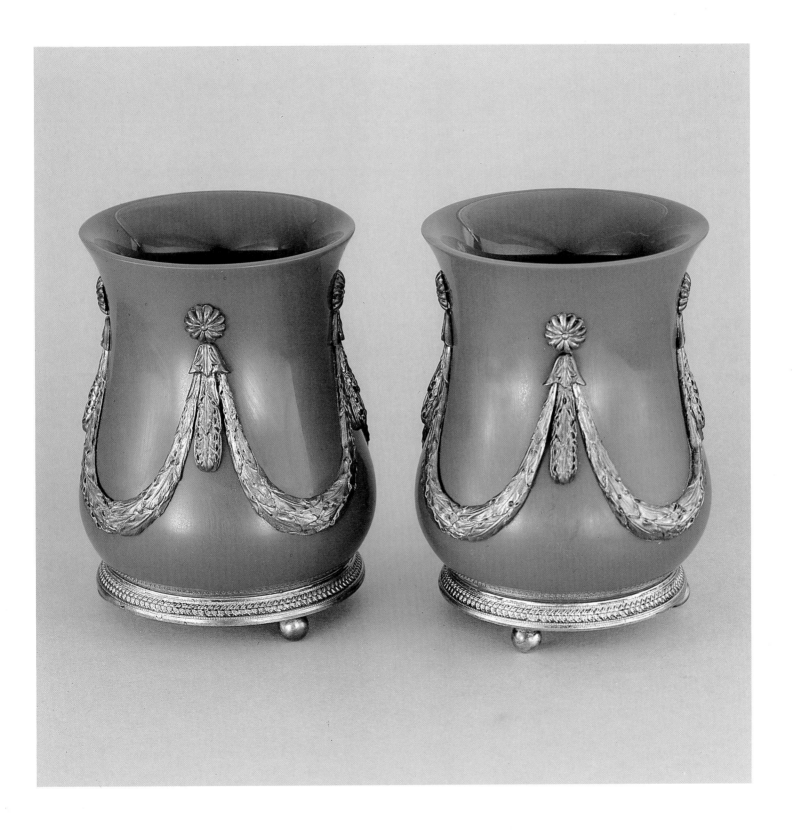

118 Five decanters

Set of five conical decanters of glass cut on the wheel with hexagonal prunts with pyramids between, and with star-cut bases. Each decanter is mounted with a silver collar cast with laurel swags suspended from a band of pellets above a border of anthemions against a striped ground. The stoppers of the decanters are cast as the heads of a capercaillie, a curlew-sandpiper, a wolf, a lynx and a fox.

Dimensions
Height of each: approx 26 cm; diameter: approx 12 cm

Provenance
K 15 I 0 + P

Marks

On the collar of each decanter
1 Maker's mark of Julius Alexandrovitch Rappoport, goldsmith registered in St Petersburg from 1883 until 1916[1]
2 Mark of the firm of Fabergé used in St Petersburg[2]
3 Standard mark of St Petersburg for silver of 88 zolotniks (91.6%) used before 1899[3]

On the stoppers formed as the heads of a capercaillie, a curlew-sandpiper and a fox 1 and
4 Mark used in St Petersburg before 1899

On all the stoppers
5 French mark for silver imported from countries without customs conventions, since 1 June 1893[4]

Russian, St Petersburg, *circa* 1890, by Julius Alexandrovitch Rappoport for the firm of Fabergé

For biographical details of Rappoport, see cat. no. 117.

The workshop of Julius Rappoport on the Ekaterininski Canal was noted for its models of animals in silver.

The heads of game birds and wild animals[5] here used as stoppers suggest that these decanters were designed for use in a hunting lodge. As with the silver-mounted bowl (cat. no. 131) the origin of the glass is uncertain although the quality of the metal and of the cutting suggest that it is of Russian origin.

Notes
1 Habsburg, no. 31
2 Habsburg, no. 10
3 Habsburg, no. 1 illustrates the comparable mark for 84 zolotniks
4 Carré, p 213
5 I am very grateful to Miss Joyce Pope, of the British Museum (Natural History) for her assistance in identifying the animals and birds

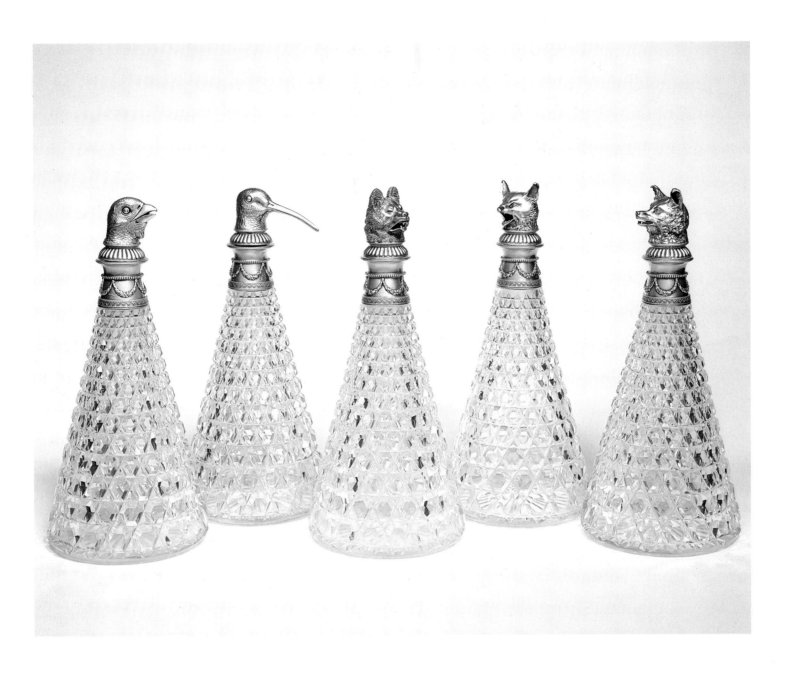

119 Cigarette case

Small oblong cigarette case of silver, enamelled in translucent purple over an engine-turned ground, with two parallel bands of diamonds running around the box, and with a moonstone thumbpiece. Where not enamelled, the silver is gilt.

Dimensions
Height: 1.4 cm; length: 7.8 cm; depth: 4.2 cm

Provenance
Christie's, Geneva, 20 November 1973, lot 330
K166B

Marks

In the lid and in the base
1 Maker's mark of August Frederik Hollming, workmaster for the firm of Fabergé in St Petersburg from 1880 until 1915[1]
2 Mark of the firm of Fabergé in St Petersburg[2]
3 Standard mark of the St Petersburg assay-master Jakov Ljapunov for silver of 88 zolotniks (91.6%) used between 1899 and 1908[3]

Russian, St Petersburg, 1899–1908, by August Frederik Hollming for the firm of Fabergé

August Frederik Hollming was born at Loppis in Finland on 3 December 1854. After moving to Tavatshus (Hämeenlinna), he left Finland for an apprenticeship in St Petersburg in 1876 and became master four years later. His workshop was initially at 35 Kasanskaya Street but in 1900 he moved into Fabergé's premises. His workshop was noted above all for the production of cigarette cases, many of which bear his mark A H, with the star between which differentiates it from that of the jeweller August Holmström. Hollming died on 4 March 1913 in Helsinki but management of the workshop was continued by his son with the assistance of another Finn, Otto Hanhinan.[4]

Notes
1 Habsburg, no. 21
2 Habsburg, no. 10
3 Habsburg, no. 4 illustrates the comparable mark for 56 zolotniks
4 Bainbridge, pp 125–26; Snowman (1962) p 123; Helsinki p 37

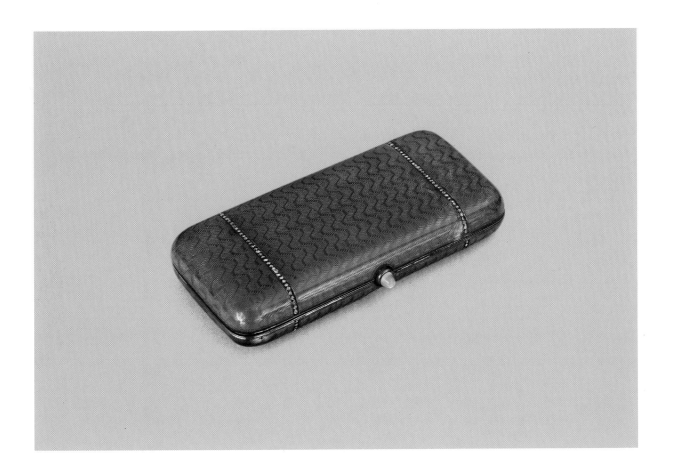

120 Cigarette case

Rectangular silver cigarette case of slightly curved profile enamelled in translucent red over an engine-turned ground, with a thumbpiece of diamonds and a gilt interior.

Dimensions
Height: 1.5 cm; length: 8.5 cm; depth: 5.8 cm

Provenance
Christie's, Geneva, 1 April 1974, lot 215
K 234 A

Marks

In the lid
1 Maker's mark of August Frederik Hollming, workmaster for the firm of Fabergé in St Petersburg from 1880 until 1915[1]
2 Mark of the firm of Fabergé used in St Petersburg[2]
3 Russian standard mark for silver of 88 zolotniks (91.6%)[3]

In the base 1, 2 and
4 Standard mark of the St Petersburg assay-master Jakov Ljapunov for silver of 88 zolotniks (91.6%) used between 1899 and 1908[4]

Russian, St Petersburg, 1899–1908, by August Frederik Hollming for the firm of Fabergé

1

2

3

4

For biographical details of Hollming, see cat. no. 119.

Boxes of this slightly curved shape first make an appearance in early nineteenth-century France. Two boxes of the type dated 1809–19 are illustrated by A.K. Snowman (1966, pls 418–19). It is probable that the change in fashion towards jackets with high tight waist bands, and, for the evening, tight trousers, necessitated this practical shape.

Notes
1 Habsburg, no. 21
2 Habsburg, no. 10
3 Goldberg, nos 18–24 show comparable marks for different standards
4 Habsburg, no. 4 illustrates the comparable mark for 56 zolotniks

Additional bibliography
Solodkoff, fig 86

121 Cigarette case

Cylindrical cigarette case of gold enamelled around the walls in translucent red over an engine-turned ground, and set at each end with a ten ruble gold piece of 1774 and 1776 surrounded by diamonds in silver settings, and with a diamond thumbpiece.

Dimensions
Length: 8.5 cm; diameter: 3.3 cm

Provenance
Sotheby's, Monte Carlo, 29 November 1975, lot 98
K125H

Marks

In both sides
1 Maker's mark of August Frederik Hollming, workmaster for the firm of Fabergé in St Petersburg from 1880 until 1915[1]
2 Mark of the firm of Fabergé used in St Petersburg[2]
3 Standard mark of the St Petersburg assay-master Jakov Ljapunov for gold of 56 zolotniks (14 carats) used between 1899 and 1908[3]

Russian, St Petersburg, 1899–1908, by August Frederik Hollming for the firm of Fabergé

For biographical details of Hollming, see cat. no. 119.

Coins dating from the reign of Catherine II, the Great, were frequently mounted by Fabergé's workmasters in order to identify with the Golden Age of eighteenth-century Russia. The present coins, ten ruble pieces, were both struck at the St Petersburg mint and bear portraits of the Empress dated 1774 and 1776.[4]

Notes
1 Habsburg, no. 21
2 Habsburg, no. 10
3 Habsburg, no. 4
4 H. M. Severin, *Gold and Platinum Coinage of Imperial Russia from 1701–1911* (New York, 1958) nos 307 and 311A

122 Thermometer and bell-push

Combined thermometer and bell-push of nephrite mounted in silver-gilt; the bell-push of moonstone rises from a dome of leaves in silver-gilt set below the glass mercurial thermometer calibrated in Fahrenheit mounted on a white marble ground beneath swags of laurel tied with a ribbon and hung between studs, all in silver-gilt, the whole being bordered by chased laurel leaves.

Dimensions
Height: 16 cm; width: 4.8 cm

Provenance
Sotheby's, Monte Carlo, 22–26 June 1976, lot 624
K 125 R

Marks

On the left-hand side of the frame
1 Maker's mark of Johann Victor Aarne, goldsmith working for the firm of Fabergé in St Petersburg from 1891 until before 1917[1]
2 Mark of the firm of Fabergé used in St Petersburg[2]
3 Standard mark of the St Petersburg assay-master Jakov Ljapunov for silver of 88 zolotniks (91.6%) used between 1899 and 1908[3]

Russian, St Petersburg, 1899–1908, by Johann Victor Aarne for the firm of Fabergé

Johann Victor Aarne was born on 6 May 1863 at Tampere in Finland where he began his apprenticeship in 1875. In 1880 he attained the mastership and moved to St Petersburg where he apparently worked for the firm of Fabergé for ten years, before returning to Tampere to set up his own business. In 1891, however, he returned to St Petersburg and worked for Fabergé once again from workshops at 58 Demidov Street (Ekaterininski Canal). These premises were sold to K.G.H. Armfeldt (see cat. no. 128) in 1904. At some time before 1917 Aarne returned to Finland where he set up in business in Viipuri and continued to work as a goldsmith until his death in 1934.[4]

Notes
1 Habsburg, no. 17
2 Habsburg, no. 10
3 Habsburg, no. 4 illustrates the comparable mark for 56 zolotniks
4 Bainbridge, p 125; Snowman (1962) p 123; Helsinki, p 40

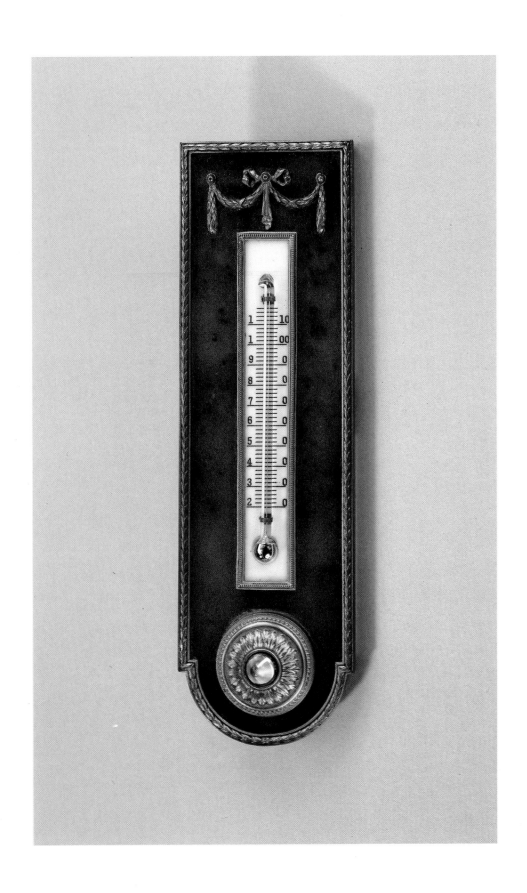

123 Stamp damper

Rectangular stamp damper of nephrite on four gold bun feet, the sides with swags of green gold laurels set with cabochon rubies hung from red gold ribbons and rose diamond studs, the upper rim of red gold supporting a border of laurel leaves chased in green gold. The roller is of matted rock crystal.

Dimensions
Height: 3.8 cm; length: 6.2 cm; depth: 4 cm

Provenance
Christie's, Geneva, 19 November 1979, lot 331
K 190F

Marks

On the upper rim
1 Maker's mark of Fedor Afanassiev, goldsmith working for the firm of Fabergé in St Petersburg[1]
2 Standard mark of the St Petersburg assay-master A. Richter for gold of 56 zolotniks (14 carat) used between 1899 and 1908[2]

On one ribbon on each side
3 Mark of the St Petersburg assay-master A. Richter used between 1899 and 1908

Russian, St Petersburg, 1899–1908, by Fedor Afanassiev for the firm of Fabergé

1 2

3

A stamp damper of white agate, decorated in very much the same style and by the same maker was in the collection of Robert Strauss.[3]

Little is recorded about the goldsmith Fedor Afanassiev. He is known to have been of Russian birth, and his mark is usually found on small work such as miniature Easter eggs.[4]

Notes
1 Habsburg, no. 18
2 See Habsburg, no. 5 for the mark used by Richter for 72 zolotniks
3 Christie's, London, 9 March 1970, lot 20; Snowman (1962) pl 166
4 Bainbridge, p 127; Snowman (1962) p 124

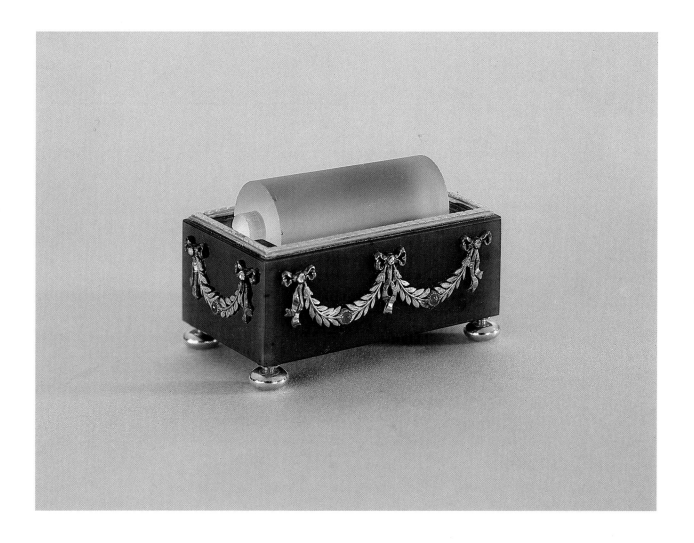

124 Parasol handle

Parasol handle of rock crystal mounted in gold chased with a band of green gold leaves with rubies and sapphires between, all on a matted ground, from which rises a further band of openwork leaves and flowers set with rubies and sapphires. The handle has been lengthened by the addition of a further matted band of gold and converted to hold a magnifying glass.

Dimensions
Length of whole: 19.7 cm; length of handle: 8 cm

Provenance
Sotheby's, Monte Carlo, 29 November 1975, lot 88
K125G

Marks

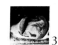

On the lower band of the handle
1 Maker's mark of Henrik Immanuel Wigström, goldsmith working for the firm of Fabergé in St Petersburg from (?) 1886 until 1917[1]
2 Russian standard mark for gold of 72 zolotniks (18 carats)[2]
3 Russian mark for small work used between 1908 and 1917[3]

Russian, St Petersburg, 1908–1917, by Henrik Immanuel Wigström for the firm of Fabergé

Henrik Immanuel Wigström, a Swedish Finn, was born in Ekenäs (Tammisaari) on 2 October 1862. In 1878 he moved to St Petersburg and six years later he joined the workshops of Michael Perchin (see cat. nos 110–13). Following the latter's death in 1903, Wigström assumed the position of chief workmaster and continued the production of the Imperial Easter Eggs until the Revolution. Described by Bainbridge as 'A big, fat, jolly man', traits which are not immediately apparent from a photograph of him, Wigström also oversaw the production of the hardstone figures and animals. He died at Kivinapa in 1923, but his son Henrik Wilhelm continued as a goldsmith in Helsinki for a further eleven years.[4]

Notes
1 Habsburg, no. 40
2 Goldberg, nos 18–24 show comparable marks for different standards
3 Habsburg, no. 9
4 Bainbridge, p 125; Snowman (1962) p 122; Helsinki, pp 29–30

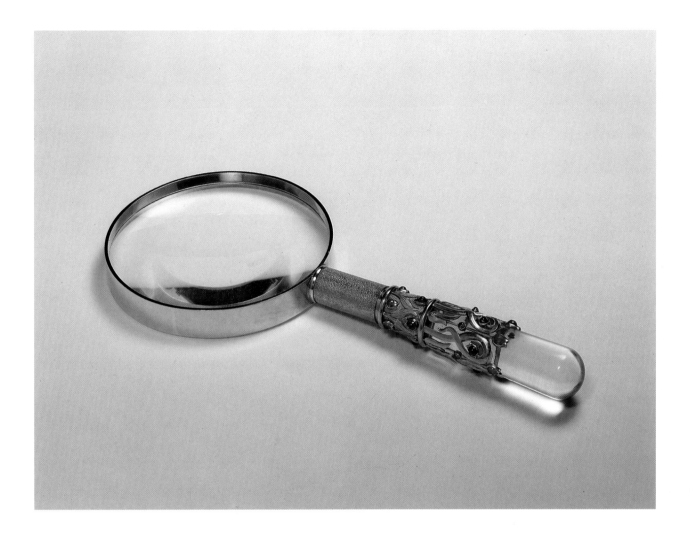

125 Desk set

Desk set comprising a standing clock, an ink pot, match box, bell-push, blotter, tray, pen and propelling pencil, with a table clock, a pair of candlesticks and a gum pot of nephrite mounted in two coloured gold (red and green) and silver-gilt.

Dimensions

1 STANDING CLOCK height: 20.5 cm; diameter of base: 9 cm
2 INK POT height: 11.75 cm; diameter of base: 8.3 cm
3 MATCH BOX height: 3 cm; width: 6.7 cm; depth: 7.1 cm
4 BELL-PUSH height: 4.8 cm; diameter: 6 cm
5 BLOTTER height: 7 cm; width: 11.3 cm; depth: 6 cm
6 PEN TRAY height: 2.5 cm; length: 21.5 cm; depth: 5.4 cm
7 PEN length: 16.5 cm
8 PENCIL length: 13.1 cm
9 TABLE CLOCK height: 6.8 cm; diameter: 8.5 cm
10 CANDLESTICKS height: 11.2 cm; diameter: 7.1 cm
11 GUM POT height: 9.7 cm; diameter: 5 cm

Provenance

nos 1–8: Egyptian Royal Collections, sold Sotheby's, Koubbeh Palace, Cairo, 11 March 1954, lot 146
Sir Bernard Eckstein Collection
nos 9–11: Dr James Hasson Collection
K190C

Marks

On the back of 1, on the rims of 2, 3 and 11 and on the sides of 5 and 6
1 Maker's mark of Henrik Immanuel Wigström, goldsmith working for the firm of Fabergé in St Petersburg from (?) 1886 until 1917[1]
2 Mark of the firm of Fabergé used in St Petersburg[2]
3 Standard mark of the St Petersburg assay-master A. Richter for gold of 56 zolotniks (14 carats) used between 1899 and 1908[3]

On the upper band of 4, on the laurel band of 8, on the central band of 9, on the lower band of 10 and 11 and on the brush holder of 11 1 and 3 only

On the rim of the lid of 2 and on the mount of the glass bottle in 2
4 Russian assay mark used between 1899 and 1908[4]

Russian, St Petersburg, 1899–1908, by Henrik Immanuel Wigström for the firm of Fabergé

For biographical details of Wigström, see cat. no. 124.

This large desk set has been assembled from two sources. The candlesticks, gum pot, and table clock were formerly in the collection of Dr James Hasson,[5] while the remainder of the set was in the possession of that inveterate collector King Farouk of Egypt.

Fabergé made a number of desk sets with varying contents, and in different stones. One in Kalgon jasper mounted in oxidised silver was in the collection of the late Sir Charles Clore,[6] and another in pale green bowenite in silver-gilt mounts is illustrated by Kenneth Snowman.[7]

Notes
1 Habsburg, no. 40
2 Habsburg, no. 10
3 Habsburg, no. 5 illustrates the equivalent mark for 72 zolotniks
4 Habsburg, no. 9
5 Bainbridge, pl. 40
6 Snowman (1962) fig 179
7 Snowman (1962) fig 187

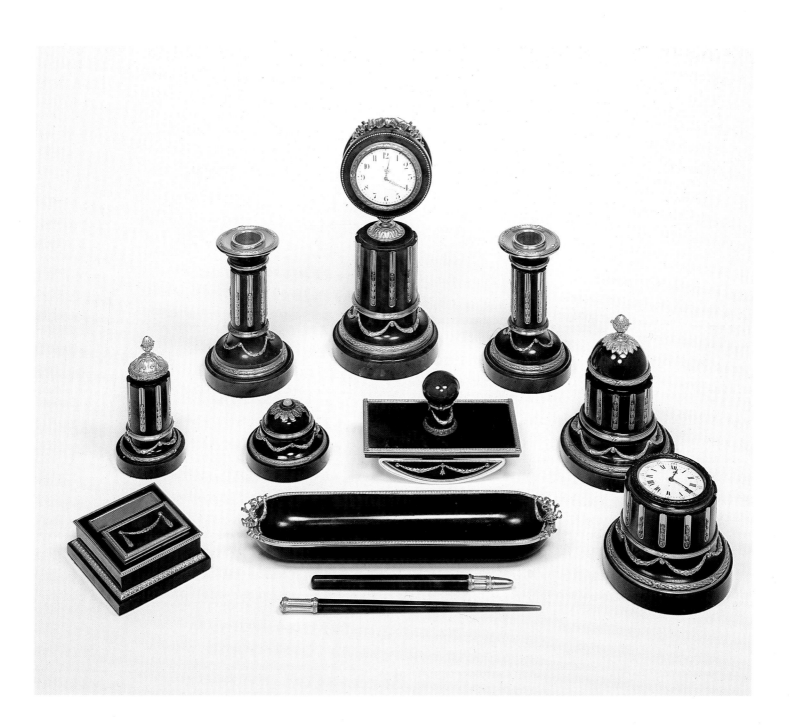

126 Casket

Large rectangular casket of nephrite mounted in gold enamelled in opaque white as rods bound at intervals by chased gold ribbons. The lid is supported by two hinges and a sliding strut.

Dimensions
Height: 7 cm; length: 19.75 cm; depth: 8.5 cm

Provenance
Sotheby's, Zurich, 13–14 November 1979, lot 526
K 148 H

Marks

On both hinges
1 Maker's mark of Henrik Immanuel Wigström, goldsmith working for the firm of Fabergé in St Petersburg from (?) 1886 until 1917[1]
2 Russian standard mark for gold of 56 zolotniks (14 carat)

On the left-hand hinge 1, 2 and
3 Mark of the firm of Fabergé used in St Petersburg[2]

Russian, St Petersburg, 1899–1917, by Henrik Immanuel Wigström for the firm of Fabergé

For biographical details of Wigström, see cat. no. 124.

Fabergé's predelection for Siberian nephrite is never better demonstrated than when the stone is cut so thin as to be almost translucent and used in large flat sheets as on this casket.

Notes
1 Habsburg, no. 40
2 Habsburg, no. 10

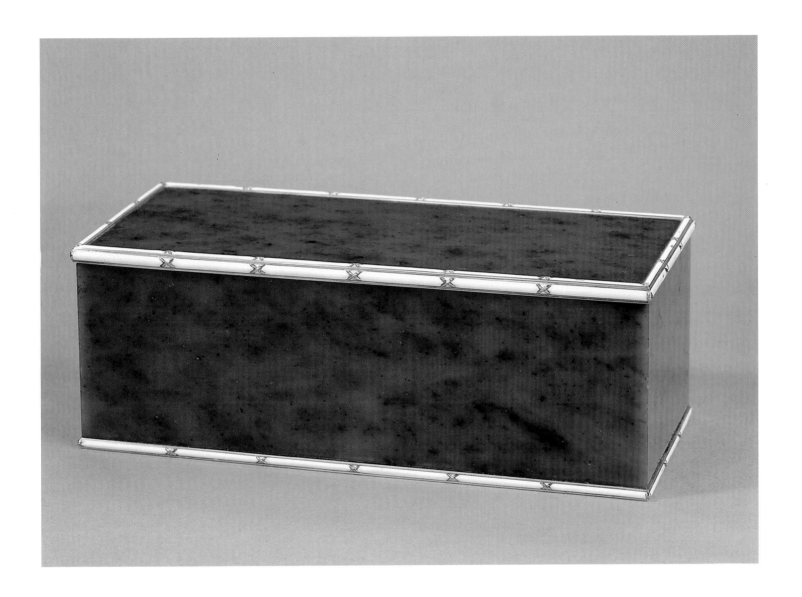

127 Cigarette case

Rectangular gold cigarette case engine-turned in a diaper pattern with, at each side, a continuous Vitruvian scroll of opaque white *champlevé* enamel, and with a thumbpiece of diamonds in silver settings.

Dimensions
Height: 1.7 cm; length: 9 cm; depth: 6.4 cm

Provenance
K172E

Marks

In the lid
1 Partly erased mark of Henrik Immanuel Wigström, goldsmith working for the firm of Fabergé in St Petersburg from (?) 1886 until 1917[1]
2 Mark of the firm of Fabergé used in St Petersburg[2]
3 Russian standard mark for small work used between 1908 and 1917[3]

On the front bezel of the lid 3

In the base 1 and
4 Standard mark of St Petersburg for gold of 56 zolotniks (14 carat) used between 1908 and 1917[4]

Russian, St Petersburg, 1908–17, by Henrik Immanuel Wigström for the firm of Fabergé

For biographical details of Wigström, see cat. no. 124.

Of the cigarette cases made by Fabergé's craftsmen, Henry Bainbridge was justifiably proud, saying that 'no gentlemen of Europe considered himself adequately equipped without at least three or four of them'.[5] He continued, 'Of all the productions of Fabergé, even counting the Imperial Easter Eggs, flowers, animals and all the other objects of fantasy, and if the lapse of time is finally to give Fabergé a place that can never be assailed, the same which the comparatively few who know him give to him now and that on a par with the makers of the 18th century French snuff-boxes (and do not let us forget the English), I say of all the productions of Fabergé, it's in my opinion, his cigarette cases which should finally bring about this happy consummation'.[6]

Notes
1 Habsburg, no. 40
2 Habsburg, no. 10
3 Habsburg, no. 9
4 Habsburg, no. 7 illustrates the comparable mark for 72 zolotniks
5 Bainbridge, p 104
6 Bainbridge, p 126

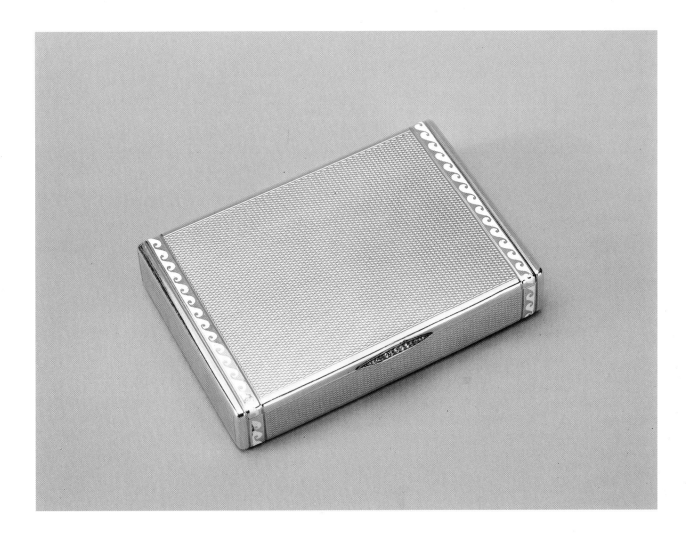

128 Frame

Frame of silver cast with laurel leaves bound at intervals with crossed ribbons bordered by Karelian birchwood, the upper part of which is set with a silver coronet. The edges of the glass in the frame are bevelled. A lyre-shaped wooden strut resting on two feet projects from the wooden back which is held in place by eight silver screws.

Dimensions
Height: 31.4 cm; width: 25.2 cm

Provenance
Sotheby's, Zurich, 23 November 1978, lot 138
K125T

Marks

On the lower side of the silver mount
1 Maker's mark of Karl Gustav Hjalmar Armfeldt, goldsmith working for the firm of Fabergé in St Petersburg from 1895 until 1916[1]
2 Mark of the firm of Fabergé used in St Petersburg[2]
3 Standard mark of St Petersburg for silver of 88 zolotniks (91.6%) used between 1908 and 1917[3]

On the other three sides
4 Russian mark for silver of 88 zolotniks (91.6%) used between 1908 and 1917[4]

Russian, St Petersburg, 1908–16, by Karl Gustav Hjalmar Armfeldt for the firm of Fabergé

Karl Gustav Hjalmar Armfeldt was a Finn of Swedish extraction born at Artjärvi in Finland on 6 April 1873. At the age of thirteen he began his apprenticeship to the Finnish goldsmith Paul F. Sohlman at 58 Gorohavaya Street, St Petersburg. He completed his apprenticeship in 1891 and subsequently worked as a journeyman in the workshops of Anders Navalainen from 1895 until 1904. In that year he acquired the workshops of J. V. Aarne (see cat. no. 122) together with twenty workmen and three apprentices. Armfeldt apparently continued to live in Russia following the Revolution but moved to Tavatshus (Hämeenlinna) in Finland in 1920. He died on 22 July 1959 in Helsinki.[5]

Notes
1 Habsburg, no. 19
2 Habsburg, no. 10
3 Habsburg, no. 7 illustrates the St Petersburg mark for 72 zolotniks
4 Goldberg, no. 18 illustrates a comparable mark for 87 zolotniks
5 Bainbridge, p 126; Snowman (1962) p 123; Helsinki, p 41

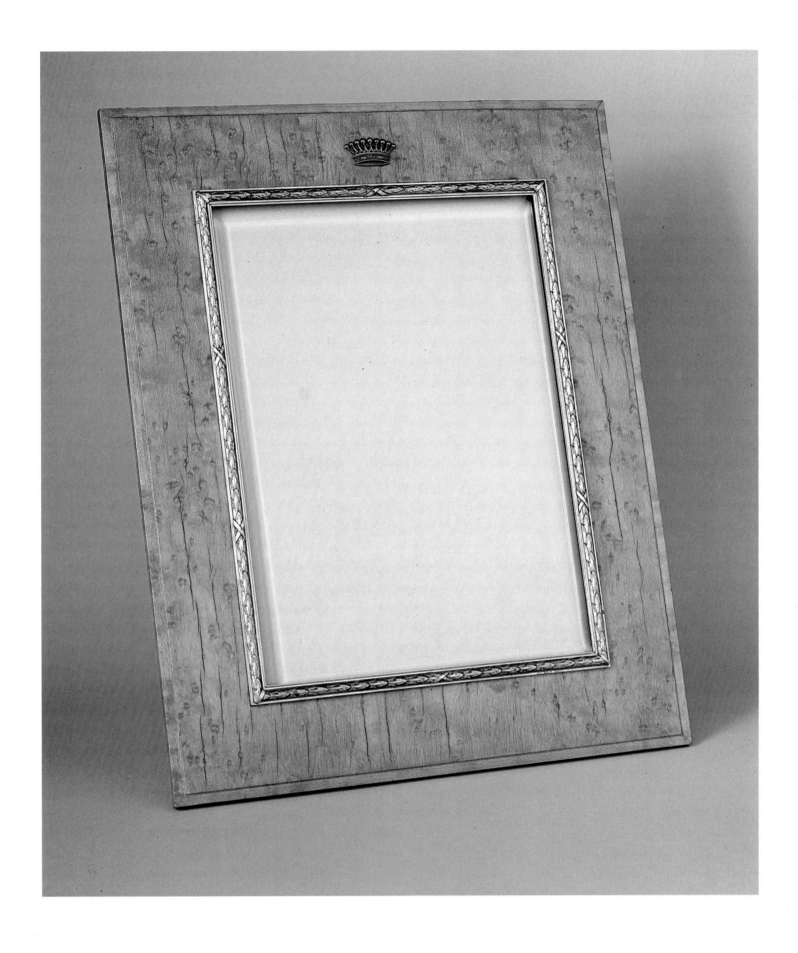

129 Frame

Ovoid frame of translucent pink enamel over a ground engraved with radiating lines around the oval glass which is surrounded by a border of silver-gilt pellets. The glass is flanked by two laurel branches and the whole frame surmounted by a ribbon knotted about a cabochon ruby. The ivory back of the frame supports a silver-gilt strut.

Dimensions
Height: 6.5 cm; width: 4.6 cm

Provenance
Christie's, Geneva, 1 May 1974, lot 220
K132D

Marks

On the lower left-hand side of the frame
1 Maker's mark of Karl Gustav Hjalmar Armfeldt, goldsmith working for the firm of Fabergé in St Petersburg from 1895 until 1916[1]
2 Mark of the firm of Fabergé used in St Petersburg[2]
3 Standard mark of the St Petersburg assay-master Jakov Ljapunov, for silver of 88 zolotniks (91.6%) used between 1899 and 1908[3]

On the strut 1 and 3

Russian, St Petersburg, 1899–1908, by Karl Gustav Hjalmar Armfeldt for the firm of Fabergé

1 2

3

For biographical details of Armfeldt, see cat. no. 128.

It is clear from surviving pieces that several workshops, including those of Perchin, Aarne and Navalainen made frames similar to the present example by Armfeldt. Alexander von Solodkoff has demonstrated that the London branch of Fabergé sold enamelled frames for between £20 and £30 in about 1912.[4]

Notes
1 Habsburg, no. 19
2 Habsburg, no. 10
3 Habsburg, no. 4 illustrates the comparable mark for 56 zolotniks
4 A. von Solodkoff, 'Fabergé's London Branch', *Connoisseur* CCIX (February 1982) p105

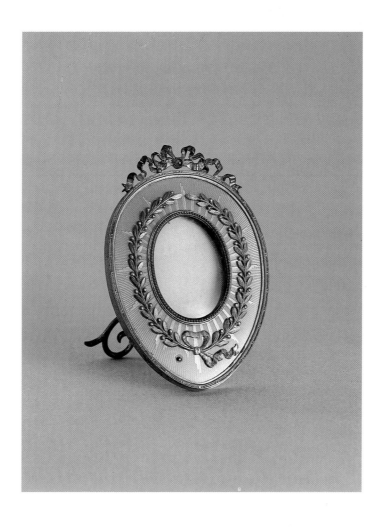

130 Kovsh

Silver-gilt *kovsh* of traditional boat-shaped form, mounted on a flaring foot and with a handle formed as a fleur de lis. The matted body is decorated in *cloisonné* enamel with bands of stylised roses in opaque yellow with green leaves, above scrolling foliage and flowers in opaque green, white, purple and yellow, the two bands of ornament being separated by silver-gilt chased as ropes bordered by stripes of opaque brown enamel. The upper surface of the handle is bordered by ropework and set with a plaque enamelled with the arms of the family of Prince Ouroussov[1] beneath a princely crown and mantled in a cape of red lined with ermine.

Dimensions
Height: 11.9 cm; length: 28.4 cm; depth: 15.6 cm

Provenance
Sotheby's, Zurich, 17 November 1976, lot 301
K 200M

Marks

Beneath the foot
1 Mark of the firm of Fabergé used in Moscow from 1887 until 1918[2]
2 Standard mark of Moscow for silver of 88 zolotniks (91.6%) used before 1899[3]

Russian, Moscow, 1887–99, by the firm of Fabergé

The *kovsh* is a traditional Russian vessel used in the service and drinking of mead. Metal *kovshi*, derived from wooden prototypes, emerged in the fourteenth century and continued to be made, largely for presentations, until the middle of the nineteenth century. However, the period following the Pan-Russian Exhibition of 1882 saw a revival of traditional Russian forms including the *kovsh*.[4]

Notes
1 R.J.Ermerin, *La Noblesse Titrée de l'Empire de Russie* (1898) pp111–12
2 Habsburg, no.13
3 Solodkoff, p221
4 Solodkoff, pp84–87

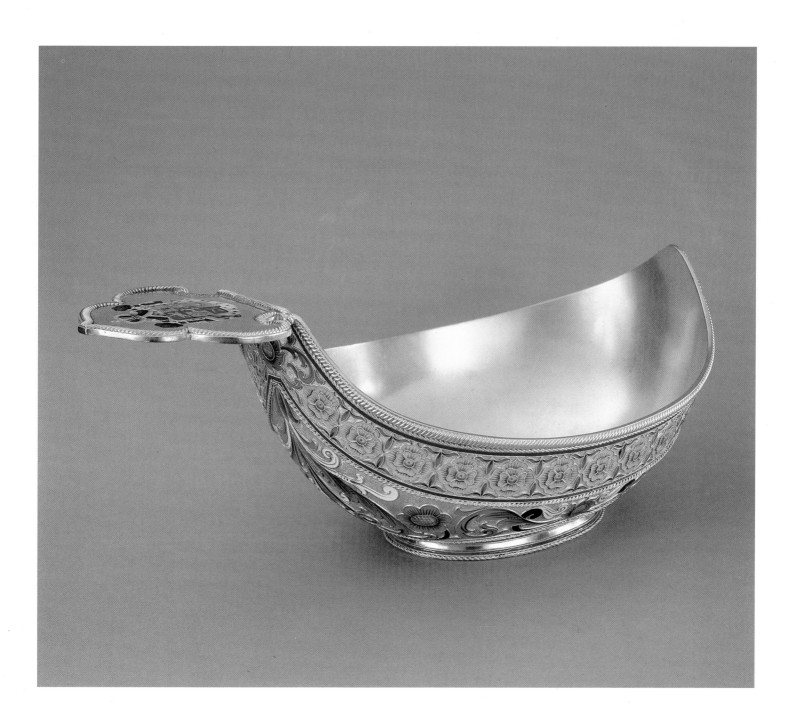

131 Rose-bowl

Circular bowl of clear glass cut on the wheel and mounted with a silver rim cast as bound reeds and two handles cast as shells bordered by sprays of foliage.

Dimensions
Height: 10.8 cm; maximum width: 23.7 cm

Provenance
K 200 Y

Marks

Inside the rim
1 Mark of the firm of Fabergé used in Moscow between 1887 and 1918[1]
2 Russian standard mark for silver of 84 zolotniks (87.5%)[2]
3 Russian mark for small work used between 1908 and 1917[3]

Russian, Moscow, 1908–17, by the firm of Fabergé

Whereas there is no doubt about the origin of the silver mount, the same cannot be said about the bowl itself. Glasshouses throughout Europe and the United States produced and cut glass of this type in the early years of this century, and the absence of a mark, rare enough in any glass, makes it unwise to attribute the bowl to any factory or country.

Although frequently referred to as caviar bowls, it is probable that bowls of this shape were intended to hold flowers rather than to be used for containing food. The rose-bowl emerges as a form in the latter part of the nineteenth century presumably in response to the demand for a vessel which could be seen from all sides displayed on tables which were then placed in the centre of rooms, rather than against the walls as they had been in preceding centuries.

Notes
1 Habsburg, no. 13
2 Goldberg, nos 18–24 show comparable marks for different standards
3 Habsburg, no. 9

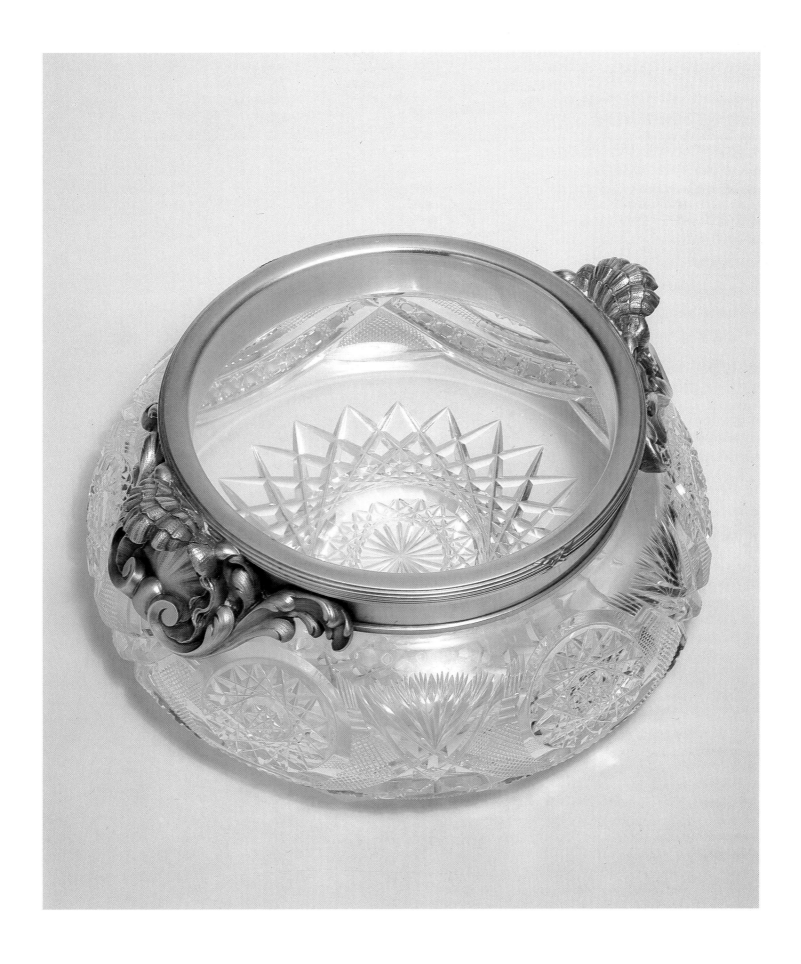

132 Vase

Large vase in the form of a Greek volute crater, the oviform body of which is of glass cut on the wheel with two bands of pyramids above and below a frieze of stylised flowers and concave circles. The vase is supported on a facet-cut stem the square foot of which is mounted in silver cast with rosettes, laurel leaves and a Greek key pattern, resting on four claw feet from which rise anthemions. The body of the vase has a mount of silver cast with laurel leaves and two lion masks from which spring volute handles, ribbed and punctuated by rosettes which terminate at the neck with paterae. The silver neck mount is cast with lotus.

Dimensions
Height: 34 cm; maximum width: 19 cm

Provenance
Sotheby's, Zurich, 13–14 November 1979, lot 513
K148G

Marks

On the foot of the glass vase
1 Mark of the Cristalleries de Baccarat, glass makers in the department of Moselle et Meurthe, France, since 1764

On the upper rim mount of the vase, on the central mount and beneath the foot
2 Mark of the firm of Fabergé used in Moscow from 1887 until 1918[1]
3 Russian mark for small work used between 1908 and 1917[2]

On the upper rim only 2, 3 and
4 Russian standard mark for silver of 84 zolotniks (87.5%)[3]

Beneath the foot 1, 2 and
5 Standard mark of the Moscow assay office for silver of 84 zolotniks (87.5%) used between 1908 and 1917[4]

Russian, Moscow, 1908–17, by the firm of Fabergé

It is clear that Fabergé did not restrict himself to using glass made at the Imperial Glass House in St Petersburg. His use of glass from Baccarat is not surprising since this firm had enjoyed an excellent reputation for cut lead crystal since the early nineteenth century. For coloured iridescent glass, so popular at the turn of the century, Fabergé appears to have patronised the firm of Lötz Wittwe in Klöstermuhl and Tiffany in New York.[5]

Notes
1 Habsburg, no. 13
2 Habsburg, no. 9
3 Goldberg, nos 18–24 show similar marks for different standards
4 Habsburg, no. 8
5 London, Victoria and Albert Museum, *Fabergé, 1846–1920* (London, 1977) nos s. 1–3

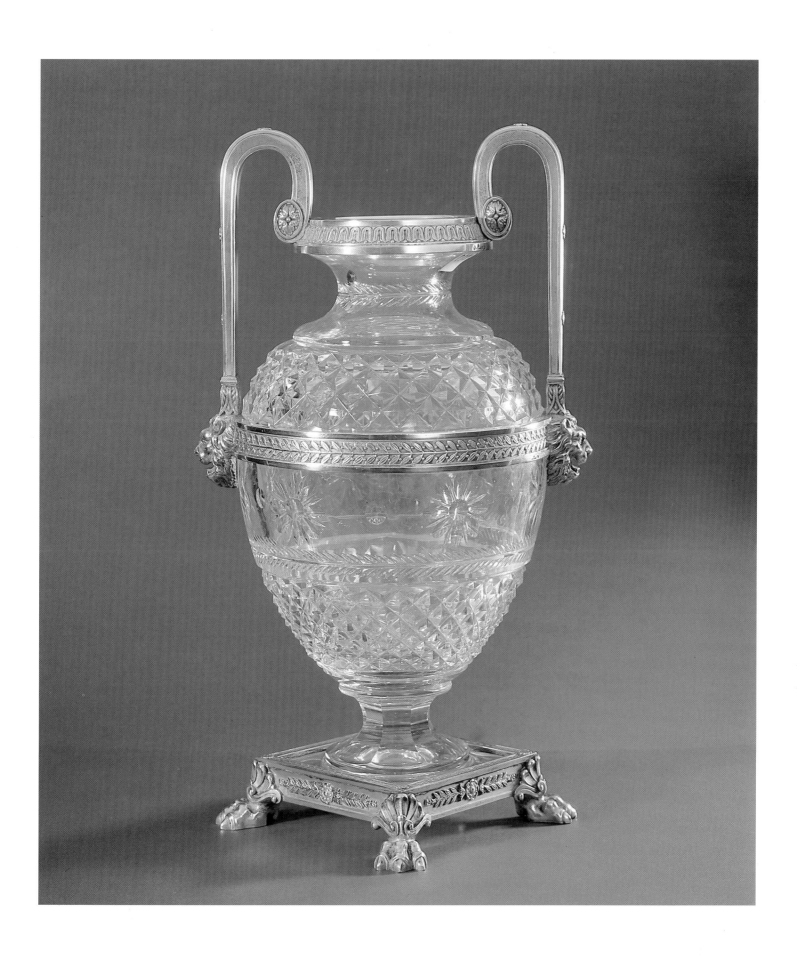

133 Cigarette case

Rectangular silver cigarette case of oval profile, the raised thumbpiece set with a sapphire, and the lid set with Cyrillic initials HH (NN) in monogram beneath an imperial crown; the interior with matt gilding.

Dimensions
Height: 9.3 cm; width: 6.3 cm

Provenance
Grand Duke Nicolai Nicolaivitch Collection
Grand Duchess Apoukhtine Collection, 1929
K190D

Marks

In the base
1 Mark of the firm of Fabergé used in Moscow from 1887 until 1918[1]
2 Mark of the Moscow assay office for silver of 88 zolotniks (91.6%) used between 1908 and 1917[2]

In the lid 1 and
3 Russian standard mark for silver of 88 zolotniks (91.6%)[3]

On the bezel of the lid
4 French mark for silver imported from countries without customs conventions, since 1893[4]

Russian, Moscow, 1908–17, by the firm of Fabergé

The initials on this cigarette box are those of the Grand Duke Nicolai Nicolaivitch who was a regular customer of Fabergé's. It was he who first suggested the idea of caricatures in hardstone, when he ordered a model of Queen Victoria. Henry Bainbridge recalls seeing the result, made in jadeite, but its present whereabouts is unknown.[5] From 1914 until the end of 1915, the Grand Duke was commander of the imperial army at the start of the First World War.

Another cigarette case bearing the Grand Duke's initials is in the collection of H.M. the Queen,[6] and a third is illustrated by Géza von Habsburg and Alexander von Solodkoff.[7] Despite the initials being Cyrillic, their Roman reading has an undoubted attraction of their present owner who shares the initials HH.

Notes
1 Habsburg, no. 13
2 Habsburg, no. 8
3 Goldberg, p 153
4 Carré, p 213
5 Bainbridge, p 112
6 London, Victoria and Albert Museum, *Fabergé, 1846–1920* (London, 1977) no. K. 31
7 Habsburg, fig 74

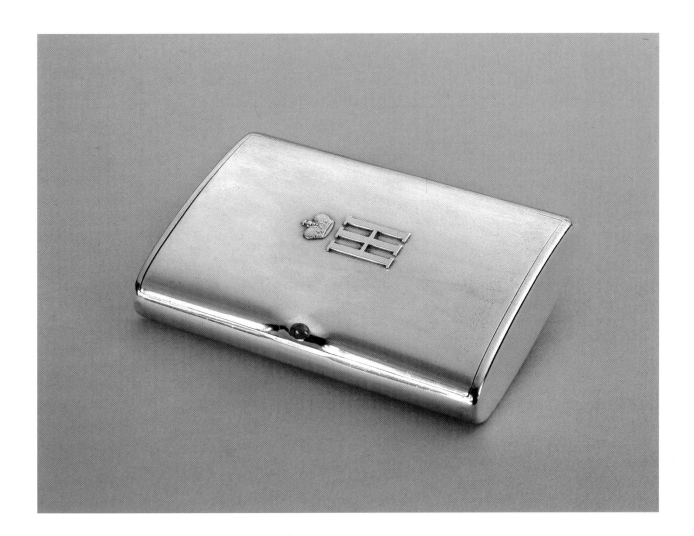

134 Cigarette case

Small rectangular silver cigarette case with rounded corners, the lid of which is decorated with a *champlevé* enamel scene of a peasant girl considering the attentions of her suitor. A circular thumbpiece operates a steel spring catch, and the interior is gilt.

Dimensions
Height: 1.8 cm; length: 8.5 cm; depth: 3.9 cm

Provenance
K 1480

Marks

In the lid
1 Maker's mark of Ivan Petrovitch Khlebnikov, goldsmith registered in St Petersburg between 1867 and 1871, and in Moscow, from 1871 until 1917[1]
2 Mark of the Moscow assay-master Victor Savinkov, 1878[2]
3 Russian standard mark for silver of 88 zolotniks (91.6%) before 1899[3]
4 Town mark of Moscow before 1899[4]

Russian, Moscow, 1878, by Ivan Petrovitch Khlebnikov

Ivan Petrovitch Khlebnikov was one of the more prolific of Russian goldsmiths. He began business in St Petersburg in 1867 but four years later moved to Moscow where he remained until the Revolution. Like Fabergé he held the imperial warrant, and the imperial eagle is frequently found in conjunction with the firm's mark. Work by Khlebnikov was exhibited at Vienna in 1873 and at the Pan-Russian Exhibition of 1882. In that year the firm was said to employ between 150 and 200 craftsmen.[5]

Notes
1 Solodkoff, no. 208
2 Goldberg, nos 620 and 621
3 Goldberg, no. 19
4 Goldberg, no. 528
5 Solodkoff pp 194–95, 207 and 217; Goldberg, no. 1035

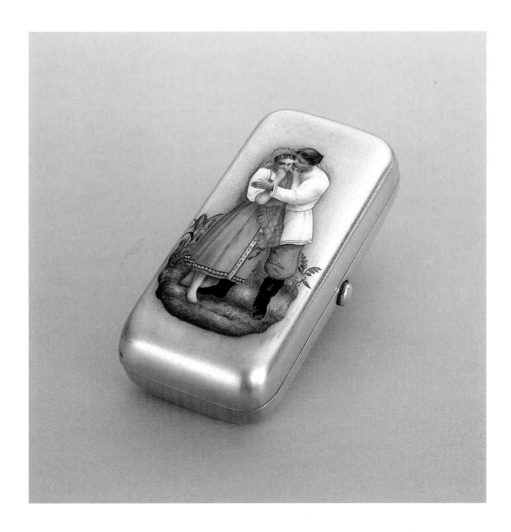

135 Cigarette case

Oblong silver cigarette case with rounded corners, on the cover of which are enamelled in translucent red and opaque black, blue, green and red the arms of Lobanov Rostovsky mantled in a scarlet cape lined with ermine beneath a princely crown, and the base is enamelled with a pattern of blue, black, and white crosses, around a circular motif of the same colours. The interior is gilt.

Dimensions
Height: 2.7 cm; length: 11 cm; depth: 6.5 cm

Provenance
K 1481

Marks

On the left-hand side of the bezel
1 Maker's mark of Ivan Petrovitch Khlebnikov, goldsmith registered in St Petersburg between 1867 and 1871, and in Moscow from 1871 until 1917[1]
2 Russian standard mark for silver of 88 zolotniks (91.6%)[2]
3 French mark for silver imported from countries without customs conventions, since 1 June 1893[3]

Russian, Moscow, 1871–96, by Ivan Petrovitch Khlebnikov

For biographical details of Khlebnikov, see cat. no. 134.

The enamelled coat-of-arms is probably that of Prince Alexis Borissovitch Lobanov Rostovsky (1824–96) who was Russian ambassador to the court of Vienna and subsequently Minister of Foreign Affairs in St Petersburg.[4] It must be assumed therefore that this box was made by Khlebnikov for him and it is thus unlikely to date from after his death.

Notes
1 Solodkoff, no. 208
2 Goldberg, no. 19
3 Carré, p 213
4 R. J. Ermerin, *La Noblesse Titrée de L'Empire de Russie* (1898) pp 83–84, ills 166–67, and Arnaud Chaffanjon, *Le Petit Gotha Illustré* (1968) p 423

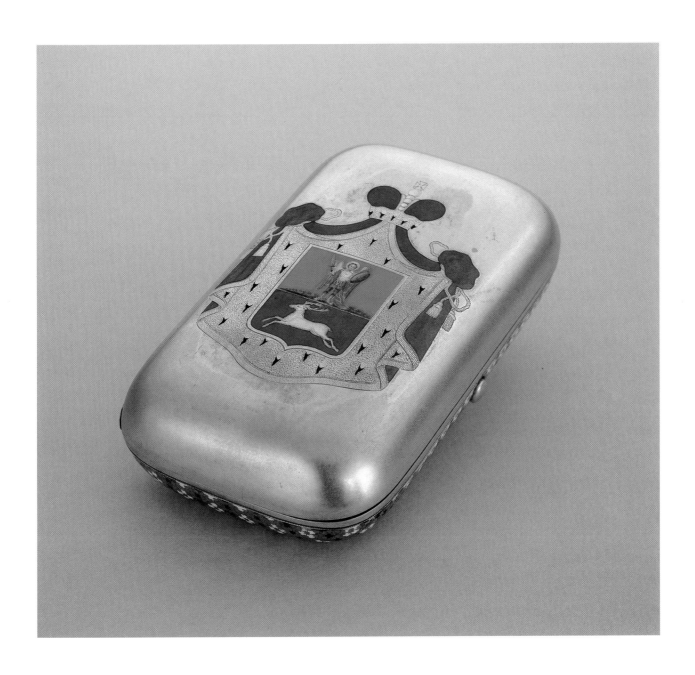

136 Frame

Small frame of gold, engine-turned with radiating lines and enamelled in translucent red around an oval wreath of chased green gold laurel leaves enclosing a bevelled glass. The vertical sides and arched top of the frame are decorated with a border of gold spheres, and the whole is mounted on three gold feet. The back of the frame is ivory with a gold strut of interlaced scrolls.

Dimensions
Height: 7.6 cm; width: 5.3 cm

Provenance
Christie's, Geneva, 1 May 1974, lot 220
K I 3 2 E

Marks

On the base
1 Maker's mark of Alexander Edvard Tillander, goldsmith registered in St Petersburg from 1860 until 1917[1]
2 Standard mark of the St Petersburg assay office for gold of 56 zolotniks (14 carats) used before 1899[2]

Russian, St Petersburg, *circa* 1890, by Alexander Edvard Tillander

1 2

Alexander Edvard Tillander may be considered to be one of Fabergé's leading rivals, and like him held the imperial warrant. Born in Helsinki on 30 June 1837 Tillander moved to Russia in 1848 when he was apprenticed to the goldsmith F. A. Holstenius at Tsarskoe Selo. In about 1855 he joined the firm of Carl Beks, a German jeweller in St Petersburg, and two years later he moved to the workshop of C. R. Schubert in Gorohovaya Street. In association with several other goldsmiths he established a business in Bolshaya Morskaya Street in 1860 and ten years later he became sole owner of the business and moved to 28 Bolshaya Morskaya Street and 13 Gorohovaya Street. In 1911 Tillander moved into the premises lately vacated by the firm of Hahn at 26 Nevsky Prospekt and acquired the Paris firm of Boucheron's outlet in Moscow. The firm closed both branches in 1917 and the Tillander family left Russia for Helsinki. Alexander Edvard Tillander died the following year but his son Alexander Theodor established a jewellery business which continues to flourish.[3]

Notes
1 Goldberg, no. 1362
2 Habsburg, no. 2
3 Goldberg, no. 1362; Helsinki, pp 62–72 (article by Herbert Tillander)

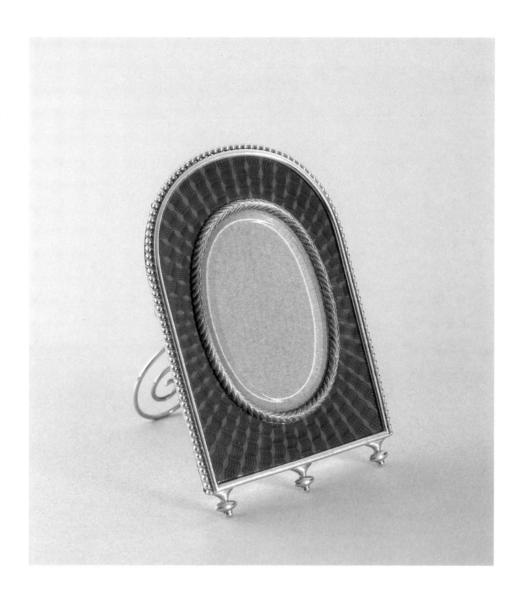

137 Cigarette case

Rectangular gold cigarette case of oval profile, with deeply chased lines radiating from the
rear left-hand corner, and with a raised thumbpiece set with a cabochon sapphire.

Dimensions
Height: 1.8 cm; length: 9.6 cm; depth: 6.2 cm

Provenance
Zervudachi, Vevey, 1975
K 236 A

Marks

In the base
1 Maker's mark of Karl Bok, goldsmith working in Moscow and St Petersburg in the late
 nineteenth and early twentieth centuries[1]
2 Standard mark of St Petersburg for gold of 56 zolotniks (14 carat) used between 1908 and
 1917[2]

In the lid 1 and
3 Russian mark for small work used between 1908 and 1917[3]

Russian, St Petersburg, 1908–17, by Karl Bok

Karl Bok's workshop specialised in gold cigarette cases many of which are similar
to those produced by Fabergé. In the case of the present box, comparison should
be made with an example in the Royal Collection, England, and with a box by
August Hollming in the collection of Sir Ralph Anstruther.[4] Bok's mark is found in
conjunction with the standard marks of both Moscow and St Petersburg, so it
must be assumed that he had shops in both cities.

Notes
1 Goldberg, no. 707
2 Habsburg, no. 7 illustrates the
 comparable mark for 72 zolotniks
3 Habsburg, no. 9
4 Snowman (1962) figs 199 and 132

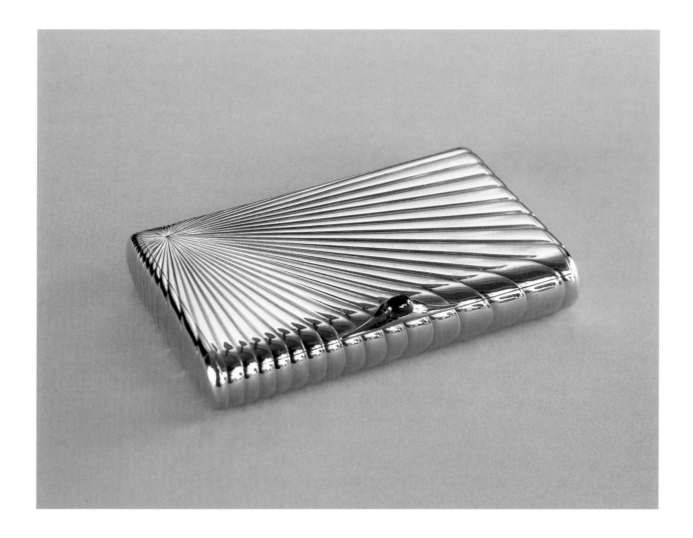

138 Cigarette and match case

Rectangular silver case of oval section, the upper part of which forms a container for matches, and the spine of which contains a tube for the tinder cord, closed by a ball on a chain attached to the cord. The whole is encrusted with silver, gold and enamelled monograms, coronets and badges including a bicycle, a sword, a lyre inscribed 'A. Oblakov', a whip, and miniature epaulettes with the cyphers of Tsar Alexander I and his brother, Nicholas I.

Dimensions
Height: 9.7 cm; width: 6 cm

Provenance
Christie's, New York, 19 October 1981, lot 348
K 177C

Marks

In the lid and in the base
1 Maker's mark of Henrik Lassas, goldsmith registered in St Petersburg from 1859 until 1890[1]
2 Mark used by the St Petersburg assay office for silver of 84 zolotniks (87.5%)[2]

Russian, St Petersburg, *circa* 1880, by Henrik Lassas

Henrik Lassas was born in Finland in 1843 but moved to St Petersburg to study in 1859. Four years later he entered into his apprenticeship and became master in 1869. It is recorded that he himself took in apprentices in 1890.[3]

As with cat. nos 114 and 139, the meaning of the symbols and monograms on this box has not been identified. However, since several of the encrustations cover engraved signatures and decoration, it is evident that they post-date the manufacture of the box itself.

Notes
1 Goldberg, no. 1529
2 Habsburg, no. 1
3 Goldberg, no. 1529

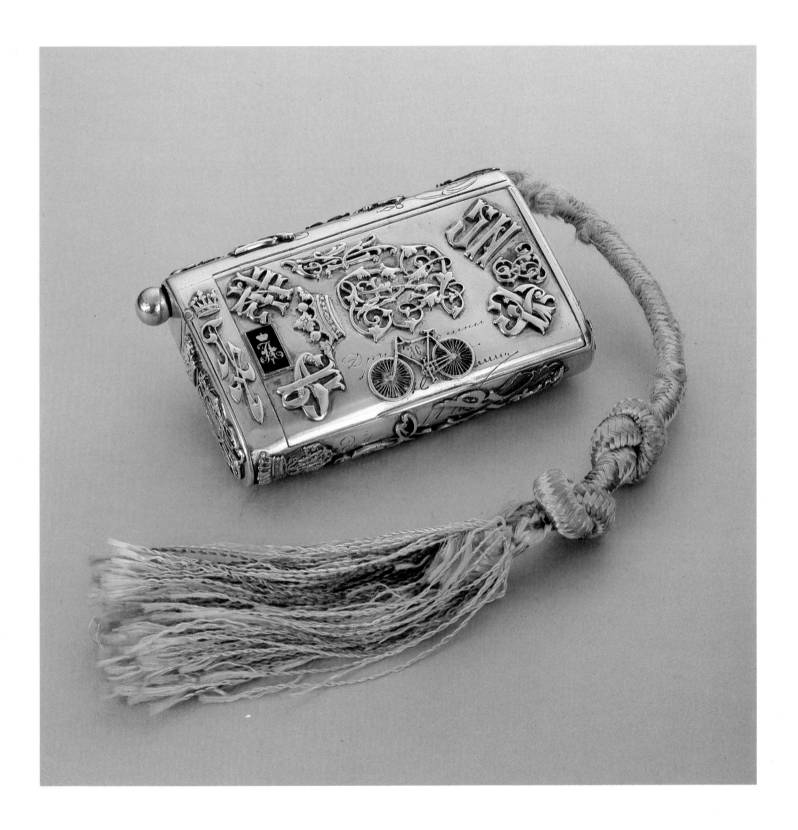

139 Cigarette case

Blued steel cigarette case encrusted with a variety of devices, signatures, monograms, and badges in gold and enamel and silver, and with coral, pearls, a diamond, an emerald, and a thumbpiece of silver-gilt with a cabochon sapphire. A silver label inside the case bears the inscription 'Je te veux'.

Dimensions
Height: 9.2cm; width: 8.4 cm; depth: 2 cm

Provenance
Sotheby's, Zurich, 13–14 November 1979, lot 467
K 148 K

Apparently unmarked

Russian, *circa* 1890

As with the silver-gilt case by August Holmström (cat. no. 114), it is no longer possible to interpret the meaning of all the encrustations on this case. Apart from a gold coin of the reign of the Emperor Napoleon I, the case bears the arms of Finland, a pig, an epaulet of a brigadier serving under Tsar Alexander III, a fly, a button, a cadet's epaulet and the helmet of an officer in the Pavlovski regiment.[1]

Although frequently referred to as 'gun metal' the material used to make this case is blued steel. More properly gun metal should be used to describe an alloy of copper and tin which was originally used in the manufacture of cannon.[2]

Notes
1 I am indebted to Mr Alexander von Solodkoff and to Miss Anne Hobbs, National Art Library, Victoria and Albert Museum, for their assistance in identifying the devices etc on this box
2 Alfred Bonnin, *Tutenag and Paktong* (Oxford, 1924) pp 76–77

Bibliography

Where references are used in three or more instances an abbreviated form has been employed

Alcouffe, D., 'The Collection of Cardinal Mazarin's Gems', *The Burlington Magazine* LXVI (September 1974) pp514–26

Allemagne, Henri René d', *Les Accessoires du costume et du mobilier* (Paris, 1928)

Amsterdam, Rijksmuseum catalogue *Uit de Schatkammer* I (Amsterdam, 1967)

Andolenko, Serge, *Badges of Imperial Russia* (Washington DC, 1972)

ANDRÉN Erik Andrén, *Svenskt Silversmiede, 1520–1850* (Stockholm, 1963)

Anon (ed) The 1596 inventory of the goods at death of Archduke Ferdinand II at Ruhelust, Innsbruck and Ambras, *Jahrbuch der Kunsthistorischen Sammlungen* VII (1888) pt II, ppCCXXVI – CCCXII

Anon (ed) Archive material published in *Jahrbuch der Kunsthistorischen Sammlungen* XX (1899) pt II

Anon (ed) 'Liste des peintres, sculpteurs, architectes, graveurs et autres artistes de la Maison du Roi . . . pendant le 16e, 17e et 18e siècles', *Nouvelles Archives de l'Art Français* (1872) pp55–108

Aschengreen Piacenti, K., *Il Museo degli Argenti* (Milan, 1968)

Azur, J. A., *Almanach des fabricans* (Paris, 1810)

BABELON E. Babelon, *Catalogue des camées antiques et modernes de la Bibliothèque Nationale* (Paris, 1897)

Baer, Winfried, 'Ors et Pierres des boîtes de Frederic-le-grand', *Connaissance des Arts* CCCXLVI (December 1980) pp100–105

BAINBRIDGE H. C. Bainbridge, *Peter Carl Fabergé* (London, 1949)

Balbinus, B. A., *Miscellanea historica regni Bohemiae* (Prague, 1679–88)

Baltimore, Museum of Art, 1962–68, see Lesley

Bannister, J., 'Fabergé, 1846–1920', *Connoisseur* CXCVI (September 1977) p70

BAPST (1883) G. Bapst, *Inventaire de Marie-Josèphe de Saxe, Dauphine de France* (Paris, 1883)

Bapst, G., *Histoire des Joyaux de la Couronne de France* (Paris, 1889)

Baring-Gould, S., *The Lives of the Saints* (Edinburgh, 1914)

BAUER AND HAUPT R. Bauer and H. Haupt (ed), 'Die Kunstkammer Kaiser Rudolphs II in Prag: ein Inventar aus den Jahren 1607–11', *Jahrbuch der Kunsthistorischen Sammlungen* LXII (1976)

Bennet, Douglas, *Irish Georgian Silver* (London, 1972)

Berlin, Kunstbibliothek, *Katalog der Ornamentstichsammlung der staatlichen Kunstbibliothek* (Berlin, 1936)

Berliner, R., *Ornamentale Vorlageblätter* (Leipzig, 1925)

Bernhardt, M., *Die Bildnismedaillen des Karls den Fünften* (Munich, 1919)

BERRY HILL Henry and Sidney Berry Hill, *Antique Gold Boxes* (London, 1960)

BIRINGUCCIO V. B. Biringuccio, *De la Pirotechnia*, trans and ed by C.S. Smith and M. Gnudi (New York, 1959)

Blair, Claude, *Three Presentation Swords* (HMSO London, 1972)

Boardman, J. and M.–L. Vollenveider, *Catalogue of the Engraved Gems and Finger Rings in the Ashmolean Museum* I (Greek and Etruscan) (Oxford, 1978)

BØJE Chr. A. Bøje, *Danske Guld-og Sølv Smedemaerker før 1870* (Copenhagen, 1954)

Bøje, Chr. A., *Danske Guld-og Sølv Smedemaerker før 1870* revised by Bo Bramsen, vol. I (Copenhagen, 1979)

Bonnin, Alfred, *Tutenag and Paktong* (Oxford, 1924)

DE BOODT A. Boetius de Boodt, *Le Parfaict Joaillier ou Histoire de Pierrerie* (Lyon, 1644)

Bottineau, Yves, *Catalogue de l'Orfèvrerie* (Paris, 1958)

Bradby, J. W., *Dictionary of Miniaturists* (London, 1898)

BRAMSEN Bo Bramsen, *Nordiske Snusdåser på Europaeisk Baggrund* (Copenhagen, 1965)

Bruck, R., *Die Sophienkirche in Dresden, ihre Geschichte und ihre Kunstschätze* (Dresden, 1912)

Burgold, K. and E. Schenk zu Schweinsberg, *Das herzogliche Museum zu Gotha* (Gotha, 1934) p144, ill.

Bury, Shirley, *Jewellery Gallery Summary Catalogue* (London, Victoria and Albert Museum, 1982)

Campardon, E. and J. Guiffrey, 'Gérard de Bèche', *Nouvelles Archives de l'Art Français* 1e serie (1876) pp359–72

Campbell, M., 'The Campion Hall Triptych and its Workshop' *Apollo* CXI (June 1980) pt 2, pp418–23

CARRÉ Louis Carré, *A Guide to Old French Plate* (London, 1971)

CELLINI *The Treatises of Benvenuto Cellini on Goldsmithing and Sculpture*, trans and ed by C. R. Ashbee (London, 1898)

Chaffanjon, Arnaud, *Le Petit Gotha Illustré* (Paris, 1968)

Champeaux, A. de, *Portefeuille des Arts Decoratifs* (Paris, 1888–89)

Chapu, Philippe, *Les Porcelainiers du XVIIIe siècle Français* (Paris, 1964)

Churchill, S. J., *Bibliografia Celliniana* (London, 1907)

Clouzot, Henri, *Dictionnaire des Miniaturistes sur Email* (Paris, 1924)

CORDEY Jean Cordey, *Inventaire des biens de Madame de Pompadour, rédigé après son décès* (Paris, 1939)

COURAJOD L. Courajod (ed) *Livre-Journal de Lazare Duvaux, marchand-bijoutier ordinaire du Roy* (Paris, 1873)

Dacier, Emile, *Catalogue de ventes et livrets de Salons illustrés par Gabriel de Saint-Aubin* XI (Paris, 1921)

DALTON (1912) O. M. Dalton, *Catalogue of Finger Rings in the British Museum* (London, 1912)

DALTON (1915) O. M. Dalton, *Catalogue of the engraved gems of the post-classical period in the British Museum* (London, 1915)

Darmstadt, Schlossmuseum, *Mopsiade* (Darmstadt, 1973)

Davey, Neil K., *Netsuke* (London, 1974)

Delaney, Mrs, *Life and Correspondence* (1861)

DENNIS Faith Dennis, *Three Centuries of French Silver* (New York, 1960)

Distelberger, R., 'Die Sarachi-Werkstatt und Annibale Fontana', *Jahrbuch der Kunsthistorischen Sammlungen* LXXI (1975) pp95–164

'Beobachtungen zur Steinschneidewerkstätten der Miseroni in Mailand und Prag', *Jahrbuch der Kunsthistorischen Sammlungen* LXXIV (1978) pp78–152

Doering, O., 'Des Augsburger Patricier Philipp Hainhofer Beziehungen zum Herzog Philipp II von Pommern-Stettin', *Quellenschriften für Kunstgeschichte und Kunsttechnik* II (1894)

DOSSIE Robert Dossie, *A Handmaid to the Arts* (London, 1758)

DOUET S.P.Douet, *Tableau des Symboles de l'Orfèvrerie de Paris* (Paris, 1809)

EICHLER AND KRIS F.Eichler and E.Kris, *Die Kameen im Kunsthistorischen Museum* (Vienna, 1927)

ENCYCLOPÉDIE Denis Diderot and Jean d'Alembert, *Encyclopédie, ou Dictionnaire raisonné des Sciences, des Arts at des Metiers* (Paris, Amsterdam, Neufchâtel, 1757–80)

Eriksen, Svend, *The James A.de Rothschild Collection at Waddesdon Manor, Sèvres Porcelain* (Fribourg, 1968)

Ermerin, R.J., *La Noblesse Titrée de l'Empire de Russie* (Sorau, 1898)

EVANS J.Evans, *A History of Jewellery 1100–1876* (London, 2nd edn 1970)

FALKE, von O.von Falke, *Die Kunstsammlung Eugen Gutman* (Berlin, 1912)

Feulner, A., *Stiftung Sammlung Schloss Rohoncz* III (Lugano-Castagnola, 1941)

FOCK (1974) C.W.Fock, 'Der Goldschmied Jacques Bylivelt aus Delft', *Jahrbuch der Kunsthistorischen Sammlungen* LXX (1974) pp89–178

Fock, C.W., *Der Goldschmied Jaques Bylivelt aus Delft* (Alphen aan de Rijn, 1975) p.38, note 106

FOCK (1976) C.W.Fock, 'Les Vases en lapis-lazuli des Collections Medicéenes du 16e siècle', *Münchner Jahrbuch der bildenden Künste* XXVII (1976) pp119–54

Foelkersam, Baron, 'La Calcédoine et son application aux arts', *Starye Gody* (St Petersburg, March 1916)

Foster, J.J., *Dictionary of Painters of Miniatures* (London, 1926)

FRANKENBERGER M.Frankenberger, *Die Alt-Münchner Goldschmiede und ihre Kunst* (Munich, 1912)

Gans, M.H., *Juwelen en Mensen* (Amsterdam, 1961)

Gaxotte, Pierre, *Le Faubourg St Germain* (Paris, 1966)

GOLDBERG T.Goldberg, F.Michoukov, N.Platanova, M.Postnikova-Losseva, *L'Orfèvrerie et la Bijouterie Russes aux* XV–XX *Siècles* (Moscow, 1967)

Goodison, N., *Ormolu: the work of Mathew Boulton* (London, 1974)

GRANDJEAN Serge Grandjean, *Les Tabatières du Musée du Louvre* (Paris, 1981)

Grommelt, G. and C.von Mertens, *Das Dohnasche Schloss Schlobitten in Ostpreussen* (Stuttgart, 2nd edn 1962)

Guiffrey, J., 'Liste de Scellés d'Artistes et d'Artisans', *Nouvelles Archives de l'Art Français* 2e serie, V (Paris, 1884)

HABSBURG Géza von Habsburg-Lothringen and Alexander von Solodkoff, *Fabergé* (London, 1979)

Hackenbroch, Y., 'Jewellery', *The Concise Encyclopedia of Antiques* (London, 1954) pp168–72

'Commessi', *Bulletin of the Metropolitan Museum of Art* XXIV (March 1966) pp212–24

'Jewellery at the Court of Albrecht V at Munich', *Connoisseur* CLXL (June 1967) pp74–82

'Un gioiello Medíceo inedito', *Antichità Viva* XIV (1975) pp31–35

HACKENBROCH (1979) Y.Hackenbroch, *Renaissance Jewellery* (London, 1979)

Jahrbuch der Hamburger Kunstsammlung II (1952)

Hampe, Th. von (ed), 'Nürnberger Ratsverlässe über Kunst und Künstler 1474–1618', *Quellenschrifte für Kunstgeschichte und Kunsthandel* XI (1904)

HANSMANN AND KRISS-RETTENBECK Hansmann and L.Kriss-Rettenbeck, *Amulett und Talisman* (Munich, 1966)

Harden, D.B., 'A Julio-Claudian Glass *phalera*', *The Antiquaries' Journal* LII (1972) pp350–53

HAVARD Henry Havard, *Dictionnaire de l'Ameublement et de la Decoration* (Paris, 1887–90)

Hayward, J.F., *The Art of the Gunmaker* (London, 1963)

HEAL Sir Ambrose Heal, *The London Goldsmiths, 1200–1800* (Cambridge, 1935)

Henkel, A., and A.Schöne, *Emblemata: Handbuch zur Sinnbildkunst des* XVI *und* XVII *Jahrhunderts* (Stuttgart, 1967)

HELSINKI Helsinki, The Museum of Applied Art, *Carl Fabergé and his Contemporaries* (Helsinki, 1980)

Herding, Klaus, *Pierre Puget* (Berlin, 1970)

Herman, H.J. (ed), Part of the 1542 inventory of the possessions of Isabella d'Este in 'Pier Jacopo Alari-Bonacolsi, genannt Antico', *Jahrbuch der Kunsthistorischen Sammlungen* XXVIII (1909–10) pp201–88

Hildburgh, W.L., 'Images of the Human Hand as Amulets in Spain', *Journal of the Warburg and Courtauld Institutes* XVIII (1955) pp67–80

Holzhausen, Walter, 'Email mit Goldauflage in Berlin und Meissen nach 1700', *Der Kunstwanderer* (September 1930) pp4–12 and 73

Johann Christian Neuber (Dresden, 1935)

'Johann Christian Neuber', *Apollo* LII (October 1950) pp104–106

Honey, W.B., *Dresden China* (London, 1946)

Honour, Hugh, *Goldsmiths and Silversmiths* (London, 1971)

Hunt, J., 'Jewelled neckfurs and *Flöhpelze*', *Pantheon* XXI (May 1963) pp151–57

Ilchester, the Earl of, 'Cameos of Queen Elizabeth and their reproductions in contemporary portraits', *Connoisseur* LXIII (1922) pp65–72

Innsbruck, Schloss Ambras, *Catalogue of the Kunstkammer* (Innsbruck, 1977)

Jeannerat, Carlo, 'De Gault et Gault de St Germain', *Bulletin de la Société de l'histoire de l'Art Français* (Paris, 1935) pp221–35

JEAN-RICHARD Pierrette Jean-Richard, *L'oeuvre gravé de François Boucher* (Paris, 1978)

Jewitt, Llewellyn, *Ceramic Art of Great Britain* (London, 1878)

Kalamajska-Saeed, M., '*Emaux sur verre* recently discovered in Poland', *Pantheon* XXXV (June 1977) pp126–30

Kansas City, William Rockhill Nelson Gallery, *Renaissance jewels selected from the Collection of Martin J.Desmoni* (1954), no. 75

Klar, Martin, 'Die Tabatieren Friedricks des Grossen', *Der Cicerone* XXI (1929) pt I, pp7–18

'Berliner Galanteriewaren aus Friederizianischer Zeit', *Pantheon* V (1930) pp69–72

'Berliner Golddosen aus Friederizianischer Zeit', *Pantheon* IX (1932) pp60–62

Kohlhaussen, H., *Nürnberger Goldschmiedekunst des Mittelalters und der Dürerzeit* (Berlin, 1968)

KREMPEL U.Krempel, 'Augsburger und Münchner Emailarbeiten des Manierismus', *Münchner Jahrbuch der bildenden Künste* XVIII (1967) pp111–86

Kris, E., *Meister und Meisterwerke der Steinschneidekunst* (Vienna, 1929)

 Steinschneidekunst in der Italienischen Renaissance (Vienna, 1929)

 Goldschmiedearbeiten des Mittelalters, der Renaissance und des Barock (Vienna, 1932)

Kunckel, Johann, *Ars Vetraria Experimentalis* (Jena, 1679)

LABARTE J. Labarte, *Description des Objets d'Art qui composent la collection Debruge Dumenil* (Paris, 1847)

LACROIX P. Lacroix (ed), 'Inventaire des Joyaux de la Couronne de France en 1560', *Révue Universelle des Arts* III (Paris, 1856) pp335–50; IV (Paris, 1856–57) pp445–56, 518–36

Lalonde, Richard, *Oeuvres diverses de Lalonde, decorateur et dessinateur, contenant un grand nombre de dessins pour la decoration interieure des apartements* (Paris, n.d.)

LE CORBEILLER Clare Le Corbeiller, *European and American Snuff Boxes, 1730–1830* (London, 1966)

Le Corbeiller, Clare, 'James Cox, a biographical review', *The Burlington Magazine* CXII (June 1970) pp351–58

Leithe-Jasper, M., 'Der Bergkristallpokal Herzog Philipps des Guten von Burgund – das 'Vierte Stück' der Geschenke König Karls IX von Frankreich an Erzherzog Ferdinand II', *Jahrbuch der Kunsthistorischen Sammlungen* LXVI (1970) pp227–41

LEROY Pierre Leroy, *Statutes et Privilèges du Corps des Marchands-Orfèvres-Joyailliers* (Paris, 1759)

LESLEY Parker Lesley, *Renaissance Jewels and Jewelled Objects from the Melvin Gutman Collection* (Baltimore, 1968)

LHOTSKY A. Lhotsky, 'Die Geschichte der Sammlungen', *Festschrift des Kunsthistorischen Museums zur Feier des Fünfzigjährigen Bestandes* (Vienna, 1941–45)

LIEB N. Lieb, *Die Fugger und die Kunst* (Munich, 1958)

Locquin, Jean, 'Catalogue raisonné de l'Oeuvre de Jean-Baptiste Oudry', *Nouvelles Archives de l'Art Français* 4ᵉ serie, VI (Paris, 1912) pp1–209

London, British Museum, *Jewellery through 7000 years* (London, 1976)

London, Delomosne and Sons Ltd, *Gilding the Lily* (London, 1978)

London, The Queen's Gallery, Buckingham Palace, *Sèvres from the Royal Collection* (London, 1979)

London, Royal Academy, *European Masters of the Eighteenth Century* (London, 1954)

London, South Kensington Museum, *Special Exhibition of Works of Art* (London, 1862)

London, Victoria and Albert Museum, *Catalogue of the Jones Collection, Part II Ceramics etc* (London, 1923)

 Catalogue of the Jones Collection, Part III Paintings and Miniatures (London, 1923)

 Third International Art Treasures Exhibition (London, 1962)

 British Antique Dealers Association Golden Jubilee Exhibition (London, 1968)

 Fabergé 1846–1920 (London, 1977)

London, Wartski, *A Thousand Years of Enamel* (London, 1971)

Luthmer, F., *Der Schatz des Freiherrn Karl von Rothschild. Meisterwerke alter Goldschmiedekunst aus dem 14.–18. Jahrhundert* (Frankfurt, 1882)

MAZE-SENCIER Alphonse Maze-Sencier, *Le Livre des Collectionneurs* (Paris, 1885)

Molinier, Emile, *Dictionnaire des Emailleurs* (Paris, 1885)

Molinier, E. and G. Migeon, *Le legs de Adolphe de Rothschild aux Musées du Louvre et de Cluny* (Paris, 1902)

Molle, F. van, 'De Pax van Averbode in Hofkirche te Innsbruck en het Borstkrus van Abb. Mattheus 's Volders', *Revue Belge* XLI (1972) pp3–20

MULLER P. Muller, *Jewels in Spain 1500–1800* (New York, 1972)

Munich, Schatzkammer of the Residenz, *Official Guide* (Munich, 3rd edn 1970)

Munich, Staatliche Münzsammlung, catalogue in the series *Antike Gemmen in Deutschen Sammlungen* (Munich, 1975)

Munich, Völkerkundemuseum, *Wittelsbach und Bayern, Krone und Verfassung* (Munich, 1980)

Neri, Antonio, *L'Arte Vetraria* (Florence, 1612)

New York, A la Vieille Russie, *The Art of the Goldsmith and Jeweler* (New York, 1968)

New York, Metropolitan Museum of Art, *The Grand Gallery*, 19 October 1974–5 January 1975

New York, National Antique and Art Dealers Association of America, *Art Treasures Exhibition* (Parke-Bernet Galleries, New York, 1967)

NOCQ H. Nocq, *Le Poinçon de Paris* (Paris, 1926–31)

NOCQ AND DREYFUS H. Nocq and C. Dreyfus, *Tabatières, boites et étuis. . . du Musée du Louvre* (Paris, 1930)

Norman, A. V. B., *Gold Boxes* (London, Wallace Collection, 1975)

NORTONS R. and M. Norton, *A History of Gold Snuff Boxes* (London, 1938)

OMAN C. C. Oman, *Catalogue of the Rings in the Victoria and Albert Museum* (London, 1930)

L'Ordre des Francsmaçons trahi et le Secret des Mopses revélé (Amsterdam, 1763)

D'OTRANGE M. L. D'Otrange, 'A Collection of Renaissance Jewels at the Art Institute of Chicago', *Connoisseur* CXXX (September 1952) pp66–74

D'Otrange-Mastai, M. L., 'Jewels of the XVth and XVIth Centuries', *Connoisseur* CXXXII (November 1953) pp126–33

D'OTRANGE-MASTAI M. L. D'Otrange-Mastai, 'A Collection of Renaissance Jewels', *Connoisseur* CXXXIX (April 1957) pp126–32

Paris, Grand Palais, *Porcelaines de Vincennes* (Paris, 1977)

Paris, Musée du Louvre (Cabinet des Dessins), *Dessins Français de l'Art Institute de Chicago de Watteau à Picasso* (Paris, 1976)

Paulys, *Real-Encyclopedie der Klassischen Altertumswissenschaft* (Stuttgart, 1894–1967)

PAZAUREK Gustav E. Pazaurek, *Deutsche Fayence – und Porzellan-Hausmaler* (Leipzig, 1925)

Pechstein, K., *Goldschmiedewerke der Renaissance. Kataloge des Kunstgewerbemuseums Berlin* V (Berlin, 1971)

Piacenti Aschengreen, K., *Il Museo degli Argenti* (Milan, 1968)

Pigler, A., *Barockthemen: eine Auswahl von Verzeichnissen zur Ikonographie des 17. und 18. Jahrhunderts* (Budapest, 1956)

POULLIN DE VIEVILLE Poullin de Vieville, *Code de l'Orfèvrerie* (Paris, 1785)

PRINCELY MAGNIFICENCE London, Victoria and Albert Museum *Princely Magnificence: Court Jewels of the Renaissance 1500–1630* (London, 1980)

PULSKY, RADISIC AND MOLINIER C. Pulsky, E. Radisic and E. Molinier, *Chefs-d'oeuvre d'Orfèvrerie ayant figuré a l'Exposition de Budapest* I and II (Paris, 1884–86)

READ C. H. Read, *Catalogue of the Works of Art bequeathed to the British Museum by Baron Ferdinand Rothschild M.P. 1898* (London, 1902)

REITLINGER G. Reitlinger, *The Economics of Taste* II (London, 1962)

Ripa, C., *Iconologia* (Padua, 1611)

ROSENBERG Marc Rosenberg, *Der Goldschmiede Merkzeichen* (Berlin, 1922–28)

Ross, Marvin C., *The Art of Carl Fabergé and his Contemporaries* (Norman, Oklahoma, 1965)

ROUQUET André Rouquet, *The Present State of the Arts in England 1755*, ed by R. W. Lightbown (London, 1970)

Savill, Rosalind, 'Six enamelled snuff boxes in the Wallace Collection', *Apollo* CXI (April, 1980) p305 ff

Scheicher, E., *Die Kunst- und Wunderkammern der Hapsburger* (Vienna, 1979)

Schlosser, J. von, *Die Kunst- und Wunderkammer der Spätrenaissance. Ein Beitrag zur Geschichte des Sammelwesens* (Leipzig, 1908)

Secrets concernant les arts et metiers 4 vols (Paris, 1790)

Seidel, Paul, 'Die Prunkdosen Friedrichs des Grossen', *Das Hohenzollern Jahrbuch* V (1901) pp74–86

Seling, H., *Die Kunst der Augsburger Goldschmiede 1529–1868* (Munich, 1980)

Severin, H. M., *Gold and Platinum Coinage of Imperial Russia from 1701–1911* (New York, 1958)

SIEBMACHER J. Siebmacher, *Grosses und allgemeines Wappenbuch in einer neuen vollständig geordneten und reich vermehrten Auflage mit heraldischen und historisch genealogischen Erläuterungen* (Nürnberg, 1854–)

Smols' Kaya, N., *Teniers* (Leningrad, 1962)

SNOWMAN (1962) A. K. Snowman, *The Art of Carl Fabergé* (London, 1962)

SNOWMAN (1966) A. K. Snowman, *Eighteenth Century Gold Boxes of Europe* (London, 1966)

SNOWMAN (1974) A. K. Snowman, *Eighteenth Century Gold Boxes of Paris* (London, 1974)

Snowman, A. K., *Carl Fabergé*, (London, 1979)

SOLODKOFF A. von Solodkoff, *Russian Gold and Silver* (London, 1981)

Solodkoff, A. von, 'Fabergé's London Branch', *Connoisseur* CCIX (February 1982) pp105–108

Solodkoff, A. von and Géza von Habsburg-Lothringen, 'Tabatièren Friedrichs des Grossen', *Kunst und Antiquitäten* III/83 (Munich, 1983) pp36–41

Soltl, J. M., *Max Joseph, König von Bayern* (Stuttgart, 1837)

Sponsel, J. L., *Das Grüne Gewölbe* (Leipzig, 1929)

Stettiner, R., *Das Kleinodienbuch des Jacob Mores* (Hamburg, 1915)

Strong, R., *Portraits of Queen Elizabeth* (Oxford, 1963)

Tait, H., 'Historiated Tudor Jewellery', *The Antiquaries' Journal* XLII (1962) pp226–46

'Heröld and Hunger', *British Museum Quarterly* XXV (1962) pp39–41

TARDY Tardy, *Les Poinçons de Garantie Internationaux pour l'Or* (Paris, 6th edn 1967)

TAYLOR AND SCARISBRICK G. Taylor and D. Scarisbrick, *Finger rings from Ancient Egypt to the Present Day* (London, 1978)

Thomas, B., 'Die Münchner Waffenvorzeichnungen des Etienne Delaune und die Prunkschilde Heinrichs II von Frankreich', *Jahrbuch der Kunsthorischen Sammlungen* LVIII (1962) pp101–68

Tillander, H., 'Die Tafeldiamanten der Schatzkammer in Munchen', *Gold und Silber* (April 1969) pp96–101

Torneus, Marina, 'Elegance and Craftsmanship' *Apollo* CI (June 1975) p469

Trésors d'Art, Les, en Russie II (St Petersburg, 1902)

Vial, H., A. Marcel and A. Girodie, *Les Artistes Decorateurs du Bois* (Paris, 1922)

VOET Voet jr, Elias, *Nederlandse Goud-en Zilvermerken* (The Hague, 7th edn 1974)

WADDESDON CATALOGUE Serge Grandjean, Kirsten Aschengreen Piacenti, Charles Truman, Anthony Blunt, *The James A. de Rothschild Collection at Waddesdon Manor. Gold Boxes and Miniatures of the Eighteenth Century* (Fribourg, 1975)

Walpole, H., *Description of the Villa of Horace Walpole . . . at Strawberry Hill* (1774)

Walters, H. B., *Catalogue of the Engraved Gems and Cameos, Greek, Etruscan and Roman in the British Museum* (London, 1926)

Waterfield, Hermione and C. Forbes, *Fabergé* (New York, 1978)

Watin, J. W., *L'Art de peintre, doreur, vernisseur* (Paris, 1758)

Watney, B. and R. Charleston, 'Petitions for Patents, etc', *Transactions of the English Ceramic Circle* VI (London, 1966) pt 2, pp57–123

Watson, F. J. B., 'Beckford, Mme de Pompadour, the duc de Bouillon and the taste for Japanese lacquer in Eighteenth Century France', *Gazette des Beaux Arts* LXI (February 1963) pp101–27

The Choiseul Box (Oxford, 1963)

WATSON F. J. B. Watson, *The Wrightsman Collection vol* III, *Furniture, Gold Boxes* (New York, 1970)

Watzdorf, E. von, 'Fürstlicher Schmuck der Renaissance aus dem Besitz der Kurfürstin Anna von Sachsen', *Münchner Jahrbuch der Bildenden Künste* XI (1934) pp50–64

'Gesellschaftsketten und Kleinöde vom Anfang des XVII Jahrhunderts', *Jahrbuch der Preussischen Kunstsammlungen* LIV (1933) p267 ff

Weiss, F., 'Bejewelled Fur Tippets and the Palatine Fashion', *Costume: the Journal of the Costume Society* IV (1970) pp37–43

Wells-Cole, Anthony, *Gold boxes and étuis in the Leeds Art Gallery* (n.d.)

WILHELM G. Wilhelm, 'Der historische lichtensteinische Herzogshut', *Jahrbuch des historischen Vereins für das Fürstentum Lichtenstein* LX (1960) pp7–20

Williamson, G. C., *Catalogue of the Collection of Jewels and Precious Works of Art, the Property of J. Pierpont Morgan* (London, 1910)

Winter, J., and others, *Smalti, Gioielli, Tabacchiere* (Milan, 1981)

Index of Marks

Page references appear beneath the marks which are reproduced four times actual size

ROMAN LETTERS

A

290 250 214 212 320 330, 332, 334 376

A **B**

322, 324 114 364 242 216, 218 360 190

C **D**

200 252 292 302 166, 168 188

D **E**

202 248, 250 172 220 258 176, 188, 202, 260 232, 318

F

252 292 174 216 176

G

174 222, 224 248 262 180 110

H

176, 178 226 368 340, 342, 344, 346

I

326, 328

J

180, 182 246 186, 192 238 196, 208 176 292

K

86, 190, 192 228, 230

L

194 228 222 236, 238

M

196 226

N

198, 200 232, 234 254 210

N

254 194

P

202 168 232 166

P

172 228, 232, 234 230 218, 224, 228 220 258

R

206

S

236, 238 260 302

T

238

V

180, 304

X

208

Z

212

CYRILLIC LETTERS

336 366 324, 348 354, 356 352, 358

312, 314, 318 316 338 314, 316, 318, 320, 330, 332, 336, 342, 344, 346, 350 326 360, 362 348, 350

NUMBERS

276 262 174 260 312, 314, 316, 364 344 342

318, 334, 338 346, 366 340 354, 356 368 356 360

326, 332, 358, 362 320, 322 352 324, 330, 332, 336, 350 326, 348 358

HUMAN BEINGS

360 236, 238 242 222, 224, 226, 230 252 338, 342 340, 346, 354, 366 166, 168, 172, 174, 176, 178, 180, 182

248 258 234 232

ANIMALS

242 276 246 210, 212, 214, 216, 218, 220, 296 184, 186, 188, 190, 192, 194, 196, 198, 200, 202 254 228, 234 250

236 236

BIRDS

166, 174, 178, 184, 196, 206, 208, 210, 230, 234, 236, 238, 250, 292 274 322, 358, 362 242 184, 186, 188, 190, 192, 194, 196, 198, 200, 202 246 178, 182 298 218

FISH

266 234 166, 168, 170, 172, 174, 176, 178, 180, 182 248 258

INVERTEBRATES

218 180, 266 188 204, 206, 208 254

PLANTS

222, 224, 226, 228, 230 252 262 210, 212, 214, 216, 218 250 176, 184, 202 240

MISCELLANEOUS ARTICLES

174, 262 204, 206, 260
 208

BUILDINGS

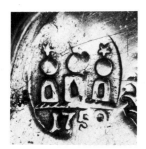

292

UNIDENTIFIED

170 174 178 184 184 198 206 214

220 230 260

General Index